24.50

INTERIM SITE

EVANSTON PUBLIC LIBRARY

3 1192 00569 7170

701 Tilli.P

Tillich, Paul, 1886-1965.

On art and architecture

(

F

FEB

D1248166

JUN 13 1988

On Art and Architecture

Paul Tillich

On Art
and Architecture

Edited and with an Introduction by
John Dillenberger, in collaboration with Jane Dillenberger

Translations from German Texts by Robert P. Scharlemann
Plates selected by Jane Dillenberger

EVANSTON PUBLIC LIBRARY
1703 ORRINGTON AVENUE
EVANSTON, ILLINOIS 60201

CROSSROAD • NEW YORK

1987

The Crossroad Publishing Company
370 Lexington Avenue, New York, N.Y. 10017

Copyright © 1987 by The Crossroad Publishing Company

All rights reserved. No part of this book may be reproduced,
stored in a retrieval system, or transmitted, in any form
or by any means, electronic, mechanical, photocopying,
recording or otherwise, without the written permission of
The Crossroad Publishing Company.

Printed in the United States of America

Library of Congress Cataloging in Publication Data

Tillich, Paul, 1886–1865.
On art and architecture.

Includes index.
1. Art—Philosophy. 2. Tillich, Paul, 1886–1965—
Aesthetics. 3. Christian art and symbolism—Modern
period, 1500– . I. Dillenberger, Jane.
II. Dillenberger, John. III. Title.
N68.T55 1987 701 87-6899
ISBN 0-8245-0829-7

Contents

Part III: Writing from the American Period

The Visual Arts

Art and Architecture

Part IV: Statements for Exhibitions and Journals

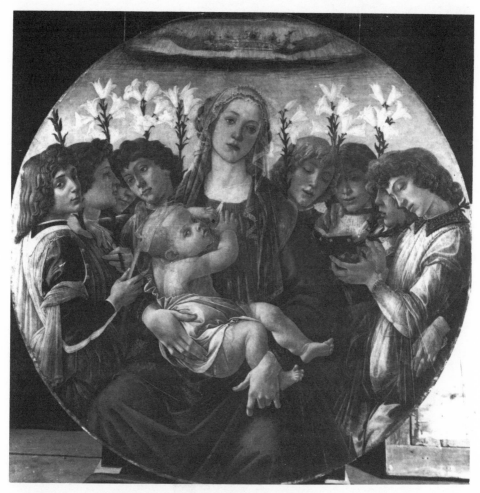

1. Sandro Botticelli, *Madonna and Child with Singing Angels*
(1477; Berlin-Dahlem Museum, Berlin).

2. *Apollo* (ca. 460 B.C.E.; Olympia Museum, Olympia).

3. *Venus de Milo* (ca. 200–100 B.C.E.; Louvre, Paris).

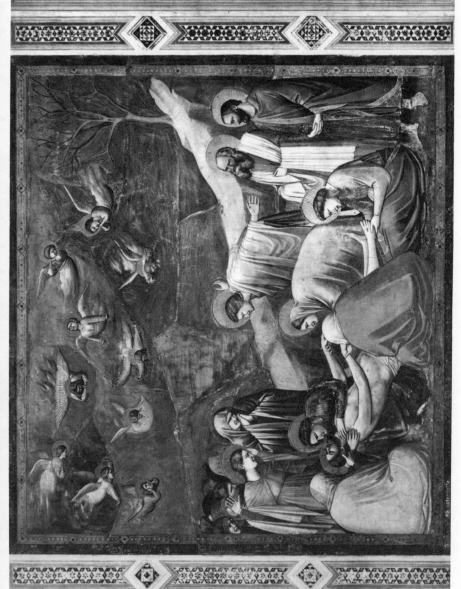

4. Giotto di Bondone, *Lamentation over the Dead Christ* (1305; Arena Chapel, Padua).

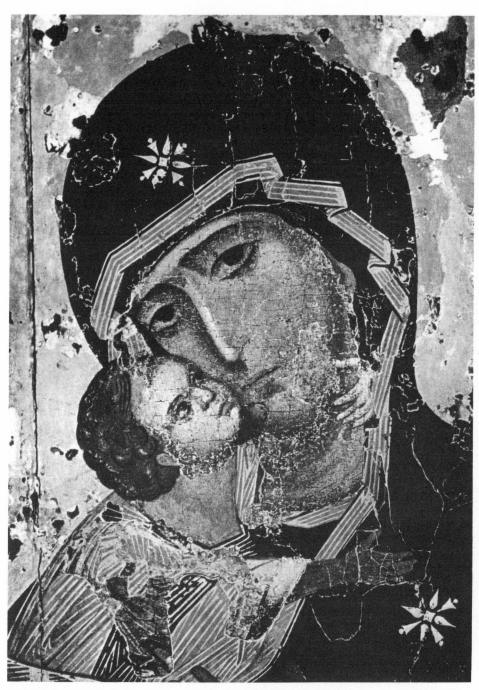

5. *The Vladimir Mother of God* (12th century; Cathedral of the Dormition, Moscow).

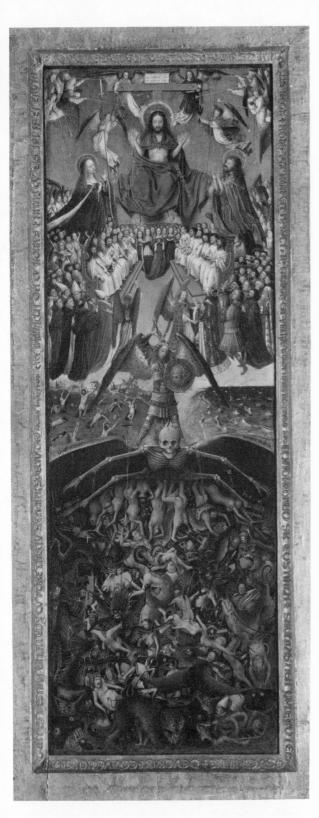

6. Jan van Eyck,
 The Last Judgement
 (ca. 1425–1430;
 The Metropolitan Museum
 of Art, New York.
 The Fletcher Fund, 1933).

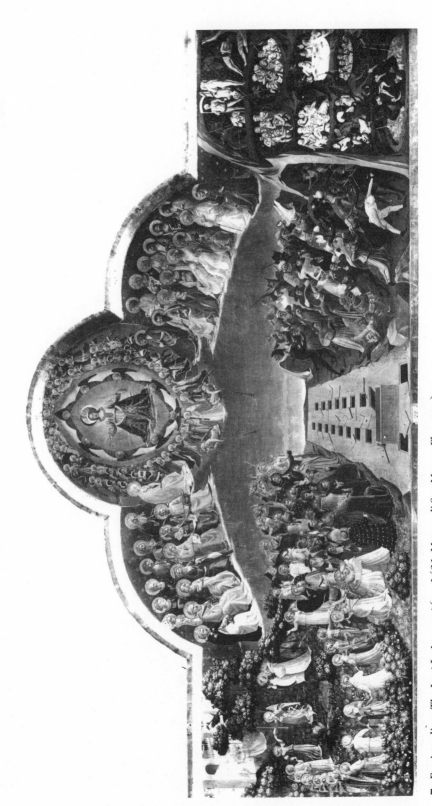

7. Fra Angelico, *The Last Judgement* (ca. 1431; Museo di San Marco, Florence).

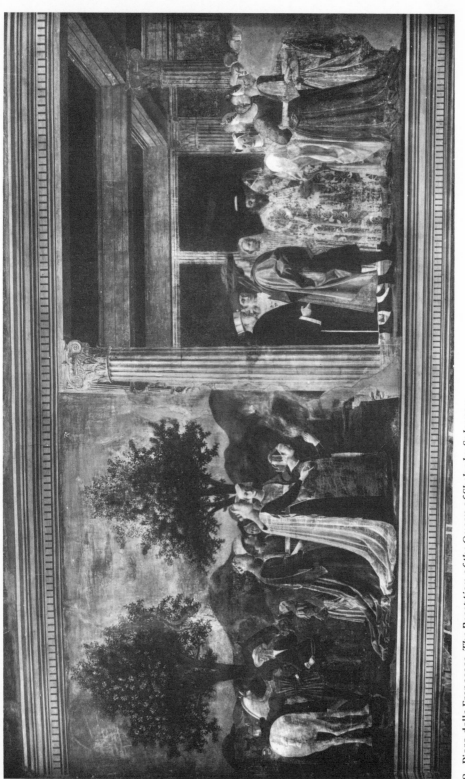

8. Piero della Francesca, *The Reception of the Queen of Sheba by Solomon* (1452–1466; Chiesa di San Francesco, Arezzo).

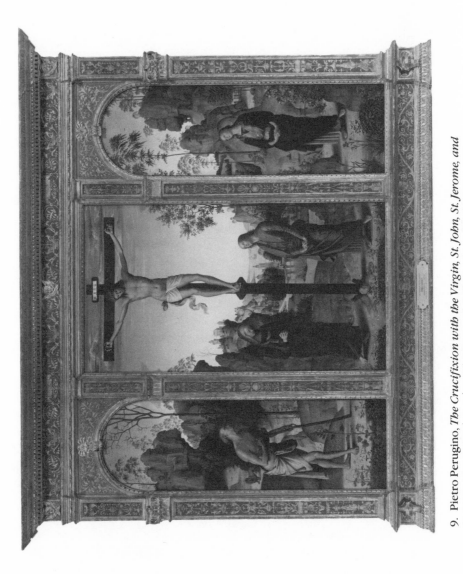

9. Pietro Perugino, *The Crucifixion with the Virgin, St. John, St. Jerome, and St. Mary Magdalen* (ca. 1485; The National Gallery of Art, Washington, D.C. The Andrew W. Mellon Collection).

10. Raphael Sanzio, *The Alba Madonna* (1508–1511; The National Gallery of Art, Washington, D.C. The Andrew W. Mellon Collection).

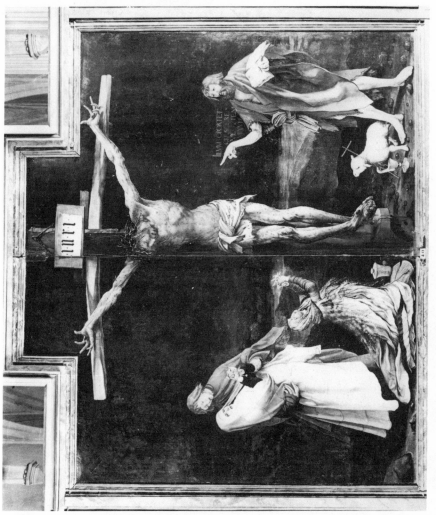

11. Mathias Grünewald, *The Crucifixion*, *The Isenheim Altarpiece* (ca. 1515; Musée d'Unterlinden, Colmar).

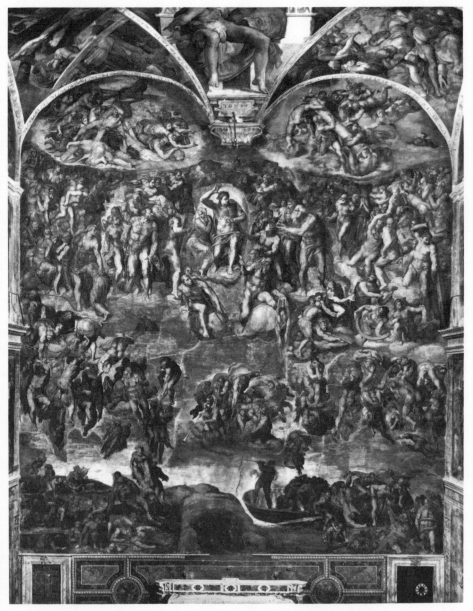

12. Michelangelo Buonarroti, *The Last Judgment* (1536–1541; The Sistine Chapel, Vatican City).

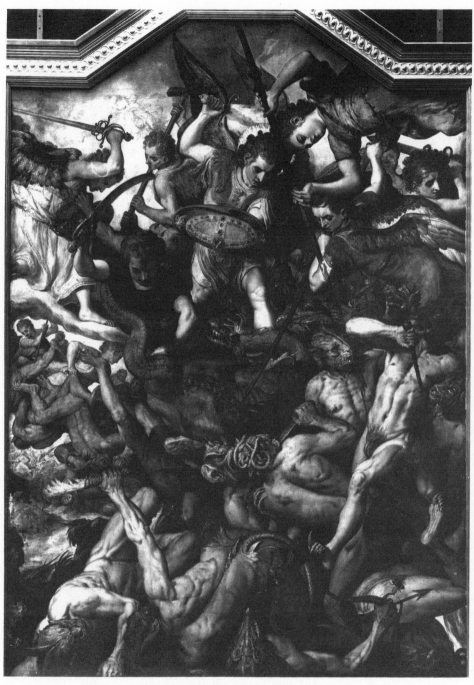

13. Frans Floris, *The Fall of the Rebel Angels* (1554; Antwerp Museum, Antwerp).

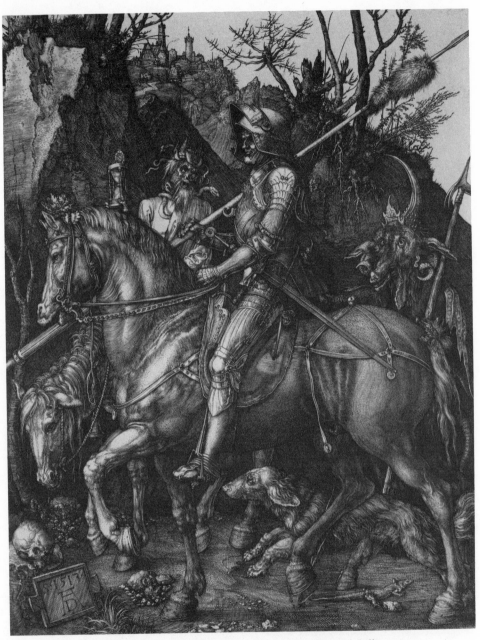

14. Albrecht Dürer, *Knight, Death and the Devil* (1513; The National Gallery of Art, Washington, D.C. Gift of W. G. Russell Allen).

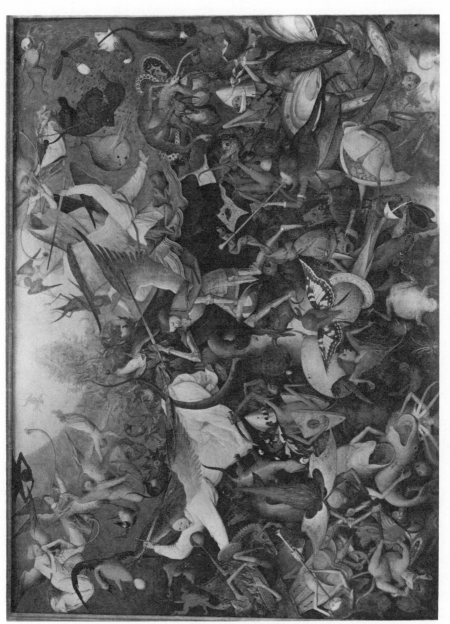

15. Pieter Brueghel, *Fall of the Rebel Angels* (1562; Musée de Beaux Arts, Brussels).

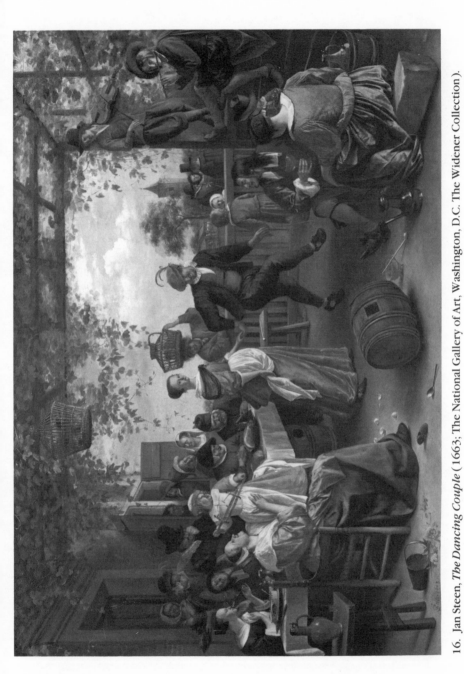

16. Jan Steen, *The Dancing Couple* (1663; The National Gallery of Art, Washington, D.C. The Widener Collection).

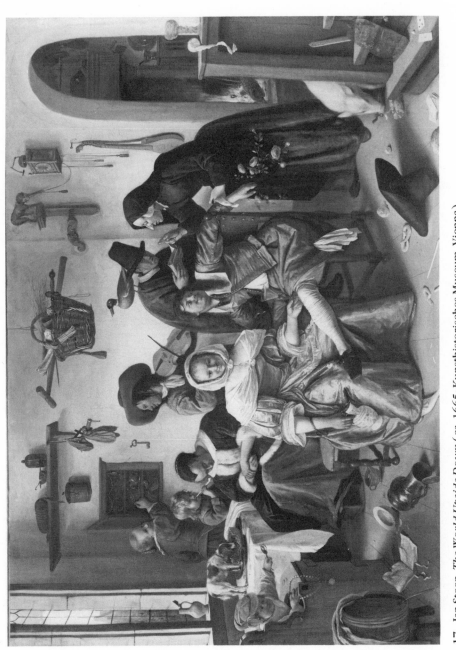

17. Jan Steen, *The World Upside Down* (ca. 1665; Kunsthistorisches Museum, Vienna).

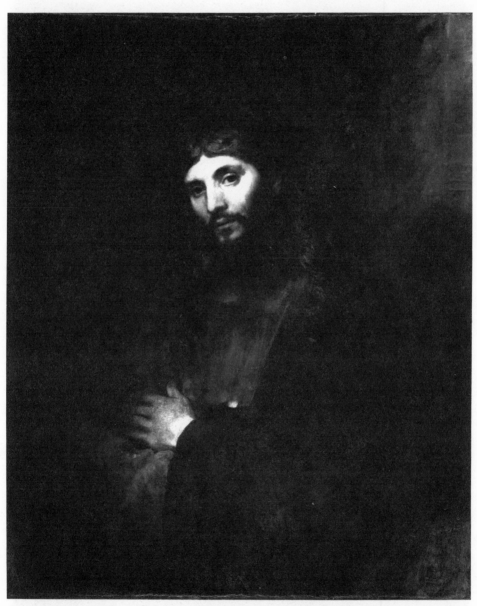

18. Rembrandt van Rijn, *Christ with Folded Arms* (n.d.; The Hyde Collection, Glens Falls, New York).

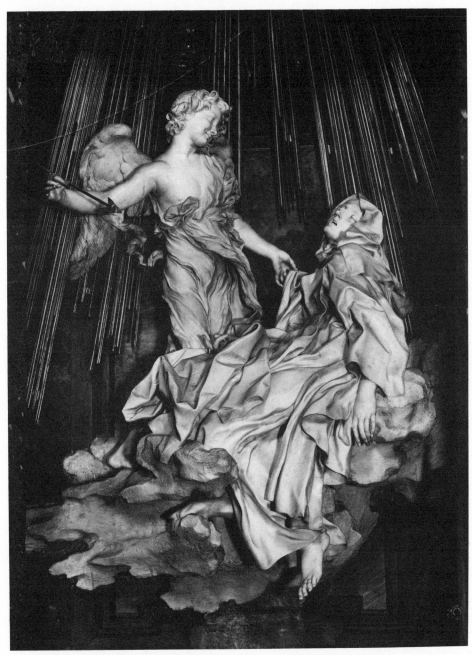

19. Gian Lorenzo Bernini, *The Transverberation of St. Teresa* (1644–1647;
Chiesa di Santa Maria della Vittore, Rome).

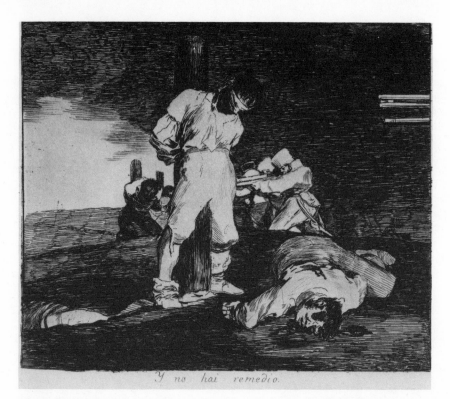

20. Francesco de Goya, *Los Desastres de la Guerra, Plate #15: Y no hai remedio!* (1810–1813; The National Gallery of Art, Washington, D.C. The Rosenwald Collection).

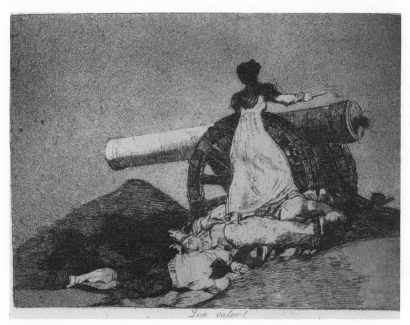

21. Francesco de Goya, *Los Desastres de la Guerra, Plate #7: Que Valor!* (1810–1813; The National Gallery of Art, Washington, D.C. The Rosenwald Collection).

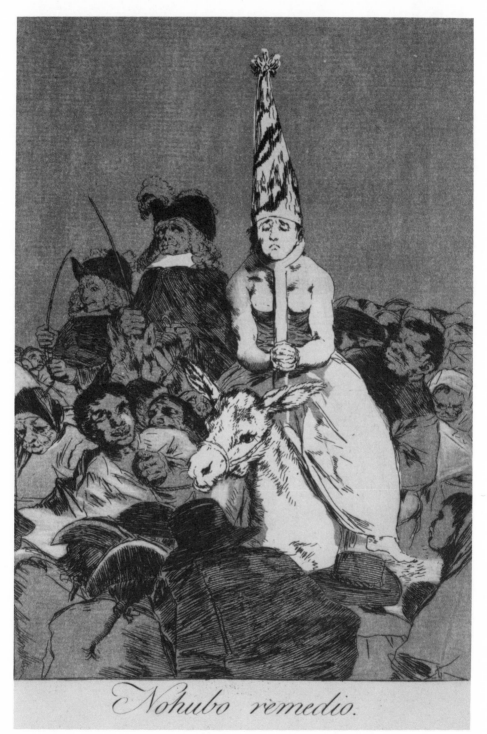

22. Francesco de Goya, *Los Caprichos, Plate #24: Nohubo remedio* (1796–1798; The National Gallery of Art, Washington, D.C. The Rosenwald Collection).

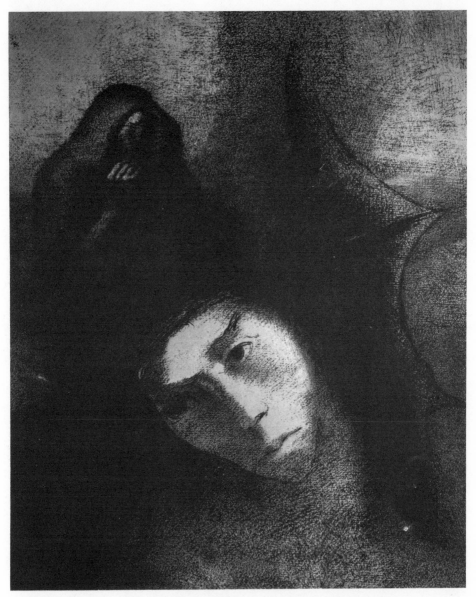

23. Odilon Redon, *The Temptation of St. Anthony, Plate #18: Anthony: What is the object of all this? The Devil: There is no object!* (1896; The Museum of Modern Art, New York. Gift of Abby Aldrich Rockefeller).

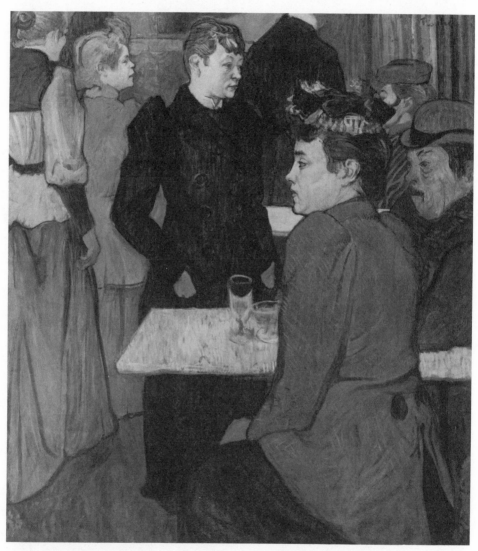

24. Henri Toulouse-Lautrec, *A Corner of the Moulin de la Galette* (1892; The National Gallery of Art, Washington, D.C. The Chester Dale Collection).

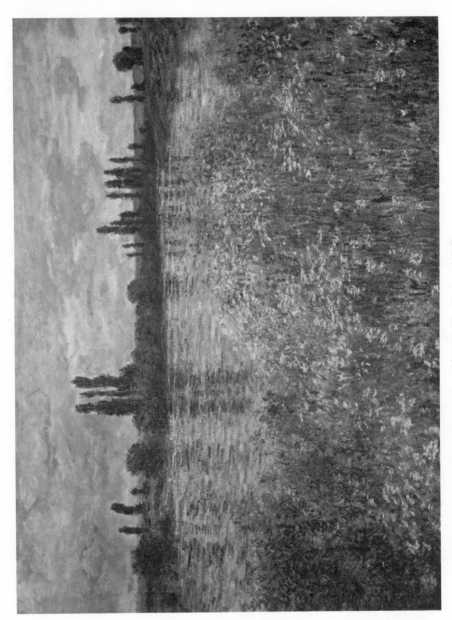

25. Claude Monet, *Banks of the Seine, Vetheuil* (1880; The National Gallery of Art, Washington, D.C. The Chester Dale Collection).

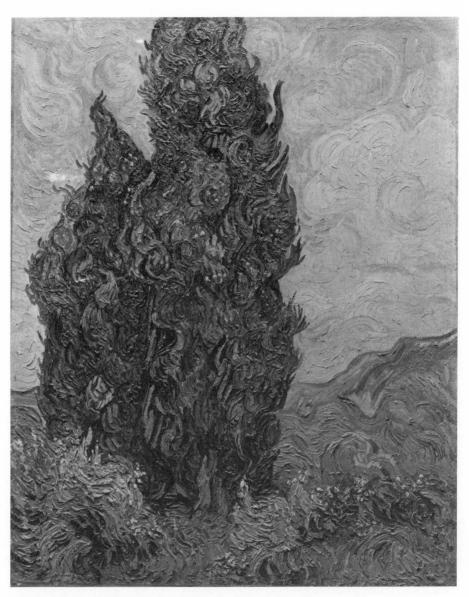

26. Vincent Van Gogh, *Cypresses* (1889; The Metropolitan Museum of Art, New York. The Rogers Fund, 1949).

27. Vincent Van Gogh, *The Night Café* (1888; Yale University Art Gallery, New Haven. Bequest of Stephen Carlton Clark, B.A., 1903).

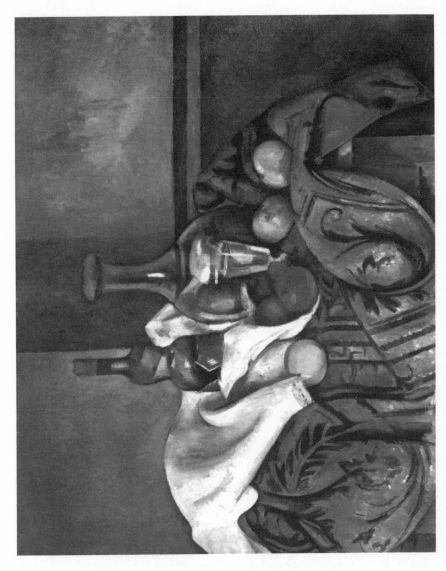

28. Paul Cézanne, *Still Life with Peppermint Bottle* (ca. 1894; The National Gallery of Art, Washington, D.C. The Chester Dale Collection).

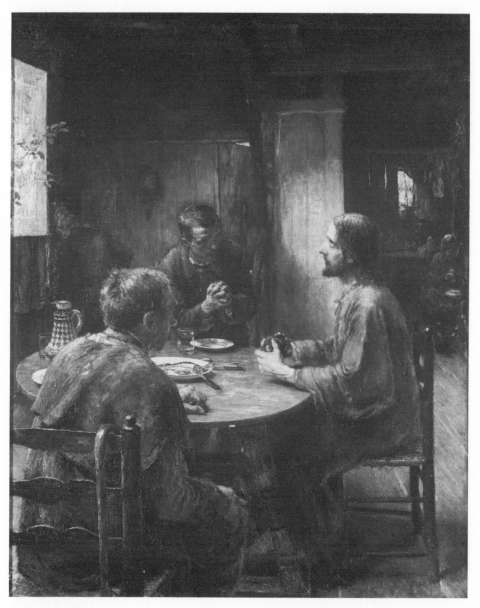

29. Fritz von Uhde, *Christ at Emmaus* (1885–1900; Staedel Kunstinstitut, Frankfurt am Main).

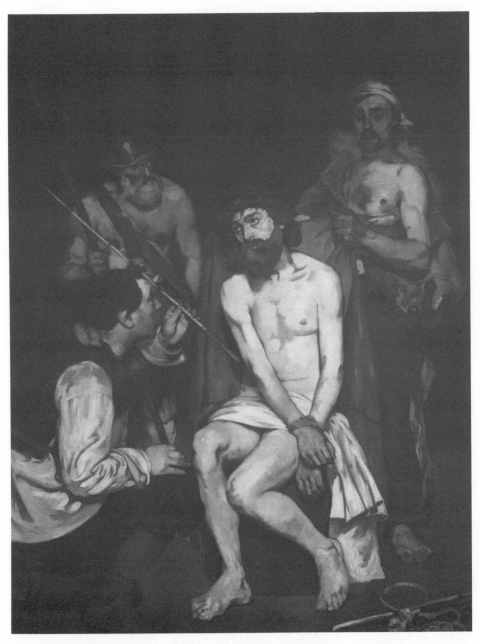

30. Edouard Manet, *The Mocking of Christ* (1865; The Art Institute of Chicago, Chicago. Gift of James Deering, 1925).

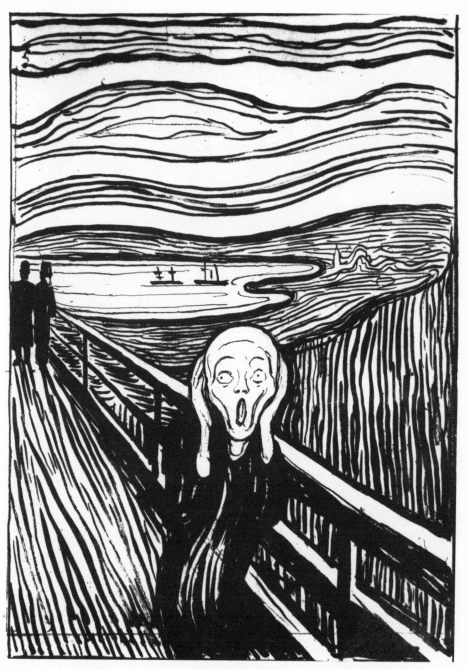

31. Edvard Munch, *The Scream* (1893; Oslo Municipal Museum, Oslo).

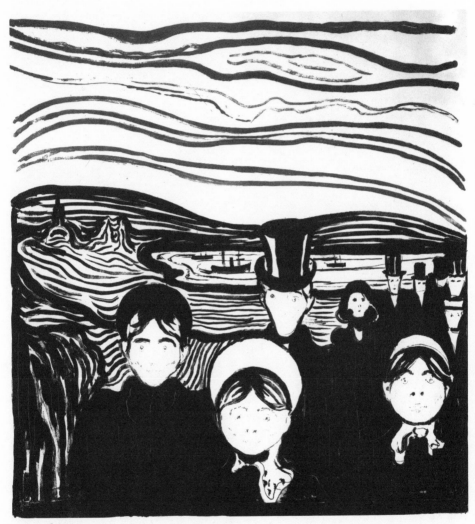

32. Edvard Munch, *Anxiety* (1896; The Museum of Modern Art, New York. Purchase).

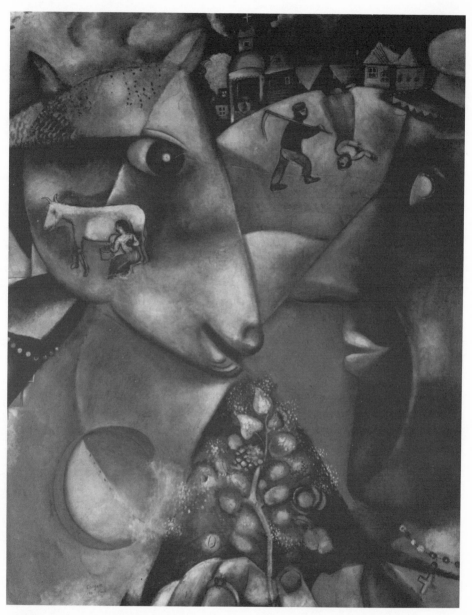

33. Marc Chagall, *I and the Village* (1911; The Museum of Modern Art, New York. Mrs. Simon Guggenheim Fund).

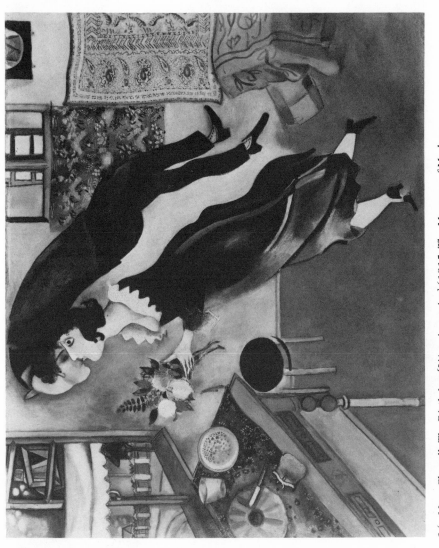

34. Marc Chagall, *The Birthday [L'Anniversaire]* (1915; The Museum of Modern Art, New York. Acquired through the Lillie P. Bliss Bequest).

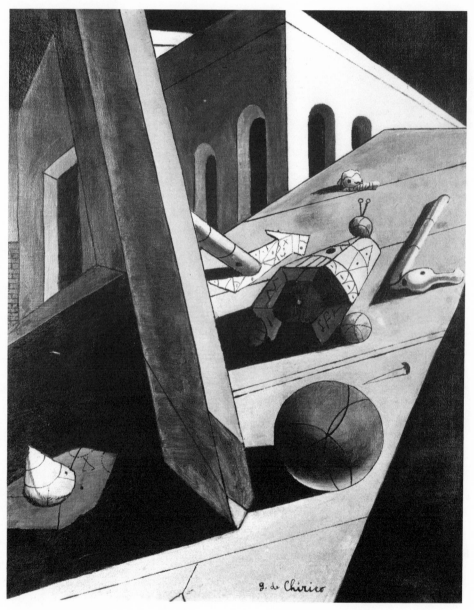

35. Giorgio de Chirico, *The Evil Genius of a King* (1914–1915; The Museum of Modern Art, New York. Purchase).

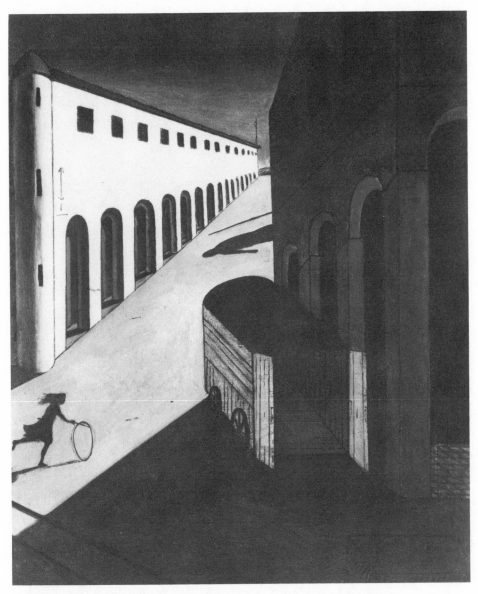

36. Giorgio de Chirico, *The Mystery and Melancholy of a Street* (1914; Private collection).

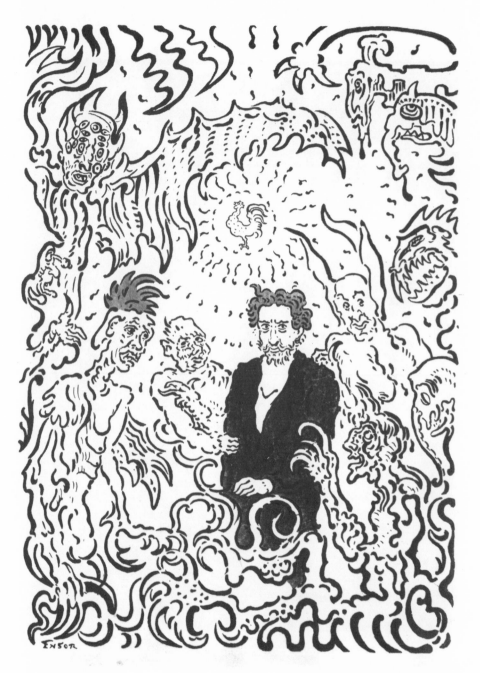

37. James Ensor, *Self Portrait with Demons* (1898; The Museum of Modern
Art, New York. Purchase).

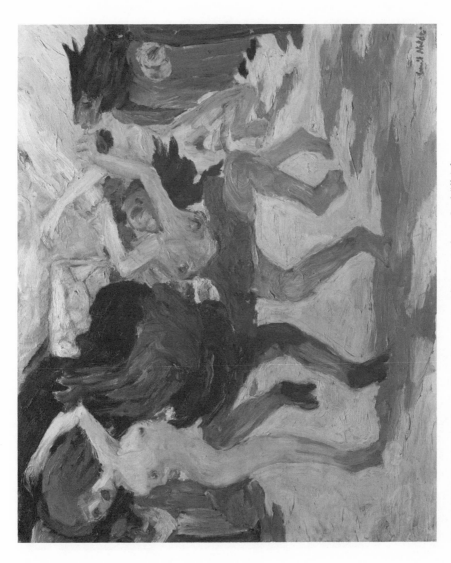

38. Emil Nolde, *Dance Around the Golden Calf* (1910; Stiftung Seebüll Ada und Emil Nolde, Neukirchen).

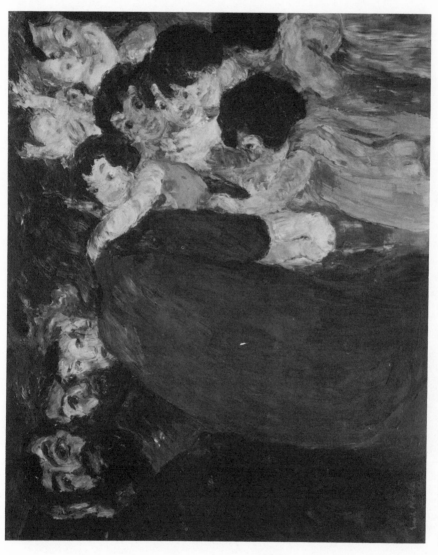

39. Emil Nolde, *Christ Among the Children* (1910; The Museum of Modern Art, New York. Gift of Dr. W. R. Valentiner).

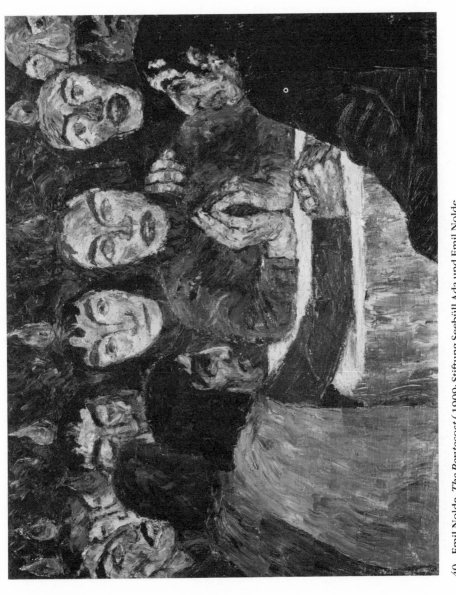

40. Emil Nolde, *The Pentecost* (1909; Stiftung Seebüll Ada und Emil Nolde, Neukirchen).

41. Karl Schmidt-Rottluff, *Landscape with Lighthouse* (1922; The Museum of Modern Art, New York. Purchase).

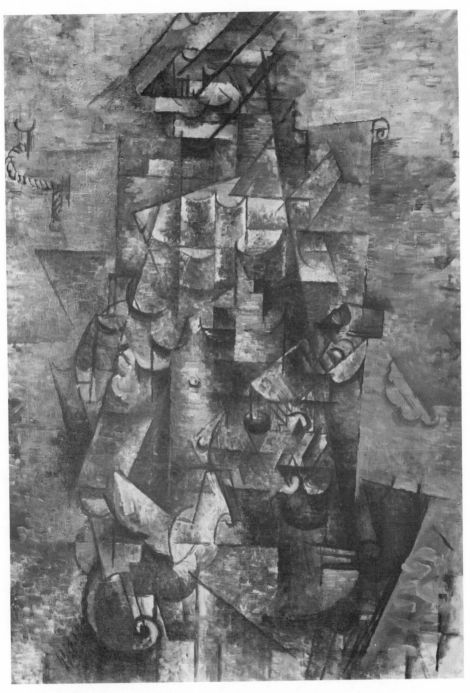

42. Georges Braque, *Man with a Guitar* (1911; The Museum of Modern Art, New York. Acquired through the Lillie P. Bliss Bequest).

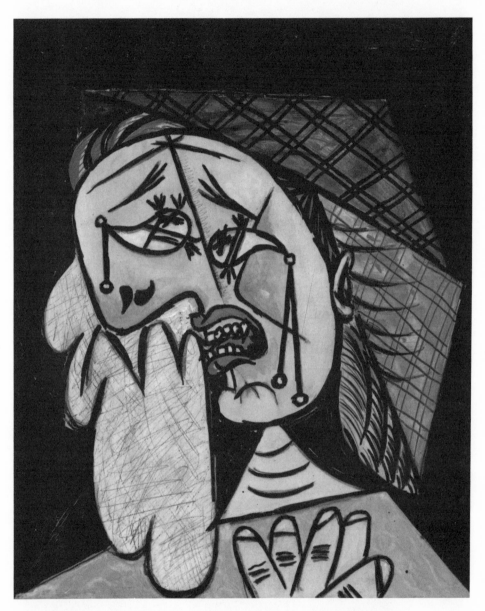

43. Pablo Picasso, *Weeping Woman with Handkerchief* (*A Study for Guernica*) (1937; Los Angeles County Museum of Art, Los Angeles. Gift of Mr. and Mrs. Thomas Mitchell).

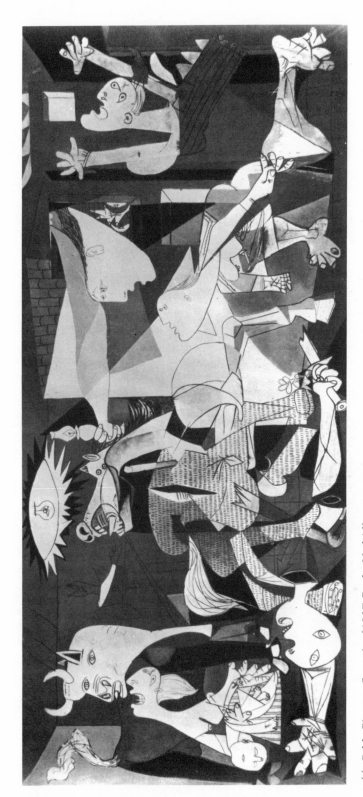

44. Pablo Picasso, *Guernica* (1937; Prado, Madrid).

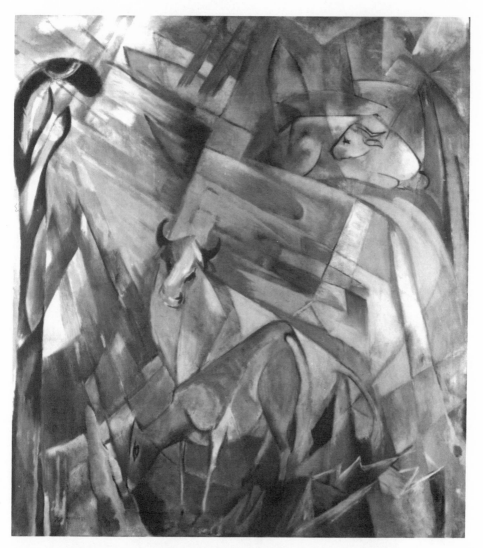

45. Franz Marc, *Animals in a Landscape* (1914; Detroit Institute of Arts, Detroit. Gift of Robert H. Tannahill).

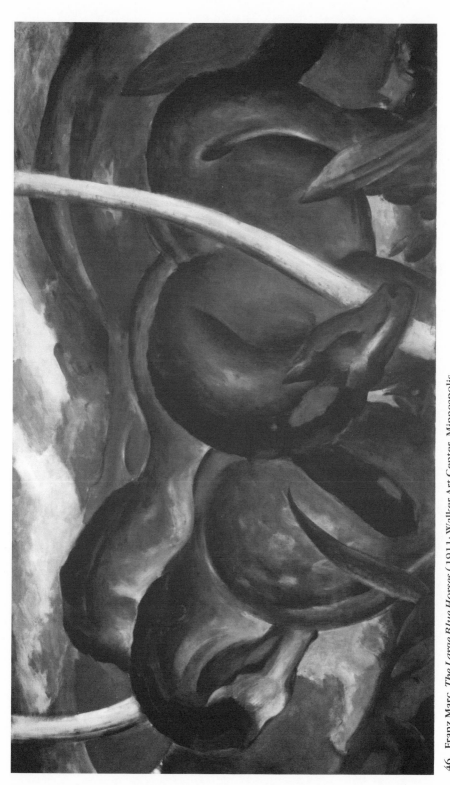

46. Franz Marc, *The Large Blue Horses* (1911; Walker Art Center, Minneapolis. Gift of the T. B. Walker Foundation, Gilbert M. Walker Fund, 1942).

47. Paul Klee. *Equals Infinity* (*Gleich Unendlich*) (1932; The Museum of Modern Art, New York. Acquired through the Lillie P. Bliss Bequest).

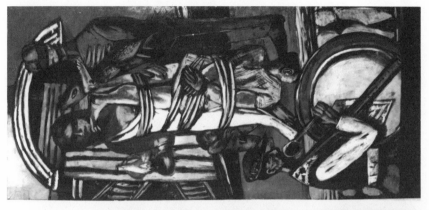

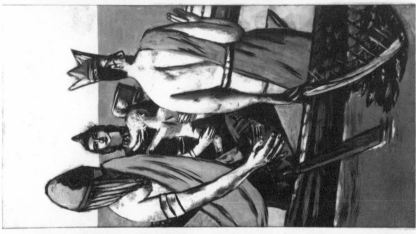

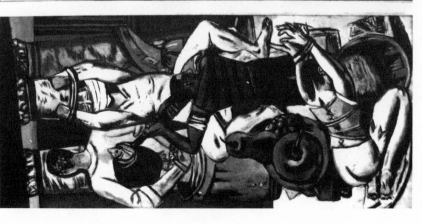

48. Max Beckmann, *Departure* (1932–1933; The Museum of Modern Art, New York. Given anonymously [by exchange]).

49. Georges Rouault, *Head of Christ* (1905; The Chrysler Museum, Norfolk, Virginia. Gift of Walter P. Chrysler, Jr.).

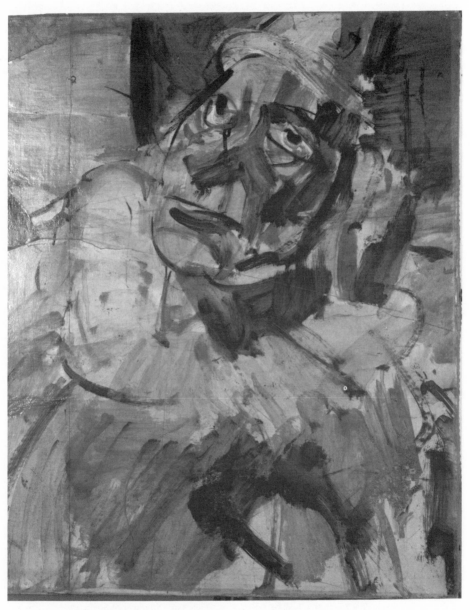

50. Georges Rouault, *Clown* (n.d.; Dumbarton Oakes Research Library and Collection, Washington, D.C.).

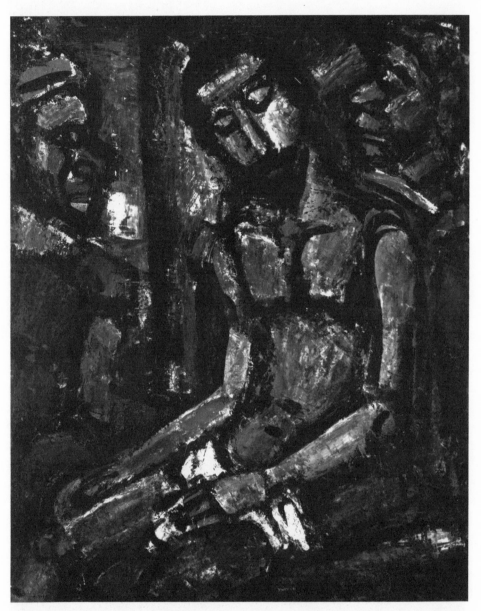

51. Georges Rouault, *Christ Mocked by Soldiers* (1932; The Museum of Modern
Art, New York. Given anonymously).

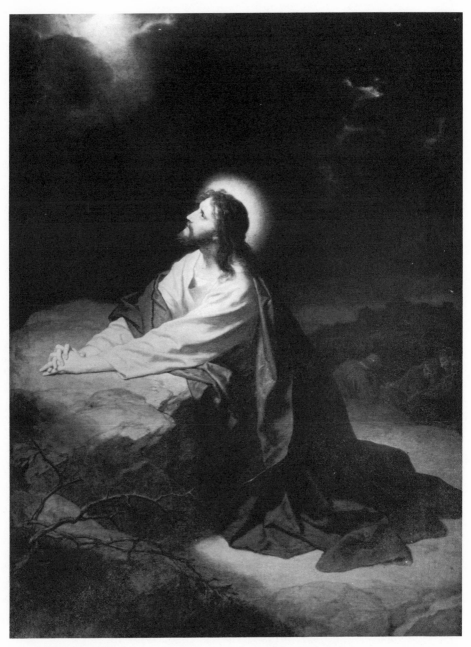

52. Heinrich Hofmann, *Christ in Gethsemane* (ca. 1875–1880; The Riverside Church, New York).

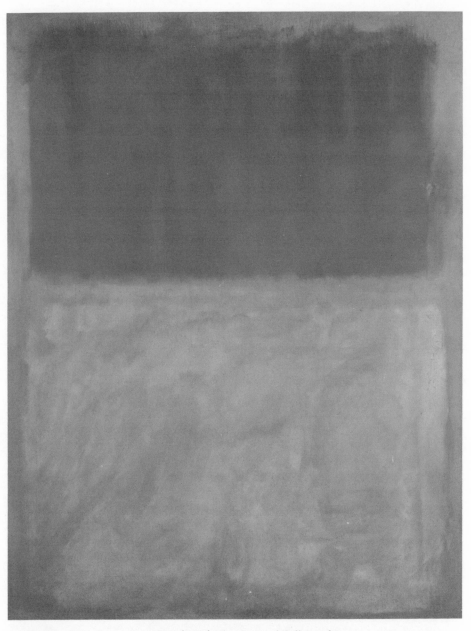

53. Mark Rothko, *Orange and Tan* (1954; The National Gallery of Art, Washington, D.C. Gift of Enid A. Haupt, New York).

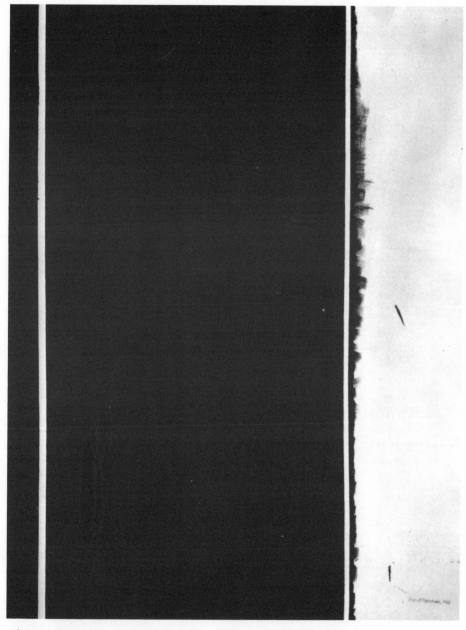

54. Barnett Newman, *Stations of the Cross: Station #12* (1965; The National Gallery of Art, Washington, D.C. The Robert and Jane Meyendorf Collection).

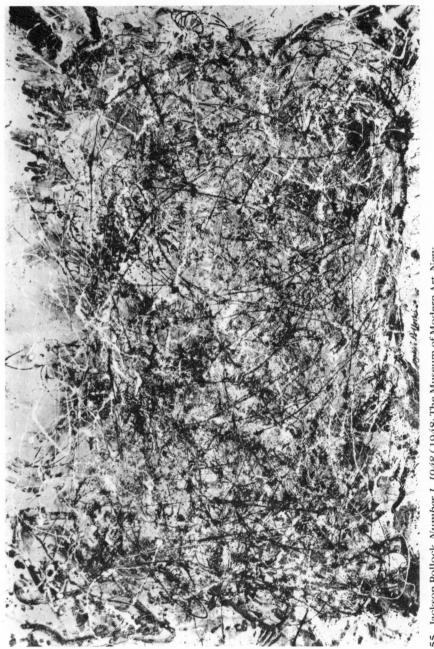

55. Jackson Pollock, *Number 1, 1948* (1948; The Museum of Modern Art, New York. Purchase).

56. Richard Lippold, *Variation Number 7: Full Moon* (1949–1950; The Museum of Modern Art, New York. Mrs. Simon Guggenheim Fund).

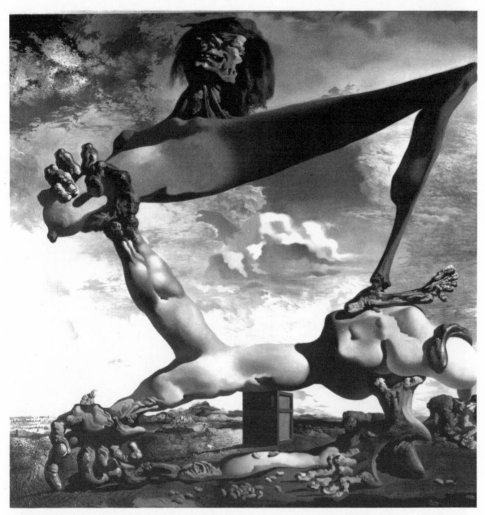

57. Salvador Dali, *Soft Construction with Boiled Beans: Premonition of Civil War* (1936; Philadelphia Museum of Art, Philadelphia. Louise and Walter Arensberg Collection).

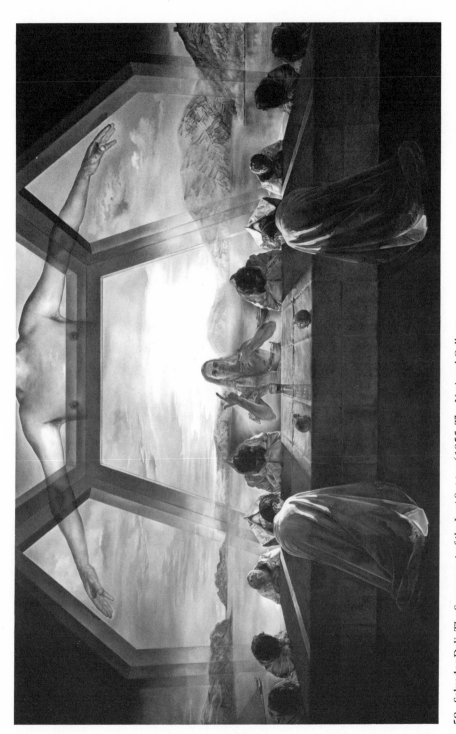

58. Salvador Dali, *The Sacrament of the Last Supper* (1955; The National Gallery of Art, Washington, D.C. The Chester Dale Collection).

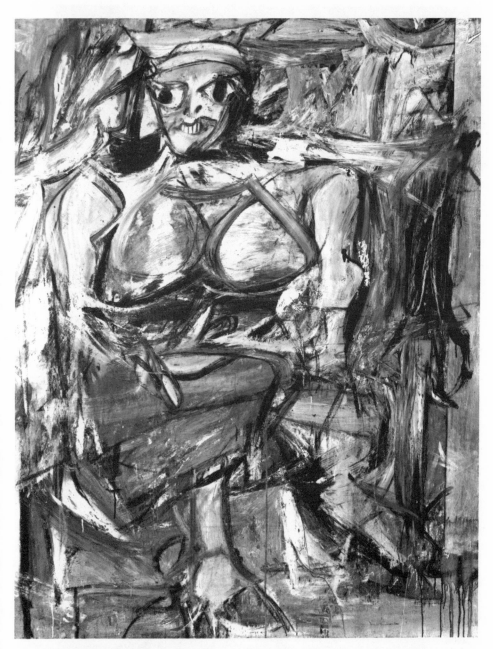

59. Willem De Kooning, *Woman I* (1950–1952; The Museum of Modern Art, New York. Purchase).

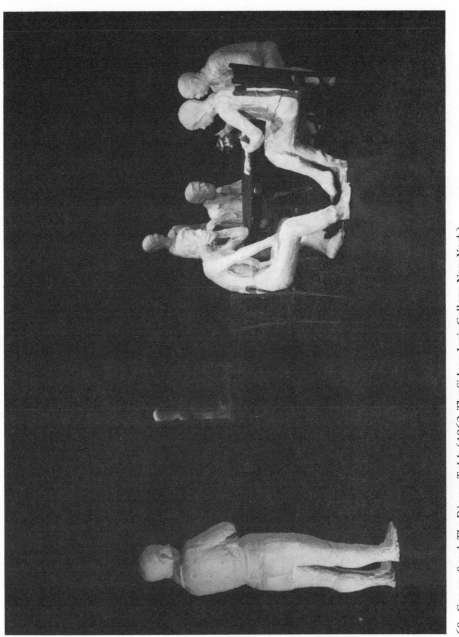

60. George Segal, *The Dinner Table* (1962; The Sidney Janis Gallery, New York).

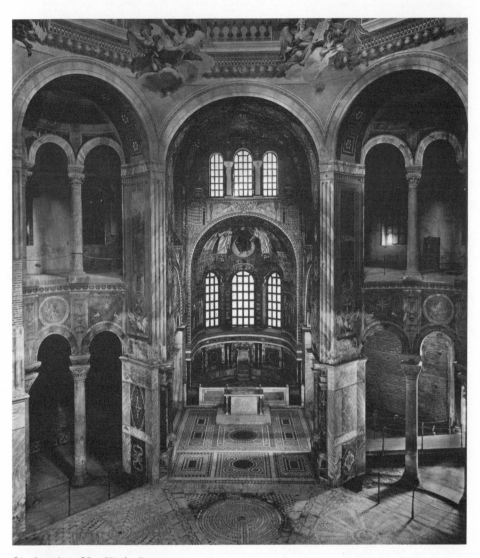

61. Interior of San Vitale, Ravenna.

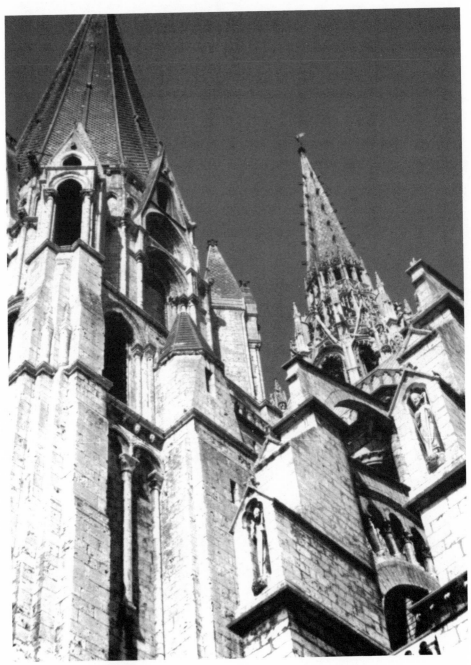

62. Cathedral of Notre Dame du Chartres, Chartres.

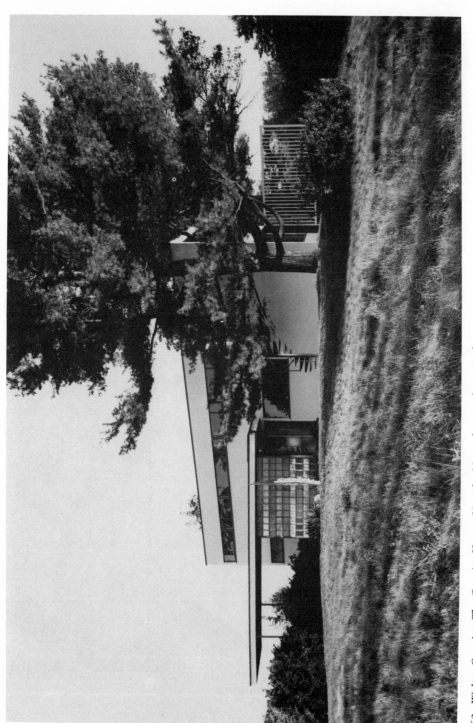

63. Walter Gropius, The Gropius House, Lincoln, Massachusetts (exterior).

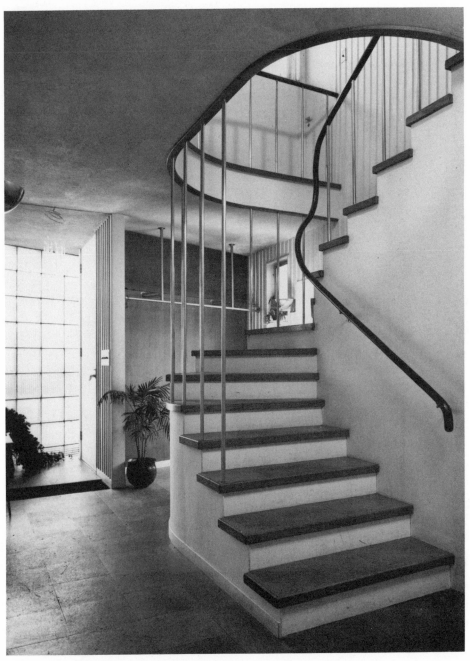

64. Walter Gropius, The Gropius House, Lincoln, Massachusetts (interior).

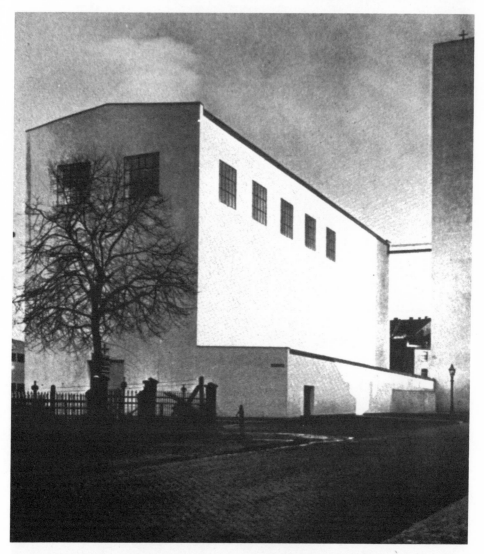

65. Rudolf Schwarz, Corpus Christi Roman Catholic Church, Aachen (exterior).

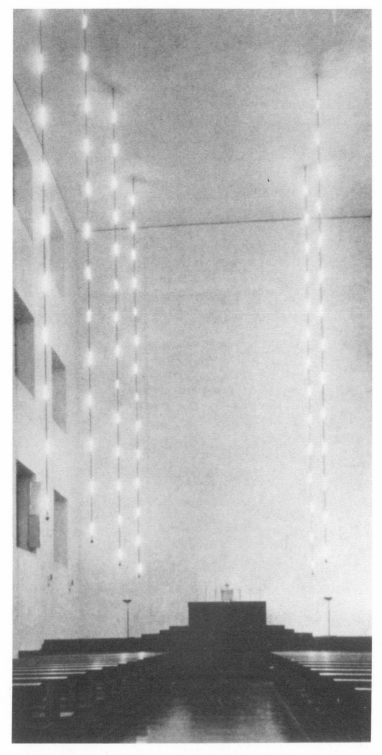

66. Rudolf Scharwz, Corpus Christi Roman Catholic Church, Aachen (interior).

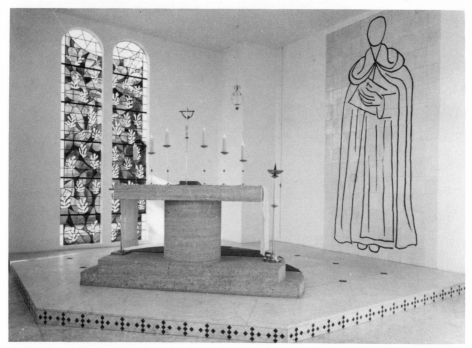

67. Henri Matisse, Chapel of the Rosary, Vence (interior).

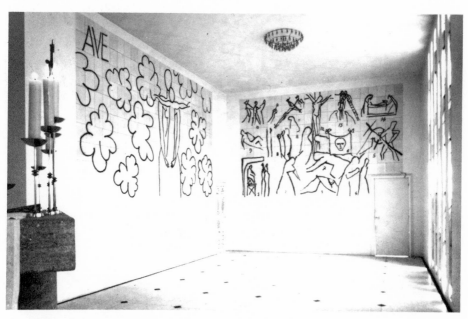

68. Henri Matisse, Chapel of the Rosary, Vence (interior).

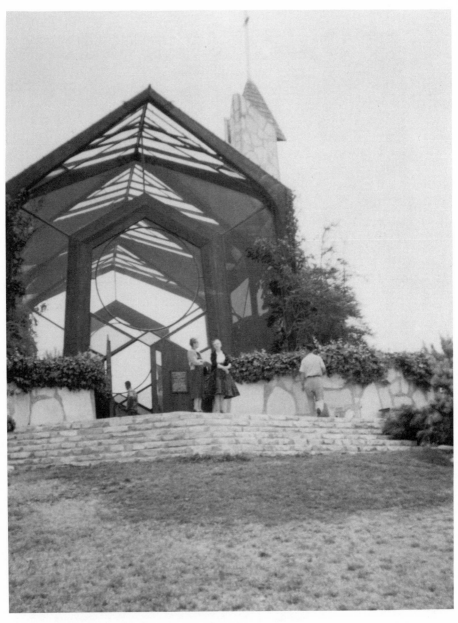

69. Lloyd Wright, The Wayfarers Chapel (interior).

70. Philip Johnson, The Roofless Church, New Harmony, Indiana (exterior).

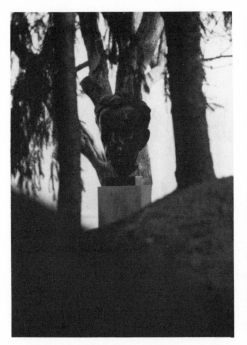

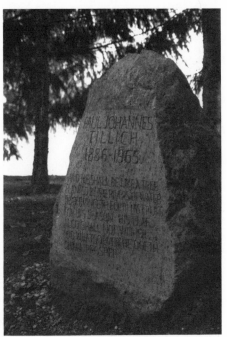

71. Memorial Bust of Paul Tillich,
 Paul Tillich Park, New Harmony, Indiana.

72. Memorial Stone, Paul Tillich Park,
 New Harmony, Indiana.

73. Paul Tillich Park, New Harmony, Indiana.

Introduction

IT IS WELL ESTABLISHED that Paul Tillich was interested in the visual arts and architecture. Exactly how central they were to his life and thought is less well known. This volume includes previously unpublished materials, translations from his German writings, and major pieces either currently out of print or in fugitive publications. Taken together, they testify to a formative and continuing role for the arts and architecture that is more than a peripheral or special interest. It is therefore appropriate that Tillich is memorialized in the Paul Tillich Park (plates 70–73) at New Harmony, Indiana, in the midst of the old utopian community that is also a living presence of artistic distinction, featuring works by Jacques Lipchitz, Philip Johnson,[1] Richard Meier, and Stephen DeStaebler, all made possible by the discerning spirit of Jane Owen.

Between his first public lecture defining the scope of his thought, "On the Idea of a Theology of Culture,"[2] and 1933 when he left Germany, Tillich's writings include extensive use of the visual arts in his analysis of the cultural scene. Then there is a hiatus of almost twenty years. With the exception of references to art in his 1946 essay, "The World Situation,"[3] where he deals with Giotto, Titian, and Rembrandt, Tillich's writings have no significant references to the visual arts until the early 1950s. These are the two decades of the early period in his newly adopted country when he faced the problems of learning to speak and to lecture in a new language, as well as a host of problems attendant to moving from the status of refugee to that of citizen. During this period, however, Tillich continued to see art in museums and became acquainted with artist

1. Tillich particularly admired Johnson's Roofless Church (plate 70) at New Harmony, Indiana.

2. The materials on the arts in this essay are reproduced in footnote 3 of chap. 4 of this collection.

3. A chapter in *The Christian Answer*, ed. Henry P. Van Dusen (New York: Charles Scribner's Sons, 1946), pp. 1–44; the material on the arts is reproduced in footnote 2 of chap. 5 of this collection.

neighbors in New York City and East Hampton. Moreover, students at Union Theological Seminary knew of his interest in art and architecture through his extensive references to them. From that time until his death, lectures and writings on art and architecture again became a significant part of his public life, including the later years at Union, his period at Harvard, and particularly at Chicago. In his later years, Tillich's interest in Eastern religions, particularly Buddhism, increased. While in Japan, he had extensive conversations with Buddhists and saw much of the art with interest. However, it was so alien to what he knew of art that he could not incoporate it into his being as much as he could its philosophical aspects. His interest in art was Western, and he was aware of its most recent currents.

It is evident that biographical elements are important for understanding Tillich's relation to the visual arts and architecture.[4] He grew up in the world of the church; his father officiated at Sunday services and had administrative responsibilities as well. Interested in music, his father also composed. But he was suspicious of the visual arts, so that after visiting museums on Sunday afternoons, Tillich and his sister found the family situation uncomfortable. This memory of Tillich's and his accounts of roaming in the countryside, viewing nature and Gothic buildings with curious eyes, testify to a concern from his childhood with what the eye brings to one's world. Perhaps this was not unusual among Tillich's contemporaries from the same social class. It is clear, however, that from childhood Tillich's experiences were passionately incorporated into his life and thought in a singular fashion. One could even speculate whether his lifelong love of nature, in which the sea played a special role, was not a way in which the eyes uniquely opened special avenues of knowing. His early interest in buildings, too, was exceptionally visual. At one time he thought of becoming an architect, but later stated that he had built with concepts instead. Seeing was an important modality for Tillich, a particular form of sensation that exercised the imagination. On occasion, Tillich referred to play as an overall category of the imagination, of which seeing was a central ingredient.[5] Play for Tillich did not mean competitive games, but the physical delight of sailing, of being on the beach, of mountain climbing, of food and drink, of personal encounters, of seeing and incorporating into life what presented itself to him. Yet such chosen and

4. Autobiographical accounts are to be found in "Between Reality and Imagination" and "What Am I?" chaps. 1 and 2 of this collection, respectively. A biographical source is Wilhelm and Marion Pauck, *Paul Tillich: His Life and Thought* (San Francisco: Harper & Row, 1976).

5. See "Between Reality and Imagination," chap. 1 of this collection.

chance occasions also provided grist for his conceptual work. Moreover, because such encounters continued in life, they forged enriching materials for his conceptual work. In this sense, one can say that he moved more from the visual to the conceptual, than from knowing to seeing.

This interpretation of Tillich is confirmed by subsequent events. In the four years he spent as a chaplain in the trenches of World War I, Tillich faced the ugliness and the terrors of life and death. He was subsequently decorated for his valor in trying circumstances. This war experience, which brought him to the edge of both physical and psychic collapse, was counterbalanced by his viewing works of art in whatever cheap reproductions he could find. He saw them as solace, order, and beauty, aspects of life threatened by the world of the trenches around him. Among the works that he knew from reproductions was Sandro Botticelli's *Madonna and Child with Singing Angels*[6] (plate 1). When he saw the actual painting while on leave in Berlin, the power of the original became a revelatory experience, an ecstatic encounter. While the painting belongs to the Renaissance world (about whose paintings he later became ambivalent), the order, beauty, and form of this painting was to the Tillich on leave from the battlefield an anchor in an uncertain world. Moreover, in Botticelli's work, especially in this painting, the sorrow of the world is suggested by the Madonna's expression which is simultaneously joy-filled and melancholy. Beauty is not without its dark side.

In Tillich's own developing ideas on the visual arts, the shadow, the dark side, or what one might even call the underside, eventually became the key element in determining the significance of a work of art, and in one lecture he dealt specifically with the demonic in art.[7] The dark side, however, has no life of its own. It is a distortion of the good or beautiful. Those who do not see its reality in our existence actually become the dangerous ones. In their rejection of the dark side, they prefer a beautifying naturalism, in whose defense they disclose their own demonic natures. Hence Tillich increasingly stood against the beautifying naturalism he saw in the art around him, an art which had no ultimate concern and reinforced the outlook of the petty bourgeoisie. In opposition to such art, Tillich became interested in "expressionism" in the arts; that is, art in which the surface of things and of life is challenged by disruptive forces that designate an uncertain future. His boyhood friend, Eckart von Sydow, had written a significant book on German Expressionism, and G. F. Hartlaub, Director of the Dresden Museum, had written on religion and

6. For Tillich's vivid account of this experience, see "One Moment of Beauty," chap. 23 of this collection.

7. See "The Demonic in Art," chap. 10 of this collection.

art, and the possibility of a new religious art. Hannah Tillich writes of the post–World War I period and the role of Eckart von Sydow.

> I met Eckart and Dox, Paulus's two oldest friends. . . . [Eckart] educated Paulus in modern art after Paulus returned from the war, where he had tried to teach himself through available periodicals, wading through an abyss of bad taste. Eckart, Paulus, and I visited exhibitions of works by Nolde, Kandinsky, the Futurists, Chagall, Cézanne, Gauguin, and van Gogh.[8]

While Tillich's interest antedated his knowing Hannah, she, along with von Sydow, was a part of his education both in literature and the arts. She was a part of his life when he wrote those early works which utilized art as an avenue into cultural understanding. Hannah and Paul Tillich particularly recalled their 1924 trip to Ravenna, for there the art of the classical and eastern Mediterranean world was discovered with fresh power by both of them. In a review article involving the books of von Sydow and Hartlaub, titled "Religious Style and Religious Material in the Fine Arts,"[9] Tillich articulated his own views: form, import or depth content (what he called depth in later writings), and style are the predominant categories for understanding art. The poles of art involve form and import, while style is the particular way in which form and import are expressed. Form is structure, that which is given in the classical mode. Import is that which is suggested, conveyed behind, through, and beneath all subject matter, beyond all psychological, biographical, sociological, or national approaches. Both form and import are necessary for a work of art, but at any particular time, one may be more dominant than the other. It is obvious that in his mind import is the essential mode against beautifying and heteronomous forms.

Style is the particular, concrete way in which the form expresses the import, meaning or depth content. In this interpretation, style discloses a metaphysical base, the way in which reality is understood. Hence analysis of works of art provides us with the meaning of a culture in immediate terms. It is for this reason that religion and culture are intertwined, that they cannot be separated. As Tillich said, "religion is the substance of culture and culture is the form of religion." Moreover, cultures disclose their meaning, that which is of ultimate importance, quite apart from whether what they disclose is worthy of ultimacy.

It is this seeing of what is beneath that discloses reality. We have all

8. Hannah Tillich, *From Time to Time* (New York: Stein and Day, 1973), p. 100.

9. Reprinted in chap. 4 of this collection.

been made aware of Tillich's statement in "The Religious Situation" that "it is not an exaggeration to ascribe more of the quality of sacredness to a still-life by Cézanne or a tree by van Gogh than to a picture of Jesus by Uhde."[10] Five years before, in "Religious Style and Religious Material in the Fine Arts," Tillich had already written,

> It is indeed possible to see in a still life of Cézanne, an animal painting of Marc, a landscape of Schmidt-Rottluff, or an erotic painting of Nolde the immediate revelation of an absolute reality in the relative things; the depth-content of the world, experienced in the artist's religious ecstasy, shines through the things; they have become "sacred" objects.[11]

In such an approach the subject matter or content of a work of art is less important than the form and import, that is, its style. From that base, Tillich approached the issue of mass movements in society by analyzing past movements in terms of their art.[12] "Painting is a mute revealer and yet to the interpreting spirit it often speaks more clearly than the word that conveys a concept." Utilizing that conviction, he examines the Gothic paintings of social masses, in which masses and individuality are interdependent, in which the central figure or figures are merely larger than the rest, mediating and giving focus to common convictions. In the late Gothic or early Renaissance paintings, the individual has come to the fore, and nature, coupled with the new discovery of perspective, receives more attention. The unity which is left is the picture itself, for the individuals have become distinct, and society has lost its common base. In the Baroque period, as in Bernini's *Transverberation of St. Teresa* (plate 19), interest has shifted to inner, vibrant personal convictions of faith. It is Impressionism, however, which shows what has happened in the loss of a feeling for a common humanity and the loss of the dynamics of the Baroque. It represents the individualistic outlook of the nineteenth-century middle class, one in which everything is surface, in which one has momentary vision, and in which there are objects not subjects. Monet (plate 25), Degas, and Renoir are seen as artists who subordinated everything to the surface of nature, to the light that plays easily on the surface. But here one must be careful, for while Tillich made this historical judgment, he enjoyed Renoir, as Hannah Tillich reminds us. It is possible to enjoy that which may be said not to be profound.

It is the revolt against this nineteenth-century world that Tillich sees in Nietzsche, Marx, Kierkegaard, and, artistically, in the Expressionist paint-

10. The relevant portion of "The Religious Situation" is reprinted in chap. 6 of this collection, see especially p. 69.

11. See p. 54 of this collection.

12. See "Mass and Personality" in chap. 5 of this collection.

ers. While their paintings show nature with more disintegration than the Impressionists, their vision, reinforced sometimes by specific religious understandings, is also the basis for new hope, for a new mysticism, for a feeling of the depths of both the holy and the demonic in common things, and for being born anew. Unlike the Gothic age, this time has no supernatural base, but wells up from below, an immanent reality.

As elsewhere, one may argue with Tillich's particular typology. But the point is that Tillich has used the tradition of paintings as a clue to cultural understanding, developing theoretical concepts in light of the arts. What has been suggested throughout is that the visual arts played a fundamental role in the formation of his thought, that the visual arts represented fundamental, not peripheral interests, even if he never mastered art history.

The approach to understanding the visual arts in Tillich cannot go from the philosophical or theological to the visual. The visual arts represent a fundamental ingredient in the formation of his thought. Since Tillich published sermons, monographs on specific subjects, and wrote his *Systematic Theology* in the United States (the writings to which we were all introduced), it is understandable that his lectures on the visual arts, though more numerous in the United States since the 1950s than while he was in Germany, were seen as adjuncts rather than indigenous to his thought.

During his lectures at Union Theological Seminary, Tillich's custom of circulating photographs, for example, of Greek art as he lectured on the early Greek period, was no oddity as some thought; rather it was central to all that he was about. Whenever Tillich returned to Europe, his notes reveal a consistent and conscious exposure to European art no matter where he was. His published diary of 1936 has hardly a page which does not have an account of his seeing of paintings, sculpture, and architecture.[13]

It would be as much a mistake to state that the source of Tillich's thinking is the visual, as it is to base his thought wholly on the philosophical. Indeed, he talked of a revelatory experience confronting being, the mystery and shock of recognizing that something is, rather than that it is not. According to his lectures at the Minneapolis Institute of Arts,[14] this awareness emerged at the time of his early experiences with the visual arts, though, according to the Paucks,[15] a similar experience happened

13. *My Travel Diary: 1936. Between Two Worlds*, ed. Jerald C. Brauer, drawings by Alfonso Ossorio (San Francisco: Harper & Row, 1970).

14. These three lectures have been included in chap. 3 of this collection.

15. Pauck, *Paul Tillich: His Life and Thought*, p. 2.

much earlier. Tillich studied and taught philosophy and theology, and his major writings are in that area. However, a recognition that the visual had a fundamental role in his formative period and continued to be integral to his thought is undeniable in the light of the history we have delineated. Similarly, it is clear that his major interest was in philosophical theology, a theological enterprise that utilized insights from all disciplines and that saw societies as cultural wholes in which central motives and styles genuinely tell us what is going on. While the visual arts may have been less consciously present in his initial American theological writings than in his German texts, Tillich never abandoned the idea that the arts were the most immediate barometer of what is transpiring in a culture. In "Mass and Personality," he had written,

> Painting is a mute revealer and yet often speaks more perceptibly to the interpreting mind than concept-bearing words. For it impresses us with the irrefutable power of immediate intuition.[16]

And in "The Religious Situation" he had written,

> Art indicates what the character of a spiritual situation is; it does this more immediately and directly than do science and philosophy for it is less burdened by objective considerations.[17]

This theme is repeatedly stressed in his lectures from the American period.[18]

Tillich himself tells us that he was not as involved in the arts in the United States as he had been in Germany. Referring to his years in Berlin, he noted that he lectured on a wide range of subjects, including the arts. Speaking of his time at Dresden and Marburg in *My Search for Absolutes*, he wrote,

> Dresden was a center of visual art, painting, architecture, dance, opera, with all of which I kept in close touch. The cultural situation was not much different when, in 1929, I received and accepted a call as professor of philosophy at the University of Frankfurt.[19]

After telling in the same work of his invitation to Union Theological Seminary and the new setting for his work in a community of worship as well as of intellect, Tillich adds:

16. See p. 58 of this collection.
17. See p. 67 of this collection.
18. In one form or another, this point is made in chaps. 9–16 of this collection.
19. See p. 8 of this collection.

For external and practical reasons it became impossible to maintain the relationship to artists, poets, and writers that I enjoyed in postwar Germany. But I have been in permanent contact with the depth-psychology movement and with many of its representatives, especially in the last ten years.[20]

One can surmise what some of these reasons may have been. The world of the artists Tillich had enjoyed in Germany, with their bohemian lifestyle, at that time would have been suspect at Union Theological Seminary. Moreover, Tillich had to master a new language, and he was busy heading a refugee committee which literally made new lives possible for numerous individuals. His deepening interest in depth psychology was undoubtedly based in enriching his understanding of the human predicament in personal terms, the social world he had known having been shattered, leaving little hope for the future. Moreover, depth psychology provided new facets for his theological work.

While Tillich went to museums and spoke at some of the major museums in the United States—such as the Museum of Modern Art, the National Gallery of Washington, the Art Institute of Chicago, and the Minneapolis Institute of Art—he lost living contact with new movements in the arts, most notably Abstract Expressionism. The result was that he continued to see all of the visual arts through the prism of German Expressionism, which he had broadened to include "expressiveness" in art throughout history.

As an art movement, Expressionism originally referred to developments in Germany and France in which the natural, self-contained finite world was rejected in favor of a view of the world in which depth and ultimacy were affirmed beneath the surface of reality as then perceived by society. As indicated previously, the art world to be overcome was that of a naturalistic realism. Here the world is represented in terms of itself, as if what one saw around one was the real. This involved a beautifying naturalism, a facile art without depth, which Tillich characterized with the German word *Kitsch*. Speaking in 1956 before the Institute of Contemporary Art, Tillich referred to Salvador Dali's Christ in *The Sacrament of the Last Supper* (plate 58) as

a sentimental but very good athlete in an American baseball team. . . . The technique is a beautifying naturalism of the worst kind. I am horrified by it. [It is] simply junk.[21]

20. See p. 10 of this collection.

21. *Time* Magazine 19 November 1965, p. 46. *Time* also refers to teetotaler Dali hearing "junk" as "drunk" when Tillich's judgment was reported to him.

In that category, religious paintings were particularly offensive, as in Heinrich Hofmann's *Christ in Gethsemane* (plate 52).

Impressionism in which light played on the surface, never reaching beneath the surface was also considered a surface reality. It seemed to purvey no more than the bourgeois world it portrayed. By contrast, Expressionist artists broke the surface of things in order to penetrate to a deeper level beneath appearances. Central among such figures is Cézanne (plate 28), in whom the natural has been given depth, in which a transparency of metaphysical meaning is present. Van Gogh (plates 26–27) is interpreted as projecting the creative forces of nature in light and color. Munch purveyed the cosmic dread. Franz Marc (plates 45–46), once a theological student like Van Gogh, painted horses to disclose depths not apparent in traditional art forms. Other Expressionist painters included Schmidt-Rottluff (plate 41), Kirchner, Heckel, and Nolde (plates 38–40), the latter particularly important as one who also did religious paintings with depth, as in *Pentecost* (plate 40). Rouault (plates 49–51) also is mentioned positively. But with considerable perceptiveness, Tillich notes that Rouault's paintings of clowns (plate 50) seem to have more profundity than his religious subjects, as if traditional religiousness vied with deeper dimensions of a secular nature.

For Tillich, the uncertain, tragic, demonic aspects of humanity were recognized by these artists as a disclosure of depth and ultimate issues at the heart of humanity, as in Nolde's *Dance Around the Golden Calf* (plate 38). The camouflaging of such dimensions only meant that the unrecognized demons would break forth as in the fury of the Nazis. Looking at his contemporary cultural situation, Tillich was convinced that crucifixion not resurrection had to be the dominant motif, for destructiveness rather than harmony characterized contemporary existence. It was in this context that Tillich understood Picasso's *Guernica* (plate 44), calling it the example par excellence of a Protestant understanding in which allegedly nothing is covered up and reality is squarely faced.

German Expressionism was important for Tillich because it was the first time that the human dimensions of ultimacy, both the tragic and the grand, had occurred since Rembrandt. From the mid-seventeenth century until the turn into the twentieth century, art itself was captive, a barometer of surface that covered over rather than revealed human dimensions.[22] Looking at past history, Tillich saw "expressiveness"—that which is the central ingredient of German Expressionism—in other cultural periods: Byzantine, Romanesque, Gothic, and Baroque, as well as in

22. See "Contemporary Visual Arts and the Revelatory Character of Style" and "Theology and Architecture," chaps. 12 and 17 of this collection, respectively.

the critical realism of a small circle of artists who Tillich believed had been able to be realistic without being banal, and who, for him, had become the basis on which he spoke of "belief-ful" realism.[23] It is interesting that the Renaissance artists are not included, for they seem to Tillich to convey an unreal harmony with a self-sufficient finitude, making their religious subject matter essentially secular. In them, form appears without expressiveness. At other times, he places Renaissance art into the category of anticipation, of expressing an ultimate, if not eschatological harmony.

Both in his writings and in his lectures, it is clear that Tillich extolled theonomous periods, including Byzantine and early Gothic as well as the early Greek period. He also knew that the modern world was not theonomous in nature, that the expressiveness he had seen in past periods now operated only as a vehicle of illumination rather than as the ingredient that formed a reigning culture. Expressiveness that discloses the human condition is the essence of art for Tillich, and it is the art which is nearest to a religious understanding, or in the service of religious comprehension. It is the point where religion and art intersect, where art in its pointing to the truth about the human condition expresses that ultimacy which is religious. Again, that is why expressive art without religious subject matter is more religious than religious art which does not disclose ultimacy.

Complicating Tillich's analysis is the fact that Expressionism as an early twentieth-century art movement is oriented from the side of disclosing the negative in human experience. The art historical periods he mentions as "expressive" are mainly theonomous in nature; that is, they convey a broken world seeing its own ground in a specific, vibrant religious tradition that forms a cultural unity even as it is present as its saving ingredient. Since that theonomous ground disappeared, Tillich had to concede that the incipient hopes he had seen for the German scene proved to be impossible. Moreover, Tillich knew that hopes for another future could not be created at will. The spirit of a culture is expressed in art; it is not created by art or by any artifact. Therefore the immediate situation is one in which one can only hope against hope. For Tillich, the contemporary world was always seen with considerable gloom. Not a few heard him say that all is finished, *kaput*, as he put it in German.

Ironically, while the visual arts provided him with central evidence for cultural analysis, his heavy reliance on Expressionism in art hindered Tillich from seeing precisely those facets in contemporary art which ac-

23. See "The Religious Situation" and "Protestantism and Artistic Style," chaps. 6 and 11 of this collection, respectively.

corded with his own viewpoint. The work of the Abstract Expressionists like Mark Rothko (plate 53), Adolf Gottlieb, and Barnett Newman (plate 54) resonated with expressions of the tragic, the sublime, the demonic —all elements familiar to Tillich's cultural analysis. Yet Tillich did not seem to see or to understand this fully since the style of these paintings, in their large format with their vast areas of often unarticulated color, did not accord with the mode of Expressionism in which the surface is broken through and disrupted by forms from the depths, as in *Guernica* (plate 44).

In his own life and the history he knew, Tillich had experienced the destructiveness expressed in *Guernica*. He had also experienced the ecstasy of the sublime as evidenced by his own account of experiencing Botticelli's *Madonna and Child with Singing Angels*. He told how he first saw reproductions of the great and moving paintings of the ages while a chaplain during the four years he served in the trenches of World War I.

> To take my mind off the mud, blood and death of the Western Front, I thumbed through the picture magazines. . . . In some of them I found reproductions. . . . At rest camps and in the lulls in the bitter battles, especially at Verdun, I huddled in dugouts studying this "new world" by candle and lantern light.
>
> But at the end of the war I still had never seen the original paintings in all their glory. Going to Berlin, I hurried to the Kaiser Friedrich Museum. There on the wall was a picture that had comforted me in battle: *Madonna [and Child] with Singing Angels* painted by Sandro Botticelli in the fifteenth century.
>
> Gazing up at it, I felt a state approaching ecstasy. In the beauty of the painting was Beauty itself. It shone through the colors of the paint as the light of day shines through the stained-glass windows of a medieval church.
>
> As I stood there, bathed in the beauty its painter had envisioned so long ago, something of the divine source of all things came through to me. I turned away shaken.
>
> That moment has affected my whole life, given me the keys for the interpretation of human existence, brought vital joy and spiritual truth.[24]

Tillich's experiences at the seashore and in the presence of nature testify to his openness to the very emotions which Newman, Rothko, and Still were delineating in their large paintings of the 1950s. However, there is no evidence that Tillich understood the relevance of the Abstract Expressionists to his own thought. While the visual arts helped form his

24. See pp. 234–35 as well as p. 12 of this collection.

early theological work, his mature theological work demanded a fuller understanding of contemporary art.

How did this happen? In the United States Tillich lost direct contact with contemporary artists, confining his viewing largely to what he saw in museums. While Tillich knew the artists Willem De Kooning (plate 59) and Alfonso Ossorio, and the art critic Harold Rosenberg, all neighbors in East Hampton, and Robert Motherwell, through associations with the Society for the Arts, Religion, and Contemporary Culture,[25] he makes no reference that I know of to Mark Rothko or Barnett Newman, though Hannah Tillich informed me that he was fascinated by Rothko's paintings. In part, that is because the museum world was relatively slow in acquiring the works of the Abstract Expressionists, who, until they were established, were largely ignored. Tillich's conversations and lectures were in museums and on college and university campuses. Having lost contact with the full range of the contemporary artistic community, Tillich knew the world of the Abstract Expressionists through the few works that had come to prominence only in museums.

In addition to his general statements about an abstract art in which every trace of the world as we know it had disappeared, he made specific references to Hans Hofmann, known in this country as a seminal teacher in the abstract tradition, and to Jackson Pollock, whom Tillich placed in the mystical type of religious experience. Of Pollock's *Number 1, 1948* (plate 55), Tillich said,

> I must say I found it difficult to evaluate him, but since seeing some of his very best pictures at the Brussels Exhibition, I have become very much reconciled with this fullness of reality without a concrete subject matter.[26]

Perhaps this is the way he felt about Rothko, too.

In "Religion and Art in the Light of the Contemporary Development," he refers to Abstract Expressionism as a manifestation of cosmic imagination.[27] Furthermore, Tillich was involved as an adviser to an exhibition of Contemporary Religious Art and Architecture presented by the Reli-

25. When it appeared that the National Council of Churches would not adequately develop new directions in the arts and religion, Marvin Halverson, with the encouragement of Tillich, Wilhelm Pauck, and others started this independent society, which has just celebrated its twenty-fifth anniversary. Alfred Barr was its first president, Pauck served as chair of the executive committee, and for a time, Tillich was vice president.

26. See p. 147 of this collection.

27. Reprinted in chap. 15 of this collection.

gious Art Committee of the student body at Union Theological Seminary in 1952. The exhibition featured works by Ossorio, Richard Pousette-Dart, Theodore Stamos, and Gottlieb, as well as thirty other artists. Of these, only Pousette-Dart and Gottlieb were at the center of the Abstract Expressionist movement.

Given how little Tillich entered into the world of the Abstract Expressionists, his instincts about it were not negative, but undeveloped. And yet he seemed uncomfortable with it, preferring an art that showed traces of reality without falling into naturalism and idealism. Indeed, he was looking for developments on the other side of Abstract Expressionism. In that sense he now seems to have been prescient, for that is where we now are, though the other side is what it is precisely because we have passed through the Abstract Expressionists. In any case, when Peter Selz, then a curator at the Museum of Modern Art and himself an authority on German Expressionism, visited Tillich and asked him to write an introduction to the exhibition catalogue *New Images of Man*,[28] Tillich was ready. He was convinced that the time was right for a new figural art, which in the light of twentieth-century art, would not, he was certain, be a return to the art that he had deplored, that of the nineteenth century.

Having missed the full power of Abstract Expressionism, Tillich continued to use his categories of expressive art without modification. This was unfortunate, for the Abstract Expressionist movement could also have given new nuances to his theories of expressionistic art. It was precisely the nature of this movement to combine a nonnaturalistic style with a content which included the tragic and the grand or sublime. Here was an art in which the subject matter was not a recognizable one, and in which the polarities of form and import, fundamental to his thinking about art, were genuinely expressed. Here was an art in which the surface was not necessarily disrupted, a qualification so central to Tillich's view of expressionistic art. Yet this art had depth and ultimacy, and the range of the human condition. Had Tillich come to terms with that Abstract Expressionist art, even his interpretation of *Guernica* might have changed. *Guernica* is a painting in which everything is disrupted, and, in this sense, Tillich called it a Protestant painting, for in it the human condition is totally unmasked. But there is also a fundamental unity, a grandness of humanity in the midst of destruction, a fact which Tillich hints at but never develops, when he suggests that a painting requires a form to be a painting at all, in order to be able to reveal meaning.

Tillich was interested in Picasso and Braque (plate 42), for in them he saw the breaking up of the surface in terms of lines and planes, thus

28. Reprinted in chap. 25 of this collection.

alluding to the ways in which the world is not perceived as it is directly seen. Ironically, while Tillich mentions paintings by Kandinsky and had met him, there is no evidence of any influence of Kandinsky's writings, such as *Concerning the Spiritual in Art*, in which Kandinsky proposes that religious meanings and abstraction belong together.

Other contemporary art movements received sympathetic consideration from Tillich. He saw De Kooning's return to a figural phase as one in which expressiveness is confirmed without a return to naturalism. Tillich saw Pop art as a return to the surface of things in such a way that the banality shocks us into perceptions that are beyond surfaces. In George Segal (plate 60), Tillich sees the frozeness that startles us; in Roy Lichtenstein, the vulgar reality that jars us; and in Tom Wesselman, the banality that is aggressively fascinating and repulsive at the same time. Indeed, Tillich says similar things about the art of Rauschenberg, Jasper Johns, Claes Oldenburg, and Op art, of which he is unclear.[29]

Tillich, however, is unsure about these movements. While they do not represent the surface realities in the old ways, he asked, do they ignore the ultimate depth of reality? Nevertheless, in "Religious Dimensions of Contemporary Art" Tillich affirms that

> artists are attempting to attend to the conventional aspects of experience again. Yet the style, growing out of the expressionistic explorations, is not a simple return to naturalism. It represents a fresh and original encounter with reality. Furthermore, it discloses both an artistic and a religious change. It is a desire for concrete meaning, for filling the everyday reality with the discoveries which have been made by the expressionistic ventures into the depths below the broken surface of nature.[30]

Finally, we turn to Tillich's typologies or categories of art. Robert P. Scharlemann has summarized most of them.

> The simplest typology is that of naturalism, idealism, and expressionism. Another has four types, depending on whether the content and the style are religious or non-religious ["Existentialist Aspects of Modern Art"]. A third typology coordinates five elements of style (imitative, subjective, idealist, realist, expressive) with types of religion ["Protestantism and Artistic Style"]. A fourth has six types: impressionism and realism, both form-dominated; romanticism and expressionism, both *Gehalt* [import] dominated;

29. See "Religious Dimensions of Contemporary Art," chap. 16 of this collection.

30. Ibid., p. 180.

idealism and classicism, both exhibiting a balance of form and *Gehalt* ["Religiöser Stil"].[31]

One is tempted to ask, which one is the real one, but that would be to ask a question not relevant to Tillich. He is concerned in each instance to forge understanding by analysis and classification in particular contexts. Sometimes that context is more art historically oriented; at other times, in terms of religious understanding; and, still others, in terms of general cultural understanding. Moreover, Tillich is aware that types or categories of classification do not fit everything, that there are always exceptions, that is, crossings of the boundaries. His aim is illumination rather than a careful putting of things in their place, as was the case in orthodox theologies. A critical question can then only arise when the exceptions that cross the boundaries become so numerous that attention shifts to them, a situation in which the illuminating power of types has been lost. One is perilously close to that situation in his "Existentialist Aspects of Modern Art,"[32] which is undoubtedly the most widely known writing of his on religion and art. Here the categories are: (1) nonreligious style, nonreligious content, as in Jan Steen (plates 16–17); (2) religious style, nonreligious content, as in Van Gogh (plates 26–27); (3) nonreligious style, religious content, as in Raphael (plate 10); and (4) religious style, religious content, as in Grünewald (plate 11). Of Grünewald's *Crucifixion* from the *Isenheim Altarpiece* (plate 11), Tillich wrote,

I believe it is the greatest German picture ever painted, and it shows you that expressionism is by no means a modern invention.[33]

In these categories, Tillich, in line with his questions about Renaissance art, is most negative about type three: nonreligious style with religious content. For Tillich, Raphael's art is an example of this category, a beautifying naturalism which he deplored. Surely Raphael does not need to be understood that way. But beyond such issues, the typology does not fit much of Western art. It is remarkably helpful, as Jane Dillenberger has noted, when one limits oneself to the collections Tillich knew exceptionally well, the Berlin museums and the Museum of Modern Art.

31. Robert P. Scharlemann, "The Religious Interpretation of Art," in *The Thought of Paul Tillich*, ed. James Luther Adams, Wilhelm Pauck, and Roger Lincoln Shinn (San Francisco: Harper & Row, 1985), p. 173.
32. Reprinted in chap. 9 of this collection.
33. See p. 99 of this collection.

Even these excellent museums do not give us the full range of Western art. As a result, the insights which Tillich provides are lost to art historians because for them the exceptions to his categories invalidate his schema. In a conversation with Jane Dillenberger, Tillich admitted that, for example, neither Rogier van der Weyden's *Annunciation* nor Michelangelo's Sistine Ceiling fits within his four categories.

Tillich was increasingly aware of this problem and he was attacked precisely on this typology. In the Tillich Archives are notes in which he tries to answer his critics, but his arguments are not convincing. One may even surmise that he was himself unsure, for in subsequent lectures he begins to shy away from types, or levels, and begins to talk instead of dimensions. That different approach made it possible for him to characterize what he saw without falling into the use of types that drew attention away from his intent, namely, to show the expressive depths in different forms of art. In an address to the Columbia Philosophy Club,[34] he speaks of keys and characteristics, aspects that open up and are not in danger of confining definition. Hence he speaks of seven characteristics of contemporaneous expressive styles: (1) the painting of a picture which lacks traditional kinds of subject matter; (2) the artist's use of two-dimensional rather than three-dimensional orientations; (3) the disruption of the surface; (4) the surrealist breaking of rational structures; (5) the dissolution of the organic surfaces to show the inorganic, planes, cubes, lines; (6) the disappearance of all identifiable forms, except the form which characterizes it as a painting; and (7) wholly nonrepresentational art, in which there is only color, in which physical materials as materials have been turned into a painting.

While such characteristics may be more helpful than either classification or types, they also disclose Tillich's commitment to expressive style and to his understanding abstraction merely in expressive terms. At the end of his discussion of these characteristics, Tillich notes that the expressive style deals with the symbol of the cross, but not the resurrection. There is a sense, then, in which the affirming nature of art is subsumed to that of its shattering of all forms of life. Tillich assumes that there is a form, even at the basis of all disruption, a structure that makes things what they are. His *Systematic Theology*[35] elaborates both form and disruption. It is surprising that for him the major function of art is so

34. See "Contemporary Visual Arts and the Revelatory Character of Style," chap. 12 of this collection.

35. See the selections from *Systematic Theology*, vol. 3, reprinted in chap. 14 of this collection.

singly related to disruption. While he contended that art affirms ultima-
cies beneath all disruption, he nevertheless centered on disruption as a
prophetic mode. It is in this sense that Abstract Expressionism, which he
understood only in his own interpretation of expressiveness, was actu-
ally a movement which fit his theological work better than the express-
iveness which he continued to use as a category for understanding art.

There is a rationale for Tillich's use of types or dimensions, however
adequately or inadequately defined. As a cultural theologian, Tillich be-
lieved that nothing lay outside the purview of the believer who was also a
thinker. Anchored in understanding, his approach knows the limits of ac-
tion and of change. Perhaps his feeling that change happens more by acci-
dent, by inexplicable shifts in perception, was fed by his own disillusion-
ment, as the programs with the objective of change, such as the religious
socialist movement with which he was associated, proved to have no fu-
ture. Hence, for Tillich, a total understanding was a matter of finding illu-
mination, of seeing the symbols about us, of thereby telling us where we
are, but mainly being unable to project the future.

There are affinities between Tillich's views of the visual arts and archi-
tecture. In all the arts, integrity, that is, a style that represents the present
and does not repristinate the past, is essential. That is why neo-Gothic
buildings in a non-Gothic period are essentially dishonest. He did not like
Riverside Church and opposed the Gothicizing tendencies of the already
mediocre Interchurch Center on Riverside Drive. On the positive side, it
is also why he was interested in the Bauhaus, though he was less than
positive about some of its metaphysical assumptions. At the same time,
while art and architecture call for creating forms that disclose depth in
contemporary form and style, it is easy to become part of the mood of
any present and therefore to become ephemeral.

Architecture is an exercise in creating space. As such, it has two neces-
sary characteristics: first, to create a space which is our space, whether a
private space like a room or a house, or a public space involving wider
publics; second, to make finite space open to the infinite. Architecture
should express our finitude and our openness to the infinite.[36]

Architecture in relation to religion is usually expressed in church
buildings. Here a building, while it serves a purpose, is also a symbol.[37]
But its symbolic character should be expressed in its form and style; that

36. See "Dwelling, Space, and Time" and "Theology and Architecture," chaps. 8
and 17 of this collection, respectively.

37. See "On the Theology of Fine Art and Architecture," chap. 19 of this collec-
tion.

is, the creation of a space which in and of itself declares its purpose and being without the need for special accoutrements or signs to signify what it is.

While Tillich referred to Roman Catholic as well as Protestant propensities in his views of the visual arts, his writings on architecture are mainly in the Protestant domain. His preference for stained glass that is nonfigural but at the same time brings in suffusing and mystical light is a combination of his Protestant and Roman Catholic sensibilities; whereas his negativity about sculpture in the round and his consequent preference for reliefs and murals are influenced by his views of ancient temples and his Protestant understanding. His most Protestant sympathies centered in the requirements of a space in which liturgical events take place in the midst of the people, but this was before Vatican II, in the light of which some of these differences disappeared. In contrast to the apparent clutter of objects in many Roman Catholic churches, Tillich, for theological reasons, preferred the "sacred emptiness" of the building itself.[38] But here he was clear that he did not mean emptiness as such, such as all-purpose buildings with their usual clutter of chairs, tables, and so on. Rather, the architectural achievement must be one in which the created space expresses the numinous over against all clutter and the need for signs. To create such buildings is precisely the contribution of great architects.

Of all the theologians in our century, he alone set the agenda for the role of the arts in theological work, despite the questions raised by his writings and lectures on art and architecture. That some of his views are limited, that he could not see his way past the expressionistic modality that formed so much of his thinking, is hardly a criticism. Similar limitations occur also among art historians who work in one historical period and are then incapable of accurate judgments in others. What is surprising is that, however much Tillich returned to the same themes and subjects, he usually disclosed new nuances and seemed to have had a fresh eye for seeing. He knew what so few theologians knew, that the visual arts, like the arts generally, give us facets of understanding that they alone can provide, and that, in this way, they are as fundamental to our fully formed humanity as the other sensibilities that make up our being.

While the literature on Tillich and the visual arts is not extensive, some excellent works, which I have used with profit, do exist. In many ways,

38. See "Theology and Architecture," "Contemporary Protestant Architecture," and "Honesty and Consecration in Art and Architecture," chaps. 17, 20, and 21 of this collection, respectively.

the pioneering work is James Luther Adams's *Paul Tillich's Philosophy of Culture, Science, and Religion.*[39] Adams wrote extensively on the arts, including their setting in Tillich's thought. John Clayton Powell's *The Concept of Correlation: Paul Tillich and the Possibility of Mediating Theology* attends to the relation of the visual arts to Tillich's systematic work.[40] Michael F. Palmer's extensive interpretative monograph, *Paul Tillich's Philosophy of Art*, is based on original sources.[41] Robert P. Scharlemann's chapter, "Tillich and the Religious Interpretation of Art," in *The Thought of Paul Tillich*, is the most succinct, solidly based short work on Tillich and the arts.[42] Also of significance and interest in the same volume is John Powell Clayton's "Tillich and the Art of Theology." John Newport did an overview of Tillich's life and thought in which the arts are also covered.[43] Everyone is, of course, indebted to Wilhelm and Marion Pauck for their *Paul Tillich: His Life and Thought.*[44] It is the standard work for consultation of all facets of Tillich's life, including the visual arts.

Charles W. Kegley's "Paul Tillich on the Philosophy of Art"[45] is primarily concerned with philosophical issues in relation to the arts. William H. Willimon's article, "Tillich and Art: Pitfalls of a Theological Dialogue with Art," is apparently based on the standard published works in English on art by Tillich.[46] There are also articles and books in which Tillich's views on art are considered along with others, among whom one would automatically mention works by Doug Adams and John W. Dixon, Jr.

In doing this volume, we are obviously indebted to the work of others. The only claim here is that the range of Tillich's views on art and architecture is more fully covered in this introduction and these texts than has been the case in other volumes. Since others have written exten-

39. James Luther Adams, *Paul Tillich's Philosophy of Culture, Science, and Religion* (San Francisco: Harper & Row, 1965).

40. John Powell Clayton, *The Concept of Correlation: Paul Tillich and the Possibility of a Mediating Theology* (Berlin and New York: Walter de Gruyter, 1980).

41. Michael F. Palmer, *Paul Tillich's Philosophy of Art* (Berlin and New York: Walter de Gruyter, 1984).

42. See n. 31 above.

43. John Newport, *Paul Tillich* (Waco, Texas: Word Books, 1984).

44. See n. 4 above.

45. Charles W. Kegley, "Paul Tillich on the Philosophy of Art," *Journal of Aesthetics and Art Criticism*, Winter 1960, pp. 175–84.

46. William H. Willimon, "Tillich and Art: Pitfalls of the Theological Dialogue with Art," *Religion in Life*, Spring 1976, pp. 72–81.

sively on Tillich's views of religion and of symbols, an analysis of those aspects in relation to the arts has not been included in the introduction, though the Tillich texts in this book include such aspects. The introduction is deliberately confined to the arts.

While the introduction in its present form was written for this volume, much of the material was first written for lectures, including the Paul Tillich Lecture for the Society for the Arts, Religion, and Contemporary Culture, New York City, in May 1986; a lecture for the Akademische Zentenarfeier für Paul Tillich, Frankfurt, Germany, in May 1986; a lecture for the conference Christian Spirituality and the Visual Arts, Christ Church Cathedral, Houston, Texas, in November 1986; and a lecture for the North American Paul Tillich Society, Emory University, Atlanta, Georgia, in November 1986. Obviously these lectures have been part of the celebrations of the centennial of Tillich's birth.

Since the introductory comments before each of Tillich's writings in this volume provide their context, such material is not included here. But a word about the editing may be in order. While Tillich today would undoubtedly not have used sexist language, it did not seem appropriate to make such changes. For the materials taken from tapes and typescripts of lectures, we have tried to smooth the flow of the sentences without changing the character of the spoken word. For materials from Tillich's own drafts, we have done less editing, but again with the purpose of clarity and a smooth flow of the English language. The English documents have been reproduced as originally printed, and Robert P. Scharlemann's translations obviously reflect the text of the German publications.

My thanks go to the following for facilitating and directly helping in the execution of this project: Hannah Tillich, Mutie Tillich Farris, James Luther Adams, Jerald C. Brauer, Maria Grossman, Robert C. Kimball, Robert W. Lynn, Betty Meyer, and Marion Pauck. As in a previous volume for the Crossroad Publishing Company, I want to thank Diane Apostolos-Cappadona for editorial assistance, planning the shape of the volume, and expediting so many issues involved in a publication such as this. Werner Mark Linz and Frank Oveis of Crossroad have provided a congenial, professional relation. Robert P. Scharlemann has my special thanks for the translations from the German, interrupting his busy schedule because he believed it was important to do them.

Finally, and as usual, Jane has been involved in every phase of this project. Only the fact that I did most of the writing justifies my general editorship, for she has been a collaborator in every sense of the term. She knows how much I thank her for that as well as for her selection of the plates.

JOHN DILLENBERGER

Part I

Art in Tillich's
Life and Thought

1

Between Reality and Imagination

While Tillich alluded to important events in his life on many occasions, he wrote three pieces that provide major autobiographical information and reflections: (1) On the Boundary, *which first appeared in* The Interpretation of History *in 1936 but which was revised and freshly translated in 1966; (2) his letter of 23 May 1943 to Thomas Mann, in* The Intellectual Legacy of Paul Tillich *(ed. James R. Lyons [Detroit: Wayne State University Press, 1969]); and (3) the essay "What Am I?" in* My Search for Absolutes, *written shortly before his death in 1965. For biographical information, the reader is referred to Wilhelm and Marion Pauck, Paul Tillich:* His Life and Thought *(San Francisco: Harper & Row, 1976). Excerpted here is the section in* On the Boundary *in which Tillich speaks of the arts, followed in chapter 2 by passages from "What Am I?"*

THE DIFFICULTIES I experienced in coming to terms with reality led me into a life of fantasy at an early age. Between fourteen and seventeen, I withdrew as often as possible into imaginary worlds which seemed to be truer than the world outside. In time, that romantic imagination was transformed into philosophical imagination. For good and for ill, the latter has stayed with me ever since. It has been good in that it has given me the ability to combine categories, to perceive abstractions in concrete terms (I would almost say "in color") and to experiment with a wide range of conceptual possibilities. It has been of doubtful value insofar as

"Between Reality and Imagination" is excerpted from Paul Tillich, *On the Boundary: An Autobiographical Essay* (New York: Charles Scribner's Sons, 1966), pp. 24–30. Reprinted with the permission of Charles Scribner's Sons.

such imaginative ability runs a risk of mistaking the creations of the imagination for realities, that is, of neglecting experience and rational critique, of thinking in monologues rather than dialogues, and of isolating itself from cooperative scientific effort. Whether good or bad, this imaginative tendency (plus certain other circumstances), prevented me from becoming a scholar in the accepted sense of the word. Amongst intellectuals of the twenties there was a kind of aversion against the scholar in the restricted sense of "expert."

Imagination manifests itself, among other ways, in a delight in play. This delight has accompanied me all my life, in games, in sports (which I never took as more than play), in entertainment, in the playful emotion that accompanies productive moments and makes them expressions of the sublimest form of human freedom. The romantic theory of play, Nietzsche's preference for play as opposed to "the spirit of gravity," Kierkegaard's "esthetic sphere," and the imaginative element in mythology were always both attractive and dangerous to me. Perhaps it was an awareness of this danger that drove me more and more to the uncompromising seriousness of prophetic religion. My comments in *Die sozialistische Entscheidung* (Socialistic Decision)[1] about the mythological consciousness were a protest not only against the ultimate lack of seriousness in nationalistic paganism, but also against the mythical-romantic element not conquered in myself.

Art is the highest form of play and the genuinely creative realm of the imagination. Though I have not produced anything in the field of the creative arts, my love for the arts has been of great importance to my theological and philosophical work. At home my father maintained the musical traditions associated with the evangelical ministry. He himself wrote music. Like most German Protestants, however, he cared little for architecture and the fine arts. Since I am not artistically inclined and only later gained an appreciation of the visual arts, my longing for art was directed toward literature. This was in line with the humanist tradition in education at the *Gymnasium.* Schlegel's classical German translation of Shakespeare became particularly important for me. I identified myself (almost dangerously) with figures like Hamlet. My instinctive sympathy today for what is called existentialism goes back in part to an existential understanding of this great work of literature. Neither Goethe nor Dostoievsky had a similar effect on me. I came to know Dostoievsky too late in my life. Goethe's work seemed to express too little of the boundary situation in the Kierkegaardian sense; it did not then seem to be existential

1. See Paul Tillich, *The Socialist Decision*, trans. Franklin Sherman (San Francisco: Harper & Row, 1977).

enough, although I have revised this judgment in my maturity. Even after my infatuation with Hamlet, which lasted for some time, I preserved the capacity for complete identification with other creatures of poetic fancy. The specific mood, the color as it were, of certain weeks or months of my life, would be determined by one literary work or the other. Later this was especially true of novels which I read infrequently but with great intensity.

Literature, however, contains too much philosophy to be able to satisfy fully the desire for pure artistic contemplation. The discovery of painting was a crucial experience for me. It happened during World War I, as a reaction to the horror, ugliness and destructiveness of war. My delight even in the poor reproductions obtainable at the military bookstores developed into a systematic study of the history of art. And out of this study came the experience of art; I recall most vividly my first encounter—almost a revelation—with a Botticelli painting [plate 1] in Berlin during my last furlough of the war.[2] Out of the philosophical and theological reflection that followed these experiences, I developed some fundamental categories of philosophy of religion and culture, viz., form and substance. It was the expressionist style emerging in Germany during the first decade of this century and winning public recognition following the war and the bitter struggle with an uncomprehending lower middle-class taste that opened my eyes to how the substance of a work of art could destroy form and to the creative ecstasy implied in this process. The concept of the "breakthrough," which dominates my theory of revelation, is an example of the use of this insight.

Later, when expressionism gave way to a new realism, I developed my concept of "belief-ful realism" from a study of the new style. The idea of "belief-ful realism" is the central concept of my book, *The Religious Situation*,[3] which for that reason is dedicated to an artist friend. My impressions of various representations of individuals and groups in Western art gave me the inspiration and material for a lecture, "Masse und Persönlichkeit" (Mass and Personality).[4] My growing preference for the old Church and her solutions to such theological problems as "God and the World," "Church and State," was nourished by the deep impression made on me by early Christian art in Italy. The mosaics in the ancient Roman basilicas accomplished what no amount of studying church history could have

2. See espec. "One Moment of Beauty" in chap. 23 of this collection.

3. The section on art from *The Religious Situation* is reprinted in chap. 6 of this collection.

4. The excerpts on art from "Mass and Personality" are reprinted in chap. 5 of this collection.

done. My interest in painting is directly reflected in the article, "Stil und Stoff in der bildenden Kunst" (Style and Material in Plastic Art),[5] in my address at the opening of an exhibition of religious art in Berlin in 1930, in the pertinent sections of *Das System der Wissenschaften nach Gegenständen und Methoden* (System of the Sciences),[6] in my "Religionsphilosophie" (Philosophy of Religion),[7] and in *The Religious Situation.*

This vital experience of modern painting also opened the way for an appreciation of modern German literature, as represented by Hofmannsthal, George, Rilke, and Werfel. I was most deeply impressed by the later poetry of Rilke. Its profound psychoanalytical realism, mystical richness, and a poetic form charged with metaphysical content made this poetry a vehicle for insights that I could elaborate only abstractly through the concepts of my philosophy of religion. For myself and my wife, who introduced me to poetry, these poems became a book of devotions that I read again and again.

5. "Religious Style and Religious Material in the Fine Arts" is reprinted in chap. 4 of this collection.

6. For the relevant sections, see Paul Tillich, *The System of the Sciences according to Objects and Methods*, trans. Paul Wiebe (Lewisburg, Pa.: Bucknell University Press, 1981), pp. 178–81.

7. For the materials on the "Philosophy of Religion," see Paul Tillich, *What Is Religion?* trans. James Luther Adams (San Francisco: Harper & Row, 1973), pp. 58–76.

2

Excerpts from What Am I?

In this extensive account of his life, written just before his death, Tillich again makes reference to the arts. It is surely appropriate that the volume in which this account appears, My Search for Absolutes, *includes drawings by Saul Steinberg.*

AS A PRIVATDOZENT OF THEOLOGY at the University of Berlin (from 1919 to 1924), I lectured on subjects which included the relation of religion to politics, art, philosophy, depth psychology, and sociology. It was a "theology of culture" that I presented in my lectures on the philosophy of religion, its history and its structure. The situation during those years in Berlin was very favorable for such an enterprise. Political problems determined our whole existence; even after revolution and inflation they were matters of life and death. The social structure was in a state of dissolution; human relations with respect to authority, education, family, sex, friendship, and pleasure were in a creative chaos. Revolutionary art came into the foreground, supported by the Republic, attacked by the majority of the people. Psychoanalytic ideas spread and produced a consciousness of realities which had been carefully repressed in previous generations. Participation in these movements created manifold problems, conflicts, fears, expectations, ecstasies, and despairs, practically as well as theoretically. All this was at the same time material for an apologetic theology.

It was a benefit to me when, after almost five years in Berlin, my friendly adviser, the minister of education, Karl Becker, forced me against my desire into a theological professorship in Marburg. During the three

Excerpts from "What Am I?" have been taken from Paul Tillich, *My Search for Absolutes* (New York: Simon and Schuster, 1967), pp. 41–45, 49. These excerpts are reprinted by permission.

semesters of my teaching there I encountered the first radical effects of neo-orthodox theology on theological students: Cultural problems were excluded from theological thought; theologians like Schleiermacher, Harnack, Troeltsch, Otto were contemptuously rejected; social and political ideas were banned from theological discussions. The contrast with my experiences in Berlin was overwhelming, at first depressing and then inciting: A new way had to be found. In Marburg, in 1925, I began work on my *Systematic Theology*, the first volume of which appeared in 1951.[1] At the same time that Heidegger was in Marburg as professor of philosophy, influencing some of the best students, Existentialism in its twentieth-century form crossed my path. It took years before I became fully aware of the impact of this encounter on my own thinking. I resisted, I tried to learn, I accepted the new way of thinking more than the answers it gave.

In 1925 I was called to Dresden and shortly afterward to Leipzig also. I went to Dresden, declining a more traditional theological position in Giessen because of the openness of the big city both spatially and culturally. Dresden was a center of visual art, painting, architecture, dance, opera, with all of which I kept in close touch. The cultural situation was not much different when, in 1929, I received and accepted a call as professor of philosophy at the University of Frankfurt. Frankfurt was the most modern and most liberal university in Germany, but it had no theological faculty. So it was quite appropriate that my lectures moved on the boundary line between philosophy and theology and tried to make philosophy existential for the numerous students who were obliged to take philosophical classes. This, together with many public lectures and speeches throughout Germany, produced a conflict with the growing Nazi movement long before 1933. I was immediately dismissed after Hitler had become German Chancellor. At the end of 1933 I left Germany with my family and came to the United States.

In the years from 1919 to 1933 I produced all my German books and articles with the exception of a few early ones. The bulk of my literary work consists of essays, and three of my books—*Religiöse Verwirklichung*,[2] *The Interpretation of History*,[3] and *The Protestant Era*[4]—are collections of articles which themselves are based on addresses or speeches. This is not accidental. I spoke or wrote when I was asked to do

1. The University of Chicago Press, vol. 1, 1951; vol. 2, 1957; vol. 3, 1963.
2. Berlin, 1930.
3. Charles Scribner's Sons, 1948.
4. The University of Chicago Press, 1948.

so, and one is more often asked to write articles than books. But there was another reason: Speeches and essays can be like screws, drilling into untouched rocks; they try to take a step ahead, perhaps successfully, perhaps in vain. My attempts to relate all cultural realms to the religious center had to use this method. It provided new discoveries—new at least for me—and, as the reaction showed, not completely familiar to others. Essays like those on "The Idea of a Theology of Culture,"[5] "The Overcoming of the Concept of Religion in the Philosophy of Religion,"[6] "The Demonic,"[7] "The Kairos,"[8] "Belief-ful Realism,"[9] "The Protestant Principle and the Proletarian Situation,"[10] "The Formative Power of Protestantism"[11] and, in America, "The End of the Protestant Era,"[12] "Existential Philosophy,"[13] "Religion and Secular Culture"[14] and my books *Dynamics of Faith*[15] and *Morality and Beyond*[16]—these were decisive steps on my cognitive road. So were the Terry Lectures which I delivered at Yale in October 1950 under the title "The Courage to Be."[17] This method of work has the advantages referred to, but it also has its shortcomings. There is even in a well-organized work such as my *Systematic Theology* a certain inconsistency and indefiniteness of terminology; there is the influence of different, sometimes competitive motives of thought, and there is a taking for granted of concepts and arguments which have been dealt with in other places.

* * *

[After his account of life at Union Theological Seminary, Tillich adds the following.]

5. Published in *What Is Religion?* trans. and with an introd. by James Luther Adams (San Francisco: Harper & Row, 1969), pp. 151–81.

6. Ibid., pp. 122–54.

7. Published in *The Interpretation of History*.

8. Published in *The Protestant Era*.

9. See "Realism and Faith," in *The Protestant Era*.

10. Published in *The Protestant Era*.

11. Ibid.

12. Ibid.

13. Published in *The Theology of Culture*, ed. Robert C. Kimball (New York: Oxford University Press, 1959), pp. 76–132.

14. Published in *The Journal of Religion* 26, no. 2 (April 1946): 78–86.

15. Harper & Row, 1958.

16. Harper & Row, 1963.

17. Yale University Press, 1952.

For external and practical reasons it became impossible to maintain the relationship to artists, poets, and writers which I enjoyed in postwar Germany. But I have been in permanent contact with the depth-psychology movement and with many of its representatives, especially in the last ten years.

3

Art and Society

In 1952 Paul Tillich gave three lectures for the faculty, students, and friends of the Minneapolis School of Art at the Minneapolis Institute of Arts. Since these previously unpublished lectures represent Tillich's early and most comprehensive lectures on art in the United States, they have been assigned an introductory place in this volume. The text is a version of the typescript in the Tillich Archives, edited in the light of a tape of the lectures provided by the Minneapolis Institute of Arts.

Lecture 1/ Human Nature and Art

LADIES AND GENTLEMEN: It is my first and pleasant duty to thank the director and faculty of the Minneapolis School of Art for the invitation to speak in this famous institute. The more I appreciate this honor, the less I feel adequate to my task. I am neither an artist, an art historian, an art critic, nor even a philosopher whose special subject is art. I am a philosophical theologian as the name of my chair at Union Theological Seminary indicates. And this is certainly no reason for being invited to give three lectures in an art institute.

I have only one excuse for having accepted this invitation (which came to me as a surprise), namely, that some things happened to me that have some bearing on the problems I intend to discuss in these three lectures. As a son of a Protestant minister in Germany I was brought up in an atmosphere in which music was the art that counted, my father having been a good dilettante composer besides being something like a Lutheran bishop. Besides music, the word, above all the biblical word, was important. But the visual arts, though not denied, were badly neglected and looked at with some suspicion, especially when, as I remember, my

sister and I regularly visited the Berlin museums after the Sunday services in which my father presided.

But it was the dirt, the horrors, and the ugliness of the First World War in which I participated as a chaplain which induced me systematically to study the history of art and to collect as many as possible of the cheap reproductions available to me in the battlefields. Then on one of my furloughs, I happened to visit the Berlin [Kaiser Friedrich] Museum and stood before a round picture by Botticelli [*Madonna and Child with Singing Angels* (plate 1)] and had an experience for which I do not know a better name than revelatory ecstasy. A level of reality was opened to me which had been covered up to this moment, although I had some intimations of its existence.[1]

Shortly after this the war came to an end. When I came home two additional things happened. First, a friend of mine, a well-known art historian who wrote a basic book on German expressionism, Dr. Eckart von Sydow,[2] introduced me to modern art by interpreting to me some rather radical works of the new style. Again my eyes were opened. Since that hour, more than thirty years ago, I have been an ardent adherent of the art of the twentieth century, even in its more extreme forms.

About the same time I had the second experience. Exactly in the way in which the picture of Botticelli produced an ecstatic feeling of revelatory character, a special encounter with the seemingly abstract concept of being created a similar experience. It was, as I would call it today, an encounter with the power of being itself. It was the astonishing awareness that something is and not nothing, and that I participate in its power to be. That made this moment unforgettable. The concurrence of these two experiences, the artistic and the philosophical, created a union of the two realms in my mind which thereafter was never disrupted. Many of the categories I use in some of my most abstract philosophical analyses are actually derived from my preoccupation with modern art. On the other hand, I cannot speak of modern art and for that matter of art at all, without emphasizing its relation to being itself, to the ground and the power of being.

Apologizing for this rather lengthy confession, I have to repeat that it is the only way of justifying my acceptance of the invitation to speak to you and, beyond this, it is a way of showing that the cognitive realm is not strange to the artistic realm, since both point to a level of reality which transcends the ordinary level of encountering things.

1. See "One Moment of Beauty," chap. 23 of this collection.
2. *Die deutsche expressionistische Kultur und Malerei* (Berlin, 1920).

The philosopher deals with art, as with everything else, philosophically. The artist deals with philosophy, as with everything else, artistically. The philosopher analyzes what the artist does and the artist expresses what the philosopher does, the first in an aesthetic theory, the latter in artistic symbols. Each function can become the subject matter of the other but this is possibly only because the philosopher as a philosopher participates in the power of the artistic function and the artist as an artist, whether he knows it or not, participates in the power of the philosophical function. No creative philosophy is completely lacking in artistic spirit and no creative art is completely lacking in philosophical spirit. Human nature resists compartmentalization. For reasons of expediency we must maintain and sometimes even increase the division of labor, but if we ask what is the end of our becoming more and more expedient, the answer must be: the final goal of man's activities is man. And if it is something else, dehumanization has started. Man has become estranged from himself. A division of functions without continuous reunion in man himself means that man has become estranged from himself. All his functions are rooted in the one human nature and the aim of all of them is he himself.

This is one of the reasons why I was happy about your invitation. It is one more symptom within a large number of symptoms which indicate that a reaction against a compartmentalized state of man's creative activities is under way. But such a movement can be successful only if it is conscious of the place on which the different compartments have their unity. This place is man as man. He is the unity in which all cultural functions are rooted. Nevertheless, man has created the different spheres of cultures. He has divided his world and himself into sections; for instance, into body and mind, into theory and practice, into intellect and emotion, into the religious and the secular. In each of these sections a part of himself appeared but he himself disappeared. Man learned many things about the physical, chemical, biological conditions of his bodily existence. But the body as the organ of his being vanished from his sight. Man dived into the inexhaustible complications of his psychological structure. But the personality, as the center of his being, was removed by psychology; so he was without psyche, without soul. Man analyzed the working of his intellectual and aesthetic functions but the ultimate meaning and the relation to the world were obscured.

However, in the long run, man realized that he had lost himself in his world, and that he had lost his world in what he had made of it. And when he began, perhaps at the turn of this century, to realize this, his spiritual odyssey, the return to himself, started, and like Odysseus in his return to

Ithaca, he experienced infinite delays, dangers, and shipwrecks. So man in his return to himself has already experienced, and will experience even more, threats, failures, and catastrophes.

But Odysseus finally returned. Perhaps man also will return to himself. I believe that the history of existential philosophy, which starts in the first third of the last century and is now [1952] more than one hundred years old, as well as the history of art since the beginning of our century, must be understood in the light of man's desperate attempts to return to himself. They are the adventures of Odysseus in his return.[3]

This is the reason why I have given my first lecture the title "Human Nature and Art." Our question is: What is the nature of a being that is able to produce art? Man is finite. He is, as one could say, mixed of being and nonbeing. Once he was not. Now he is and some time he will not be. He is not by himself, but thrown into existence and he will be thrown out of existence and cease to be for himself. He is delivered to the flux of time which runs from the past to the future through the ever-moving point which is called the present. He is aware of the infinite. He is aware that he belongs to it. But he is also aware that he is excluded from it.

In Greece men called themselves the mortals, and they called their gods the immortals. In these classical names the human situation is profoundly expressed. Animals are also mortal. But they are not called the mortals because they do not belong to the infinite and are not excluded from that to which they belong. Man is aware of his finitude and this awareness is alive as anxiety. Anxiety is the awareness of one's finitude. This anxiety is not the fear of a special danger; it is not something that ap-

3. The following paragraph from *The Courage to Be* (New Haven: Yale University Press, 1952), pp. 136-37, shows the connection Tillich saw between existential philosophy and the history of art since the beginning of this century:

Since the last decades of the 19th century revolt against the objectified world has determined the character of art and literature. While the great French impressionists, in spite of their emphasis on subjectivity, did not transcend the split between subjectivity and objectivity but treated the subject itself as a scientific object, the situation changed with Cézanne, Van Gogh, and Munch. From this time on, the question of existence appeared in the disturbing forms of artistic expressionism. The Existentialist revolt, in all its phases, produced a tremendous amount of psychological material. Existentialist revolutionaries like Baudelaire and Rimbaud in poetry, Flaubert and Dostoievsky in the novel, Ibsen and Strindberg in the theater are full of discoveries in the deserts and jungles of the human soul. Their insights were confirmed and methodologically organized by depth psychology, which started at the end of the century. When with July 31, 1914, the 19th century came to an end, the Existentialist revolt ceased to be revolt. It became the mirror of an experienced reality.

pears and disappears according to the presence or absence of external threats, but it is a continuing driving force in the depths of our being since our finitude cannot be removed. Out of the anxiety, and the double awareness that we are finite and that we belong to infinity from which we are excluded, the urge arises to express the essential unity of that which we are in symbols which are religious and artistic. Man creates the gods as symbols of that which has created him, the infinite from which he comes, from which he is separated and to which he is longing to return. In anticipation of the unity and the religious artistic expression of this anticipation, he wins the courage to take his finitude and the anxiety of his finitude upon himself. He wins the courage to be.

No realm of human culture, no human creation whatsoever is understandable without an insight into the structure of man's finitude and anxiety, of his potential infinity and his courage to be.

But before building on these foundations we must look into other directions. Man is not only excluded from the infinite to which he belongs; he is also excluded from everything finite that is not himself. The more individualized a human being is, the more self-centered one is, the more one excludes everything else by nature from oneself, and the more one is excluded from those things that are equally centered in themselves. Man is a completely centered being, and as an individual self is most lonely; for this reason, he is most desirous to return to that to which he belongs and away from his separation from other beings.

Man wants to participate in other beings. Manifold are the ways in which he fulfills his longing for reunion. Knowledge is one of these ways. Through cognitive participation, the individual self takes into itself its world. Where there is knowledge, there is participation. This is the reason why human beings are driven by the desire to know. But it is a participation which is restricted to the appearance and structures of the thing and to its relation to other things. Something is lacking, we all feel, in our cognitive participation in our world, namely, the participation in what things mean for themselves.

I know the appearance and structure of a tree and its relation to the surrounding realities. Science can tell me volumes about every tree in this respect. But I do not know its inner meaning, the way in which it expresses the power of being which is present in everything that is. But there is a way of penetrating into this hidden quality of the thing and this way is artistic creation. All the arts penetrate into the depths of things which are beyond the reach of cognition.

The tree registered and explained by Linnaeus, the great biologist, and the tree shown by Van Gogh, the painter [plate 26], could be the same tree but the kind of participation is quite different. When we look at the

pictures of Van Gogh we experience the power of being—and in his case a tremendous dynamic power of being—which is effective in the life and struggle of the tree. We participate in it. We encounter a new quality. We become aware of something about the tree which neither the appearance of the tree nor the analysis of its structure and growth can show us. Art makes us aware of something of which we could not otherwise become aware. We realize the quality of things which, without artistic intuition and creation, would remain covered forever.

In this sense, the history of art is the history of continuous discoveries. The repeated, often ecstatic joy in encountering such discoveries is rooted in the fact that intuitive participation in works of art liberates us from the loneliness of our separated existence in a much more radical way than cognitive participation can. In knowledge, distance and detachment always remain decisive. In art, union, that is, uniting love, dominates.

Anticipating elements of my next lecture, I must, however, add that there is a possibility of reunion which transcends both the cognitive and the artistic, namely, the person-to-person relationship. This is the highest form in which the isolation of the individual is overcome. It is the highest form because the distance between person and person is the deepest of all possible distances. It is the highest because the conquest of this deepest gap leads to a communion which is a fulfillment of participation. But participation is not identity. In participating in another being we are in the other one without losing our own identity, and only such a communion is worthwhile. Every other encounter is neurotic and perverted.

One may ask: Is not the artist who paints a portrait of another man, or the novelist who encounters man on the level of his individual characteristics, equally near to the other one, as the man is who participates in a person-to-person relationship? If this question is asked I must answer No. We must say No even more emphatically if the psychologist asks us: Does not the psychological insight we have into this man give us more participation than the artist and the loving friend disclose? Neither of them knows the other person as well as we do, the psychologists may say. To this we must again answer No. You may know something of him, perhaps everything *of* him, but you do not know *him.* Knowing a person in terms of cognition means not knowing him in terms of communion. Perhaps you gain the possibility, as our dictators did, of manipulating men and the masses. But insofar as such calculation is followed, it is not he himself. In order to know him you must be *with* him. The knowledge of communion is not cognitive knowledge. The artist is nearer to it than the others, but communion is more than even artistic participation.

Looking back now at what we have said about the separation and re-

union of the individual being, we understand why all forms of participation have been called love. The power which drives to cognitive reunion of the separated has been called Eros by Plato. It is the same power which drives to artistic reunion. The union of persons as persons in Greek is called *philia*—friendship. Its highest Greek form is the New Testament *agape*. All these words mean love. Love is the urge for the reunion of the separated. Man is the most separated being. Therefore, he is the most loving being. Knowledge, art, and communion are three forms of love, three movements toward reunion of that which is separated, although they belong to each other.

Man stands between the finite he is and the infinite to which he belongs and from which he is excluded. So he creates symbols of his infinity. Man is separated from man and all other beings and so he drives toward reunion with them in the threefold form of cognitive, artistic, and communal participation.

Now the question arises: How can he do this? How can he create symbols of his infinity and forms of his participation? The answer is: Man is not only finite, he is not only individual self; he also has another quality, he is free. Man is creative because he is free. Taking all of this together, man can be defined as finite freedom. It is not that he has finite freedom, as if he were something else and finite freedom were an attribute of him; in his very essence he is finite freedom. In these two words his greatness and his destiny are included. The term *freedom* produces many painful or passionate connotations: passionate because one fights for the freedom of one's self or others; painful because the discussion of the freedom of the will is an obsolete, inconclusive, and self-defeating discussion.

Now I am going to speak of something which is neither political freedom nor the freedom of the will. It is the finite freedom which constitutes us and which is not controversial if rightly understood. Man's freedom is his power of transcending every given state of his finitude. He can transcend it in several directions. One of them is the technical direction. Man has the freedom of making tools. The higher animals can use some found objects as tools for a special situation but they do not make lasting tools. *Homo faber*, man who fabricates means for ends, is that being who is free and who is able to create a world above the world of technical products which is unlimited in time and space.

Another form of man's freedom is his freedom for deliberating and deciding. Only the sick man, a man in the laboratory, for instance, is subjected to the curve of stimulus and response. The healthy man receives the stimulus, then stops his reaction, deliberates, uses universal categories and principles, logical and ethical norms, and responds with the whole of his personality. That means he is ethically free. The power of de-

liberation which makes him responsible for what he does is itself an expression of his freedom. In this sense, not his isolated will but every cell and nerve of his body are free. They participate in the freedom of his centered personality.

The third expression of human freedom is freedom from bondage to the given. Man is not only able to sketch something new in terms of means; he is also able to create something new in terms of ends. He is able to create the world of artistic forms which express and transform the given. Of this creative freedom we speak when we speak of the arts. Many of you are art students. Have you ever realized the creative freedom which is the basis of every art in every moment?

Let us more carefully analyze the nature of this freedom. There is something profoundly paradoxical in man's ability to actualize creative freedom. For instance, one could call artistic freedom the freedom to play. Nothing is more astonishing than this possibility of human nature. Man can liberate himself from the seriousness of reality; he can play in imagination and realization. It has often been discussed whether animals can play. In some sense they obviously can, but not in the sense in which man can play. Their play is never an expression of their freedom to transcend reality. They are bound also to their play. Therefore, nothing is created by this play. But man's ability to play is his ability to create a world above the given world, the world of the arts. The arts are play insofar as they transcend the appearance and the structures of reality. But they are not arbitrary play. They express something which lies on a level which can be discovered only through man's creative freedom from the given.

This implies that art is both creation and discovery. In the arts something which is rooted in the ground of being is discovered, and this discovery presupposes the freedom of man from the given; it presupposes his power to introduce the discovered into the realm of the given in forms which transcend the given. This is what has been called the miracle of art. It discovers and shows the discovered realm of reality in forms which are taken from ordinary reality but simultaneously point beyond it. The way in which art can express the deepest fear of being, where one is suddenly freed from ordinary reality, is the subject of the next and final inquiry of this first lecture.

Art does three things: it expresses, it transforms, it anticipates. It expresses man's fear of the reality which he discovers. It transforms ordinary reality in order to give it the power of expressing something which is not itself. It anticipates possibilities of being which transcend the given possibilities.

Expression is the universal category referring to everything that is. One can understand, and philosophically has understood, apparent real-

ity as an expression of the ground of reality. But in the ground of being, as potentiality becomes actual in the world of appearance, the term *expression* presupposes the distinction of that which is expressed and that in which it is expressed.

This distinction would be easy if we could say that something internal is expressed in something external. Expressionism in the narrower sense of the word has often been understood as a style in which the emotional side of man expresses itself in artistic symbols. Nothing could be more removed from the true meaning of expressionism. Expressionism expresses a level of reality other than realism, impressionism, and idealism. But these also express a level of reality and none of them expresses mere subjectivity.

In order to remove this misunderstanding we should distinguish between two levels of artistic expression. First, expression is the general characteristic of art insofar as it expresses a quality of reality which transcends mere objectivity and mere subjectivity. The arts are not only arts; they are more than a subjective outcry. Young poets are to be considered as poets only, and not as young, if they are able to objectify their subjective emotions. Conversely, an art is only art if it is more than an objective record. Photographers are artists only if they discover the artistic realm of reality through their lenses. This sometimes happens. The combination of eye, soul, and camera occasionally can transform the photographer into an artist. Art expresses a level of reality and, in doing so, fulfills our desire to be reunited with the meaning in everything.

The second level on which the meaning of expression appears is the expressionistic form of art. It not only expresses but it also shows that it is expressive. It expresses its expressing power. Therefore it is farther removed from the ordinary reality of our technical existence than the non-expressionistic styles. Expressionism makes manifest what is present in all art—expression. For this reason, some of the expressionistic works of art in primitive art, archaic art, Byzantine art, early Gothic art, and recent art belong to great artistic creations. On the other hand, expressionism can become arbitrary, uncontrolled, subjective, expressing nothing more than the state of the artist and not the state of reality, and then it is not art but outcry.

The second characteristic of artistic creativity is transformation. In order to express, art must transform. It must transform the given reality into a form which expresses the dimension of reality which the arts are supposed to express. This transformation is determined by the artistic rules which have a universal and a particular side. There are rules of transformation which dominate every art. And there are rules of transformation which determine a special style. In many cases it is doubtful

whether a way of transformation denies art as art, or only as special styles of art. The adherents of an earlier style are inclined to say that the new style is not artistic at all; yet there is no criterion which could be used either for or against transformation.

Some people say the proper criterion is that reality is not transformed but imitated. Yet there is no imitation which is not transformation. An infinite gap separates the most imitative art from the reality it imitates. Artistic form and natural form are never the same. This introduces an element of risk into artistic transformation. But risk, in every aspect of life, must be taken.

It can also be said that art must create beauty. Works of art are supposed to be beautiful. An art that is not beautiful, according ot this criterion, is not art. Those who so speak must give us a definition of the beautiful; otherwise we cannot use it as a criterion. The word *beautiful* has an old-fashioned sound. But perhaps it can be saved, like many other words which need salvation. If beautiful means a creation whose harmonious forms produce immediate pleasure, only a few and very questionable artistic styles are concerned with beauty. If, however, beautiful means the power of mediating a special realm of meaning by transforming reality, art is bound to be beautiful. But, unfortunately, the term is ordinarily used in the first and not the second sense. And those who use it in this first way establish as a criterion of artistic transformation a kind of idealizing naturalism which rejects expressionism in any sense of the word.

But transformation and beauty can mean something quite different. They can mean that the given is transformed in such a way that it becomes a symbol for that which transcends the given. The gold ground of the Byzantine or early Gothic picture is not chosen in order to beautify an otherwise ugly form of existence. It is chosen because it symbolizes the heavenly sphere which is beyond color and reach. A Dutch landscape shows the discovery of that power of being which appears in and through the trees and fields and roads and wide horizons of this painting. It is not the landscape as we meet it in an ordinary encounter; neither is it a piece of nature rearranged by the painter in order to make it look more beautiful. It is the result of the creative encounter with what one could call the spirit of the intrinsic power of the landscape. The joy produced by this encounter is the joy of Eros, of love, which has reached its reuniting aim. This, however, can only happen through the aesthetic form which makes manifest those qualities of being toward which the reuniting Eros drives us.

The third element in artistic creativity is what I have called anticipation. The question, of course, is: What is anticipated? The most natural answer would be the state of perfection which transcends the state of

imperfection in which we exist. But such an answer would cover only special styles and special contents of artistic creativity. It would most emphatically contradict the expressionistic function of art, for objects of expression include distortion as well as the perfect. The anticipating function seems to reestablish the classic ideal of beauty as perfection. The question then is: Must the function of anticipation be excluded from a consideration of human nature and art? It depends on the meaning of the perfection which is anticipated. In classicism that which is conquered in perfection remains hidden within it. It is not completely lacking, as the classic sculptures of Greece and some of the classical pictures of the high Renaissance show.[4] Other styles manifest the ugly, the distorted, the horrible, the evil, and the demonic in intentionally distorted forms. Often works of art in this style select preferentially distorted contents.

What is the meaning of anticipation and perfection in such forms, forms which in number surpass the classical styles? It is the power of an artistic form which creates a nonclassical perfection. It is the possibility of taking the completely disharmonious, not into a harmony which is present in the content, but into a harmony which is identical with the artistic form. It is the courage to take one's own anxiety, finitude, meaninglessness, and estrangement upon one's self and express this courage in artistic form. This is the element of anticipation even in the most radically distorted form of art.

Therefore, one can say that in art salvation is anticipated. But this leads us to our third lecture—that on art and religion.

Lecture 2/ *Culture, Society, and Art*

In the first lecture we inquired into the roots of artistic creation in human nature. In trying to find answers we looked at the individual, his finitude, his awareness of his potential infinity, his separatedness from all other finite beings and his longing for union with them. In other words, we abstracted individual man as such from man in society. This abstraction, like scientific abstraction, is preliminary but necessary. Man as man

4. In "Between Utopianism and Escape from History," *Colgate Rochester Divinity School Bulletin* 31, no. 2 (May 1959): 36, Tillich wrote as follows:

The great creations of the Renaissance before Michelangelo, Fra Angelico, Botticelli, Raphael, which for a long time were the criteria of every artistic style, and which since the turn of our century fell into disrepute, must be understood in their greatness and their limits as the anticipated fulfillment of the highest human potentialities. They express our human predicament only insofar as they show images of the state of things in which this predicament is overcome.

is actually social man. So we must contrast the individualizing abstraction of the first lecture with consideration of man and art within society today.

Society, not individual men, produces culture. That involves individual men but only insofar as they function as members of a social group. Only in this constellation do they produce culture, for only in this setting do they have language.

There is one element in every cultural creativity which is not an element beside others, but the substance of all the others, namely, religion. I do not speak of religion as a function of the organized church or as the function of the pious individual; rather, I speak of religion as a state of being ultimately concerned. Religion in this universal sense is valid of religion, as well as of nonreligion, and it is the substance of culture. It gives meaning to all cultural creations.

In this lecture we must concentrate on society, culture, and art. Man's social existence is determined by the fact which one could call the ego-thou encounter. The ego becomes an ego by the encounter with the thou and conversely. How does this happen?

It happens because through the other, man experiences the unconditional limits of his own power of being. He realizes that there is a limit which he cannot trespass. The claim of the other, which is equal to my own claim, must be acknowledged. It is a claim to be accepted as a person, as a power of being and meaning which constitutes the actuality, dignity, and danger of being a person.

If man lived with subhuman nature alone, he would never become a person. There would be no resistance against his desire to make all material powers into parts and organs of his own power. Certainly he must struggle with nature in order to subject it, but this struggle has too great a promise of ultimate success, as history has shown and is showing daily.

This is not so in the encounter of man with man. On the contrary, there is evidence that the resistance of man against man's attempt to treat him like a thing, as utility or as object, is increasing in human history. We have not only the well-known development from slavery to the acknowledgement of the rights of man; it is also evident in the less conspicuous but more important development from despotic to liberal types of family relations. The valuing of every potential person as an actual person, and the acknowledgement of his just claim, is a basis of our civilization, so much so that even the totalitarian reaction against it has arisen in the name of what it tries to destroy, namely, the intrinsic right of every person to be acknowledged as a person.

The importance of this consideration for an analysis of human culture is that in the person-to-person encounter, the category of the ought-to-be

is discovered; first, practically, then, also theoretically, and in the theoretical realm not only for the cognitive but also for the aesthetic sphere. The idea of law, with its obligations, is born in the person-to-person encounter and it is transferred from there to nature in terms of physical laws and to the mind in terms of cognitive and aesthetic laws.

Whenever we speak of law in our scientific language, we should remember it is the social law, the juristic law, which is the oldest and earliest concept of law. Law is born out of the person-to-person encounter, even if we speak today of physical laws.

The vehicle of all this, and accordingly, the vehicle of the culture as a whole, is language. Language lives in universals, and in the use of universals human freedom expresses itself. The animal always remains in the bondage of the particular, of this tree, this river, this food. In encountering this tree, man experiences at the same time treehood, the universal, that which makes a tree a tree. He always encounters this universal in every particular tree which he recognizes as a tree.

Therefore, he can give a name to things. Giving names to things means being free from their particular appearances, transcending them toward the universal, and this power gives man language. This power liberates him through language and language permeates his being. Language, however, is not bound to the spoken word. It is present in writing and reading. It is present in silence as well as in talk. It is effective in the visual arts, in the creative as well as the receptive act. We cannot encounter a color without encountering it as a particular color, the name of which is dimly in our consciousness. We cannot see grades of light and darkness, forms of balance, structural elements, meanings expressed, without recognizing them as what they are through silent language.

Only that being which can speak can also paint. Therefore even such cultures as the Greek and the Roman have made the word, the *logos*, the *verbum*, the principle of the divine self-manifestation. They were predominantly visual cultures, but they recognized that no visual encounter with reality is meaningful without the silent word by which we grasp reality. In the word the spirit finds itself, the human as well as the divine. But language could not be designative if it were not communicative. It is one and the same event in which person, language, and culture arise. It is the event in which man is born as man.

On this basis culture grows and within it the arts. If one tries to construct a system of man's cultural activities, one notices not only the difficulty of the task but also the fact that in the moment in which it is performed, man's cultural creativity produces something new which eludes all previous divisions. The only value, therefore, such an attempt has, is that it gives a scheme which makes the description of some relations be-

tween different cultural activities easier. If we ask which is the place of the arts within the whole of culture, any answer to such a question requires an articulated picture of man's creative activities, however preliminary this picture of creative activity may be.

Setting aside for now the relation of art to religion, we can distinguish three cultural realms whose relation to art must be considered: the technical, the practical, the theoretical. Art can either have an intimate relationship to one of these realms or it can constitute a fourth realm. Such a discussion is important only if it gives significant insight into the nature of art and its function in society. Semantic considerations point to an intimate relationship of the arts to technical production. In German the *Künstler* means literally "he who can," that is, he who can do something. The Greek *poietes*, "poet," is derived from *poiein*, "making," "producing." The Latin *ars* is the skill to fabricate something.

These linguistic references reflect the fact that the technical and the liberal arts originally were not separated. Often both of them were united in the magical function attributed to things of practical use. This union has never completely been dissolved, as the arts of design in our day show. But alongside this historic unity, two developments took place.

Tools became mere tools, determined exclusively by their use, and artistic activity liberated itself from union with technical production and created the arts as an independent sphere of culture. But the problem of the relation between technical and artistic creativity was not solved. The tension between both functions is especially obvious in the buildings in which we live.

An expression of man's finitude is his necessity to dwell, to have a place. He is excluded from the infinite space and, even if he pushes into it without a definite limit to the farthest stars, he must start in a definite place and return to another definite place. Dwelling in a cave, a tent, a house, a city is only partly a matter of protection. It is also a matter of providing a definite space for one's self.

The philosophical analysis of man's having to dwell in a place is most revealing for his relation to the finite and to the infinite, and is most fruitful for the solution of the technical, social, and artistic problems of architecture.[1] Whether the finite side is emphasized and the house approaches a cave, or whether participation in the infinite is emphasized and the house approaches open space, involves a tremendous decision for the development of architecture. Modern architecture tends mainly toward the second direction; earlier forms, in the first direction. This

1. See "Dwelling, Space, and Time," chap. 8 of this collection, and chaps. 17 through 21 in Part III.

shows that a house is both a technical and an artistic creation and the relation between them is of highest cultural interest. The predominance of the artistic point of view in former periods has been followed by the dominance of the technical point of view in our own period.

This is a rather superficial distinction. If we ask the question, "In which sense do you use the word *technical?*" and we answer as we must, "In the sense of using the adequate means for an end," the whole distinction between the technical and the artistic element becomes questionable. For now we must ask: What is the end of building a house? Certainly habitation; but what is the meaning of habitation? When we ask this, we are again in the metaphysics of housing. This means that the so-called *Wohn-maschine,*[2] the machine for dwelling, is the wrong solution. But, although wrong—because it limits the technical element to physical techniques and does not consider that there are other purposes, namely, finding a space for body, soul, and mind—it is right in its criticism of the opposite solution, that which says, first build technically and then trim artistically. The aesthetic horrors of the nineteenth-century cities are the consequence of this prescription. It also underlies the unspeakable ugliness of the inner decoration of buildings in the same period. Both show a human predicament in which artistic creativity has retreated from its fundamental union with the technical realm, because the economic technical development has drawn into itself all aspects of human existence. To the degree in which this control of life by physical techniques has happened, art itself became either formalistic, in the sense of the famous *l'art pour l'art* slogan, or it became traditional, using past styles for the decoration of realities whose essential structure was completely untouched by artistic vision. The miserable, imitative church buildings since the middle of the nineteenth century are witnesses to this repulsive situation.

Hence, while in the older, more magical feeling, technical and artistic creation are identical, and while in a dominating technological consciousness art is separated from techniques, the technical process itself produces artistic expression, transformation, and anticipation.

Fortunately, this is the direction of modern architecture, and it will be successful if it avoids the interdependent pitfalls of interpreting the technical element as machine techniques alone and then of adding ornamentation which has nothing to do with the meaning of dwelling and the technical means used for it. In this sense, technical and artistic creativity belong to each other in spite of their relative independence. Moreover,

2. See "Honesty and Consecration in Art and Architecture," chap. 21 of this collection.

in the same sense, the different arts, after their separation from the technical realm, that is, sculpture from architecture, and painting from both, can again be joined. In the unity of work which is technical and at the same time artistic, a reunion of the disrupted functions of artistic creativity may be possible.

On the basis of language and technical production, human culture grows in two directions, the theoretical and the practical, the former comprising the cognitive and the aesthetic functions, the latter the social and ethical functions of man's creativity. This division requires showing an intimate relation between the cognitive and the aesthetic functions. The Greek language can give an indication of what I mean. The word *theoria*, "theory," is derived from *theoreo*, which means looking at something. It suggests almost the opposite of what we mean today when we say rather stupidly, "This is right in theory but false in practice." If it is false in practice, this is so because we have not looked carefully at the reality in question. In other words, the practice is false because the theory was wrong.

Even more characteristic is the derivation of the Greek word *eidenai*, "to know," from *idein*, "to see." The object of knowledge is the *eidos* or the idea (the two words mean the same) of a thing, that which you see in a thing as its essence, for instance, treehood in a tree. Finally, we must remember that *aesthetics*, the word itself, is derived from *aisthanomai*, that is, I am aware of something.

All this shows the point of identity between the cognitive and the aesthetic functions. Both receive reality without changing it as such. They transform it into images, concepts, sounds, words, colors. But they do not transform the objects as such. They do not transform personalities, bodies, social structures, political systems, or even nature. The theoretical transformation of what is given to us does not transform the actual state of the given. It transforms the content of the ordinary encounter into an object of cognitive or aesthetic reception. It is, exactly defined, transforming reception. On the basis of this identity the differences can be described: *theoria* as cognitive reception and transformation gives an analysis of what the things are in their relation to each other. *Theoria*, as aesthetic reception and transformation, gives the vision of what the things are for themselves.

This answers the painful question, discussed among philosophers, whether art mediates knowledge. If knowledge is defined as the aim of the cognitive function, the answer must be that art does not mediate knowledge. If knowledge stands for aesthetic awareness of a level of reality, the answer must be that art does mediate knowledge. But one may question whether it is wise to call the aesthetic awareness of what things are, for themselves, knowledge.

Science, as the most conspicuous form of cognition, describes the calculable relations of the elements of matter ideally in mathematical functions. If such a description is applied to a concrete object, we learn about this object, a tree, an animal, nothing except its calculable internal and external relations.

If the same object is shown by a creative painter, we experience something of the power of being in this object as it is discovered by the artist. Such a discovery is certainly impossible without the participation of the artist himself in the meaning of the object which he expresses. In this sense, every art includes an element of subjectivity. But subjectivity is not arbitrariness. It is the empathetic union of the subject with the object on a level which is deeper than both of them. The work of art is a third thing beyond mere objectivity. This is the reason why it is completely wrong to interpret naturalistic art as merely objective, and expressionistic art as merely subjective. A definite kind of objectivity of the qualities of things are discovered, expressed, and shaped in expressionistic art.

A definite kind of subjectivity discovers, expresses, and shapes the qualities of things as they appear in naturalism.

In every work of art an encounter between the artist and his world is expressed. Works of art witness to a creative encounter. Since in every encounter both sides participate, they witness to the objective as well as to the subjective side of the encounter. Art, as the result of all those considerations, discovers reality. It is theoretical in the genuine sense of *theoria* but it is not cognitive.

Now we must ask how the artistic function is related to the practical function. There are two main answers to this question: the Kantian and the Kierkegaardian. Kant and, even more outspoken, the neo-Kantian school during the whole nineteenth and early twentieth centuries, interpreted art as a synthesis between the theoretical and the practical functions of the human mind, between pure and practical reason, as they called it. In this way the arts took on a tremendous significance, replacing, for instance, in the Romantic followers of Kant from Fichte to Hegel, religion by art. The influence of these ideas is manifest in the whole intelligentsia of the nineteenth and early twentieth centuries, namely, in their way of despising all forms of classical religion and valuing the arts as the elevation of the soul which, after the vanishing of religion, is the domain of the educated man.

It is difficult for an American audience to understand the significance of this attitude for the spiritual life in Europe during almost one hundred years, up to the First World War. In and after the First World War, the belief in the arts as a substitute for religion broke down. Art was not able to open up the sources of power to meet the catastrophes of the twentieth century. It did not unite, as the Kantians believed, the practical with the

theoretical. It remained in the realm of *theoria.* The anticipatory function of the arts produced the image of perfection in the mind, but not in reality.

The moment this became apparent, the voice of Kierkegaard could be heard. He contrasted the ethical with the aesthetic realm and showed their basic conflict. For him they are stages of man's self-realization. One must leave the aesthetic stage in order to reach the ethical stage. However, the concept of the aesthetic has, for Kierkegaard, a much larger meaning than it ordinarily has. Aesthetics for him is the attitude of detachment which looks at things and persons without being existentially involved in them. Taken in this sense, the whole realm of what we have called theoretical is called aesthetic by him; being aware, enjoying the awareness, without feeling personally responsible for that of which one is aware, is the aesthetic attitude. His classical example is the diary of the seducer,[3] who, for the sake of the aesthetic, erotic ecstasy of one night, sacrifices the personal existence of the woman whom he uses. The metaphysical expression of this attitude is the explanation of evil through the assertion that light is light only in contrast with darkness. Harmony is harmony only through the conquest of disharmony.

In the trenches of the First World War, those who once spoke in those terms, found themselves on the dark side of existence and their previous aesthetic detachment broke down. Such realities show that the artistic realm cannot claim to be the synthesis of all other realms of human culture.

If we ask about the unity of culture, we have to look at the depths out of which culture grows, its spiritual substance, the ultimate concern which determines all its forms, the practical as well as the theoretical. This ultimate concern, which I have called religion in the largest sense of the word, expresses itself in all forms of a culture—a historical period, a movement, a group, and the total work of an individual. This over-all expression is called a style.

The word *style* was used in the artistic realm and this is, so to speak, its home station, one to which it always must return. But it can be taken from the artistic realm and used for other functions. One can speak of a style of thinking, of ethical and social behavior, even of politics.

In these realms, one can discover the ultimate concern of a society. One can, for instance, show what kind of a society was able to produce the early Greek philosophers and their archaic style of thinking, and

3. See Søren Kierkegaard, "Diary of a Seducer," in *Either/Or: A Fragment of Life,* 2 vols., trans. David F. Swenson and Lillian Marvin Swenson (Princeton: Princeton University Press, 1946), 1:249–382.

which changes in that society led to the dissolution of the aristocratic tradition and to the sophistic movement. One can show which ultimate concern lies between the ecclesiastical and imperial politics of the Middle Ages or behind the balance of power politics of the nineteenth century. In these cases, the term *style* is used in a transferred sense.

The term comes into its own in the artistic field. Here we must first give an exact definition of the concept of style and then tentatively apply it to different forms of Western styles of art.

The first question to be asked refers to the relation of style and form. If we look at a landscape by Monet [plate 25], for instance, a picture of the grand boulevards in Paris, we can distinguish three levels of form. The first level is the natural form of these trees which one recognizes as such, especially if one knows Paris well, even though their objective structure experienced in the ordinary encounter with them is dissolved into impressions of light and color, the latter being the second level of form. This, however, implies a third level, namely, a form which is not the special form of this picture but the general form of most pictures of Monet and of a whole group of painters. We recognize him as an impressionist and we discover in the special artistic form of this particular picture the general artistic form which we are used to calling impressionistic.

Style is the common form which partly determines the special form of a particular work of art. In its artistic style, a society, more than anywhere else, betrays its ultimate concern, its spiritual substance. This is evident in the fact that we call whole periods of history by terms taken from the arts. We have already mentioned the archaic period in Greece, the Romanesque and Gothic periods of Western history, the Renaissance and the Baroque periods, Rococo culture and naturalism of the nineteenth century. Some of these words have connotations which transcend the artistic sphere; but all of them have a predominantly artistic meaning. The reason for this fact is the expressive power of the arts as we discussed it in the first lecture. Artists do not merely express a moment of the social situation of their time. They express the dynamics in the depths of society which come from the past and run toward the future. Therefore, they have a prophetic character. It is not that artists have a vision of a future which is not yet real. They are not romantics, but in their creative depths they are aware of those elements in the present which will determine the future of a society.

A most telling example of the prophetic function of the artist was the way in which the expressionistic painters before the First World War foresaw the catastrophes of the twentieth century. They foresaw it, not consciously, but in expressing it in their new style. Equally prophetic was the way in which Michelangelo [plate 12], at the height of the Renais-

sance, prepared the new dynamism of the Baroque [plate 19], foreshadowing the periods of the Counter-Reformation and absolutism.

Now I want to show the relation of some typical styles to typical societies. The basic issue in all of them is the relation of the work of art to ordinarily encountered reality, for it is the relation to the reality principle which determines the styles. A given reality, that is, the ordinarily encountered reality, can be accepted and reproduced. Even when represented in a work of art, however, it is not a repetition of nature but a selection from it. "Magic realism"[4] is a way that the elements of reality present the illusion of a copy of the real. The spirit of this illusionary naturalism is connected with the bourgeois attitude to reality, namely, the desire to transform it into an object of scientific analysis and technical control.

Further, this naturalistic style includes another principle of choice, when what is given is transformed into the ideal. What we have called anticipation, drives these artists to the naturalistic expression of perfection in the sense of harmony and beauty. This approach can produce the greatness of the cinquecento Renaissance painters where the ideal form is still filled with the spiritual power of a prebourgeois, religious-aristocratic tradition. But the same idealistic naturalism can lead to shallow, beautifying forms, approaching the emptiness of advertising pictures of women in which nothing is expressed except the primitive instincts of a dreaming adolescent. But it is just the reduction to this state of mind which an advertisement-controlled society needs. It is a symptom of the nonspiritual state of the churches that they have shown, until recently, a preference for this type of beautifying naturalism.

Over against this type of realism, which is preserved in society by an alliance of members of the high bourgeoisie with the lower-middle classes, revolutionary naturalism arises. It is carried out by an alliance of members of the ruling classes with the intelligentsia and representatives of the fighting revolutionary classes. This kind of revolutionary naturalism, like idealizing naturalism, uses the illusionistic, objectifying forms of expressing the given, but the emphasis is on that which contradicts perfection, harmony, and beauty. It is not that such a work of art lacks harmony and beauty, but that the reality which is expressed in our ordinary encounters with reality is felt to be negative in revolutionary naturalism.

4. Magic realism is a term used for works of art which represent persons, places, and things of the visible world in sharp focus detail, thus magnifying the sense of "reality." At the same time, the artist hides the painter's means, brushstroke and texture, presenting a smooth surface and no traces of the painter's gesture.

On the opposite pole of both forms of naturalism, that is, the idealistic and the revolutionary, lies the expressionistic style. Here the natural forms are used as means for pointing to something else, that is, not to other objects, but to a dimension of themselves and of reality as a whole. Here also one may distinguish two main types: the positive and negative. The positive expressionistic style is the one most frequently found in the history of art. It pervades primitive cultures, the archaic periods of great cultures, also the Byzantine, the Romanesque, and, in part, the Gothic and Baroque styles. It is the expression of society in which the spiritual substance shines through the natural forms of reality. It is the style of cultures in which ultimate concern is transparent and in which, consequently, things as they appear in ordinary encounters provide the materials for symbolic expression. In contrast, the negative expressionistic style undercuts the naturalistic and idealistic ways of preserving the natural forms in the ordinary encounter with reality. Negative, or as one also could call it, critical expressionism, shows the demonic, disruptive elements in the depths of reality, not through the content, but through the style of its creations. This aspect is not lacking in the positive or, as one also could call it, affirmative types of expressionism. But it is predominant in the critical type.

Critical expressionism is the expression of a society which has become insecure in its objectifying attitude toward reality. It is prepared by revolutionary naturalism, but it is more radical, for it does not expect a change without a change in the basic attitude to reality.

Obviously, this is the style of our period, prepared in the nineteenth century, actualized in the twentieth. It is a style which appears not only in the visual arts but in all expressions of life. It is the expression of Western man in the twentieth century. In terms of artistic styles, it is not restricted to that early and short-lived period of expressionism in the narrower historical sense. It refers to all original styles since the end of the nineteenth century.

The question we must ask in terms of a religious philosophy of culture is: Will critical expressionism be able to turn from its critical side into an affirmative stage? Passionate attempts and tragic failures to do so lead to the problem of my last lecture.

Lecture 3/ Religion and Art

In our former discussions I pointed to the distinction between religion in the broader sense and religion in the narrower sense. This distinction is fundamental for everything I want to say in this lecture. Religion in the larger sense has been defined as the state of being ultimately con-

cerned. Being ultimately concerned means being grasped by a concern which is not preliminary, as all finite and temporal concerns are. It is a concern which remains in power even when many of the objects of preliminary concern have disappeared; it can be derived from what is known in religion as the Great Commandment, to love God with all one's heart, strength, and power. If we are related to somebody or something with all our heart, strength, mind, and power, then this is an ultimate or, as I also could say, an unconditional concern, or as I further could say, an infinite concern, a concern which is not threatened.

In dealing with the problem of ultimate concern, another distinction that can be made is not important, namely, the distinction between different kinds of content. For the definition of religion with respect to ultimate concern, it is sufficient to know that the object, or the content of this concern, can be what is usually called religious in the narrower sense—gods or God—and that it can be something secular, an institution, a person, a value, or whatever.

If we accept this definition of religion in its fundamental sense, then the question immediately arises: What about religion in the narrower sense? The narrower sense includes not only organized religion in the churches but also personal religion in a person-to-person relationship to God. Does not, one could ask, the larger concept of religion make obsolete concrete religion in the narrower sense of the word? That is not the case, for we are neither in heaven nor in paradise. We are separated from that which is a true object of unconditional concern, namely, the ground and meaning of our being. Since we are separated from the ground of being, we are continuously drawn into preliminary and secular concerns, into those concerns which fill our lives, even though they may disappear at any moment and certainly will do so at the end.

In other words, the unconditional concern is not actual as a permanent reality in our lives and it is the function of religion in the narrower sense to keep it alive. Organized religion and personal religion both point to ultimate concern as more than they are in themselves. Through them we stand in a special place, a concentrated, definite place in which nothing is meant, intended, or symbolized but our ultimate concern. Religion in the narrower sense is thus an element of our culture, a necessary part of culture insofar as culture is rooted in an ultimate concern.

If we compare these two concepts, it is apparent that neither the church nor the secular realm of culture can judge the other. The church cannot judge the secular realm because the church itself is only a power which points to something which is more than the church, and here the church includes personal piety. On the other hand, the secular realm, for instance, the realm of artistic creation, cannot judge the church or re-

place it and its concrete embodiment of the holy. They are inescapable poles in human existence.

Let me explain this as clearly as possible. When I am asked to give evidence for what the church calls original sin, what I would call the tragic and universal estrangement of mankind from its creative ground, I reply with a paradoxical statement. The existence of concrete religion, organized or personal, side by side with a secular realm, including artistic creation—this side-by-side of the holy and the secular, of God and the world—is the fundamental expression of our estranged status and in this sense the evidence for what was called original sin in classical theology.

Both are necessary. The ground of both religion in the narrower sense and of secular culture is religion in the larger sense, namely, our being ultimately concerned. There is no one who does not participate in some way in religion in the larger sense. Every human being has some point in which he is ultimately concerned. If we dig deeply enough into the hidden places of our soul, hidden often even to ourselves, we find the point where one could become a martyr, and that means where one is ultimately concerned.

This is the first consideration which underlies everything that follows and which was decisive, although not expressed, in the two preceding lectures. This gives me the possibility to consider the relation of religion and art on four different levels.

First, there is the general level of expressive power. Art, the arts, artistic creation indirectly express, whether we like it or not, an ultimate concern through their style. This means that every artistic expression is religious in the larger sense of religion. No artistic expression can escape the fact that it expresses qualities of ultimate reality in the forms it shows.

Let me give an example. When I was asked some time ago to speak about religion and art, I went through the National Gallery in Washington and looked at nonreligious pictures or secular pictures, and my eyes were caught by one of the peasant scenes by Jan Steen, the Dutch painter [plate 16]. Suddenly I realized that in these scenes of peasant vitality something of the divine ground of being was expressed, that they had eternal light and pointed to the nature of the divine ground out of which they came. The Steen painting is thoroughly secular, and has no relationship to religion in the narrower sense of the word. But it expresses the power of being and everything which expresses the power of being is indirectly religious.

On another occasion I collected pictures of a similar nature from different periods, that is, social scenes of an extremely secular character, and I asked myself the same question, what do they express? One of these pictures was a shepherd scene by Fragonard in eighteenth-century

France; another was by Toulouse-Lautrec, a scene of the Moulin-Rouge which reminded me of the first decade of this century when I was in Paris for the first time and it still looked like this picture [plate 24]. Today I momentarily saw a Claude Lorrain in your gallery. In all of these completely secular paintings, the power of being is expressed. Pictures of social gaiety and even perversion in the Moulin-Rouge picture by Toulouse-Lautrec expressed something of the power of being, of ultimate reality.

The second level to which I want to point was indicated already in the second lecture. There I described two styles based on the different attitudes of the artist to the reality which he ordinarily encounters in daily life, namely, the basically naturalistic style and the basically expressionistic style. I indicated that the expressionistic style, in some of its forms, is an expression of a society which still lives out of a religious substance, and in which art discloses the symbols of this substance. This means that in the basically expressionistic type of art, something becomes manifest which is hidden in the naturalistic types. That which is always indirectly present as an expression of the ground of being in naturalistic styles is directly pointed to in expressionistic styles. This seems to me to be the reason for the religious character of so many styles of the past; they express something more than they describe. In these styles the encountered reality is used as material for symbolizing an ultimate concern.

Let me give you some characteristics of such an expressive style. One thing is the relationship to space. Space, in an ordinary encounter, such as when we are sitting in a room and looking at the opposite wall, is determined by three dimensions. In the case of sculpture, one can walk around it, one can see it from all sides. In a style which is predominantly expressive, however, the situation is different. The three-dimensional space either does not appear, or is indicated in color relations, or in shadow and light; it is not expressed in a perspectival form. It does not attempt to reproduce the illusion of three dimensions because three-dimensional space does not have the expressive power which paintings are supposed to have. The archaic sculptures of the Greeks before the classical period [plate 2] are not made for us to walk around, as later on is the case, as with the Venus de Milo [plate 3]. Archaic sculptures are made so that one can go toward them. They stand at the end of the temple and look at one. One approaches them as representatives of the holy, which are to grasp one as one approaches. Such sculpture is supposed to fill the room of the temple.

Another characteristic is that in archaic statues and sculptures, the gods and goddesses, and even other figures, are immovable. The relationship they have to each other is not of interest to the artist because he is

not concerned with the realm of objectivity, the categories of time and space. He is interested in the expressive power embodied in the power of being which such a culture represents. This is the reason for the immovable and static character of most of the earlier expressionistic styles.

Another characteristic is the way the individual is represented. In naturalistic art the individual becomes important; the portrait becomes important. The character of the individual is painted. If you look at the art of the more expressionistic periods, you will always find a pronounced trend toward typology. They prefer types that express something, to individuals who are merely interesting as individuals.

Another element is the relation to nature. In centuries in which the expressionistic type or style is dominant, man and nature participated together in a common symbolization. But one of the main problems in the history of art is to show how a different relation to nature developed in the late Gothic and in the transition to the Renaissance. The more the development goes in the naturalistic direction, the more man is a part of nature. He stands within nature. Nature, not man, is the embracing reality. Even if for humanistic reasons, man is still very important and predominant; he is preeminently a part of nature, and nature is decisive.

Now a remark about light and color. The gold ground which is the symbol of transcendent light or the broken light of the stained-glass windows which gives us the manifoldness of nature, not as it is outside, but through their so-to-speak heavenly colors represents an expressive style. But another step was taken by the preaching orders in the later Middle Ages and then by Protestantism, namely, the accent on daylight, the rational light, the natural light. Here the difference between an expressive and a naturalistic style is evident.

Now I come to the third realm, namely, to the realm of religious contents [subject matter]. When we speak of religious art we usually speak of religious subjects, subjects which are taken from the mythological, the legendary and the ritual-symbolism of a living religion. These subjects can be dealt with in every style and it is not necessary that a special expressionistic style be used. But a major question emerges. In what sense is a picture of the high Renaissance or in the style of nineteenth-century naturalism religious, even though it includes Christian symbols such as Christ and the Virgin, but in a style which is naturalistic and not expressive? One can, of course, always paint one of the biblical stories. The artist can paint a picture of Christ and the Virgin or whatever. But if the artist paints it in a style in which human relations are the pattern and model, and not that which lies behind them, do we not then have a tremendous incongruity between style and content? Do they not contradict each other? That is a great problem for religious art in our time.

Another theological problem is important for the future development of Protestant art. Protestantism does not make a fundamental distinction between the secular and the religious. It does not make a distinction between the minister and the layman; every layman is a priest for everyone else. On this basis, is it possible to take aspects of the secular and its human power into the orbit of religious painting?

I will leave that problem with you but will myself answer in terms of the fourth level to which I now come, namely, religious art in which the content and style are both religious in the sense of being transparent or predominantly expressive. It may be that this style is also able to transform secular contents, which have nothing to do with holy legends, into forms which mediate ultimate concern. These are questions put before us, and as a philosopher, I have to ask them. But the artist has to give an answer, because only the creative artist can answer whether or not something is possible.

In any case, liturgical art is situated on this fourth level. Liturgical art, art used in cult, in litany, should unite religious style and religious content, even if the religious content, under special conditions, is taken from the secular realm.

Let me repeat the four levels because they are decisive for everything we do in the relation of religion and art:

1. First level, the universally expressive power of every art, even the most secular, even semifrivolous art.

2. Second level, the art which expresses the ground of being or ultimate concern, in special stylistic characteristics which contradict reality as we encounter it in the natural world view in which we daily live.

3. Third level, the level of religious content, independent of any particular style and then the question of whether or not a naturalistic style is possible.

4. Fourth level, in which religious subjects and religious style come together.

Now I come to a third consideration which makes manifest what has already been pointed to in the lectures, namely, the concept of religious symbols. A theory of symbols is more needed than anything else in philosophy and I am glad to repeat what I said to a group of philosophers at luncheon, that there are many philosophical attempts in different universities which deal with the problem of symbols more profoundly than has been the case in the last one hundred years. This is necessary because symbols are the way in which we can enter the meaning of the religious,

t them we can only distort religion.

ive you four characteristic marks of symbols. The first is that

the symbol points beyond itself. In this a symbol is the same as a sign. Both point beyond themselves to something else. The red light points to the stopping of the car; religious symbols point to the divine. This pointing beyond themselves makes a symbol a symbol and a sign a sign.

I come immediately to the second mark of symbols, participation. Here the difference between symbols and signs is clear. The symbol participates in the meaning and power of what it symbolizes. The sign does not. Therefore, the symbol is irreplaceable. The symbol cannot be invented. It grows and dies. It is dependent upon the relationship to that which it symbolizes on the part of those who acknowledge it as a symbol. A sign can be changed according to the principle of expediency. The sign can be invented; a symbol cannot. When one uses the phrase, "only a symbol," which I, too, have occasionally done, one commits a sin against the meaning of symbol, because in all cases where symbol is needed we cannot say "only a symbol," for it is just the symbol that speaks the truth. If something is less than a symbol, if it were unsymbolic literally, it would hide the truth which the symbol reveals. So the combination of the two words, *symbol* and *only*, is a combination I would like to destroy.

The third characteristic of symbols is their revealing power. They reveal the meaning of something which cannot be approached in any other way. Therefore, I stated that a literal approach to their revealing aspects is impossible and only a symbol can do what must be done, namely, reveal a whole realm of reality. The flag reveals, perhaps, the meaning of the state for somebody who approaches it and feels awed by it. Revealing realms of existence which cannot appear to us in any other way is thus the third character of the symbol.

The fourth character of the symbol is opening up the soul for what is revealed to it. Since symbols come out of the depths of our soul, we cannot intentionally produce them.

Symbols with these four characteristics have a double-edged character, or a double-edged function. The one function is to open up, to reveal something which otherwise does not enter into our consciousness. The other side is to use some aspects of reality, for instance, healing, statehood, a concept of being or whatever it may be, in order to provide material for the symbolization of that which transcends everything finite. In doing so, symbols at the same time draw the realm from which they are taken into the realm of the unconditional which they symbolize. I will give you an example. For hundreds of years theological and medical faculties fought each other. But the central concept of Christianity, salvation, is taken from the medical function, namely, healing. As long as one understood that salvation meant healing, healing also meant something which is related to salvation, like the healing miracles of Jesus in the New

Testament. In the New Testament Jesus is called a physician. Healing and salvation are not two realms. Healing is the symbol for the ultimate re-union with the ground of our being for the ultimate overcoming of es-trangement. If this is the case, healing itself, in its ordinary sense, has a re-lationship to the ultimate.

This is the function of symbolic thinking. That our world has become so secularized is the consequence and the cause, at one and the same time, of the fact of secularization; these realms lie beside each other and the interrelationship has been cut.

There are two main levels of religious symbolism to which I now turn. The first is the transcendent level dealing with God, God's attributes and actions and the divine realities connected with it. It is the transcendent level of symbolism.

There is also a second or an immanent level of symbolism, namely, the sacramental realities, the holy legends, the stories, the persons, the pres-ence of the transcendent in this world. It is a sacramental viewing of the world and presents problems for the artist. The artist can depict God the Father, or the Assumption of the Virgin, or the Ascension of Jesus or the crowning of Mary by God the Father and the Son, the angels and saints. We have wonderful pictures of the transcendent glory by van Eyck [plate 6] and by Fra Angelico [plate 7]. But remember that such painting then was still possible, because a comparatively unbroken tradition of living with religious symbols existed in which the question of their literal meaning was not asked. But in the moment in which their literal meaning is focused, such pictures, as when executed today, become dangerous. They support a kind of sophisticated primitivism, a limited understanding of the religious symbols as if there were a world above our world, a tri-partite world, of heaven, earth, hell, and divine beings going from one place to the other. This is supernaturalism in its bad sense. I always expe-rienced a kind of repulsion when I saw religious pictures of today in which this kind of symbolism is embodied. It's not *en kairō*: it is not ap-propriate today.

Now let me relate what I said before to the relationship of artistic styles to religious symbols and discuss the problem of idealizing natural-ism and traditional religious symbols. I have already asked whether an in-adequate style can represent a subject matter which demands another style. It is a profound philosophical decision which each artist has to make, perhaps without realizing that it is philosophical. You must decide whether you want to make that which transcends nature and man into a beautiful form of human existence. You must decide for or against artistic humanism as it was most powerfully expressed in the high Renaissance. You must decide whether, instead of that, you want to suggest a human

existence which points beyond itself. If you want to do this, if you want to paint ultimate concern, or to form it in other ways, then you cannot use a style which contradicts the subject.

The second style of which I spoke in my second lecture was called critical or revolutionary naturalism. What does this style do to the religious subjects? It identifies the religious symbols, not with idealized or beautified forms, but in relation to negative forms; for instance, it paints Jesus as a revolutionary or as a proletarian, or Paul as an epileptic. Now in all this, there is truth. But what I have against it is that the stylistic tools which are used are taken from an ordinary encounter with reality while the meaning of religious symbols is precisely to point beyond that reality. When we come to this style of critical expressionism or negative expressionism, as I also called it, then some painters show the absolute negativity of man, often in a symbolic way by pointing to the Christ as the suffering man, proletarian or Marxist; or by trying to reach the divine in a manneristic-ecstatic way. I think of men like Nolde and Rouault. I like Nolde very much and I knew him personally. But I would say that, when he tried to paint religious subjects, he could do it only in a way which must be called "manneristic-ecstatic" [plates 38–40].

When I saw the Paris exhibition of Rouault a few months ago, I was surprised to find that his religious pictures were the least religious, while the pictures of all kinds of human negativity, morally and externally, were those in which the demonic ground of reality was powerfully visible [plates 49–51].[1] This means that critical expressionism is not able to create religious symbols, or to express religious symbols with artistic means.

In my second lecture I referred to affirmative expressionism, the expressionistic styles of the past. Why not paint like the archaics in Greece, or have mosaics like the Byzantine, or use the forms of the Romanesque or the Gothic? Why not? Because expressionism expresses something which is; it cannot produce what no longer exists. Do not believe that if you paint religiously, or paint religious subjects, that you can produce religious substance. One can create art out of the religious substance one has, and one can use the traditional religious symbols validly, if they are in our very being. But if not, let them alone. This is the advice I give to most present-day religious artists.

Let me close with an answer to the question: What can be done about the relation of religion and art under these circumstances? In order to answer this I must go back to something which I began in the second lecture, namely, the relationship of technical and artistic production. The

1. See "The Demonic in Art," chap. 10 of this collection.

renewal of religious art must come out of the house, the building, the building for the assembly of those who are grasped by an ultimate concern and express it in similar symbols. We must start with the unity of technical and artistic creation. In most creative centuries, church buildings gave the most important impulse to everything religious art was doing. I believe that this has to be done again. We do not know how far we can go, but we know that if we start soberly, asking ourself what is the meaning, the purpose, the aim of a building in which the ultimate concern shall be the dominating reality—ask this in terms of external, physical techniques and of technical means to produce this meaning—then we may find a way which avoids the terrible distortion of religious art in the last century. Purpose, in building assembly houses for ultimate concern, means not external purposes; it means adequacy to the religious character of the ultimate concern which is supposed to be expressed.

A number of things which have happened must simply be acknowledged as the dying of symbols. Symbols are born and, since they are born, they die. They cannot be produced intentionally; they cannot be removed intentionally. They die at the moment when the relationship they have mediated in opening up the soul is no longer powerful. Then we should not reproduce symbols which have died.

I addressed a seminar of artists and professors in New York two or three years ago on religion and art. I boldly suggested that the most expressive form of art today in connection with religion might be sacred emptiness; an emptiness which does not pretend to have at its disposal symbols which it actually does not have. In all realms of life today we must have some emptiness. It can become desperate emptiness; it can become sacred emptiness. We have examples of such sacred emptiness in the history of religious art and in the history of assembly houses among those who are ultimately concerned with each other. On the basis of a preliminary sacred emptiness, something may develop. It may happen that sculpture returns, not in and of itself, but to being part of a building as it was in church buildings of the past. Sculpture may return in the form of reliefs, for instance, not as something which one can walk around and look at from all sides, but as something which looks at one. One can answer its look; but it is not at one's disposal. One cannot move around it, one cannot taste it, and observe it from all sides. One can never do that with that which is transcendent.

Perhaps religious painting may return by trying to bring in those symbolic forms which are still expressive and which have not died for us. They may look very secular; they may be only forms, as are some of the stained-glass windows in modern churches where there are no figures, no imitations of Romanesque or Gothic, but simply cubic and other

forms which we understand today. If this is done, it may become a way to a new artistic expression of religious symbols.

It is a very hard way, and it is a way which needs much spiritual radicalism. We cannot restore symbols which have died and use forms which are not adequate anymore to the ultimate concern. Ultimate concern requires what creativity always needs, and for which I have no better words than: Open your heart, and that which is there in the depths of reality will enter your heart, and you will be able to create.

Part II

Writings from the German Period

4

Religious Style and Religious
Material in the Fine Arts

*This 1921 review article represents Tillich's reflections on the re-
lations of religious style to religious material in light of two
books on the visual arts that touch on the subject, one by his boy-
hood friend Eckart von Sydow, and the other by a subsequent col-
league at Dresden, G. F. Hartlaub. While Tillich's ideas are based
on his first published speech, "On the Idea of a Theology of Cul-
ture" (1919), this review article is his first publication in the arts.*

I

I HAVE BEFORE ME two valuable books, documents of the present and
forerunners of the future: *Die deutsche expressionistische Kultur und
Malerei*[1] and *Kunst und Religion: Ein Versuch über die Möglichkeit
neuer religiöser Kunst.*[2] It is not my intention to write a review of the
two books. Much good has been said about both, and rightly so; that need
not be repeated here. Rather, the content of both presents me with a
problem, equally interesting and current from a religious as well as an

"Religious Style and Religious Material in the Fine Arts" is translated by Robert
P. Scharlemann from "Religiöser Stil und religiöser Stoff in der bildenden Kunst."
This essay is from *Die religiöse Substanz der Kultur, Gesammelte Werke* (Stutt-
gart: Evangelisches Verlagswerk, 1967), 9:312–23. The article first appeared in
Das neue Deutschland 9 (1921):151–58. The translator notes that he has ren-
dered *die bildende Kunst* as "the fine arts," for it includes painting, sculpture, and
architecture.
 1. Eckart von Sydow (Berlin, 1920).
 2. G. F. Hartlaub (Leipzig, 1919).

aesthetic standpoint—the problem of religious style and its relation
to religious material. In order to characterize the position of these two
books on this problem, let me give a brief review of the contents with
particular emphasis on the points of most interest for our question.

It might initially be a source of irritation that I restrict a book like
Sydow's to the special question of religious art since it is a comprehen-
sive treatment of expressionism. Anyone acquainted with the book or,
better, anyone who has an inner relation to expressionism, as both the
author of the book and the author of these lines have, will not be sur-
prised that, vis-à-vis expressionism, one sees the deepest question in the
question of the religious meaning of the expressionistic style. For that
does come to expression in all parts of the book: in the first three general
sections, which treat the cultural movement of expressionism, the aes-
thetics of expressionism, and the kinds of content in expressionistic
works of art; also in the special part, which treats the individual painters
under the illuminating categories of "dynamic," "concrete," "abstract,"
and "arabesquelike" expressionism. When it is shown how the inversion
of individualism leads down deep to the subindividual substantialities,
into the "core of the world, into eternity," and how just this is the root of
expressionistic religiosity; when, for a decadent life-mood, the "revolu-
tion proceeding from a mystical disposition," the radical will to life that
finds its fulfillment in the primitive, is set down as the mark of expres-
sionism, that already anticipates in a certain way what is summarized and
developed in the chapter on "the religious consciousness of expression-
ism": expressionistic mysticism is not transcendent and does not rest in
God as does medieval mysticism; rather, it is immanent, ecstatic over life
in the Nietzschean sense. Nietzsche murdered only the one, the other-
worldly, side of God but, in return, all the more squeezed the highest dy-
namics of life into the other, the this-worldly side. (Compare the analo-
gous and similar remarks about Nietzsche's effect in Hartlaub, who is
religiously the more positive of the two.) "In the consciousness of the
unity, however felt, of all being"—not in the Goethean but in the primi-
tive, mystical sense—lies the core of the modern and expressionistic
feeling of the world. From this follow consequences for style: the
monumental dimensions, in which the connection with the absolute is
expressed; the quality of its surfaces, in which a bodiless spirituality is
triumphant; and the uniformity and schematization, in which the symbol-
ical is victorious over the corporeally real. After that there follows a pre-
sentation of the individual painters: hymns, lyrical pieces of empathy,
works of art about art; all, moreover, deeply gripping and all, even the
formal aspect, derived from a universal world-feeling. In sum: a model of
religious styling in fine art.

I have not yet mentioned the section on "the religious art of expressionism." For our purpose it is the most important because it takes a direct position with regard to our problem. "If expressionism is really religious at its core, why then still fence off or limit a religiosity of a higher potency?" That is the one question. The other question is this: "Why go back to a religion that even at Goethe's time was almost too ancient for us?" Even so, there is an acknowledgement that religious production contains the high point of Nolde's [plates 38–40], Schmidt-Rottluff's [plate 41], Hölzel's, and Eberz's creativity. To be sure, this is so in different ways. With some of them, like Eberz and Hölzel, there is a submitting to church tradition, to myths of salvation and dogmas, that is somewhat like incense and ecclesiastical atmosphere without the original powers of renewal. With others, the Protestants, there is a presentation of the life-powers of Christ, newly born out of the inner parts of the man of the present, "no stylizing, but rebirth: 'steering the ships of our heart in the spirit of God—sinking in the flood of divine spiritualization.'" Here too there are crucifixions and burials. But why does one not say what one really means—not Christ, but "man"? If we understand this section correctly—the problems in its formulation reflect the problems of the situation—then it establishes the inclination of the religious style toward religious subject matter, but shows the difficulty of wresting symbols for the present from the world of traditional symbols and throws doubt on the necessity of this task at all.

Here Hartlaub's book leads further—or intends to lead further. In four chapters—"Art, Religion, Future"; "The Basis of Religious Art" (style, object, disposition); "Art and Religion in the Nineteenth Century"; "New Religious Art"—and in two valuable excursuses on general cultural parallels and the problem of object, the question is treated in one part dealing with the principles (style and subject matter) and in another part dealing with a critique of the present (new religious art). The book begins with a deep and broad presentation of the relation between art and religion. "Religion is for us a reuniting of the human soul with its original suprasensible ground, which it recognizes as its home and whose midpoint it recognizes as the individual essence of God (and the gods)." "Art is the creative human activity of producing palpable symbols of the feelings." "A work of art is, thus, religious if the feelings expressed by it are religious, that is, if they stand in connection with representations of a religious nature." In these three fundamental propositions the position with regard to our problem is established, and established in such a way that it is obviously in significant contradiction to the basic conception of Sydow. The contradiction is deepened through what is said in more detail about the basically antithetical relation of religion and art: "The es-

sence of art is creation, devotion to what is created, not to the Creator, this-worldliness, a continuation or even an enhancement of nature"; "Religion, by contrast, is a return and a turning inward, whether that occurs in an ascetic withdrawal from the flesh or in an active sanctification of the flesh." Nor can this opposition, which has always led to a secret or open battle between the artist and the saint, be hidden by the fact of the birth of art out of the spirit of religion. But these thoughts do not exhaust the position Hartlaub takes on the problem. Next to the first line of thought, there is a second one, not entirely reconciled with it. Even if art has freed itself from religion and even if it has full aesthetic autonomy, or, for that matter, is elevated above all else, this condition, which is embodied in impressionism, is not final; there is a return, and it has begun in the present. The meaning of the more recent development in spirit is a growth toward mysticism, though a mysticism that contains the active impulse of *Zarathustra* in itself as an imperishable Western blessing—a synthesis of romanticism and Nietzsche (both of which have aesthetic roots) as the foundation of a futurist piety, and hence an "emergence of religion out of the spirit of art," announced in advance by modern expressionism. The analogy with Sydow's ideas is obvious. It is strengthened by what is said in more detail about the relation of styles to religion. Within the pairs of opposites "idealist-realist" and "expressionist-impressionist" style there is always the primary style, which has an inner affinity to religion. That does not mean it is to be called religious—there is no such thing as a religious style—but it can be called *prereligious*. In this concept of prereligious style, both lines of thought in Hartlaub meet; it is the pregnant formulation, though hardly the solution, of the problem. Besides a prereligious style, there also belongs to a religious work of art a religious object. To want to forgo such an object is an aftereffect of impressionism's ideal of pure form mixed with its pantheistic world-feeling, or it is, in other words, a polite atheism. At the same time, however, it is to be expected of the artist himself that, besides his prereligious disposition, which is expressed in the style, he also have an inner relation to the religious objects themselves, or that he come to them on the basis of being innerly grasped by them. Only where all these requirements are fulfilled is religious art possible. That art in the nineteenth century was not religious in that sense is shown by a brief, penetrating restrospective survey from the Nazarenes to the forerunners of the modern "prereligious style," Gauguin, Van Gogh [plates 26–27], Munch [plates 31–32], Hodler. But the twentieth century has not yet reached the goal either. As much as it may be true that in a Beckmann [plate 48] and a Nolde [plates 38–40] the religious objects form the high point of their creativity, and as much as this art owes an intensification to being steeped in Christian

symbols, still even these artists did not arrive at a really religious, faithful grasping of these symbols. They still live in the sphere of the prereligious. Passion and ecstasy are the inner means of access to the Christian tradition: the double experience of present-day man, of present-day mankind, namely, a mightily intensified spirituality but without a feeling of freedom that is reconciled with the world. "We find ourselves in an intermediate realm and can only look up toward the promised land." Expressionism, however, can take us along to the goal if it does not get onto "decorative" by-ways but, true to itself, works out its artistic intention more purely, and advances to monumental figuration. What it has accomplished so far is a presentiment of religious art, not religious art itself.

II

For purposes of taking my own position, it will be well to work out what is common to both authors and then to show where they part. Common to both is the view that artistic style can have significance in and of itself, that this property applies in a special measure to the expressionistic style, and that the attempts to apply this style to religious objects suffer from the inwardly broken relation of contemporary artists to the symbols of the religious tradition. We do have a religiously usable style, but not the possibility of using it on religious subject matter. That is the similarity between the two authors. The difference, however, lies in the judgment of this state of affairs from the perspective of religious art. For Sydow, religious style is religious art: Why is a specifically religious subject matter needed? For Hartlaub, a style is at most "prereligious"; religious subject matter creates religious art only when it is grasped with a religious disposition.

The root of the contrast lies in the concept of religion. For Hartlaub, religion in the full sense is real only as a relation to the essential suprasensible ground of our existence, the personal God. For Sydow, there is a piety which does indeed have a right to claim the name of religion and which is a world-affirming, immanent mysticism. Basically, it is the contrast between theistic and pantheistic conceptions of God that is behind their difference. It cannot be our task to get into a theological discussion of the difference nor to ascertain which of the two directions is more in accord with developing tendencies today—whether, for example, we are not moving toward a more theistic wave while Sydow's conception still has strong bonds with the impressionistic world-feeling. What is at issue is this: to show the extent to which both conceptions are innerly consistent and objectively adequate. Here I should like right at the start to anticipate my judgment: Sydow's view is the more internally consis-

tent, Hartlaub's the more objectively comprehensive. For Hartlaub, it is impossible to unite the concept of prereligious style with his concept of religion. For even the choice of the cautious and indefinite concept "prereligious" does not relieve one of the obligation to show wherein the affinity of this style to religion is grounded. If "style" is the expression of a world-feeling in the way form is given, and if one speaks of a prereligious style, then a style must be the expression of a prereligious feeling of the world; but that is an impossible concept. If it is true that only a world-feeling which finds its center in a personal God is religious, then any feeling whose center lies elsewhere is unreligious. There cannot be any intermediate members; for the very longing for a personal God, for example, already has its center in him, even if the symbols are still missing. The difference lies in the expressive capacity, not in the feeling that creates the style. Strict theism knows no religious style but no prereligious one either; its purely objective representations must be graspable for any style. If they are not so graspable, this shows that pure theism is inadequate in the aesthetic area; the fact of a religiously related style refutes the purely theistic concept of God.

On the other side, Sydow cannot make intelligible why it is that precisely the greatest expressionists have a strong inclination to religious symbols, in particular, to the New Testament. The explanation that, after all, it is always "human being" that is involved makes it even more difficult to understand. For why, in that case, take the detour through the literarily established symbols of the Christian tradition, when there is available an abundance of analogous human destinies in the present world? What is the purpose of taking the detour? It is no detour, that is the point! What has become living reality is not the empirical human being but an ideal man, the God-Man. It is the pressing toward a universally valid, generally intelligible, absolute symbol, and it is the longing for objectivity, for a community of believers, that meet in *one* symbol. It is a will toward a theistic conception and objectivation, but on a pantheistic basis. Decisive is not a theoretical existential judgment about the special concept "God" or about the individual concept "Christ"; the basis on which the special symbol has arisen is the universal symbolism. Yet one can say in reply to Sydow: The fact of the search for religious subject matter refutes pure pantheism, just as the fact of a religiously valuable style refutes pure theism; only a synthesis of both does justice to both.

III

Let me now express my own position on these problems in a few statements concerning principles. For this purpose I should like to distinguish

three circles: the largest one having to do with style itself, a smaller one having to do specifically with religious style, and the smallest having to do with religious subject matter.

Style is the immediate influence of depth-content (*Gehalt*)[3] on the form. That among the unlimited number of possibilities which form of-

3. The translator comments as follows: "*Gehalt* designates the third of three elements in cultural creation: form, content, and *Gehalt*. James Luther Adams translated it, with Tillich's approval, as 'import' when the early writings were published in English. Tillich himself used 'substance,' not 'import,' in his English writings. Thus in *Systematic Theology*, 3 vols. (Chicago: University of Chicago Press, 1951–63), 3: 60, style is called, in a phrase closely parallel to the one here, 'a particular qualification of the form by the substance.' 'Depth-content' is used here in order to indicate the relation between the two terms *Inhalt* (content) and *Gehalt*. In other contexts Tillich also used the word *Tiefe* (depth) for this element." The editors add that the terms are also used in *The System of the Sciences* (1923; Lewisburg, Pa.: Bucknell University Press, 1981), p. 178, and in "Philosophy of Religion" (1925) and "On the Idea of a Theology of Culture" (1919), both of which appeared in *What Is Religion?* trans. James Luther Adams (San Francisco: Harper & Row, 1969). The following excerpts are taken from *What Is Religion?* pp. 163–65.

Various references have been made in the last few pages to an autonomy and theonomy of cultural values. We have to follow these up still further: that is, I would like to propose the hypothesis that the autonomy of cultural functions is grounded in their form, in the laws governing their application, whereas theonomy is grounded in their substance or import, that is, in the reality which by these laws receives its expression or accomplishment. The following law can now be formulated: The more the form, the greater the autonomy; the more the substance or import, the greater the theonomy. But one cannot exist without the other; a form that forms nothing is just as incomprehensible as substance without form. To attempt to grasp import disengaged from form would constitute a relapse into the worst kind of heteronomy; a new form would immediately come into being, now opposing the autonomous form and limiting it in its autonomy. The relation of import to form must be taken as resembling a line, one pole of which represents pure form and the other pole pure import. Along the line itself, however, the two are always in unity. The revelation of a predominant import consists in the fact that the form becomes more and more inadequate, that the reality, in its overflowing abundance, shatters the form meant to contain it; and yet this overflowing and shattering is itself still form. . . .

Attention must be paid to two things in regard to the cultural-theological analysis. The first is the relation between form and substance. *Substance or import* is something different from content. By content we mean something objective in its simple existence, which by form is raised to the intellectual-cultural sphere. By substance or import, however, we understand the meaning, the spiritual substantiality, which alone gives form its significance. We can therefore say: *Substance or import is grasped in a content by means of the form and given expression* [translation slightly revised]. Content is accidental, substance essential, and form is the mediating element.

fers one is actualized with an inner necessity by an era, a people, a stratum of society, a confession, a school, an individual, or a stage of an individual's development is the revelation of the spiritual depth-content of these circles or individuals. Style is not only a further development of form that can be understood on formal grounds. It is that too, certainly, and it can never be separated from the dominance of the form, otherwise one leaves the sphere of aesthetic value. But it cannot be understood only as a development of form. From the infinitely abundant material of form what strikes the creative spark of this style is not in turn a form but a spiritual depth-content. The proof can be given in this way (and, for important areas, has already been given enough times): in other value-spheres a quite analogous styling sets in simultaneously with quite different formal laws. In fact, the homogeneity of a cultural circle and a cultural period rests upon this unity of style in all cultural areas. The root of the unity of style is the common depth-content.

If we examine the depth-content more closely, we shall find that it is not constituted by arbitrary elements of an individual psychology, be they biographical or sociological or national. All of that does also have an influence; it provides the subjective basis of the possibility of a style just as form provides the objective basis. But the basis of possibility is not the basis of the actuality. The essence of depth-content lies beneath all these subjective factors; it is a definite basic orientation to reality in general. It is the final interpretation of meaning, the deepest grasping of reality; it is the function of unconditionedness that sustains all conditioned life-experience, colors it, and prevents it from plunging into the emptiness of nothing. The particular mode does indeed depend on those empirical conditions, but the essence remains always the same. It is transempirical; for it is a necessary and universal function, indeed the sustaining function, of spirit as such. If we do decide—and it is my conviction that we must so decide—to lay claim to this function as the religious function, then all culture, to the extent that it brings depth-content to expression, is religious. All art is religious not because everything of beauty stems from God—in that, Hartlaub is right—but because all art expresses a depth-content, a position toward the Unconditional. The fact of style decides for the religious quality of all art and culture. These thoughts, which I first expressed in my address "On the Idea of a Theology of Culture"[4] and which I cannot develop in more detail here, appear to show the way toward a solution of our problem too. True, that only lays the foundation, and it even seems that further progress is barred; for if all art

4. See n. 3.

is religious, why then still a religious style and religious subject matter? That leads to the second circle of our discussion.

If we think of depth-content as the sun, and form as the planetary orbit, then there are for every cultural form a perihelion and an aphelion vis-à-vis the depth-content. If it is the power of the sun that reveals itself in the perihelion, it is the independent power of the planetary movement that is expressed in the aphelion; yet it is the sun that sustains both, the proximity and the distance. Thus there are styles in which the dominance of the depth-content over form is as conspicuous as is, in others, the form's own movement; and yet both styles, as styles, are an expression of depth-content. This peculiar dialectic makes it possible then to speak of a religious style in the narrower sense. If there were not, even in and for itself, a reference to the religious function in the essence of the style, it would be impossible to see how it could get into the style; and, conversely, if the contrast between domination by depth-content and domination by form were not at work within this sphere, it would be impossible to abstract a special religious style.

If we start the typology of styles from the contrast of form and depth-content—one among several possible points of departure—three basic types of style are the result: the form-dominated styles (impressionism-realism), the *Gehalt*-dominated styles (romanticism-expressionism), and the balanced styles (idealism-classicism). The doubleness within each type depends on the difference between subjectivity and objectivity. Whereas in impressionism the subjectivity of the pictorial form drives toward the shattering of the things' own forms and, in doing so, prepares the way for expressionism, realism allows the proper form of things to emerge all the sharper. Whereas in romanticism the subjectivity of feeling intends to break also the pictorial form, abstract expressionism[5] tries to bring to expression an objective spirituality. Whereas idealism tries to intensify the subjectivity of the individual toward the universality of the type, classicism intends to draw the real forms of things into the quiescent perfection of completed form. With this we have also provided a validity within the typology for the fundamental difference between the subjective and objective attitudes of spirit, which is of highest significance even for religion. That would give us two types in which the depth-content reveals itself immediately in the manner of breaking through the forms: the abstract expressionistic (since the concrete expressionistic type belongs to the romantic) and the romantic. The first is

5. Abstract expressionism here refers to art such as that of Kandinsky, not to the Abstract Expressionists of the 1950s in New York City.

the form of revelation for an objectively valid, mystically immediate spiritual substance of an era or cultural circle: it is the hieratic—and perhaps, one day, the socialistic—style. The romantic style is the form of the subjective and individual, revolutionary and ecstatic piety with the coloring of aristocratic spirit; much of the Baroque belongs here.

If we are justified in calling these styles religious in the narrower sense and, conversely, in calling the realistic-impressionistic types unreligious in the narrower sense, then it must be possible to show that the religious styles give to any material which they treat a religious quality and, conversely, the unreligious styles secularize (relatively, never absolutely) the subject matter. This demonstration can easily be provided initially for the unreligious types by considering their treatment of religious materials and noticing their inability to give expression to the depth-content proper to these materials. Hartlaub's observations are here all the more compelling since they stand in a not entirely resolved tension with his own presuppositions. For, if his series of observations is correct, it follows with rigorous consistency that the other series, according to which every religious style has the capacity to color every material religiously, must also be correct. It is indeed possible to see in a still life of Cézanne [plate 28], an animal painting of Marc [plates 45–46], a landscape of Schmidt-Rottluff [plate 41], or an erotic painting of Nolde [plate 38] the immediate revelation of an absolute reality in the relative things; the depth-content of the world, experienced in the artist's religious ecstasy, shines through the things; they have become "sacred" objects.

Here too there is, of course, a limitation, which is in accord with Hartlaub's demand for a "religious disposition" from the artist. When a religious style is applied without the stylistic disposition from which the style has proceeded, the religious effect is, of course, absent. But the converse is also true: When an impressionistic style is applied without an impressionistic disposition of style, something quite different from the aforementioned profane effect can come about. That kind of thing can be observed with special frequency in transitional times, when a new style-disposition has not yet found its adequate style, but also in average artists, pupils, and epigones, who take over a form without having experienced the depth-content. Only in that way can one explain the profane effect of many paintings in religious styles.

It is worth noting again, however, that this contrast of secular (profane) and religious is meant only in a relative sense and moves within a comprehensive sphere, that of the style-creating world-feeling in general.

We come now to the third and smallest of the circles, that of religious subject matter, and, again, it can be asked, as it was when we moved from the first to the second: Why still have religious objects if all objects can

become "sacred" objects through style? To answer that, we must have re-
course to the relation of form and *Gehalt*. The depth-content, the reli-
gious intuition, can shine through every object-form; but the object, be-
sides having this meaning of being the bearer of a depth-content, always
has the other sense of being a piece of objective reality, placed in an or-
der of goals and of forms of things in general. Thus the religious style,
when applied to secular objects, always has an obstacle to overcome,
namely, the material's own *Gehalt*, which is not religious and must first
be elevated to the religious through a negation of its secular (profane) re-
lations. Now, it is possible to think of a piety that can be satisfied with this
paradoxical grasping of the religious or that even sees in it the sublime,
and it appears as if such a manner of feeling would be consistent with
Protestantism. On the other hand, it is not surprising that the religious
consciousness also wants to grasp itself in forms which have no profane
significance of their own and whose whole meaning is to give expression
to the religious. Objectivity and correctness, or connections of purpose
and cause, play no role here; truth is the truth of signifying, not the truth
of historical validity or of the validity of natural laws. In this world of reli-
gious symbols no significance of a thing on its own has to be overcome;
symbols are what they are only as an expression of the religious; they are
its creatures and its bearers. It is obvious that for grasping these things
only those styles are suitable which are in themselves turned more to-
ward the meaning than toward the thing, in other words, *Gehalt*-
predominating, religious styles. The others necessarily destroy, through
their "objectivity (*Sachlichkeit*)," the signifying character of the religious
symbols; they create what is historically "correct" or pictorially ingen-
ious and in this cool air of reality they let the celestial flowers, the reli-
gious symbols, fade away. An excellent example of that is the painting of
Jesus in the preceding period [nineteenth century].

If the symbols of religious consciousness do not have any "objectivity,"
they do have a necessity, which makes itself felt more effectively than
does any objective necessity. That is shown especially in the fact that in
cases of conflict the religious consciousness will, by disregarding any ob-
jective correctness, maintain the reality of its symbols; indeed, it will de-
fend itself against the very idea of its symbols as symbols in the feeling
that the intention is to diminish their value as reality. At the same time, it
has the greatest mistrust toward every objective, historical investigation
of the objective correctness of its symbols, and it feels this to be an a
priori unreligious position. For the plastic or graphic artist this contradic-
tion need have no importance; he is, from the start, in another sphere of
reality; he is not concerned with the empirical existential problem. What
comes all the more into consideration for him is the inner necessity, and

one of the most dangerous temptations for him is to approach religious symbols which have no necessity for him with a religious disposition of style. Hartlaub has shown this with gratifying rigor. He also exhibits lines that perhaps lead from inner necessity to a new understanding of what is essential to the Christian symbols. But the question must be asked whether symbols which have once been subjected to objectivity, regardless of the results, can ever again attain the immediacy that gives them the capacity to be bearers of religious certainty. Hartlaub, in fact, considers the possibility of the nonexistence of Jesus to be no hindrance. Will the religious consciousness agree with him in this? I doubt it. I believe that the religious consciousness always creates its symbols with the consciousness of their being "correct"; only then do they awaken the feeling of reality that corresponds to the inner necessity. That means, however, that the new symbolism can be raised beyond the sphere of the objective only when its "significance" must also be experienced as its "validity." The guide here is, of course, not the external correctness, but the inner necessity; but it instinctively guides according to the norms of presupposed correctness.

Now, from the moment when scientific consciousness awakens, everything individual and empirical is placed under critical questioning; in a mentality that has been scientifically suffused, as is the case with the sphere of Protestant, modern culture, there remains no place for attaching religious symbolism to something individual. Only universal contexts, insofar as they are evident as functions of spirit and are prior to every possible doubt, come into consideration; everything individual can enter into them, but the character of certainty does not then refer to the individual but to the context in which it stands.

The bearer of the symbolism is, thus, human being as such, not individual, empirical human beings, and not *an* individual historical transempirical man, but *the* human being, that is, man as a function of the absolute: man in relation to the Unconditional, in his nothingness as well as in his ideal perfection, in his guilt and his redemption, in his deepest convulsion and his religious ecstasy, in his ethical freedom and under the burden of his fate, in his world-shaping power of creativity and his infinite inadequacy and longing, man in his isolation and in the communion of souls, man as mass and man as personality—and all of that not for his own sake but for the sake of what is in him but is greater than he. It makes no difference whether we call that greater something "spirit" in the "age of spirit," of which many speak, or whether we call it the unconditionally real, before which all thinking becomes numb, or whether we call it the holy, or call it God (not in a pantheistic or a theistic sense but beyond all form-concepts: pure *Gehalt*). And because this one is "man" in the sense

of that which is more than "man," he is simultaneously "man" in the universal, all-sustaining sense: with nature praying along, sighing along, rejoicing along, under the same destiny of transitoriness, as does the one in whom it has come to itself and to its Lord; and with history as conflict and defeat and battle, as infinite dynamics with ever new creations, as an arena of contest for community and ethical freedom, as a place of revelation of the holy and its kingdom in the world of resistance; a world in which there are many individuals, standing out as guiding stars, and the one star, which shines more brightly than all the others and is in its destiny more a symbol than any other. All this is in the symbolism, moreover, without any question of historical and objective correctness, but solely in the sense of that which can be experienced at any moment by any personality in itself, namely, to be placed into the unity of *this* nature and *this* historical life, both, moreover, interpreted and lived on the basis of the Unconditional.

This, it seems to me, is the material of a future symbolism. It is only the material; for to work out clear contours and definite shapes is the task of the future, in which all aspects of the life of spirit take part under the guidance of the religious intuition. Externally, fine art could lead the way, as no other can, because of its "transobjectivity." But it can do so only if it lets itself be guided exclusively by inner necessity; for what is at issue is not a new forming of old symbols but the rebirth of symbol on the basis of a new revelation of the Unconditional, a revelation that takes hold of us with the might of destiny—and with the forms that, born of our world-consciousness, are possible and necessary for us.

5

Excerpts from Mass and Personality

"Mass and Personality" (1922), is a comprehensive essay in which the interconnections of all facets of culture are assumed and developed. Inasmuch as Tillich consciously chose periods in the history of painting as his entering point to the broader discussion of the issues, these sections, comprising approximately an eighth of the entire essay, have been excerpted.

Types of Mass

AT A TIME when the insight into the unbreakable interconnection of all aspects of cultural life is beginning to prevail everywhere, when comprehensive analyses of culture have opened our eyes to the ultimate depth in which the spring of all spiritual creations has its source and flows equally into all—in such a time of broader horizons it will not come as a surprise when I begin explicating a problem in social ethics by turning to an apparently quite strange area, or when it is in works of painting that I try to find the first perception of what the concepts "mass" and "personality" can say to us.

Painting is a mute revealer and yet often speaks more perceptibly to the interpreting mind than concept-bearing words. For it impresses us with the irrefutable power of immediate intuition. Hence I shall attempt to show the kind of mass and the way it is understood in the spirit of

"Mass and Personality" originally appeared as "Masse und Geist," in *Volk und Geist*, no. 1 (Berlin, Frankfurt: Verlag der Arbeitsgemeinschaft, 1922). It is excerpted from Paul Tillich, *Christentum und soziale Gestaltung, Gesammelte Werke* (Stuttgart: Evangelisches Verlagswerk, 1962), 2:36–41, 67–68. It is translated from the German by Robert P. Scharlemann.

the time by reference to the most important styles of painting in which masses are portrayed and placed in a pictorial relation to personalities of leadership. The abundant material for intuition that arises in the process will be an important preparation for conceptual penetration.

Let us begin with an early Gothic painting from the Middle Ages, say, a Cross-Bearing with a great crowd of people, or a Nativity with shepherds and kings, or a profane painting such as a Slaughter. The crowd is completely dominated by the overarching idea that it represents, be it the idea of discipleship or of astonished adoration or of battle. Everything individual is erased: one facial expression, one way of holding the head, one line of body and clothing, one intensity of light makes them all alike. None of them steps to the fore completely. Those in the foreground cover those standing in the background in such a way that these latter are nothing but a contribution to the throng that is merged into a *corpus mysticum*, which is filled completely by the transcendent life of a supranatural idea of cosmic dimensions, by a two-dimensional space and the prevention of any three-dimensional existence on a thing's own. And the leader, that is, the formal center of gravity of the painting, whether it be Christ or Pilate, the Madonna or a king, is emphasized not by individual characterization but by the formal position in the painting: that he is in the center, not transsected by other bodies, that he is larger than the others, more richly adorned, that he grandly represents the perfection and sway of the inner mysticism that goes through the throng; he is the mediator of revelation, the representative of the supranatural idea, who gives a depth-content (*Gehalt*) to the whole picture.

What does such a painting say to us? That we are sojourning in a time when there is neither mass nor personality as separated, independent realities but a time when everything individual, whether one or many, is borne by ideal powers, by *universalia* in the meaning that philosophical "realism" gives to universals (today we are more inclined to call it idealism): a hierarchy of real general concepts, beginning with the highest, the concept of deity, is what is real about the world. In this hierarchy, which also embraces social life, everyone has his place, leader and led, distinguished from each other only because the leader-personality makes visible more clearly, more pregnantly, the universal idea that sustains and suffuses all, articulates and arranges them. Because of this mystical realism of ideas, I should like to speak here of the *mystical concept of mass*.

We come to a late Gothic or early Renaissance painting,[1] particularly in Germany and Holland, where classical tradition was no hindrance to

1. While Tillich distinguished between the early Gothic on the one hand and the late Gothic and the Renaissance on the other, the Reformation seldom enters

the free development of the stylistic movement that was then beginning. A Mockery, a Taking Captive, a Peasant Festival—everything is changed. The individual is discovered, and the natural is discovered. The mystically enclosed mass is dissolved into sheer individuals, understood with supreme realism. They have found their natural space, the third dimension; the pictorial space has been perspectivally deepened to infinite cosmic space, the individual stands before the universal; the universal has become insignificant; the composition is dissolved, the paintings fall apart into unorganized singularities; the leaders have lost their position of leadership; even Christ has become one among the realistic throng, intersected, surrounded, at any side of the painting; equally important with the servant who strikes him, the soldier, whose ear is cut off; the mystical mass together with its leaders is dissolved purely into homogeneous, characterized, and, in their reality, interesting single figures. Yet there is something that holds even these many together, not, of course, the supranatural idea, not even nature in general (such a thing is not permitted by the nominalism of the time), but the nature of each individual, the psychological homogeneity, which does provide a cohesion in hate and pain and desire; not, of course, from above and, thus, not stylistically in the pictorial form, but from below, in the sameness of the definition of the drives of all individuals and, at the other end, in a distortion of passion that almost creates a new unity—the unity of grimace. And the leader, on whom one's gaze falls, is basically the one in whom passion has found its

Tillich's thought with respect to the theology of culture. Luther and Dürer, however, are mentioned in a passage in *The Courage to Be* which stylistically seems to place Dürer in the late Gothic and Renaissance periods, though the theology is said to be Reformation. My own opinion is that the theology of *Knight, Death, and the Devil* (plate 14) is also Renaissance rather than Reformation. The passage from *The Courage to Be* (New Haven: Yale University Press, 1952), pp. 161–62, is as follows:

According to the expressions of anxiety in his period, the negativit[ies] his [Luther's] courage had to conquer were symbolized in the figures of death and the devil. It has rightly been said that Albrecht Dürer's engraving, *Knight, Death, and the Devil*, is a classic expression of the spirit of the Lutheran Reformation and—it might be added—of Luther's courage of confidence, of his form of the courage to be. A knight in full armor is riding through a valley, accompanied by the figure of death on one side, the devil on the other. Fearlessly, concentrated, confident he looks ahead. He is alone but he is not lonely. In his solitude he participates in the power which gives him the courage to affirm himself in spite of the presence of the negativities of existence. His courage is certainly not the courage to be as a part. The Reformation broke away from the semicollectivism of the Middle Ages. Luther's courage of confidence is personal confidence, derived from a person-to-person encounter with God.

crudest expression, the ranter and agitator. It is the time in which medieval society is dissolving, in which the supranatural is beginning to pale before the newly discovered nature, in which the realism of the idea is destroyed by the nominalistic criticism and the individual is elevated to the throne, the time of the beginning social revolution, the pictorial form of the approaching peasant wars. *It is the realistic mass that relieves the mystical one.*

In Baroque art, mass gains a new significance. An Erection of the Cross, a Final Judgment, a Cavalry Battle by Rubens, say, can give us a picture of what we have before us. No longer is it the individuals, whom an identical passion might outwardly link together; it is flooding life which goes through all of them, which draws every singularity into its stream, which is realistic and yet is more deeply rooted than the psychology of mass instincts, which is again metaphysical without being supranatural. It is the inner, raging life, joining nature and man, that makes the throng, too, a dynamic unity and which embraces the leader as well, although it does so in such a way that the leader is lifted out of the flood of bodies and movements, the raging and swirling lines and is, as it were, the crest of the wave, the point at which it towers up to its strongest, most sparkling life, above the wave and yet completely in it, perfecting it and yet completely borne by it. It is the time in which the supranatural and religious have become an inner personal concern of the individual, in which all of European life is churned up in its depths and the battle for personal convictions of faith and the rebirth of society after the collapse of the medieval, universalistic unity are portrayed in vehement convulsions. Nothing and no one remains untouched by this movement. Yet it is more the urban and aristocratic society that sustains the movement, whereas, in the realistic period, it was the peasant who was in the center and, in the mystical period, the monk. *It is the dynamic mass with an aristocratic culmination that fulfills this most agitated time of European history.*

We come now to the present, which for a decade and a half has been in transition between two styles and, therewith, two life feelings: the impressionistic and the expressionistic. Impressionism is the form of style of the individualistic bourgeoisie of the second half of the nineteenth century. If we take a boulevard painting by Monet [plate 25], or a café painting by Degas, or paintings of proletariat and factory, then we see everything individual dissolved into the solitariness of nature, not nature in the metaphysical sense, but nature as the outer surface of nature. It is not the inner vitality of life, as in *baroque* art, but light which unites people and things by externally spreading over them. The mass is there; the impressionist sees it, as he sees everything that is between heaven and earth. But for him it is no substantiality; it is for him a study of light or

color or movement; it is for him a piece of the surface of nature which he intuitively experiences in a new impression, a vision of the moment, interesting, piquant, basically a piece of landscape, which is to be conquered anew in its form. And as it is with the mass, so it is with the individual. If the individual is prominent in a mass painting, then it is not the individual's objective significance that distinguishes him but a formal problem about him that is to be solved. Form is everything, the form that has become supreme technique and rationality, bright, cool, dwelling at the surface despite all the fireworks of color. This is the age of consummate technique, of world-cities and of the collapse of all firm lines and outlines. The mass is there; but it is not there as a potency of its own, as in all previous styles. It is there only as a surface, like everything else. It is there only as an object of formal technique. It is only object, not subject—an object of agitation and formation, an object of care and of contempt. This is the time of social laws, of socialist persecution, and of Marxism. *It is the technical mass that impressionism reveals, the mass as object of impression and technique.*[2]

2. In his essay, "The World Situation," in *The Christian Answer*, ed. Henry P. Van Dusen (New York: Charles Scribner's Sons, 1946), pp. 10–12, Tillich wrote in a vein reminiscent of this earlier essay.

If we study the portraits of *Rembrandt*, especially in his later period, we confront personalities who are like self-enclosed worlds—strong, lonely, tragic but unbroken, carrying the marks of their unique histories in every line of their faces, expressing the ideals of personality of a humanistic Protestantism. To compare these portraits with *Giotto's* pictures of St. Francis and his monks is to recognize the difference between two worlds. Giotto's Francis is the expression of a Divine power by which man is possessed and elevated beyond his individual character and personal experiences. So are all other figures in Giotto's paintings. Between Giotto and Rembrandt are the portraits of *Titian*—individual expressions of humanity as such, representatives of the greatness, beauty and power of man. The transcendent reality to which Giotto subjects all individuals, their actions and emotions, has disappeared; but the unique individual, as in Rembrandt, has not yet appeared. The personality which found its highest portraiture in Rembrandt's pictures is the personality of the early bourgeois spirit, still subject to absolute forces, still shaped by the Protestant conscience, but already standing by itself, independent alike of transcendent grace and of humanity. In these three painters, the development of the ideal of personality in the modern world finds classic expression.

If we take the long step to portraits painted since the middle of the *nineteenth century*, we are in still another world. Individuals with a highly developed intellectuality and strong will appear—the bearers of technical reason, the creators of large-scale world economy, of the great monopolies, the conquerors of the forces of nature and the anonymous directors of the world-wide mechanism of capitalistic society. Personality has become at once the ruler and the servant of Leviathan. Willpower and technical rationality are united, and thus the way is prepared for the

In the first decade of the twentieth century that changes. Again it is painting that is the first to announce prophetically the new spirit: things begin to get a new substantiality. True, their outward form is dissolved even more than was the case in impressionism, not, however, with the aim of staying with this dissolution but in order to get to the ground of things, of the world. Thus a new mysticism awakens, a new inner experience of things, and it creates a new style. There are many expressionistic paintings of masses; for it is not the landscape but the spirit-bearing human face that has here become the most important, not in its naturalistic factualness but in its metaphysical significance. A new homogeneous formation makes individuals similar to one another, encloses them in a space that has again become two dimensional. A torpid something weighs on these masses, a metaphysical lack of redemption and longing for redemption. For that reason they are sometimes approximated to animals, then again elevated beyond humanity to ecstatically visionary heights. The mass is subject, entirely subject; the leader, the redeemer is

Fascist type in which the last remnants of the classical and humanistic ideal of personality are completely lost.

In .the time of Giotto, relation to transcendent reality gave meaning, center and content to personal life. In Titian, belief in the divinity of the human and the humanity of the divine furnished the center of meaning. In Rembrandt, the experience of life with its tragedy and its ultimate hope determined personal existence. But the person of the period of triumphant bourgeoisie was dominated by purposes without ultimate meaning and by sensations and actions without spiritual center. It was a personality which could still use the traditions of the past for aesthetic enjoyment, but which was not shaped by them. This naturalistic personality was formed by the demands of modern economy, and by neither divinity nor humanity, even if humanitarian and religious obligations were retained in the form of the moral or conventional standards of the bourgeois era. . . .

The development of the modern idea of personality in its main stages has had its parallels in the structure of all *communities*, natural communities such as the family, and historical communities such as the state.

In the *first stage*, represented by the pictures of Giotto, every individual participates in a communal movement created by loyalty to a transcendent reality. It is an all-embracing community in which every individual, both peasant and prince, is borne forward by the same spiritual reality. In the life of the Renaissance, outstanding individuals are predominant. They are isolated, each in his own way representing general humanity, dealing with one another in the relations of a privileged society but no longer in terms of community. The person of Protestant humanism is a member of an active group united by common purposes—the defense of pure doctrine, the struggle against absolutism, the crusade for the establishment of the Kingdom of God. This is a community, however, not on the basis of the common ground of universal authority but on the basis of common devotion to particular aims for which it is necessary to fight. The spiritual center of this community lies in the future.

In the *second period* of bourgeois society, not only a common spiritual ground but a common spiritual purpose was lost. In consequence, the different forms of

missing; and one feels that he cannot come from above. He must be born from the depth of the mass longing. The Christian symbols, which find application again, are just that—only symbols. They remain strange, unless they are reinterpreted as symbols of the suffering of the mass, in which the redeemed and redeemer must be one if there is genuinely to be redemption. *It is the mass of immanent mysticism that expressionism reveals*; it is the time of world war, the outbreak of chaos in the Russian soul and of communist martyrs.

We are at the end of the overview that this philosophical history provides. The end is linked with the beginning. A new mystical mass is in the making, except that the mysticism is not guided supranaturally, from above, but remains immanent in the reality of this world, breaking forth from the depths of the soul.

The mass is always present, but it does not always have the same significance. If we group the five forms that we have read off from the paintings, we have basically three groups: *those masses which are pervaded by an immediately spiritual, mystical principle; those in which this principle is missing so that external powers, like natural instincts or technique, create the character of the masses; and those in which an inner principle struggles with motive power for configuration.* Now, there is a profound difference in these three types of mass formation, so profound that it might appear dubious to apply the concept of mass to all three. If mass is "the quantity of resistance that a body offers to the power that moves it," if its marks are: a lack of quality in all its parts (atoms), the

community disintegrated. The family disintegrated into individuals each of whom lives for himself in the service of the mechanism of society. Communities of workers were replaced by mass cooperation of a non-personal character. Patriarchal responsibility for the servant, his welfare and his loyalty, gave way to the relations of legal contract. Neighborhood as a form of community lost its meaning. The national community recovered reality only when attacked, and lost it again when danger passed. Even the community of friendship was destroyed by the universal sway of competition. Bourgeois society in its second phase destroyed community because it destroyed any common foundation and any common purpose. The service of the mechanism of mass production is not a possible spiritual center for community. It separates individuals from one another in spiritual loneliness and competition. It turns them into atoms in the service of mechanical processes. It is not based on a common idea but in the controlling economic and psychological necessity that each man subject himself to the mechanism. Thus communities disintegrate into masses. Masses have neither common ground nor common purposes. They are driven in their objective existence by the incalculable movements of the mechanism of production, subjectively by the laws of mass psychology. This was the main sociological feature of the second period of bourgeois society. Many keen observers during the nineteenth century noted the dissolution of personality into atoms and community into masses, and forecast the cultural and political self-destruction of society.

absence of any movement on its own, subjection to mechanical laws, absolute objectivity and objectification of power—if that is what mass is, then this concept seems to fit at most the second of the groups mentioned, the realistic-technical (mechanical) mass. This one is indeed the most difficult problem for considering masses, but it is not isolated from the other two. It is the result of the dissolution of the organized, mystical mass; it is the basis of the agitated, dynamic mass. It is not possible to conceive the one form without the other. For that reason, a further concept of mass, one derived from natural science, is justified. Every linking of people who, in this joining, give up in any respect their individual qualities in favor of a quality of the whole can be called a mass in this wider sense. And there is no joining of people which does not involve consciously or unconsciously placing peculiarities and idiosyncrasies in the background. More details about these things are provided by the psychology of masses, whose laws can be applied in any throng of whatever size and kind. They show that no one, not even a conscious individualist, has the right to elevate himself absolutely above the mass, and that no one and no time can be spared having to solve in itself the problem of mass and personality. Even so, it will be possible with the help of the three typical forms, which we briefly want to designate as *the mystical, the dynamic, and the technical type*, to provide the basic outlines of a generally valid solution, a solution that can be significant particularly for our contemporary problem of the "technical mass and personality." In the foreground is obviously the opposition between the mystical and the technical mass. The dynamic mass is clearly a transitional phenomenon which is shaped more either by the mystical or the technical element, although precisely as a mobile element pressing toward transformation. That is the reason for making an exception of this type as a special one. But since it is not a matter of treating mass in and for itself but of considering it in its relation to personality, it is necessary now to work out the concept of personality and pursue it in its typical formations and in its relation to the various types of mass.

* * *

Architecture with monumental lines, architecture of the fortress and its polemical dynamics, of the cathedral with its upward dynamics, of the modern factory, railway station, and harbor with their dynamics that span the earth; the inner powers that piled up and mastered all that; the accentuation of these elements of the mass soul and their intensification and transformation in the mass of the present; *the ushering into monumental space*, which it creates for itself and recreates as the symbol of its

greatness—that is the meaning of a formation of the dynamic mass. *The primitive, abstract, and monumental style in painting*, far removed from the subjective differentiations of impressionism and from purely individualistic expressionism, can create for painting too a relation to the dynamic mass-soul, which just in this area is very difficult to reach. *Dance in the mass forms of procession* and its modern derivative, the *demonstration*; in the form of procession, parade, sports events the dynamics of the mass enter into immediate sense-appearance and, as an expressive movement, give the mass a feeling of its own monumentality. *Music in the dramatic lyrics* of some chorales, hymns of procession, battle, and revolution, in the mass dynamics of an oratorio, of some operas and dramatic orchestral creations the feeling of power on the part of the inner excitement drives toward heights and consciousness and serves, as hardly anything else can, the law of intensification. More important perhaps is *drama*, so important that one can designate *mass dynamics as the sphere of the dramatic* just as the subjective sphere of feeling can be designated the lyrical. Here is the place of the heroic, not, of course, in a problem drama of subjective psychology, nor in the sense of an objective portrayal for "interested" spectators, but in such a way that the difference between actors and spectators is removed, overcome as entirely external, and the drama is experienced, played, by all together as their own most real life. Not chamber plays for connoisseurs and psychologists but the great drama for bearers of revolutionary, heroic dynamics.

6

Excerpt from The Religious Situation

The Religious Situation, published in 1926 and dedicated to the woman artist E. W. Kallen, was a religious best seller and widely discussed. Translated into English in 1932, it was the first book introducing Tillich to the English-reading public. The section on art is here reproduced.

I. PAINTING, SCULPTURE, ARCHITECTURE AND THE DANCE. While science and philosophy have an immediate and causal significance for the spiritual situation of a time, whether as destructive or constructive forces, art is to be evaluated only as a mediate cause. For its immediate task is not that of apprehending essence but that of expressing meaning. Art indicates what the character of a spiritual situation is; it does this more immediately and directly than do science and philosophy for it is less burdened by objective considerations. Its symbols have something of a revelatory character while scientific conceptualization must suppress the symbolical in favor of objective adequacy. Science is of greater importance in the rise of a spiritual situation but art is the more important for its apprehension. In metaphysics the two interests are evenly balanced. It combines the will to apprehend objectively with the symbolic character of its conceptions.

The revolt against the spirit of capitalist society has been least ambiguously expressed in painting since the beginning of the century. The tendency which we have been accustomed to call expressionism, but which far transcends the narrower meaning of that term, is particularly symptomatic of that fact.—Bourgeois France was the unchallenged leader in

This section is excerpted from *The Religious Situation*, trans. H. Richard Niebuhr (New York: Henry Holt and Company, 1932), pp. 53–70, where it is titled "III. Art." It is reprinted here by permission.

painting during the nineteenth century. In reaction against idealism and romanticism and as a genuine product of the capitalist temper the naturalistic and impressionistic tendency developed extraordinary creative and formative power since the middle of the century. But its forms are the perfect forms of self-sufficient finitude, in naturalism on the side of the object, in impressionism more on the side of the subject. Reality as it is apprehended in the interaction between a natural subject and a natural object, the temporal moment, the impression is captured. And this is done with the creative power of genius, therefore magnificently and with the force of symbolism. But nowhere does one break through to the eternal, to the unconditioned content of reality which lies beyond the antithesis of subject and object. An undertone of quiet, naturalistic metaphysics accompanies everything, it is true, but it is the metaphysics of a finitude which postulates its own absoluteness.

With a will to create objectively, Cézanne battled with the form and restored to things their real metaphysical meaning [plate 28]. With passionate force van Gogh [plates 26–27] revealed the creative dynamic in light and color and the Scandinavian Munch [plates 31–32] showed the cosmic dread present in nature and mankind. Upon this basis new forces developed everywhere, in Italy, in France, in Germany and in Russia. Expressionism proper arose with a revolutionary consciousness and revolutionary force. The individual forms of things were dissolved, not in favor of subjective impressions but in favor of objective metaphysical expression. The abyss of Being was to be evoked in lines, colors and plastic forms. In Germany the painters of the "Bridge Circle," Schmidt-Rottluff [plate 41], Nolde [plates 38–40], Kirchner and Heckel, led the way. Others accompanied them. Naturally the movement turned back to older, primitive and exotic forms in which the inner expressive force of reality was still to be found untamed. The discovery of primitive and Asiatic art came to be the symbol of revolt against the spirit of capitalist society.—One peculiar movement followed the general tendency under the catch-word titles of futurism, cubism and constructivism. The dissolution of the natural forms of things took on geometric character. Therein the feeling was expressed that every picturization of organic forms under the rule of the capitalist, rationalist spirit was insincere. At the same time the planes, lines and cubes which were used received an almost mystical transparency. In this case as in expressionism in general the self-sufficient form of existence was broken through. Not a transcendent world is depicted as in the art of the ancients but the transcendental reference in things to that which lies beyond them is expressed.

This distinction appears very clearly in the religious art of the period. Even naturalistic painting has used the old religious symbols of art; the figure of Jesus above all played a certain rôle. But the manner of repre-

sentation was clearly analogous to the liberal conception of Jesus which prevailed in the Protestant theology of the period, so that at best an ideal, finite reality but never the reference to the eternal was expressed. The religious art of capitalist society reduces the traditional religious symbols to the level of middle-class morality and robs them of their transcendence and their sacramental character. Expressionism, on the contrary, has a mystical, religious character, quite apart from its choice of subjects. It is not an exaggeration to ascribe more of the quality of sacredness to a still-life by Cézanne [plate 28] or a tree by van Gogh [plate 26] than to a picture of Jesus by Uhde [plate 29].¹ But as soon as expressionism itself turns to religious subjects its characteristic limitations are revealed. Its mysticism stands outside the religious tradition. It cannot derive inspiration from the old symbols nor can it find a new meaning in them. When it attempts to do so it becomes either a faint echo out of the past, as in the case of Eberz with his Catholic background, or it transforms the symbols and substitutes human devotion for the divine deed, as, perhaps, in Schmidt-Rottluff [plate 41], Nolde [plates 38–40], and Heckel. This process is highly characteristic of the contemporary religious situation. It indicates how the continuity of the religious tradition has been broken by capitalist culture and how the modern religious consciousness must find itself again, without the aid of any definite symbolism, in a pure, mystic immediacy. But this may be done by means of any symbol.

The method which is employed by this spiritual interpretation of reality begins with the breaking up of its natural forms, of its immediate existential character, of its self-contained finitude. The third dimension and perspective—these forms which seem to confer independent existence on things—are negated in particular. It is quite understandable why all those who do not recognize spirit or who wish to have it at best as an idealization of finite existence, but always without a break with that existence, should protest passionately against this art. But the very vehemence of this protest on the part of capitalist society shows that a vital attack has been made upon its spirit.

The extent to which this protest was historically justified became ap-

1. In *My Travel Diary: 1936*, ed. and with an introd. by Jerald C. Brauer (New York: Harper & Row, 1970), p. 104, Tillich comments as follows on this passage:

In my *Religious Situation* I wrote that a still-life by Cézanne [plate 28] has more religious quality than a *Jesus* by Uhde [plate 29]. That remark has often been quoted, and I still believe it to be true. And yet, today I feel compelled to correct it. In the first place, the physical charm of the still-life is too tremendous because of its color—independent of content. And second: Cézanne proclaims a mystical devotion to life, and does so with the tools of a very great artist. Uhde proclaims ethical-social devotion with the tools of a minor artist. But basically, he, too, is religious.

parent in the movements of the last few years which are of sufficient significance for the religious situation of our time to deserve the closest attention. A realism has suddenly appeared in art which, in George Grosz and Otto Dix, verges on caricature in its vindictive opposition to the bourgeois culture that revealed its character in the world war. It was a brutal realism which though it rejected all the romantic elements of expressionism yet had no relation to the realism of the previous period. The tendency to caricature gradually ceased and forms were developed which one may possibly speak of as the beginnings of a *belief-ful realism*.[2] The movement has frequently been regarded simply as an antithesis to expressionism so that the bourgeois spirit believed itself on the way to a new triumph. But in truth a mighty antagonist to that spirit has appeared; it is carrying the battle into the very camp of the enemy and employing his own best weapons against him. There is grave danger, of course, that this enterprise will be defeated by the overpowering force of the capitalist spirit. It is true of this battle also that the warfare is difficult and full of retreats and round-about ways to victory.

We have discussed painting so extensively because it is particularly fruitful and revelatory for our problem. Sculpture followed analogous lines while architecture made use of expressionistic forms only rarely and then with evident lack of success. For its relation to the practical end of construction forces a realism upon it from which the free arts with

2. The first paragraph of chap. 5 of Tillich's *The Protestant Era*, trans. James Luther Adams (Chicago: University of Chicago Press, 1948), pp. 66–67, titled "Realism and Faith" and published in Tillich's collected German writings, *Religiöse Verwirklichung* (1929), has the following illuminating paragraph on the meaning of belief-ful realism.

For those who have followed with sympathy or enthusiasm the development of painting in the first three decades of the twentieth century, two events will stand out in memory: first, the emergence and success of "expressionism," then the flagging of its energies and the rise of a style called *neue Sachlichkeit* ("the new objectivity"). When expressionism appeared, it was largely rejected as repulsive, dark, and ugly. But slowly it began to fascinate many people because of the riddle implied in it and the radicalism of its solutions. Finally, it won most enthusiastic adherence from groups who saw in it a new mysticism or the way to a new religious cultus. This is understandable. Expressionism was a revolution against the realism of the nineteenth century. It was a rebellion against the naturalistic-critical, as well as against the idealistic-conventional wing of realism, and it also trespassed the limits of the subjective-impressionistic realism from which it came. Things were interpreted by the expressionistic painters in their cosmic setting and their immeasurable depth. Their natural forms were broken so that their spiritual significance could become transparent. Colors, expressing divine and demonic ecstasies, broke through the

their non-utilitarian character can readily emancipate themselves. Hence architecture achieved its real successes in the service of that most realistic of modern ends, the economic end, in the construction of railroad stations, factories, commercial and office buildings, as, for instance, the Chile House in Hamburg. Yet it is a spiritualized realism which speaks out of these things. They point toward a transcendent reference in technique and economic life, toward the growth of a mythical interpretation of these functions which had been evaluated in purely rationalist and imperial terms in the capitalist period. At all events it is highly characteristic of the religious situation of the present that it is not religious buildings but economic structures which reveal a little of this tendency toward self-transcendence, of the will to break through the limits of self-sufficient finitude. Religious architecture on the other hand is like religious painting; it is without symbolic power to express the religious situation of the present.

From the point of view of our problem the art of the dance has a value all of its own. It is significant, to begin with, that this art has experienced a complete renaissance during the last quarter of a century and is recognized again as an independent form of spiritual expression. In an increasing degree it has developed away from its individualistic, estheticizing beginnings in a direction which leads toward what one may possibly identify as the ritual dance. To be sure a less hospitable soil for such a development than the soil of the Christian, specifically of the Protestant, West can scarcely be imagined. Under such circumstances achievements

gray of the daily life. It seemed as if the period of the myth had returned, and developments in other realms seemed to confirm the visions of the artists. But this feeling lasted no longer than to the middle of the third decade. At this time, works of art appeared which kept much closer to the natural forms of things than the expressionists did. They could, however, not be considered as a relapse to the nineteenth-century naturalism. They represented a post-expressionistic, not a pre-expressionistic style. They repudiated the elements of subjectivism and romanticism in the preceding period without giving up the depth and cosmic symbolism of their predecessors. Those who expected from this development a return to the idealizing of naturalism of bourgeois liking were destined to disappointment, for the new realism was not interested in the natural forms of things for their own sake but for their power of expressing the profounder levels and the universal significance of things. Nineteenth-century realism had deprived reality of its symbolic power; expressionism had tried to re-establish this power by shattering the surface of reality. The new realism tries to point to the spiritual meaning of the real by using its given forms. In these movements art is driving toward a self-transcending realism. There is no guaranty that this goal will be reached; many tendencies in our period work against it, some of them honest, some of them merely ideological. But it is a tendency which should be understood and supported by Protestantism because it has a genuinely Protestant character.

such as those of the Laban school and particularly those of Mary Wigman are all the more significant. Their group-dances indicate the defeat of individualism; the figures of the dance seek to give inner content and organization to space, the expressive gestures try to reveal metaphysical meanings. All of this is still in its beginnings and the movement would be gravely imperiled should it seek on its own initiative to create a ritual in the narrower sense of that term.

The last statement applies to the whole sphere of creative art. It can express metaphysical meanings; it cannot produce them. The inadequacy of all false romanticism—in art, science and social theory—appears in its effort to derive an absolute content from the form, that is to say, it tries to capture and preserve eternity by means of a movement in time. In contrast to such attempts the spirit of capitalist society which seeks to hold fast to the finite as something finite is more honest and therefore stronger. Eternity is first of all the "no" which is uttered against time, the shaking of the present, and only insofar as it is that can temporal forms point toward the eternal.

2. *Literature*. It is exceedingly difficult to discover in the tremendous wealth of European literature in all its types a clear line of development corresponding to our approach to our problem. It is even less possible to do this in this sphere than it is in art. Subjective bias in evaluation as well as in selection is unavoidable. Yet the influence of literature on the religious situation of a period, by virtue of the superiority of words over lines and colors, is both more direct and more general than is the influence of art. Hence we must at least make the attempt to discover in literature also the expression of the revolt against capitalist society and to inquire into its significance for the whole social consciousness.

Emile Zola was at one and the same time the friend of the impressionist circle and the most potent representative of naturalism. The spirit of scientific, rationalistic observation dominates his style completely; the scientific attitude threatens constantly to overpower the literary attitude. Content corresponds to attitude; it is critical naturalism. The self-sufficient finitude of bourgeois society is criticized with tremendous passion but the standard of criticism is that finitude itself and its ideal form as it is to be achieved under the leadership of science. There is no trace of an inner self-transcendence. This is also true by and large of Ibsen's dramatic works. In content they are a criticism of bourgeois society and of the hypocrisy of its conventions but the standards employed are those of the society itself. Yet he does transcend these limitations at certain points, as in *Peer Gynt*, for instance. Similarly Flaubert's naturalism does not prevent him from assimilating some mystic elements in the course of his development. The influence of a Catholicizing mysticism, though in a

negative and demonic form, is unambiguously present in Baudelaire's lyrics of decadence. But this element is not strong enough to bring emancipation from the bondage to the capitalist spirit. The contradiction is present but it remains dependent on that which is contradicted. It is the expression of the isolation of the culturally over-refined individual who has lost his social character and substance, the expression of his despair in his loneliness and impoverishment.

Decisive impulses toward change were given by Strindberg who moved on the one hand in the negative realm of the bourgeois period but went beyond it on the other hand both in the form and content of his work. The figures in his drama take on a typical form; they are removed beyond the accidents of existence and impression. The transcendent sphere enters into the action. The figures become symbolic and transparent; the boundaries of reality become vague. Monastic asceticism and mysticism appear to be the goal of the development.—In Germany a similar tendency appears in Gerhart Hauptmann and the other European dramatists also participate in it.—These tendencies are even more noticeable in the novel. The high regard in which the work of E. T. A. Hoffmann is held is characteristic. Directly mystical and theosophical subject matter is preferred and this begins to loosen up the fixed conception of reality established by the natural sciences. In lyric poetry Hugo von Hofmannsthal and Dehmel did not, to be sure, break through the circle of the purely immanent but in their language they did call up real emotions which were not merely subjective impressions but developed into metaphysical meanings. This movement was accompanied by the impressionistic tendency in literature which was most perfectly represented, so far as its form is concerned, by Thomas Mann and which achieved in him, as painting did in the later work of Clovis Corinth, a distinction transcending the subjectivism and estheticism of the attitude as a whole.

In Rilke poetry is given a directly religious turn. In his mysticism there is an echo of the impressionistic tendency to dissolve all nature into the feelings and contemplations of the subject. But what is really contemplated and felt is the religious content in the sense of neo-Platonic and medieval tradition. The religious influence which these poems exercised is not to be underestimated even though their strong estheticism is taken into calculation. They prepared the way for movements which could go farther. By far the most important poet of the time is Stefan George. His union of the classic with the Catholic spirit in a highly disciplined style was one of the most powerful protests against the spirit of capitalist society with its reduction of all things to a common level, a common shallowness and spiritual impoverishment. The discipline and difficulty of his diction, his earnest, ascetic efforts to find the right, symbolic word, his

fundamental, metaphysical view of life and reality, his determination to find the pure form which is superior to subject and object—all this gave an impulse which led to further consequences in the philosophy of art and spirit. There is one limitation indeed which George shares with capitalist society—the lack of a comprehensive, community-forming religious content. His aristocratic exclusiveness is conditioned by the classical element which is present in him and at that point he is in contact with the capitalist society which also derives from humanism and classicism. The sphere of the finite forms is not really transcended. The classic form not only tames chaos but also bars the way to the invasion which proceeds from the Unconditioned and which therefore breaks through every form. The creative *Eros*, in George's movement, is communicated by individual to individual, hence it remains limited to small circles and is expressed in spiritual but not in universal terms. George is not the "Lord of the Era," that is, the symbol and conqueror of our present time, as his disciples would have him be. He lacks the universality and the extraverted force of prophetic personality which are necessary for that rôle. He is a fountain of priestly spirit for many but not of the prophetic spirit for all.

The major line of literary development did not grow so much out of the synthetic and highly formal tendencies which George represents as out of the destructive tendencies which announced their appearance in Dehmel and became victorious, thanks largely to the powerful influence of Nietzsche, in the last pre-war generation. Nietzsche's battle against the hypocrisy of bourgeois convention led to a dynamic uprush of those primal forces, the will-to-power and the erotic drive. It was all still saturated, to be sure, with naturalistic influences, but contained a demonic transcendence, nevertheless, which was absolutely repulsive to the capitalist spirit. Such phenomena as Kasimir Edschmid and Heinrich Mann are typical as is Wedekind in the sphere of the drama and as are a number of lyric poets. Franz Werfel, who is akin to these in style but wholly opposed to them in his tendency, goes on his own, independent way. He substitutes humility, love of the lowliest, the acceptance of fate, for the will to power and the erotic drive. Things are seen as united in a profound, all-controlling community of suffering and love; even the vulgar and the loathsome are not excluded. The hard surfaces and the resistances in things are erased. Things are robbed of their objectivity without being dissolved into nothingness. This strange softness is expressed even in the language and in its dissolving character, in strong contrast to Stefan George.

It is in place to call attention at this point to the rediscovery of Dostoievski and to the religious significance of this event. What is religiously effective in this is the mystical realism of the Russian novelist, his contem-

plation of the demonic and negative elements in actuality on the basis of a present divine reality. Even in the most extreme antitheses to bourgeois morality this divine element is not lacking; in fact it is more readily discovered there than in bourgeois society. Thanks to the tremendous greatness of Dostoievski's characters it was not clearly perceived how alien they were to the Western consciousness and their spirit was effective even where there was no inkling of the thoroughness of the antithesis. Their effect was, in consequence, frequently only esthetic and therefore passing.

War and revolution influenced literature in this wise, that the catastrophe of capitalist civilization in the world war was regarded with revolutionary emotions and expressed in revolutionary form. It is highly significant for our situation that no literature affirming and glorifying war was produced; the slight attempts which were made in this direction were marked by such a heavy realism that one would prefer to classify them with the negative reactions. The war was experienced everywhere as a catastrophe of culture, as the unmasking of the demonic character of capitalist society. In literature as in painting the experience stimulated that super-realism which was dominated at first by social and political passions and then slowly achieved objectivity. Becher, Unruh, Toller and others used expressionistic forms to set forth these meanings. But in all of them the tendency is toward the demonic. They see the destructive demonic forces not in sex and the will-to-power, as was the case in the pre-war literature, but in the inescapable power of objective social institutions and movements. For this reason this literature is more profound, more despairing, more realistic. The romantic elements disappear. The conflict of the generations, the struggle of child with parent, which comes sharply to the fore in the most recent drama, combines the demonic forces of sex and society in peculiar fashion and indicates how completely the present has broken with the tradition of the capitalist spirit.

If we would characterize in summary fashion the religious situation of the present as it is presented in literature we should need to say that the realism and impressionism of the capitalist period have been destroyed in the development of symbolism, mysticism and expressionism but that a new realism is about to gain ascendancy; with emotional zeal at first, then with objective and metaphysical intuition it has uncovered the demonism present in the social world and, perhaps, as in the case of metaphysics and painting, it may be at the point of developing into a *belief-ful realism*.

7

Cult and Form

"Cult and Form" was an address given in Berlin, 10 October 1930, at the opening of an exhibition of liturgical vessels sponsored by Kunst-Dienst. While there are no references to specific works of art, the contours of Tillich's concern for integrity in the arts are clearly stated.

1/ Principles

RELIGION IS THE being-grasped (*Ergriffensein*), unconditionally and inescapably, by that which is the sustaining ground and consuming abyss of our existence. Religion is the shaking and transforming eruption of that which is more than our being and which alone is therefore in a position to give our being depth, seriousness, importance, and meaning.

All action taken on the basis of pure being-grasped is cult, just as all thinking done on the basis of pure being-grasped is myth; and the one does not exist without the other.

Cultic forms are all forms in which pure being-grasped has determined human configuring, in which things and actions are so formed that through them something of the demanding, sustaining, and devouring ground of being resonates. Cultic forms are those in which myth has created an expression for itself. But since that which gives all being its seriousness and depth is not a thing alongside other things but is valid for everything, the cultic forms are not forms next to others, and mythical

"Cult and Form" originally appeared as "Kult und Form" in *Die Form* 16 (1927): 578–83. It is here excerpted from Paul Tillich, *Die religiöse Substanz der Kultur, Gesammelte Werke* (Stuttgart: Evangelisches Verlagswerk, 1967), 9:324–27. It is translated by Robert P. Scharlemann.

thinking is not a thinking alongside other thinking. Rather, the claim is made upon all action to be cultic and upon all thinking to be mythical. In religious language, the whole of existence should be a service to God and every thought a thought in the sight of God. A God who exists side by side with something else, who is restricted to a special area of the cultic, is no God, but a demon, whom one does well to starve and to let die by not bringing sacrifice. Many cultic forms, also some in this exhibition, give the impression of having paid an initial discount to a demon which had admittedly become quite old and powerless, with a certain amazement over its still being there at all. Next to it, however, is the whole breadth of the rest of life, taken honestly and seriously in production and thinking. For the small lost province of the cult there remain souvenirs, unjustly called tradition, and lyricism, unjustly called consecration, and arabesques, unjustly called sacral forms. For the creators of such things the cultic form has no final, unconditional seriousness, even when they struggle with their task; for in the cultic form the real ground of its and our life does not get expressed.

2/ *Requirements*

From this there follow three requirements to be made for cultic formation today:

1. Cultic formation must be determined by the everyday.
2. Cultic formation must be determined by the present.
3. Cultic formation must be determined by actuality.

First, cultic form must be determined by the everyday. All days have an immediate direction toward the Eternal, and every time, as well as every deed at any time, belongs to the meaning of our being—belongs, religiously speaking, to God who is that meaning in truth. If we need a holy day anyhow—days, hours, spaces, actions, and words that are in a special sense turned toward the Eternal—the reason is that we live on earth and that the emphasis of the everyday strives to pull us away from the ground and abyss on which we stand, and that we need something to counterbalance our weakness and our being lost in the world.

In such a case, however, certain things are true. First, the more firmly one is grasped by the demanding and sustaining meaning of one's life, the less does one need a holy day. Second, if there is a holy day, then it is such not as a day alongside or above other days but as a day in which the other days come to themselves, to their own depth, to their own mean-

ing. That means, first, that cultic formation is superfluous to the extent that the formation of the everyday is a formation that arises from a pure being-grasped. Second, it means that, if there is a cultic formation, it must be a formation representative of what takes place in the everyday, on the basis of the meaning-giving depth of the everyday. Hence to be rejected is every cultic form that exists alongside our everyday, our work, our rest, our living and wandering, our economics and our politics, our knowledge and our perception. No sacred sphere! Rather, the disruption and transformation of every sphere—that is the first requirement of every formation. It needs to have only one pathos, that of profanity. That is the removal of every false pathos, every pathos that, in other words, is a flight from the workaday world.

The second demand of a cultic formation is contemporaneity. Not just any everyday world is to be cultically seen and cultically shaped but *our* everyday. Here are the heaviest burdens of cultic formation, here lies the necessity of the hardest struggle against most of what happens today— something to which this exhibition too is a testimony. There are, of course, overlapping elements that are common to the workaday world of all times; and there is, of course, a genuine tradition, a tradition which sustains us and without which our present would not be *this* present. Such a genuine tradition comes to expression by itself in every formation of the present. But there is also a remembering of things that are no longer genuine tradition; and this ability to remember, this intensified capacity of empathy was and is the true misfortune of cultic forming. If expressionistic forms today give us the possibility of feeling our way into the Byzantine-Roman forms of the Christian past, that does not give one the right to use this possibility in order to resuscitate past things. Be it in glass windows or crucifixes, be it in frescoes or altar paintings—to do so is a betrayal of our present. And even though it does touch us deeply for a moment, just as does everything that reemerges from one's own past, still it is followed by disappointment; for it is not *our* essence that is given a figure there. What remains is possibly the worst thing that can happen to cultic formation—an aesthetic impressiveness. One ought to be sensitive in the extreme here. It is better to be silent too long than to speak too soon. Perhaps only a small amount of the content of past cult and myth is accessible to us. In that case, we ought to confess our poverty and not try to dress it up with the richness of the past. We should have the courage to be satisfied with what we have—light, color, material, space, proportions—and to do without the contents that are formed by legend, whether that be the picture of Christ, whether it be apostles and prophets, or whether it be myths and stories. Perhaps it will be possible sometime to speak of them again, but certainly only after we have long and

honestly been silent about them. Much, very much even of this exhibition collapses before the standard of contemporaneity.

Finally, the requirement of actuality. There is a bad concept of actuality, or real life, when actuality is confused with technical and economic usefulness. The actuality of a real object is, rather, its own meaning, the meaning which sustains it. With everything, such a meaning lies deeper than its technical use and its economic usefulness. Everything has a power of its own, a radiance, a fullness of reality. True, that is no license for romantic inflation and decorative disfiguring of things. For the power of things is their objectivity, and this standard is to be applied with greatest strictness precisely at that point where cultic formation is concerned, that is, formation on the basis of a true and final power of the real object. Anyone who does cultic forming ought to know that a cross is no occasion for decorative studies, that a chalice is a drinking vessel whose meaning and power is this use of it, and that, unlike past ages, we can no longer see the power of the Scripture in its magic radiance but in its clarity, its inner appropriateness to what it expresses, its capacity to communicate thoughts—that we therefore must avoid Scripture as decoration. Such a person should know that the technical forms of an organ mediate to us today more of the power of its sounding life than a masking facade whose elements are a mixture of remembrance and arbitrariness. Such a person should know too that a church is a space in which a community of people place themselves under the word and the action that expresses the meaning of its existence today—that is, an existence dominated by technique and economics—and that no style of the past and no echoes of such a style can do it justice; that a simple space, powerful by its honest objectivity, perhaps in a house behind the street in a metropolis, could be just our church space.

What the Art Service intends to show, by example and counter example, is contained in these three requirements: everydayness, contemporaneity, actuality. They are an expression of the one requirement of truth. It is like a judgment on religion that religion, which should be the witness of truth unreservedly, is constantly put to shame by the honesty of the outsiders, who are alien to its cult and myth and who, for the sake of their own honesty, must keep their distance as long as cultic formation has not become a formation on the basis of truth and actuality.[1] It is significant and shaming at the same time for our religious situation that in this exhibition the only things that are entirely effective are the profane utensils that expressly present themselves as noncultic. A simple shell

1. The theme of "honesty" is especially articulated in "Honesty and Consecration in Art and Architecture," in chap. 21 of this collection.

puts to shame, even in the final religious sense, almost everything of cultic utensils that is assembled here. There are, to be sure, beginnings, even in the formation of cultic utensils, and we should be grateful to those who have here forged a path. But almost without exception these beginnings are thwarted by the old false understanding of cult as a special area alongside the breadth, the everydayness, and the actuality of life. Cultus of the present is almost always removed and thereby robbed of its final seriousness. We thank the Art Service for having taken up the battle for a new, contemporary, actual, and thereby convincing art form. In the sign of this battle, we open the exhibition.

8

Dwelling, Space, and Time

This is an address given for the dedication of a house in Potsdam in 1933.

WE WISH TO SPEAK of dwelling, of space, and of time. Three concepts are bound together in this theme, of which two—space and time—are the result of the highest philosophical abstraction, whereas the third—dwelling—designates concrete, living reality. Connecting the one with the other seems to contradict the dignity and remoteness from life that are proper to philosophy. But it contradicts only a philosophy removed from life; it does not contradict philosophy itself. Philosophy does not have to do, as is often thought, with the general, abstract, otherworldly. It is not a matter of self-enclosed speculation or mystical profundity. It is, rather, the interpretation of the closest, the concrete, the everyday. For in the proximate, the daily, the apparently small, there is hidden in truth the metaphysical; the here-and-now is the place where meaning is disclosed, where our existence must find interpretation, if it can find an interpretation at all. That is what dwelling, or the space of dwelling, is: something proximate, daily, apparently small over against great things. It

"Dwelling, Space, and Time" originally appeared as "Das Wohnen, der Raum, und die Zeit," in *Die Form* 8 (1933): 11–12. An English text of this work was given to Betty Meyer by Tillich. In 1985, as editor of *Faith and Form*, she edited the text and published it under the title "Domestic Architecture, Space, and Time." See *Faith and Form: Journal of the Interfaith Forum on Religion, Art, and Architecture*, Fall 1985, pp. 11–12. The version of "Dwelling, Space, and Time" which appears in this collection has been excerpted from *Gesammelte Werke* (Stuttgart: Evangelisches Verlagswerk, 1967), 9:328–32. It is translated by Robert P. Scharlemann.

is the first and most immediate relation that man has to space at all. In this relation he creates the space that is *his* space. And only by starting from his space can he thrust forward into space at large, into infinite space.

When therefore a community of people has transformed a house into the space of its communal life, as often happens, it makes sense to dedicate such space by words that characterize dwelling in its significance for our human being, for our having space and creating space. If a strong architectonic will has created these spaces, has formed them throughout on the basis of an idea, in great and in small, that will deserves to be grasped in thought and placed into overarching contexts. We wish to speak of space. But because our existing in space is also always an existing in time, and space and time meet, although also contend with each other, the consideration of space will finally lead us beyond itself to the consideration of time and, with it, to the boundaries of all creation of space.

I

Space is not a thing, nor a container in which things exist; rather, space is the manner in which living things come into existence. Space is the power over space, the power of living things to create space for themselves. There is no space in itself; rather, there are as many kinds of space as there are ways in which living things create space for themselves, and that means, ways in which life becomes actuality. It is by its spatiality that everything living, including the human, is recognizable.

The first, immediately illuminating characteristic of space is coexistence, or being next to one another. One thing fills this space, and some other thing another space. They exist next to each other, and one excludes the other. One moves the other, through pressure and impulse, from the outside; there is no inner unity of space here. The power of creating space has, in this sphere, the character of filling space, impenetrability, existence in itself and the warding off of every other thing, hardness and opposition, or being over against one another. In the space-filling power of a wall of rocks one can see the power of entities at this stage. The impenetrability and hardness of every wall of a house testifies to the same being. We call it the being of the inorganic, whose characteristic, filling space and opposition, extends even into the highest forms of creating space for oneself.

What is removed is the rigid opposition of the way space is filled in the vegetative sphere, in the being of plants, where the fulfillment is elevated to an evolving, or unfolding. Instead of coexistence, there is a thrust for-

ward beyond itself, an expansion of self, which, however, never leads to a separation; a unity, a sympathy connects all sides of developed plant life. Space is, as it were, concentrated on a single point and yet, again, unfolded in a breadth. The life process of growth signifies a mutual penetration of everything that is simultaneously coexistent. It is not some other formation in the same space as that of the inorganic; rather, it is another space that living things create for themselves.

The same is true at the next step, the space of mobility, the sphere of the animal. The filling out and unfolding are preserved, but in addition there is movement. In its expectation, an animal takes into itself the distant space toward which it is headed. It breaks through vegetative subjection to the soil, it thrusts forward into spaces that are not immediately adjacent. At the same time, however, a counterpole is developed in an animal, the longing for its own limited space, the nest and the cave. This is in accord with the fact that the higher animal is thrown into space through birth, that is, by being cast out of the originally sustaining, limiting space of its mother's womb. In the longing for nest and cave there is simultaneously expressed the drive to return to the enclosing, sustaining space.

Man creates space for himself in all the forms mentioned so far. But he also goes beyond them in two directions, outwardly and inwardly. Externally, he does it by overcoming even the limited space for movement to which the animal, even the most migratory animal, remains bound. Human being breaks through every spatial limit, it creates for itself infinite space in accord with the power of its being. Space in itself is neither finite nor infinite. A finite space as a thing or an infinite space as a thing is a nonthing, an absurdity. Space is infinite because the human mode of creating space for oneself is that of breaking through every finite boundary. Space is finite because man always stakes out a limited space in which he remains and from which he pushes forward into the infinite. Finitude and infinity of space are the polarity in which the power of human being gets expressed, in which man creates space and, therewith, existence for himself.

Connected with this external transcending is an internal one. Man is the entity that does not stay with anything given (*Gegebenes*) but presses beyond it to something still to be done (*Aufgegebenes*). He is not content with that which is but has a picture of that which is to be; he projects and configures, beyond the world as it is found, a second world, created by him. He consciously creates and shapes the space which is to be his space. As he does so, the polarity which was already observable in the animal and which in man becomes the standard for the configuration of his space takes effect. On the one side, the will to fence oneself off as much

as possible from infinite space, to make the house a cave, a mother's womb; and the desire to take into this fenced-off space copies of plant and animal life, which thus is taken into one's own space in the forms and colors of the furniture and walls. On the other side, the will to have the limited space dissolved into infinite space, to take nothing in except that which is necessarily connected with the meaning of dwelling, to open oneself wide toward cosmic space and all forms that it bears in itself, that remain outside and yet, like light and air, stream into the bounded space; the type that does not want to go back into the cave, the maternal womb, that wants to go out into infinity.

Because creating space is the way in which man, like all living things, comes to being, there is an original holiness of space. This is true, first and foremost, of that side of space which has the character of what sustains and originally bounds—the earth, or soil. House gods are the gods of the earth on which the house stands; and it has happened often enough that bloody sacrifices have been made to them. In this, a house resembles the subjection to soil that is true of plant existence. But it is not only one's own house that limits space; the neighboring house does so too, as do the locality, the city in whose sphere of influence a house stands, the landscape, the people and its soil. They all participate in the holiness of space that gives us existence. But the space-creating power of man exceeds even these boundaries and seeks to recreate the earth into an integrated house of mankind, detached from every special territory. Therewith, however, human space-creation becomes the creation of ever growing living spaces, it becomes the creation of space in the progress of time. Time gains power over space.

II

The space of mere filling out has no other relation to time than that it endures in time. Vegetative space already has a more intimate relation to time: plant life contains youth, maturity, old age as forming moments of its life process. In animal life, the future is anticipated, and the past leaves echoes. In the interior of animal life expectation and remembrance meet and create the threefoldness of time. In human life, finally, time becomes infinite, as does space. Man anticipates the unlimitedly distant future. The coming millions of years do not signify for him an end any more than the preceding millions of years signify a beginning. He goes beyond every configuration, and beyond every forming space, toward something new; and in the new, the boundary of the old space and the old configuration is breached.

It is true that time cannot annul space. Time gains presence only in

space; presence is the mode in which time is near to space. In the present, and only in the present, are space and time united. Anyone who has space, has presence; anyone who still has not found any space, or still is without any living space, lives toward the future in order to create a present out of it. But if one has found space, that is, presence, then the power of time, the power with which human beings create time for themselves, drives one into the future; for the future is the mode in which time becomes "time." To create time for oneself means to create a future for oneself, and that tears one out of the present, out of space. Again and again we have to leave space, which encompasses us, for the sake of time, of the future—just as we had to leave it when we were born. The word that came to Abraham commanding him to leave his living space for an unknown future is symbolic of being human at all. It is also symbolic especially for the spiritual and social struggle of our present, the deepest basis of which is the fact that the gods, the powers of bounded space, resist being torn out into a more comprehensive space, into a space of mankind and a future in which human being fills itself anew. It is as though the thrusts that mankind has made in the direction of a uniform space had stirred up the territorial demons and driven them once again to the highest exercise of power. So we witness today a struggle between space and time, not their unity in a satisfying present.

Every house seeks to provide such a present in a bounded space. Every house is a satisfaction of the human creation of space for oneself, of the human longing for presence. But every house also takes a risk that sacrifices will be brought to the deities of bounded space, to the house god, which are not suitable for it. One must therefore strive, and succeed in the effort, to create spaces in which the tension is balanced between the will to fence oneself off, in order to protect oneself from the infinity of space that draws one in, and the will to thrust forward into infinite space, to leave the sustaining and simultaneously constricting cave.

Part III

Writings from
the American Period

9

Existentialist Aspects
of Modern Art

Over two decades separate this English lecture (1955) from the
translations from the German in Part II of this volume. While the
lecture was given at more than one institution, the one at Drew
Theological Seminary was undoubtedly the occasion for its inclu-
sion by the editor, Carl Michalson, in Christianity *and the*
Existentialists. *The lecture, with its four levels, has been widely*
read and debated. Without abandoning the basic thrust of the lec-
ture, Tillich later preferred the term dimensions *instead of* levels
as indicated in "Religious Dimensions of Contemporary Art,"
chapter 16 of this collection.

To DO JUSTICE to my subject I should really write three books—one on
existentialism, one on art, and one on religion. Then I should relate these
three to each other. Here, however, all this has to be done in the narrow
space of a single chapter.

Meaning and History of Existentialism

Let me start with the first "book." First, I want to devote a few words to
what I believe existentialism is, just as the other contributors to this vol-

"Existentialist Aspects of Modern Art" is excerpted from *Christianity and the
Existentialists*, ed. Carl Michalson (New York: Charles Scribner's Sons, 1956), pp.
128–47. Copyright 1956 Carl Michalson; renewed 1984 Janet A. Michalson. Re-
printed with the permission of Charles Scribner's Sons.

ume have given some description or definition of what they understand by existentialism. I distinguish three meanings of this term: existentialism as an element in all important human thinking, existentialism as a revolt against some features of the industrial society of the nineteenth century, and existentialism as a mirror of the situation of sensitive human beings in our twentieth century. Of course the main emphasis will be on the last meaning of this term. I believe that most creative art, literature and philosophy in the twentieth century is in its very essence existentialist. And this is the reason why I have proposed to address myself to existentialist elements in recent visual art. I believe that the people for whom visual impressions are important will perhaps understand what existentialism means better by looking at modern art than by reading recent philosophers.

Existentialism as a universal element in all thinking is the attempt of man to describe his existence and its conflicts, the origin of these conflicts, and the anticipations of overcoming them. In this sense, the first classical philosopher who had many existentialist elements in his thinking was Plato. I refer here especially to those instances where he employs mythology, for existence, in distinction from essence (from what man essentially is), cannot be derived in terms of necessity from his essential nature. Existence is that which stands against essence although it is dependent on essence. Plato uses existentialist terms when he speaks of the transition from existence to essence or from essence to existence; when he speaks of the fall of the souls; when he speaks of the seeming but not true character of the world of appearances and opinions; or when he speaks of the bondage of the soul in the cave of shadows. In many other cases he brings into his philosophy existentialist elements, and he is wise enough to know that this cannot be done in terms of essentialist analysis.

There are existentialist elements in early Christian theology—very outspoken elements for instance in Augustine and his doctrine of man's estrangement from his true essence, from his union with God as his creative ground. There are existentialist elements in classical theology, in the Middle Ages, and in Protestantism. Wherever man's predicament is described either theologically or philosophically, either poetically or artistically, there we have existentialist elements. This is the first meaning of this word.

The second meaning is existentialism as a revolt. It is a revolt which started almost at the moment when modern industrial society found its fundamental concepts, in the seventeenth century. The man who first expressed these elements as a revolt was Pascal, although at the same time he made great contributions to the development of modern thinking by his mathematical discoveries. From Pascal on, we have had an uninter-

rupted series of men who repeated this protest against the attitude of industrial society. Man was considered to be only a part, an element in the great machine of the Newtonian World, and, later on, an element in the great social process of production and consumption in which we all are now living. The protest against this view was a protest of the existing man, of man in his estrangement, his finitude, in his feeling of guilt and meaninglessness. It was a protest against the world view in which man is nothing but a piece of an all-embracing mechanical reality, be it in physical terms, be it in economic or sociological terms, or even be it in psychological terms. This protest was continued in the nineteenth century by the founders of existentialism (in the special sense of the word). Schelling, in his old age, realized that he had to protest not only against his former pupil and friend, Hegel, but also against the Schelling of his earlier years, and introduced most of the categories in which present-day existentialism is thinking. From him, people like Kierkegaard, Engels, and Feuerbach took concepts of anti-essentialist philosophy. These protesting men—Kierkegaard, Marx, Feuerbach, Trendelenburg, later Nietzsche, and at the end of the century people like Bergson and Whitehead— these are people who wanted to save human existence from being swallowed by the essential structure of industrial society in which man was in danger of becoming a thing.

With the beginning of the twentieth century this feeling became much more universal. The people whom I have just cited were lonely prophets, often in despair, often at the boundary line of insanity in their desperate and futile fight against the over-powering forms of modern industrial society. In the twentieth century the outcry of existentialism became universal. It became the subject matter of some great philosophers, such as Heidegger, Jaspers, Sartre, Marcel, and many others; it became a topic of the drama; it became effective in poetry. After some predecessors like Beaudelaire and Rimbaud in the nineteenth century it has become widespread, and men like Eliot and Auden are widely known. It was expressed especially powerfully in the novel. In two of Kafka's main novels, *The Castle* and *The Trial*, we have descriptions of the two fundamental anxieties. The anxiety of meaninglessness is described in *The Castle.* He himself, Mr. K., tries in vain to reach the sources of meaning which direct all life in the village in which he lives, and he never reaches them. The anxiety of guilt is described in *The Trial*, where guilt is an objective factor. The protagonist does not know why he is accused, or who accuses him, he only knows he is accused. He is on trial, he cannot do anything against it, and finally the guilt overcomes him and brings him to judgment and death.

I believe that developments similar to these have taken place in the

realm of art. And out of the different visual arts I want to take, not on principle, but for reasons of expediency, painting alone. Painting will reveal some of the innermost motives of existentialism if we are able to analyze the creations since the turn of the century in the right way. In order to do this I want to go immediately to the second "book" and say a few words about religion and about the relationship of religion and art.

Levels of Relation
Between Religion and Art

Religion means being ultimately concerned, asking the question of "to be or not to be" with respect to the meaning of one's existence, and having symbols in which this question is answered. This is the largest and most basic concept of religion. And the whole development, not only of modern art but also of existentialism in all its realms—and that means of the culture of the twentieth century—is only possible if we understand that this is fundamentally what religion means: being ultimately concerned about one's own being, about one's self and one's world, about its meaning and its estrangement and its finitude. If this is religion, we must distinguish from it religion in a narrower sense, namely, religion as having a set of symbols, normally of divine beings or a divine being, having symbolic statements about activities of these gods or this god, having ritual activities and doctrinal formulations about their relationship to us. This is religion in the narrower sense, where religion is identified first of all as a belief in the existence of a God, and then with intellectual and practical activities following out of this belief. When we speak about religion and art, we must speak in terms of both concepts.

When we hear the words, "religious art," we usually believe that one refers to particular religious symbols like pictures of Christ, pictures of the Holy Virgin and Child, pictures of Saints and their stories, and many other religious symbols. Now this is one meaning of religious art; but there is another following from the larger concept of religion, namely, art as an expression of an ultimate concern. Naturally, it will be an esthetic expression, an artistic expression, but it will be an expression of ultimate concern. And if we distinguish these two ways in which art can express religion, and religion can appear in art, then it is perhaps expedient to distinguish four levels of the relation of religion and art.

The first level is a style in which ultimate concern is not directly but only indirectly expressed. It is what we usually call secular art, and it has no religious content. It does not deal with the religious symbols and rites

3M SelfCheck™ System

Customer name: Opal, Lauren
Customer ID: 21192020396461

Title: Christianity : a very short introduction
ID: 31192020475339
Due: 10/12/2014,23:59

Title: A brief history of theology : from the New
Testament to feminist theology
ID: 31192014291965
Due: 10/12/2014,23:59

Title: The Epistle to the Romans
ID: 31192004809255
Due: 10/12/2014,23:59

Title: Theology of culture
ID: 31192006707002
Due: 10/12/2014,23:59

Title: The philosophy of the Church fathers
ID: 31192003285143
Due: 10/12/2014,23:59

Title: On art and architecture
ID: 31192005697170
Due: 10/12/2014,23:59

Total items: 6
9/14/2014 1:17 PM
Checked out: 6
Overdue: 0
Hold requests: 0
Ready for pickup: 0

Thank you for using the
3M SelfCheck™ System.



ID: 31192020473339



of any special religion. This first level deals with landscapes, with human scenes, with portraits, with events, with all kinds of things on the level of secular human existence.

Neither on the second level do we have religious contents—pictures of saints, or of Christ, or of the Holy Virgin. There are no sacred scenes, but there is a style, and the style is the form which expresses the meaning of the period. If you want to know what is the ultimate self-interpretation of a historical period, you must ask, "What kind of style is present in the artistic creations of this period?" Style is the over-all form which, in the particular forms of every particular artist and of every particular school, is still visible as the over-all form; and this over-all form is the expression of that which unconsciously is present in this period as its self-interpretation, as the answer to the question of the ultimate meaning of its existence. Now the characteristic of this style is that there is something always breaking through out of the depths to the surface. Wherever this happens we have a style that is religious even if there is no religious content whatsoever depicted. I will come back to this again since it will be the center of our consideration. But first let me proceed to the third level.

The third level is the level of secular forms of nonreligious style which nevertheless deals with religious content. These are pictures of Christ, pictures of the saints, of the Holy Virgin and the Holy Child. When we think of this third realm we immediately think of the art of the High Renaissance. It is a non-religious style dealing with religious content.

The fourth level is mainly the level on which religious style and religious content are united. That is an art which, in the most concrete sense, can be called religious art. It can be used for liturgical purposes or for private devotion. In it style and content agree. However, I must conclude this description of the fourth level with the question, "Is such a religious art possible today?" And with this question I return to the four levels and call to your attention a few examples.

1. *Non-religious Style, Non-religious Content.* For the first level I could cite two examples. The first is a picture by Jan Steen, *The World Upside Down* [plate 17]. I recall another picture [plate 16], very similar to this one. It also is an interior, with play, dance, drunkenness, love, and everything together—very dynamic, very vital, as was the old Dutch way at that time. I saw that picture in the National Gallery, two or three years ago, when I first started to think about a study on religion and art. I had wanted to look at religious pictures or at least the pictures where religious style is visible. But it so happened that I could not look away from that picture [plate 16] very similar to this one [plate 17] by Steen. I asked myself, "What does this picture express in terms of an ultimate interpre-

tation of human existence?" And my answer was, "It too expresses power of being in terms of an unrestricted vitality in which the self-affirmation of life becomes almost ecstatic." Now one may say that this has nothing to do with religion. I cannot accept this. I may accept that it is only indirectly religious. It has neither a religious style, nor a completely secular style, nor has it any religious content. Nevertheless—and this is a Protestant principle—God is present in secular existence as much as he is present in sacred existence. There is no greater nearness to Him in the one than in the other, and using this as a yardstick for understanding pictures like this, I would say that this is the first level of the relation of religion and art, namely that level in which, in secular style and without religious content, power of being is visible, not directly, but indirectly. There is another example, a picture by Rubens with animals and landscape, "Return of the Prodigal." The landscapes of Rubens, for some mystical reasons, have always interested me philosophically. What is the matter with them? You are in them somehow, they take you in, you live in them, they give you a feeling for the cosmos in a rather dynamic way, though completely on the surface of colors and forms. There is something in this landscape which you never would see without the painter, and that is what art has to do, anyway. Here another entire volume could start: namely, to show in symbols, taken from ordinary experience, a level of reality which cannot be grasped in any other way. If this were not the case, art would be unnecessary from the very beginning and should be abolished. But art is necessary. It is as necessary as knowledge and other forms of human spiritual life. It is necessary for it reveals levels of reality, even in such secular objects which are, neither in style nor in content, religious.

2. *Religious Style, Non-religious Content: The Existentialist Level.* I come now to the second level, and this level is the existentialist level. The movement of modern existentialism in visual art starts with Cézanne [plate 28] in France. Let me relate one experience I had two years ago when I was in Paris. There was an exhibit of still lifes, starting with works from the sixteenth and seventeenth century and continuing through to the present day. Progressing in chronological order I noticed a strong trend towards the still life. In some way it became apparent that most modern art has transformed all of reality into forms of still life. What does this mean? It means that organic forms have disappeared, and with them has disappeared idealism which always is connected with the description of the organic forms. The forms of our existence are no more organic. They are atomistic, disrupted. These disrupted forms of our existence are taken by themselves by modern artists as the real elements of reality, and now these artists do a tremendous job with them. They reduce the color-

ful world of the impressionists and of the beautifying idealists of the past to more and more cubic forms. This treatment begins with Cézanne. Cubic forms are the unorganic forms out of which the world is constituted. But the artists do not accept the statement that these forms are only unorganic. Embodied in this very unorganic form is the power of being itself. In this way the disruptedness of expressionism, surrealism, and all the other recent forms of styles, such as cubism and futurism, is nothing else than an attempt to look into the depths of reality, below any surface and any beautification of the surface and any organic unity. It is the attempt to see the elements of reality as fundamental powers of being out of which reality is constructed.

Or, consider another artist, Van Gogh, and, for instance, his *Starry Night*. Here again we have the character of going below the surface. It is a description of the creative powers of nature. It goes into the depths of reality where the forms are dynamically created. He does not accept the surface alone. Therefore he goes into those depths in which the tension of the forces creates nature. The same is expressed from the point of view of human society in Van Gogh's *Night Café* [plate 27]. Here you see something I call late emptiness—only one figure. The waiter has left, and just one man is sitting there, and that is all. He represents, in all the beautiful colors you see, the horror of emptiness.

The Norwegian Munch [plates 31–32] could be added here. He has painted pictures not so much of emptiness—although this factor is also in them, but of horror, crime, shock, that which is uncanny, that which you cannot grasp. In this way, this Nordic man also became one of the existentialists, at the same time in which Strindberg wrote his great existentialist dramas with all the terrible tensions, sufferings, and anxieties.

Then there is Picasso. One of Picasso's most important pictures bears the title, *Guernica* [plate 44]. Guernica was a place in Northern Spain where the Fascist countries, Germany and Italy, helped the Fascist Spaniards to overthrow the Loyalist government, the official government, because it was leftist. This place, Guernica, a small town in the country of the Basques, was completely destroyed by a combined air attack by the Italians and Germans. It was the first exercise of what is called, "saturation bombing," a terrible word. That means bombing in such a way that nothing is left. Now Picasso has painted this immense horror—the pieces of reality, men and animals and unorganic pieces of houses all together—in a way in which the "piece" character of our reality is perhaps more horribly visible than in any other of the modern pictures. During one of my lectures I once was asked, "What would you think is the best present-day Protestant religious picture?" I answered almost without hesitating, *Guernica*. I named this picture, because it shows the human

situation without any cover. It shows what very soon followed in most European countries in terms of the second World War, and it shows what is now in the souls of many Americans as disruptiveness, existential doubt, emptiness and meaninglessness. And if Protestantism means that, first of all, we do not have to cover up anything, but have to look at the human situation in its depths of estrangement and despair, then this is one of the most powerful religious pictures. And, although it has no religious content, it does have religious style in a very deep and profound sense.

Now I come to a man named Braque [plate 42] in France who, in his style, is one of Picasso's followers. The picture to which I wish to refer has the name, *Table*. Here you have the dissolution of the organic realities which we usually think of when we speak of a table with things on top of it. Everything is dissolved into planes, lines and colors, elements of reality, but not reality itself. We call this "cubism"; this term naturally demands an explanation. It means that the essence of reality is contained in these original forms. What modern art tries to do is to move away from the surface which had nothing to say any more to men of the twentieth century, and to move to the *Urelemente*, the original elements of reality which in the physical realm are cubes, planes, colors, lines and shadows. From this point of view, such a picture can have a tremendous religious power, and I want to say a few words about this later.

In Germany towards the end of the nineteenth century, and in America with the building of Riverside Church in New York, many pictures were produced by two men, Uhde [plate 29] and Hofmann [plate 52]. These pictures all portray Jesus either in terms of a sentimental, religious man, as does the Hofmann work in Riverside Church, or in terms of a rheumatic or otherwise sick, dull school teacher walking through little villages. Now, this kind of picture was supposed to be very religious at that time. I would say that for me, however, religious art must show something of God and the basic structures out of which He has made His reality, and not these sentimentalisms. This, of course, does not exclude occasional romantic expressions within these genuine forms.

As another illustration of the second level I refer to Chagall's picture, *River Without Edges*. Here again we have nothing which can be understood from the naturalistic point of view. It is strongly symbolistic, and perhaps this is the limit of the picture. However, everybody feels here the metaphysics of time in the wild moving clock and the animal above it and the whole constellation of colors and forms. Here the artist tries to use some elements of the encountered world in order to go beyond the surface into the depths of the phenomenon of time. Time is a river without edges.

Or, take another picture by Chagall, named *Lovers* [*The Birthday* (plate 34)]. Notice how the fantastic element comes in, how the forms are taken out of the possibility of natural relationships. The lover comes from the clouds because he is probably in her imagination much more than in her reality.

Then there is a surrealist, Chirico. One of his pictures is called *Toys of a Prince* [*The Evil Genius of a King* (plate 35)]. It is characteristic for existentialist art. I would even say it is surrealistic. What does surrealistic mean? It means the elements of reality are brought into a context which has nothing to do with reality. Surrealism points to special dimensions and qualities of the reality as we encounter it. In some of Chirico's pictures it is infinite space into which we look or it is the loneliness, or the blinding power of the sun; or it is the occasional coming together of elements of reality which have nothing whatsoever to do with each other.

Let me deal now a little bit more systematically with this whole second realm which is the center of our interest. I would call this, in the sense of my basic definition, religious style, although I have alluded to no picture whatsoever which had a religious content. And why is it a religious style? Because it puts the religious question radically, and has the power, the courage, to face the situation out of which this question comes, namely the human predicament. In earlier centuries we have painters who did very similar things. We have it in the mannerist period, after Michelangelo. We have it in some of the Baroque pictures. We find it in people like Goya [plates 20–22]. We have it in those great demonic pictures by Brueghel [plate 15] and Bosch where elements of the psychological as well as the natural reality are brought into the picture without a naturalistic connection with each other, without a system of categories into which they are put. This is the all-important element in existentialism. The essential categories, time, space, causality, substance, have lost their ultimate power. They give meaning to our world. With their help we can understand things. We can understand that one thing follows the other, one causes the other, one is distinguished from the other, each has its space and its time and so on. But all this no longer applies. Mankind does not feel at home in this world any more. The categories have lost their embracing and overwhelming and asserting power. There is no safety in the world.

We have Psalms in this spirit in the Old Testament, especially in the Book of Job, where it is said of man, "and his place does not know him anymore," and this is repeated in the 90th Psalm. Those are very profound words. The things in these pictures are displaced. Displaced persons are a symbol of our time, and displaced souls can be found in all countries. This large scale displacement of our existence is expressed in

these pictures. All this is no positive answer to the question of our existence, and therefore I would agree that there is no Christian existentialism. There are many Christian existentialists; but insofar as they are existentialists they ask the question, show the estrangement, show the finitude, show the meaninglessness. Insofar as they are Christian, they answer these questions as Christians, but not as existentialists. For this reason, I do not believe that the ordinary distinction between atheistic and theistic existentialism makes any sense. As long as an existentialist is theistic he is either not existentialist or he is not really theistic. As far as people like Jaspers, like Kierkegaard, like Heidegger in his last mystical period, like Marcel, are Christians, or at least religious, or at least mystics, they are not existentialists but they answer their own existentialism, and that must be clearly distinguished. Existentialism describes the human situation, and as such it is a decisive element in present day religious thinking and Christian theology.

3. *Non-religious Style, Religious Content.* Now, before coming back to this, I wish to indicate a few examples of the two other levels for a complete picture of the whole situation. A picture which is extremely beautiful, which has a religious subject, is a Raphael Madonna and Child [plate 10]. It is religious neither in substance nor in style. This is one difference between the Raphael and the Chirico picture. In the Chirico, the disruptiveness of reality is visible; in the Raphael, we have a harmonious humanity which of course is indirectly religious, but is not religious in style. Or take another picture, a Madonna by the French painter Fouquet. The Madonna is a court lady of not too good a reputation. You know who she was, yet she is depicted as a Madonna. That shows that here the religious symbol in the Madonna and Child is not combined with the religious style but is reduced to the mother-child relationship of a great lady of the court of France. Or consider another, a Rubens Madonna and Child. Here is another type of beautiful lady and another type of child. It is wonderful to look at, but nobody would think that this is the mother of God in the Catholic symbolism of this relationship. This is enough to show that religious content in itself does not give a religious picture, and many of those pictures which you find in the magazines of the churches, in the little Sunday papers in the churches themselves or, even worse, in the assembly rooms of the churches or the offices of the ministers are of this same character. They have religious content but no religious style. In this sense they are dangerously irreligious, and they are something against which everybody who understands the situation of our time has to fight.

4. *Religious Style, Religious Content.* Now I come to the fourth level, namely, pictures in which the religious form is combined with the reli-

gious content. This form is generally called expressionistic, because it is a form in which the surface is disrupted in order to express something. I have already stated that there have been such pictures long before modern times. Take, for instance, Greco's *Crucifixion.* Here you have an absolutely unnatural form of the body. It is an expression of the esthetic form of the counter-reformation in which a small tenuous line goes up in ecstatic self-elevation towards the Divine with asceticism and often self-destruction. Or, an even earlier picture of the late gothic period, Mathias Grünewald's famous *Crucifixion* [plate 11] on the Isenheim Altar. I believe it is the greatest German picture ever painted, and it shows you that expressionism is by no means a modern invention.

Then there is a modern *Crucifixion* by Sutherland. There you have very similar expression but in modern forms. This is a recent expressionism using forms similar to Grünewald's, but with all the elements of disrupted style which modern art has created. In this context I put a question which I cannot answer: Is it possible to have this fourth level today? Is it possible to use these elements of expressionist visual art in dealing with the traditional symbols of Christianity? Sometimes, as for instance in the work by Sutherland, I am willing to say that it is possible. Sometimes I am not willing to say so.

Nolde, an expressionist of the German school which started in 1905, like other German expressionists tried to renew, by means of the expressionistic forms which they had created, the religious symbols of the past [plates 38–40]. Sometimes I am impressed by them—but in most cases I feel that they did not succeed. To illustrate this I refer you to Rouault's works *Christ Mocked by Soldiers* [plate 51] and plate 46 from the series called *Miserere*: attempts to use his expressionist forms in order to make Christ's story present and contemporaneous to us. The last illustration I will cite is a *Crucifixion* by Rouault. I must repeat, sometimes I have the feeling that these are solutions, at least better ones than anything we have in the traditional "junk" of religious art today. But on the other hand, I ask myself, "Is the present day man really able to answer the question put before us by existentialism?"

Existentialism and Idealized Naturalism

Idealized naturalism still is the favorite form of art for many people. What does this favorite form mean from an existentialist point of view? It means the unwillingness to see and to face our real situation; therefore the relationship to modern art and its existentialist elements is a very serious affair. Let me tell you of an experience from my past after I had

come out of the first World War, and the German Republic had been established. I was teaching at the University of Berlin, opposite the Museum of Modern Art just established by the newly formed republic. I myself used pictures in my lectures in order to show in other realms of life, especially philosophy, the relationship of form and substance, the possibility of breaking the surface form of reality in order to dig into its depths; and I must confess that I have not learned from any theological book as much as I learned from these pictures of the great modern artists who broke through into the realm out of which symbols are born. And you cannot understand theology without understanding symbols. In this museum something happened every day. The petty bourgeoisie of Germany also went to these exhibitions and I will never forget the smiling and laughing, or hostile and malignant faces in front of these pictures. What they expected in a museum was idealized naturalism. These pictures, however, had neither nature in the surface sense of the word in them, nor idealizing beauty. Instead of this they had shocking disruptions, distortions, elements of reality brought out of the depths to the surface by the painter. These petty people fought against this. This was, in the realm of art, the fight between the coming Nazism, produced by the same petty bourgeoisie, against the progressive intelligentsia which realized the dangerous situation in the industrial society. The petty bourgeoisie did not want to see that its situation had fundamentally changed, and Fascism was the attempt to maintain the old situation by means of suppression and terror. Now this shows that in artistic problems, and especially in the problems of existentialism in art, all realms are somehow present. However, let me go back to the religious realm. What has this situation to tell us about the religious realm and about our human situation? It has to tell us, first of all, that there are moments in individual life and in the life of society when something cannot be hidden, cannot be covered any more. If the surface is maintained, then this can be done only at the price of honesty, of realism, of looking into the depths of our situation, and this price always includes fanaticism, repressing elements of truth, and self-destruction. We must be able—and that was the great work of these artists—to face our present reality as what it is. These artists were accused by many of having only negative characteristics. Hitler piled up their works in a museum of decadent art, a museum which contained some of the greatest treasures which later were brought to this country as great works of art. But as for Hitler, as a representative of the desperate petty bourgeoisie which wanted to keep itself in existence, he called this distorted, degenerated art. As long as we remove from our sight what we cannot help facing, we become dishonest; then that kind of art which he favored, that kind of beautifying realism, is what covers reality. These art-

ists, therefore, who took away the cover from our situation, had a prophetic function in our time. I do not like all of them, either. But I know they created revealing works of art to look at which is the joy of participating in a level of reality which we otherwise can never reach.

And now finally about the relationship of the churches to all of this. The churches followed in most cases the petty bourgeoisie resistance against modern art and against existentialism generally. The churches believed they had all the answers. But in believing that they had all the answers they deprived the answers of their meaning. These answers were no longer understood because the questions were no longer understood, and this was the churches' fault. They did not do what the existentialist artist did. They did not ask the questions over again as they should have out of the experience of despair in industrial society. The churches did not ask the question, and therefore their answers, all the religious answers Christianity has in its creeds, became empty. Nobody knew what to do with them because the questions were not vivid any more as they were in the periods in which these answers were given. This, then, is my last statement about the whole thing. I believe that existentialist art has a tremendous religious function, in visual art as well as in all other realms of art, namely, to rediscover the basic questions to which the Christian symbols are the answers in a way which is understandable to our time. These symbols can then become again understandable to our time.

10

The Demonic in Art

*This lecture, given at Drew Theological Seminary on 9 April 1956
was the result of conversations between Jane Karlin Dillenberger
and Tillich on the demonic in art, growing out of a project on
which Jane Dillenberger was working. As early as 1926, Tillich
had written an essay, later translated as "The Demonic," the intro-
ductory pages of which introduced the subject through references
to the visual arts.[1] The slides for the current lecture were selected
by Tillich in discussions with Jane Dillenberger. The lecture was
given for her class in contemporary art but was open to the semi-
nary community. The text of the lecture, including questions and
answers, have been transcribed and edited from a tape in her pos-
session, now deposited in the Tillich Archives. The archives also
have copies of two handwritten outlines and one typed outline
for this lecture, as well as a typed copy of Tillich's final outline
which has annotations by both Jane Dillenberger and Tillich in-
dicating the slides of works of art to be used in the lecture. (See
Tillich Archives, nos. 259–401:4; 257–401:38; 252–401:33.)*

DEAN BERNHARD ANDERSON: Here at Drew we are deeply interested in the
vital subject of the communication of the gospel to the modern world,
and we are fortified in this concern by having teaching in the field of

1. Many readers will know that Tillich wrote an essay, *Das Dämonische: Ein
Beitrag zur Sinndeutung der Geschichte* (Tübingen: Verlag J.C.B. Mohr, 1926),
which was translated as "The Demonic" and published in *The Interpretation of
History* (New York: Charles Scribner's Sons, 1936), pp. 77–122. The opening
paragraphs of this essay use analysis of the arts as an entrance way into the discus-
sion of the concept. Hence they are here reproduced:

Christian art. We are happy this afternoon to welcome to our campus and to this class in Christian art and the visitors thereof, Dr. Paul Tillich of Harvard University who is going to speak to us on the subject, "The Demonic in the Visual Arts." Dr. Tillich.

The art of primitive peoples and Asiatics, embodied in statues of their Gods and fetishes, in their crafts, and dance masks, has been brought closer to us in the last decade, not only as ethnological material but also as artistic and religious reality. We have noticed that these objects matter to us, since in them are expressed depths of reality which had, to be sure, escaped our consciousness, but in the subconscious strata had never ceased to determine our existence. The history of art and religion, together with the new psychology of the subconscious have opened the way to these realities, whose description, interpretation, and evaluation, of course, are still in their beginnings, but must, when continued, decisively influence our culture.

It is a peculiar tension that these things contain, in consequence of which they were so long inaccessible to our Occidental consciousness. They bear forms, human, animal, and plant, which we understand as such, recognizing their conformity to artistic laws. But with these organic forms are combined other elements which shatter our every conception of organic form. We cannot interpret this as want of artistic power, as a primitive lack of development, as a limitation of an aptitude for artistic form, and thereby characterize this whole tremendous human production as without cultural value. We must rather watch these elements, which break through organic form, lead to a peculiar, in itself necessary and expressive, artistic form, in the face of which to speak of lack of form would betray only unfamiliarity and failure of comprehension. Those destructive elements themselves, which disrupt the organic form, are elements of the organic; but they appear in such a manner that they violate radically the organic coherence presented in nature. They break forth in a way which mocks all natural proportion; they appear with a strength, a widespread frequency, in transformations which, to be sure, still permit one to recognize the organic foundation but at the same time make of it something completely new. The organs of the will for power, such as hands, feet, teeth, eyes, and organs of procreation, such as breasts, thighs, sex organs, are given strength of expression which can mount to wild cruelty and orgiastic ecstasy. It is the vital forces which support the living form; but when they become overpowerful and withdraw from the arrangement within the embracing organic form, they are destructive principles. That it is possible to grasp these creative primeval powers as they break through organic form and to subordinate them to the unity of artistic creation is perhaps the most astonishing thing which these sculptures and masks reveal to us. For it demonstrates one thing irrefutably: There is something positively contrary to form that is capable of fitting into an artistic form. There exists not only a lack of form but also a contradiction of form; there exists not only something less positive but also something contra-positive. Only by denying, on principle, the esthetic qualities of a negro sculpture or a Shiva picture, could one escape this conclusion, *i.e.,* by making classical esthetics absolute. Whoever cannot assent to this conclusion, must admit that human art reveals to us the actuality of that which is positively contrary to form, the demonic. , . .

These realities everywhere contain the same tension as the creations of pre-classic human art: the embracing form, which unites in itself a formative and a form-destroying element, and therewith affirms something contra-positive. Here, too, one could escape this conclusion only by denying the cultural character of the whole non-

DR. PAUL TILLICH: Dean Anderson, Dean Hopper, Ladies and Gentlemen: This is the second attempt to speak to you. Two weeks ago demonic powers [a snow storm] prevented it. What I want to do today, perhaps to the disappointment of some of you, is more conceptual than visual. Mrs. Karlin[2] will add some visual elements to it according to her job, but I, according to my own, will concentrate on the conceptual side. First, I want to speak about the demonic in the general terms of defining the meaning of the concept, then diving into the ontology of the demonic; then coming to the psychology of the demonic; and finally, giving some indications of a possible theology of the demonic. Now these are the four sections: the concept, the ontology, the psychology, and the theology of the demonic.

Twenty-two years ago when I was first in this country and used the term, the *demonic,* I was asked, "Do you mean there are demons somewhere flying through the air?" I answered, "Of course that is not what I mean." But in the background of some people's minds, when they hear the word *demonic,* something of these flying demons is still there. And so it is important to state that the difference between the myth and the concept of the demonic, is the presupposition of speaking today about the demonic at all. If this distinction is not clearly made, then the whole concept will relapse into a primitive literalistic mythology. On the other hand, we should not despise the mythological expression of the demonic, especially in view of the fact that we want to speak about the visual arts. The visual arts have to deal with the mythological imagery connected with the demonic. So, after this remark of precaution, I go to the myth, not because I take any myth literally (I think this is the great sin of fundamentalism, that it takes mythology literally), but because the expressive power of the myth cannot be replaced by anything else. Although I speak conceptually, I am well aware that the real power of the thing about which I intend to speak comes from the mythological imagery.

There is one image which has come into the foreground of theological discussion today, namely, the imagery of the three stories of the universe.

humanistic history of mankind, its state and legal construction, its mentality and cults.

The tension between form-creation and form-destruction upon which rests the demonic, comprises the boundary between the latter and the Satanic, in which destruction is symbolized without creation—is only symbolized—because the Satanic has no actual existence, unlike the demonic. In order to have existence, it would have to be able to take on form, *i.e.,* to contain an element of creation.

2. Jane Karlin Dillenberger.

The three realms, the one called heaven, in which God and divine beings are dwelling; the opposite of it, the demonic, in which the enemies of God and his angels are dwelling (although they originally come from the heavenly realm, the fallen angels); and between them on earth, the human beings, in whom the divine and the demonic fight with each other. When we speak today about these things in a more conceptual way, we would say there are not three realms but that there is only one realm. This one realm is the human realm, the realm of the universe in which we live, of ourselves and our world. . . . This realm has different dimensions, and one of these dimensions is either the divine or the demonic dimension. If in myth we have both the divine and the demonic realm, in our conceptual interpretation of the myth, we have only one realm, the human. In this one realm the divine and the demonic are fighting with each other.

Let us look now at some illustrations. In Michelangelo's *Last Judgment* [plate 12], more than in the following pictures, we have the oneness of a reality in which the demons as well as the human beings are thrown into hell. All are humans; there is nothing hellish about them except for the fact that they are falling down, that they are thrown into the nether place, into the place which in mythology is the place of the demons and those who are grasped by demonic powers. It is interesting that in this Michelangelo painting, in which the transition from the Renaissance to the Baroque is evident, we have a hell which is filled with real human beings, where the demonic powers hardly can be distinguished from the human beings.

In this *Last Judgment* we see that Michelangelo borrowed Dante's imagery in representing Charon as the boatman who transports the damned across the river Styx into hell. The demonic is embodied in a quasi-human being who has permission to bring other human beings into the place of torture, until he himself will be annihilated. I shall discuss this in the next section on the ontology of the demonic, so please keep it in mind.

The *Last Judgment* shows Christ, who throws down the damned. Although Christ does not actually belong to my subject matter, it belongs to this picture as a whole and I will say a few words about it. When the pope [Paul III] unveiled this picture, he was tremendously grasped by it, but his successors, the popes of the Counter-Reformation, after a conversation with Michelangelo, commissioned one of his students to paint draperies on the figures, who were naked according to good Renaissance tradition. My reaction was, from the point of view of Christianity, that the nakedness was not the non-Christian element, but that this Christ was the problem. This Christ is not the Christ who was ever on the cross; this

Christ is an ancient God without *agape,* without the love which goes down from the highest to the lowest. He represents nothing but the judging power, embodied in similar figures in Egypt and in Greece. Now that is the only thing I want to say about it, for I consider this Christ somehow demonic himself, instead of being a judge of the demonic. This picture shows that the Renaissance, in its religious pictures, has ceased to be religious in any Christian sense.

When we turn to van Eyck's painting of the *Last Judgment* [plate 6] in the Metropolitan Museum, New York, we are concerned again with our main subject. St. Michael is seen here throwing the condemned down into hell. I want to repeat the same fundamental idea, that it is actually the human which one sees in all these figures. There certainly are some demons, but what we have are human figures and it is in man that the divine and the demonic are embodied. The interesting thing is that in most of these pictures a third sphere does not appear as an independent sphere. What the paintings represent is a fight between the upper and the lower spheres. Man is always in both of them and he is falling or rising from the one to the other.

In the hell zone in van Eyck's *Last Judgment,* we see terrified human figures, lay persons and clerics, kings and commoners falling to their doom. In all these figures it is the human which is prominent, but in distortion and agony. And I think it is important that the visual arts have shown that even hell is possible only through the creative power which creates the human body. As Dante has written over the door to hell, "I also have been created by the divine love."

It has often been said that in medieval pictures and even in Dante's *Divine Comedy,* heaven is boring. I have heard people say that they would prefer to be in hell because it at least has some interest. What is the reason for the boredom elicited by these pictures of heaven? Perhaps it is because these painters are not able to show that fulfillment also always implies a state of nonfulfillment. They would have to show that the hell through which man has gone is still present even in heaven. Perhaps no painter can do this. When we examine the heavenly zone of van Eyck's painting, we see a static and ordered assembly of apostles and saints about the risen Christ. The figures in heaven appear so superior to our life struggle that they are not only unrealistic and different from the hell figures; they also seem to be in a state in which there is no life or tension, and therefore, no ultimate dynamic.

Blessedness implies the possibility of its opposite as memory or as reality. Perhaps the fact that most religious art is not able to represent heaven as well as it does hell is based on the fact that we idealize heaven and do not show the negative element which has been overcome.

The demonic is ambiguous; it is both creative and destructive. So the demonic is the ground of everything creative but which, in the way in which it appears, becomes destructive. Whenever we hear about the demonic or about demoniacs as being possessed by demonic powers, we must always ask, where is the creative element, before we speak unambiguously about the negative or the destructive element. Take the New Testament demoniacs, they whom Jesus healed. They had a great advantage over the masses of people, and especially before the apostles or the disciples of Jesus, for they recognized Jesus as the Son of David, as they often called him, or as the Messiah, before anybody else did. Their anxiety about his coming was so great that it gave them an insight which normal people did not have. And I say this for those of you who are interested in depth psychology, particularly the analysis of neurosis. Neurosis is not always only an object for healing. It may also be a form of creative possibility. There are instances in which healing would destroy the creative element in the neurotic.

These structures of the demonic, as in neurosis—and I could add psychosis—disclose structures which are stronger than individuals. They are not individual acts of evil; they are structures of evil. The rediscovery of the concept of the demonic is connected with the rediscovery of such structures by depth psychology. It is not that we have the freedom to be good at four o'clock and evil at five o'clock; instead, we participate in a universal structure which the ancients and the New Testament called possession by structures. Since we cannot speak of demonic spirits as individual beings, (a bad literalistic mythology), we must speak of structures which keep us in bondage, experiences which we all have to some extent and which we see in some people to a larger extent. But we do not see it only in individuals; we also see it in social structures. One of the most conspicuous demonic structures in history is the present cold war. We are in a continual social neurosis by the split consciousness and possession which is implied in this inescapable structure, in which everything which is done is, either in reality or by suspicion of the other, that which strengthens the destruction of mankind.

Goya's series of etchings, *The Disasters of War* [plates 20–21], record some of the horrors of the conflict between Napoleon's forces and the Spanish. From this series about the war, this plate [20] of the mass execution of the Spanish by the French shows the brutality of war and the caption reads, "And it can't be helped." There are many others which are even more powerful expressions of the demonic structure of the destruction which we call war etched in this whole series by Goya, where the mass psychology is decisive for the situation and where the demonic is in the behavior of the masses. Goya's etching from the *Los Caprichos* series

[plate 22] has a special interest. Goya shows a woman in a crowd. She is accused and condemned as possessed, either as witch or as heretic, both then being classified as possessed by demons. Her demonic character produces fear and anxiety in the people who condemned her and who accompany her to her death. This is the basis of the antidemonic persecutions which we call witch trials and inquisition trials. In that situation, the demonic enters the persecutors, whom we today would consider as the possessed ones. Look at the faces, the police, the judges, the crowd, all possessed by anxiety, by the same demonic power which they persecute in this woman on the basis of their own anxiety. This means that the state of anxiety often produces aggression against that which supposedly creates the anxiety, and makes those who persecute more demonically possessed than those who are persecuted.

This leads me to the second consideration, the ontology of the demonic. Here, too, the demonic is dependent on the creative, on the positive, on the divine. Everything negative in the universe is dependent on the positive. For instance, Frans Floris, who painted a hell picture of the *Fall of the Demonic Angels* [plate 13], could not do so except in terms of human bodies, even though the human body is itself the highest of all possibilities of creation. The human body has characteristics which make it the image of God; but this same body is used to express the demonic, partly in giving animal features to human bodies. These animal features and the relationship of the demonic to the animal world is an interesting problem in itself; in former symbolizations, the animals symbolized divine as well as demonic tendencies in men. The symbol grasps a reality, and this means that some forces of destructiveness which appear daily in the animal world are also still realities in men. And the painter is able to bring them out. The demonic and the animal element in men which has not been humanized are profoundly connected with each other, as the history of all mythology shows. The decisive thing is that in order to show the demonic, all painters have to show the human, or the animals, that is, created goodness in distorted form. This means that the demonic is a distortion of the created and its goodness.

From this follow the self-destructive consequences of the demonic. When we look at Brueghel's *Fall of the Rebel Angels* [plate 15], we see that something astonishing is happening. What happened to the demons who are the torturers in hell? They also are figures in whom divine creativity is present. The demons are originally angels; but angels also are human realities. The fallen angels are depicted in terms of human negativities, and the demons are human realities in which specific human elements are emphasized. No painter has invented angels or demons out of nothing. In depicting angels, the painter has transformed or distorted hu-

mans; human inventive powers do not go beyond this. Of course we can combine animal figures with human figures. We can even combine unorganic forms, as Bosch often did, with human elements. These are all distortions of created goodness. Out of this follows, that the bad, the negative, cannot live without the positive which it distorts.[3]

What we see expressed in the visual arts is important for philosophy and ethics. Where there is no element of truth anymore, life cannot live; life is destroyed by itself. Where no element of goodness remains, evil is dissolved into nothingness. The symbol of eternal death, of which the Bible sometimes speaks, means that nothing good is left which can be distorted. The result is nothingness, since the negative and the evil live only from the good they distort.

In Brueghel's painting, one sees how inventive the artist was. When he wanted to show the destruction of that which is evil, he did it by leaving it to self-destruction. The angel Michael, who is always represented as throwing the damned into hell, in this picture does not do anything. He acts as if he knew the ontology of the demonic, leaving the demons to their self-destruction. And this is very wise, because if he really came into a fight, demonic elements would be evident in himself. This is the way in which the fanatics in Christianity, who fight evil themselves, become representatives of evil. But the angels know better; the angels who throw the evil ones down leave them to their own self-destruction. For theologians I would like to add that the symbol of the wrath of God does not mean that God becomes wrathful or angry (that would make God demonic), but that he lets the positive which he has given to the evil exhaust itself, so that nothing is left.

Now we come to the artistic expression of the demonic as a victory of the positive over the negative, and here I refer to some pictures of Rouault. If you look at *Christ Mocked* [plate 51], the two mocking soldiers are better than the Christ. The Christ has something of a melancholy sadness, but none of the depth of suffering which is appropriate. The painter does something which confirms my ontology of evil, that it is possible, even out of the evil of these two horrible faces, to make a great and beautiful picture. Rouault does not need the assumed beauty of the

3. In *The Courage to Be* (New Haven: Yale University Press, 1952), p. 129, Tillich connects the demonic in the Renaissance with the rise of an existentialist point of view.

The demonic subjects to which were attracted men like Bosch, Breughel, Grünewald, the Spaniards and south Italians, the late Gothic masters of mass scenes, and many others are expressions of an Existentialist understanding of the human situation (see for example Breughel's Tower of Babel pictures).

Christ in order to do this. On the contrary, this assumed beauty is ultimately less good from the point of view of the beauty of the picture than the ugliness of the soldiers who are powerfully expressed in the picture. In the moment in which the ugly is used by a great artist as subject matter, it becomes beautiful, not by being painted as beautiful (this would be a lie and this lie is very much done in beautifying naturalism in the end of the nineteenth century and beginning of the twentieth century, especially in religious art), but by leaving ugliness in these faces. Expressing their ugliness in an artistic form brings them into the sphere of beauty.

Perhaps some of you have read the Christmas issue of *Life* in which pictures of the life of Christ were published. I was on the committee of selection and I fought very much for this painting by Rouault of the *Head of Christ* [plate 49], and I am thankful that they did not reject it in spite of its being a stumbling block for many readers of *Life*.[4] Here you have a face in which there is nothing sentimental. Here he is completely adequate to the situation of extreme agony. He looks beyond the agony but is not beyond it; he is seriously and realistically in it. For this reason I think this head of Christ should be in many churches in our time, showing that the cross is not a sentimental nicety but is in Christ and in all of us as the terrible reality of existence.

In Picasso's *Guernica* [plate 44] we have the same thing. Extreme ugliness is expressed in a power of form which Picasso himself created. Nobody before him used these kinds of cubistic and abstract forms in order to describe living faith. But in doing so he wrought a picture of seemingly extreme ugliness, but in actuality, a picture of great beauty.

This ends my ontology of the demonic and the reconciling power of art, which can bring the demonic into something creative through a great painting. I come now to the psychology of the demonic. We have to deal first with the problem of temptation in Redon's lithograph of the *Temptation of St. Anthony* [plate 23]. In the stories of temptation, painters are split. It is improbable that if there is a tempter who is demonic in his external appearance, that he would ever be a temptation. Some artists have realized this and have gone against the medieval stories of temptation. Instead, they have represented the devil as beautiful. I think this is much nearer to the reality of temptation. Really tempting is only that which is positive and so the task of the artist is to show a beauty which nevertheless indicates that something destructive and ultimately ugly, ontologically ugly and negative, is behind it.

While I said that temptation comes from that which is beautiful, there is another consideration which must be taken into account in the psy-

4. This list is reproduced in chap. 24 of this collection.

chology of the demonic, the fascination of the negative. Although the negative can never be a temptation in itself, it has a fascination. We look at it not only in terms of something of which we are horrified but as something which also has fascination and attractiveness. Everybody will psychologically confirm that gruesome stories have their fascination. It is a fact that is very hard to interpret. But there is no doubt that we can see or read every morning in the *New York Times,* or in other newspapers, stories which are sensationally destructive, negative, horrifying, cruel, gruesome, yet fascinating. A whole literature of the demonic has a demonic fascination in it. Now what is the reason for the demonic fascination? It is hard to give an answer. I have the impression that those whose life is on the surface need the demonic fascination, at least in imagination, in order to overcome the boredom of surface goodness or of a normally well-regulated life. In a less profound way, this is perhaps one of the reasons for adventure stories, and certainly is the motive for many of the comics and similar literature. Fascination exists because something is lacking in life. I recall the *Three Penny Opera* by Brecht and Kurt Weill, in which men sit around after sunset in a midwestern, American city but they always say, something is missing; everything is beautiful but something is missing; and something is so much missing that they say, "Johnny might eat his own hat" because he has nothing better to do.

This is the situation out of which the fascination of the demonic is born. But probably there are profounder elements in it. I only want to say that one of Picasso's studies for *Guernica* [plate 43] has the fascination of the demonic. Here I must say a few words about Picasso's *Guernica* [plate 44] because I have been attacked by my friend Reinhold Niebuhr about it. He noticed in my NBC television performance that I had said, in a context which was badly shortened, that I consider this the most Protestant picture in modern times, because it radically shows the destructiveness of life, is honest about it, is near to a prophetic description of the time. Niebuhr was certainly right when he said that this is not the whole of Protestantism. Protestantism also has an answer, not only a question. And I would consider the *Head of Christ* by Rouault, which I showed you before, as a possible answer. What *Guernica* represents has to be understood, not only to understand modern art and its expression of the disruptiveness of reality, but also in order to understand the Protestant judgment on everything which belongs to our ordinary ways of life, even to our good ways of life. The divine is a judgment even on the best of Protestantism, and this is what I wanted to express; I think that has been superbly expressed by Picasso.

There is another point about the psychology of the demonic, the expression of anxiety. The demonic produces individual and collective anx-

iety. In Goya's etchings we have an anticipation of the Napoleonic wars. We have seen one picture of what happened in these wars, and we have other visionaries like this who anticipated the anxiety of the historical catastrophes, among them the expressionist painters of the first decade of the twentieth century. One of them, Munch, more than Goya, paints pure anxiety. Anxiety is the fundamental reality of these pictures and the human beings are only its bearers. He calls the lithograph *Anxiety* [plate 32] and he is right to do so. It stems from the same time as the philosophy of anxiety, that is, when theology, philosophy, and depth psychology won power in Europe. It was the anticipation of the inability of Europe to continue as it had and it exhibited the unconscious intention to destroy itself. Such pictures show the anxious anticipation of the demonic, which has a kind of prophetic character in Goya where it is represented in lonely individuals, and here in Munch where the whole collective society, where all Europeans so to speak, suddenly came under the power of anxiety.

The Belgian painter, James Ensor's art, like Munch's, manifests a sense of anxiety. In his print *Demons Tormenting Me* [*Self-Portrait with Demons* (plate 37)], he represents himself surrounded by invading demons. You see how much his anxiety is near to his being possessed and to his will to persecute those who are possessed.

Now I come to my last section, the theology of the demonic. An interesting part of the theology of the demonic is its imitation of the divine. Blasphemous imitations of the divine are extreme expressions of the demonic, things like witch sabbaths or black masses, where the divine realities, the bread and wine in the Mass, are turned into their opposite and used as expression of dirt and the lowest form of human vitality. Even such art shows that the demonic does not have the imagination to create in and of itself. Even in the religious realm, the Antichrist is an imitation of the Christ, a distorting and blasphemous imitation which is ontologically not original. This is proof for the fundamental Christian statement that the world is created by God and not by two gods, one evil and one good; that the world in its essence is good and that the evil is the distortion of the good, on the basis of the individual self-elevation and separation from God.

Let us finish with Fra Angelico, the most heavenly of all the painters in the Western world. In his *Last Judgment* in San Marco [plate 7], we see the predominance of the divine, and the demonic is, as the fire indicates, left to self-destruction. Fire lives only as long as it has something which is to be burned. The fire of the demonic goes out if there is not that goodness of which it is the distortion. In this context, the answer is given in terms of salvation from the demonic, and all the colors of the earth are

used in order to paint that which is beyond the earth. But since distortion has been eliminated in the midst of beauty, it is less convincing than the painting of the demonic.

The older painters used gold because gold is the transcendent color, the color which is not real color. Fra Angelico, in addition to gold, also uses the beautiful earthy colors which one finds in the dresses of the Venetians and the Florentine ladies of the time. He uses that combination to describe eternal blessedness; but the eternal is not like that, so the question remains, can human minds ever express more than the demonic and the fight between the divine and the demonic? Can they go beyond this? Perhaps the answer cannot be found in the realm of the visual arts.

Question Period

DEAN ANDERSON: Professor Tillich has kindly consented to answer a few questions. Who wants to be the first?

QUESTION: Are you equating the demonic with anxiety? Are they one and the same?

TILLICH: No, the demonic is a structure of life; anxiety is an element in this structure. But there are many other elements: hostility, cruelty, aggressiveness, and anxiety. But there is also anxiety which does not have the structure of the demonic. Every human being has anxiety without being a bearer of the structure of the demonic. So I would not identify anxiety and the demonic.

QUESTION: Would you think that the nonobjective, abstract art, would be able to create a new language where nonreality is concerned and with an entirely new way of expressing content?

TILLICH: The question is: Do you believe that abstract art will be able to paint the transcendent, the fulfillment, the blessedness better than figural art can? While you were speaking I was mentally in Chartres [plate 62] and looked at the stained-glass windows of the cathedral and thought about your question. And my answer is: to the degree in which these windows are not figurative—the figures are so small that you cannot distinguish them as figures—they have the power to mediate the feeling of transcendent blessedness. I indicated a similar idea with respect to the gold ground. I felt that very much in the baptistry of Ravenna, where the gold background gives you the feeling that you are really in transcendence, because there is no special object which is beautified, as is the case in Fra Angelico's pictures. But Fra Angelico, after all, was a Renaissance painter.

QUESTION: Would you comment in the same respect with Eastern art as opposed to Western art, where the division might be made between religious expression and liturgical expression?

TILLICH: In Eastern art I do not remember seeing much of the demonic. In Eastern art we have icons [plate 5], about which I learned from my colleague, Father [Georges] Florovsky, who was a Greek Orthodox theologian at Union Seminary and is now at Harvard. He maintained that the whole Western Catholic painting is a fall from the Eastern understanding of painting in terms of the icons. The icons are not pictures; they are bearers of religious substance. And in the Western world, long before Protestantism and its iconoclastic destruction of pictures, paintings became figures of finite things, of human beings, and so on, and in this context they must be considered as having less religious power than the Eastern icons.

QUESTION: How would you, Dr. Tillich, relate what you have said this afternoon on demonology to the Christian doctrine of depravity?

TILLICH: The word *depravity* comes from Calvin, but has been renewed by neoorthodox theologians. Now what does the word mean? Total depravity does not mean that man is totally depraved. It means that there is no special section of man in which the power of depravity is not present. The question was asked, whether human reason or, as the mystics called it, the spark in man, the divine scintilla, is beyond the state of distortion. The Reformers said there is no such unspoiled thing in man. Neither his highest possibilities nor his lowest are without the influence of the general demonic state of reality. But this also had another side, the salvation of the lower faculties of man, namely, his vitality. Vitality is not bad in itself, but it is distorted. So in the doctrine of total depravity, we have, on the one hand, the criticism of the higher faculties of man. They are also under the law of depravation. And on the other hand, we have the salvation of the so-called "lower" faculties of man, namely, all his vital faculties, which in principle are accepted in spite of this general universal law of depravation.

QUESTION: Dr. Tillich, do I remember correctly that two years ago when you lectured here on existentialism in modern visual art you hesitated to class Georges Rouault in your fourth classification. [The fourth category of relationship between art and religion is religious subject matter and religious style.] In connection with that, in your catalogue introduction to the exhibit you said that Georges Rouault was an authentic religious painter. I find it hard to reconcile this.

TILLICH: Perhaps I cannot reconcile it myself. I had the same experience two weeks ago when I had to give an introductory speech in a church in

Cambridge, Massachusetts, where the minister had brought together a collection of Rouault's, especially of the *Miserere* series, and I made the statement to which you referred first. I am ordinarily more convinced by Rouault when he is a secular painter, especially of the ugly, than when he paints pictures of Christ. I also indicated in my comments today I am skeptical of the possibility of suggesting that this approach is the way in which the Christian symbols can be recaptured today. This may mean that there is no other way today; if there is a way, then Rouault is certainly far ahead of most of the others. Perhaps [Emil] Nolde in Germany is on the same plane, but otherwise there is almost nothing. The *Head of Christ* [plate 49] is outstanding among Rouault's own work, and is not finished. It is sketchy, and perhaps for this very reason it has much more power than the stained-glass window types of the Christ Rouault often does. So I do not know whether I have made myself consistent; but I do not want to, because about Rouault's religious picture I feel inconsistent.

QUESTION: Dr. Tillich, within recent years a modern poet and painter made the statement that art, music, and poetry are the only means of communication left to man with the eternal. Would you care to comment on that?

TILLICH: This is an ambiguous statement. First of all, if you say "only," you always must put a question mark to such a statement. But there is more involved. Take, as an example, the Bach *Passion* of St. Matthew and look at the people who go to hear it, mostly people from Park Avenue. The church is on Park Avenue and the choir is excellent, and costs a lot of money, and it is hard to get a ticket. Now if you do get in, you are able to analyze the reactions on the faces of the listeners. One finds two types, and perhaps many transitions, as always in life. The one type goes to the event as a religious service and is moved by the music. The music is intentionally related for such people to the religious meaning of the last week of Lent. These who experience Bach in this way are probably not those who are able fully to judge the musical side. Then there are the others who judge the performances and the perfections of the choir and the singers, and of Bach himself as a composer. They remain in the musical realm. Now in this musical realm there is much which transcends ordinary reality, but the question is whether it transcends the preliminary concerns for the sake of ultimate concern. The question is, whether these people are moved by the music to ask the question of their own lives in an ultimate sense. If not, they remain in the aesthetic realm. In this aesthetic realm something of the ultimate is indirectly communicated but it remains indirect. They do not penetrate to the meaning this music had for Bach, and which it should have if it is performed in the context of

Lent. Art as such, whether liturgical or not, whether dealing with religious subject matter or not, penetrates the subject-object reality in which we are living; but whether it penetrates ultimate reality is another question. One of the criteria that indicates something has been penetrated is that the meaning of one's total existence is involved, not only one's aesthetic existence. I remember a poem by Rainer Maria Rilke in which he spoke about a torso of an archaic Apollo and said that whenever he looked at it, it said to him "Change thy life." Now if this is experienced, the aesthetic experience is transformed; then the aesthetic has become a matter of ultimate concern and that means a religious experience has occurred.

QUESTION: [Question not clear, but it has to do with love and the demonic.]

TILLICH: Does God act directly if somebody has surrendered himself to demonic structures which are present in all of us to some extent? The Christian doctrine threatens that God's wrath is omnipresent and that ultimate judgment will occur. Now what does this punishment mean? We must ask what does this symbol mean? Does it mean that an angry man in heaven sometimes will say, "I let you run your ways now, but wait a moment, and this moment may be a few thousand years and after this, I will show you." Now against this kind of nonsensical, nonontological literalism, we should understand the meaning of concepts like the wrath of God, not as something God additionally does, but as a reality which is implied in his love. Love implies the destruction of that which is against love, not the destruction of him who acts against love. Love always tries to save him who acts against love; love destroys the structures of that which is against love. Since these structures are connected with persons and communities, persons and communities are disrupted by surrendering to the demonic, as we can see every day. I referred to the possibility of overcoming structures of the demonic and of evil by structures of grace, structures of the destruction by structures of creativity. These are always active in everyone; but this fight is not a fight in which God could interfere and say, "I want the divine to be victorious; let's eradicate the demonic." Then God would be transforming men into what our society transforms him into, a mechanism, an object, something which is determined. Then love would not exist, because love is only possible where one can refuse to love. Only then is one able to love.

QUESTION: Dr. Tillich, I enjoyed your phrase "anticipatory reconciliation" and I wondered in the case of Goya whether you might detect any of this in his artistic purposes or whether it would be present unconsciously or at all.

TILLICH: My first reaction is that I do not see it in him, except in the beautiful form which he is able to give to the horrors of life. The reconciling character in him cannot be seen in any way in the content, as for example, is the case in Fra Angelico. It can only be seen in the fact that even the ugly can be brought into a form of beauty. But this is another form. If he is a great artist, then I would say his artistic power is able to make an artistic reconciliation, but not in terms of the subject matter itself. That is what I feel, though I do not know his whole work well enough to make a definite statement.

QUESTION: If visual art is not able fully to explain the demonic, what area can we count on the most for that explanation?

TILLICH: Oh, I did not say that. I said that visual arts can wonderfully explain the demonic, perhaps not so good the divine.

QUESTION: I mean the difference in the man. He has the demonic popping out, but he does not know what to do with the divine in itself.

TILLICH: That one often experiences. Man is able to describe the situation of being under the control of the destructive forces more than under the creative. Everybody has said that Dante's hell is fascinating reading. Dante's heaven is as boring as heaven itself. Why is this so? This is a fact that cannot be completely denied, and in some sentimental novels, we find the same thing. The good people, who always are victorious against the evil-doers—such soap opera is not even art. Why is it so difficult to express a victorious positive? Why are there so many, innumerable great pictures of the Crucifixion and so very few—I know only one—of the Resurrection, namely, *The Resurrection* by Mathias Grünewald. Why is this so? It is because Mathias Grünewald is able to show the Resurrection as a transformation of the finite into the infinite, symbolized by the sun in which the body of Christ disappears. Now this is a tremendous insight. Very often in the Resurrection pictures, Christ simply returns into the world of bodies, trees, souls, and other human beings and talks with them, as if nothing had happened before. Now this is not Resurrection.

QUESTION: Dr. Tillich, I think I asked my question about Goya in the wrong way. If we put it in terms of a negative-positive contribution, do we say that Goya's contribution artistically is negative or what is there in it that is positive?

TILLICH: The contribution is positive. He is almost an expressionist realist, a realist with a very radical point of view, without becoming naturalistic. So I would say that it is good that our century has rediscovered him and values him so highly. It is a kind of painting in which the disruptiveness of reality is disclosed through the ordinary means of his time; but it is so superior that it is not a repetitious, repeating naturalism, which is

ugly instead of beautiful. Even if it were only ugly, like Zola's novels, I would prefer that to the beautifying naturalism of most Christ pictures of the nineteenth century. It is not simply naturalism; there is much expressionism in it. And I think this is a great contribution.

11

Protestantism and Artistic Style

This provides a succinct analysis of the relation of subject matter, form, and style in understanding art, together with an account of why the expressive style in different periods of history is closer to the religious dimension than other styles.

PICASSO'S *Guernica* [plate 44] is a great Protestant painting. Of course, this statement must be qualified by saying that it is not the Protestant answer, but rather the radicalism of the Protestant question which one can find in Picasso's masterpiece. It is to this assertion that the following chapter is directed.

First, something must be said about the particular character of the Protestant understanding of man and his predicament. The Protestant principle (which is not always effective in the preaching and teaching of the Protestant churches) emphasizes the infinite distance between God and man. It emphasizes man's finitude, his subjection to death, but above all, his estrangement from his true being and his bondage to demonic forces—forces of self-destruction. Man's inability to liberate himself from this bondage has led the Reformers to the doctrine of a reunion with God in which God alone acts and man only receives. Such receiving, of course, is not possible in an attitude of passivity, but it demands the highest courage, namely the courage to accept the paradox that "the sinner is justified," that it is man in anxiety, guilt, and despair who is the object of God's unconditional acceptance.

"Protestantism and Artistic Style" was published in *The Christian Scholar* 40, no. 4 (December 1957). It later appeared in Tillich's *Theology of Culture*, ed. Robert C. Kimball (New York: Oxford University Press, 1959), pp. 68-75, from which it is reprinted here with permission.

If we consider Picasso's *Guernica* as an example—perhaps *the* out-standing one—of an artistic expression of the human predicament in our period, its negative-Protestant character is obvious. The question of man in a world of guilt, anxiety, and despair is put before us with tremendous power. But it is not the subject matter—the willful and brutal destruction of a small town by Fascist airplanes—which gives the picture its expressive force; rather, it is its style. In spite of profound differences between the individual artists and between the different periods in the development of Picasso himself, this style is characteristic for the twentieth century and, in this sense, it is contemporaneous with us. A comparison of any important creation within this period with equally important creations of any earlier period shows the stylistic unity of the visual arts in the twentieth century. And this style, as no other one during the history of Protestantism, is able to express the human situation as Christianity sees it.

In order to verify this assertion, it is necessary to discuss the relation of artistic styles to religion generally. Every work of art shows three elements; subject matter, form, style. The subject matter is potentially identical with everything which can be received by the human mind in sensory images. It is in no way limited by other qualities like good or bad, beautiful or ugly, whole or broken, human or inhuman, divine or demonic. But not every subject matter is used by every artist or artistic period. There are principles of selection dependent on form and style, the second and third elements of a work of art.

The second element is a concept which is not an ordinary one. It belongs to the structural elements of being itself and can be understood only as that which makes a thing what it is. It gives a thing its uniqueness and universality, its special place within the whole of being, its expressive power. Artistic creation is determined by the form which uses particular materials such as sounds, words, stones, colors and elevates them to a work which stands on its own. For this reason, the form is the ontologically decisive element in every artistic creation—as in any other creation. But the form itself is qualified by the third element which we call style. This term, first used to describe changing fashions in clothing, houses, gardens, etc., has been applied to the realm of artistic production universally and has even been used in relation to philosophy, politics, etc. The style qualifies the many creations of a period in a unique way. It is due to their form that they are creations. It is due to their style that they have something in common.

The problem of style is one of finding what it is that these creations of the same style have in common. To what do they all point? Deriving my answer from many analyses of style, both in art and philosophy, I would

say that every style points to a self-interpretation of man, thus answering the question of the ultimate meaning of life. Whatever the subject matter which an artist chooses, however strong or weak his artistic form, he cannot help but betray by his style his own ultimate concern, as well as that of his group, and his period. He cannot escape religion even if he rejects religion, for religion is the state of being ultimately concerned. And in every style the ultimate concern of a human group or period is manifest. It is one of the most fascinating tasks to decipher the religious meaning of styles of the past such as the archaic, the classic, the naturalistic, and to discover that the same characteristics which one discovered in an artistic creation can also be found in the literature, philosophy, and morals of a period.

The deciphering of a style is an art in itself and, like every art, is a matter of daring and risk. Styles have been contrasted with each other in several respects. If one looks at the series of styles in the visual arts in Western history after the beginnings of a Christian art in catacombs and basilicas, one is overwhelmed by its richness and variety: the Byzantine, the Romanesque, the early and late Gothic styles precede the Renaissance in which the early and the high Renaissance styles must be distinguished. Mannerism, Baroque, Rococo, Classicism, Romanticism, Naturalism, Impressionism, Expressionism, Cubism, Surrealism lead to the contemporary non-representative style. Each of them says something about the period in which they were flourishing. In each of them a self-interpretation of man is indicated, although in most cases the artists were not aware of such interpretation. Sometimes they knew what they expressed. And sometimes philosophers and art critics made them aware of it. What then are the keys which aid in deciphering the meaning of these styles?

In a famous analysis of philosophical styles, the German philosopher, Dilthey, distinguished subjective idealism, objective idealism, and realism. In this way he gave four stylistic keys which can immediately be applied to the visual arts: idealistic, realistic, subjective, objective. Every work of art contains elements of all four, but is under the predominance of one or more of them. When in the beginning of this century the predominance of the classicist style was broken and the aesthetic value of the Gothic style became visible, other keys were discovered. With the rise of Expressionism the fundamental contrast of the imitating and the expressive element became decisive for the analysis of many past and present styles, especially for the understanding of primitive art. Further, one can distinguish monumental and idyllic, particularizing and abstracting, organic and inorganic stylistic elements. Finally, one can point to the continuous struggle between academic and revolutionary tendencies in artistic creation.

It would be a useless schematization if one tried to arrange these elements into an embracing system. But one thing must be said about all of them: They are never completely absent in any particular work of art. This is impossible because the structure of a work of art as a work of art demands the presence of all elements which provide the keys for the deciphering of a style. Since a work of art is the work of an artist, the subjective element is always present. Since he uses materials found in ordinarily encountered reality, the imitating element is unavoidable. Since he comes from a tradition and cannot escape it even if he revolts against it, an academic element is always present. Since he transforms reality by the very fact that he creates a work of art, an idealistic element is effective. And if he wants to express an original encounter with reality below its surface, he uses expressive elements. But in the process of artistic creativity some elements are suppressed to a point where it is difficult to recognize them. This difficulty usually results from a combination of stylistic elements, and makes the analysis of styles fruitful and fascinating.

We must now ask the question: What is the relation of these style-determining elements to religion generally and especially to Protestantism? Are certain styles more able to express religious subject matter than others? Are certain styles essentially religious and others essentially secular? The first answer must be that there is no style which excludes the artistic expression of man's ultimate concern, for the ultimate is not bound to any special form of things or experiences. It is present and may be absent in any situation. But the ways in which it is present are manifold. It can be present indirectly as the hidden ground of a situation. It shines through a landscape or a portrait or a human scene and gives them the depth of meaning. In this way a style in which the imitating element is predominant is religious in substance. The ultimate is present in experiences in which not only the reality is experienced, but the encounter itself with reality. It is hiddenly present in the state of being grasped by the power of being and meaning in reality. This gives religious significance to the stylistic element of subjectivity and to styles in which it is predominant. And the ultimate is present in those encounters with reality in which the potential perfection of reality is anticipated and artistically expressed. This shows that a style in which the idealistic element is predominant is religious in substance. The ultimate is also present in those experiences of reality in which its negative, ugly, and self-destructive side is encountered. It is present as the divine-demonic and judging background of everything that is. This gives the realistic element in artistic styles its religious significance.

These examples could be increased by pointing to the religious significance of the other elements in artistic styles. But instead of doing so, let

us look at the expressive element in a style, for it has a special relation to religion.

First, it must be said generally that there are definite adequacies and inadequacies between style and subject matter. This has the consequence that the preferred material varies with the predominance of one stylistic element or a combination of them, and it gives importance to iconography for the analysis of the meaning of styles. For example, one must look for the adequacy of special stylistic elements in portraits, still-lifes, landscapes, human scenes, nude bodies, historical events, etc. We must restrict ourselves to the affinity of the expressive style to religion. It shares the general religious significance of all stylistic elements. But while the others are only indirectly representing the ultimate, the expressive element represents it directly. Of course, it usually does not appear alone in a work of art, and other elements may counterbalance its directly religious potentialities. But in itself it is essentially adequate to express religious meaning directly, both through the medium of secular and through the medium of traditional religious subject matter.

The reason for this situation is easy to find. The expressive element in a style implies a radical transformation of the ordinarily encountered reality by using elements of it in a way which does not exist in the ordinarily encountered reality. Expression disrupts the naturally given appearance of things. Certainly, they are united in the artistic form, but not in a way which the imitating or the idealistic or even the realistic element would demand. On the other hand, that which is expressed is not the subjectivity of the artist in the sense of the subjective element which is predominant in Impressionism and Romanticism. That which is expressed is the "dimension of depth," in the encountered reality, the ground and abyss in which everything is rooted.

This explains two important facts: the dominance of the expressive element in the style of all periods in which great religious art has been created and the directly religious effect of a style which is under the predominance of the expressive element, even if no material from any of the religious traditions is used. If this situation is compared with those periods in which the expressive element was prevented from becoming effective, one finds a definite difference. In styles which were under the control of non-expressive elements, the religious art deteriorated (as for instance in the last period of Western history) and the secular subject matter was hiding its religious background up to the point at which it became unrecognizable. Therefore, the rediscovery of the expressive element in art since about 1900 is a decisive event for the relation of religion and the visual arts. It has made religious art again possible.

This does not mean that we already have a great religious art. We do

not have it either in terms of general religious art nor in terms of artistic creations suitable for devotional purposes. An exception to this judgment is recent church architecture in which a new beginning has been made permitting high expectations for future development. Architecture is the basic artistic expression, just because it is not only art but because it serves a practical purpose. It is quite probable that the renewal of religious art will start in co-operation with architecture.

If we look at painting and sculpture, we find that under the predominance of the expressive style in the last fifty years, the attempts to recreate religious art have led mostly to a rediscovery of the symbols in which the negativity of man's predicament is expressed: The symbol of the Cross has become the subject matter of many works of art—often in the style which is represented by Picasso's *Guernica.* Symbols, such as resurrection, have not yet found any adequate artistic representation, and so it is with the other traditional "symbols of glory." This is the Protestant element in the present situation: No premature solutions should be tried; rather, the human situation in its conflicts should be expressed courageously. If it is expressed, it is already transcended: He who can bear and express guilt shows that he already knows about "acceptance-in-spite-of." He who can bear and express meaninglessness shows that he experiences meaning within his desert of meaninglessness.

The predominance of the expressive style in contemporary art is a chance for the rebirth of religious art. Not each of the varieties of this style is equally adequate to express religious symbols. But most of them definitely are. Whether, and to what degree, the artists (and the churches) will use this opportunity cannot be anticipated. It is partly dependent on the destiny of the traditional religious symbols themselves in their development during the next decades. The only thing we can do is to keep ourselves open for a new rise of religious art through the expressive style in the art of today.[1]

1. Similar views of Expressionism are already evident in Tillich's "On the Idea of a Theology of Culture" (1919), in *What Is Religion?* trans. James Luther Adams (San Francisco: Harper & Row, 1969), pp. 169–70. There Tillich wrote,

> I begin with a cultural-theological consideration of art—to be precise, with the Expressionist school of art in painting, because it seems to me to offer a particularly impressive example of the above-mentioned relation between form and substance; and because these definitions were worked out partly under its influence.
>
> To start with, it is clear that in Expressionism content has to a very great extent lost its significance, namely content in the sense of the external factuality of objects and events. Nature has been robbed of her external appearance; her uttermost depth is visible. But, according to Schelling, horror dwells in the depths of every living creature; and this horror seizes us from the work of the Expressionist painters, who

aim at more than mere destruction of the form in favor of the fullest, most vital and flourishing life within, as Simmel thinks. In their work a form-shattering religious import is struggling to find form, a paradox that most people find incomprehensible and annoying; and this horror seems to me to be deepened by a feeling of guilt, not in the properly ethical sense, but rather in the cosmic sense of the guilt of sheer existence. Redemption, however, is the transition of one individual existence into the other, the wiping out of individual distinction, the mysticism of love achieving union with all living things.

This art therefore expresses the profoundest No and Yes; but the No, the form-destroying element, seems to me still to be predominant, although this is not what the artists, with their passionate will toward a new and absolute Yes, intend.

Many of the remarks made by these artists confirm the existence of a strong religious passion struggling for expression. It is no accident that in the lively debates carried on about these pictures, the enthusiastic representatives of Expressionism make constant references to philosophy and religion and even to the Bible itself. The religious meaning of this art is to a large extent consciously affirmed by its representatives.

12

Contemporary Visual Arts and the
Revelatory Character of Style

This lecture, given at the Philosophy Club at Columbia in 1958, centers on style in the visual arts, naturalistic, idealistic, and expressive, with particular attention to the latter. Given among friends with whom Tillich had previously worked at Columbia, the lecture is carefully crafted with his listeners in mind.

Form, Subject Matter, and Style

MAY I REPORT at the beginning, that my courage to deal with the announced subject is largely due to the encouragements given to me by Mr. [Albert] Hofstaedter and Mr. [John E.] Smith and—if I rightly remember—by Mr. [Charles] Hendel. As a nonexpert in the history and valuation of the visual arts, I certainly needed such encouragement, as I need indulgence, not for what I am going to say but for the fact that I say it.

The visual arts became my hobby in the trenches of the First World War as an antidote against the enormous ugliness of life near the front. But soon they became for me a realm of human creativity from which I derived categories both for my philosophical and my theological thought. Beyond this I used, in my early lectures on the history of the philosophy of religion, analogies in the visual arts to illuminate the character of philosophical concepts. It may be of anecdotal interest to you that in these years, the early twenties, the German republic had created a

The text for "Contemporary Visual Arts and the Revelatory Character of Style" is in Tillich's handwriting in the Tillich Archives at the Andover-Harvard Library, The Divinity School, Harvard University.

museum of modern art opposite the University of Berlin, and during my lectures I saw fist fights going on between the intelligentsia who supported modern art and the petty bourgeoisie, the future supporters of Nazism, who already in 1920 considered modern art as degenerate.[1] In this atmosphere the following ideas were first conceived.

In all human creativity, whether we call it cultural or spiritual (with a small *s*), the form is that which makes a creation what it is. It is the logical-methodological form which distinguishes a scientific creation from science-fictional imaginations, or a philosophical essay from a crackpot solution of the riddle of the world. It is the aesthetic form which distinguishes a work of art from an oil print of Wilhelm II or a puppetlike statue of the holy Joseph. I want to emphasize the significance of the form, because I intend to speak of the style which is a special qualification of the form. Therefore I repeat, it is the form and not the style (and even less the content) which makes a creation of man's spiritual life into what it is. The importance of the form is conversely proportional to our ability to define it. It seems to me—and I believe that is good Aristotelian teaching—that it cannot be defined at all, because it belongs to those ultimate concepts which are presupposed in every definition. In any case, I shall not try to give a definition.

The second element in all cultural creativity is the subject matter, formed by the form. In the aesthetic realm, there is no limitation to subject matter. Every encountered reality can become the subject matter for an aesthetic art. Whether good or bad, useful or destructive, beautiful or ugly, the artistic act can give it an artistic form and elevate it into a work of art. The really degenerate art is beautifying naturalism which shies

1. In *The Courage to Be* (New Haven: Yale University Press, 1952), pp. 147–48, Tillich wrote as follows on this issue.

Modern art has been attacked as a forerunner of totalitarian sytems. The answer that all totalitarian systems have started their careers by attacking modern art is insufficient, for one could say that the totalitarian systems fought modern art just because they tried to resist the meaninglessness expressed in it. The real answer lies deeper. Modern art is not propaganda but revelation. It shows that the reality of our existence is as it is. It does not cover up the reality in which we are living. The question therefore is this: Is the revelation of a situation propaganda for it? If this were the case all art would have to become dishonest beautification. The art propagated by both totalitarianism and democratic conformism is dishonest beautification. It is an idealized naturalism which is preferred because it removes every danger of art becoming critical and revolutionary. The creators of modern art have been able to see the meaninglessness of our existence; they participated in its despair. At the same time they have had the courage to face it and to express it in their pictures and sculptures. They had the courage to be as themselves.

away from the ugly as subject matter. But although there is no limit to the choice of subject matter, artists always have chosen, according to the affinity with their style, the subject matter they prefer. They have preferred human events or portraits or landscapes or still lifes or living organisms or religious symbols. Their preferences were determined by their style.

The third element in all cultural activity is the style. Style is derived from *stilus*, pencil, the tool necessary for writing, and from there the way of writing, its special character. To write without a style means to write without a particular character. From writing the term was transferred to the changing styles of fashions, and from there to the aesthetic forms in general. But the imperialism of the term did not stop here. One spoke of a philosophical style (including the philosophical presuppositions of science); one spoke of the ethical style of a special period, for example, the present-day American suburban life; one even spoke of the style of politics, for example, of the British balance of power politics in the nineteenth century. This extensive application of the term *style* is justified if it does not prevent an understanding of the decisive importance of form in all the branches of man's cultural creativity. There is always the danger that a preoccupation with style—especially with contemporaneous style—may soften the criticism of the form. The revelatory character which I intend to attribute to style can overshadow the fact that every style gives to the form a particular quality, a direction, which is, so to speak, an overarching form, a form of forms. But in order to have a form of forms one must first have a form. A poor picture in modern style may show characteristics of this style, but it is not a work of art, just as a poor philosophical essay in a naturalistic style may use naturalist terminology but is not a philosophical creation. The validity of a work of art as a work of art always precedes its power of revealing meaning.

Basic Stylistic Possibilities and Their Interpretation

Style is that element of a work of art which qualifies its particular form by a more universal form principle—is present in the style of whole periods, of continents and countries, of artistic schools, of the development of individual artists. But I would hesitate to speak of the particular style of a particular work of art, except in cases where this work has brought to light stylistic potentialities which could have become the style of a school of a period.

In speaking of the revelatory character of style, I am using what originally was a religious symbol, God appearing to man, which first became a theological concept, and later a concept applied to experiences which

show some analogy with the sudden, unexpected, grasping character of what theology describes as revelatory experiences. Although in my *Systematic Theology* I warned against such analogous uses of the term *revelation*, I intend here to disregard this warning and use the term because I believe that a style brings to light something which in no other way can be grasped by us or—more precisely—grasps us than through the style. So I beg you, as well as myself, to excuse this appearance of religious language in the context of an aesthetic analysis.

If we now ask, what is revealed by a style, the answer may be an encounter of man with his world, in which the whole man in all dimensions of his being is involved. The content of such an encounter is both hidden and manifest. It is hidden, insofar as it cannot be expressed in a direct way. Neither ordinary nor methodologically disciplined language can inform us, or even those who experienced the encounter, about what happened in it. But in the style of the cultural creations which are born out of the encounter, something about its content is manifest. Instead of speaking of the encounter of man with his world—a spatial metaphor—one can also speak of experiences in which an answer to the question of the meaning of existence impressed itself on human beings in the totality of their being, individually and socially. That which impressed itself in such experiences was then expressed in the style of their cultural creations, most directly in the artistic creations.

Under the circumstances, in all realms of culture the intellectual historian has the task to decipher the styles of periods, countries, schools, persons, and this task is absolutely necessary if one wants to understand and to make understandable the creative work of past periods or of one's own time. Deciphering demands keys. I am going to distinguish four kinds of keys or approaches to the meaning of style, the first one quite external, the second one less so, the third one internal, and the fourth quite internal.

The most external approach is an inquiry into the general historical conditions of the group or the particular biographical conditions of the individual whose style is to be interpreted. The key must always be used as far as it goes. But there are limits in our historical and biographical knowledge which prevent a major use of this key in important cases, as, for example, in Homer or Shakespeare. This, however, is not a disadvantage, for it safeguards against a too easy sociological derivation of the style of a period or a person.

Less external and often very revealing is the second key, the comparison of the style of one cultural function with that of another one in the same period and in the same country. I do not believe that it is possible to decipher the style of the Pre-Socratic kind of thinking and speaking without reference to the archaic style in the sculpture and architecture

of their time, and, of course, vice versa. Without the knowledge of Parmenides' doctrine of being as "a well-rounded sphere," a decisive element in the style of the temples in Paestum would have escaped me. The analogy between the remnants of the naturalistic period of Hellenistic sculpture and the philosophy of the Epicurean school helps to understand both. And the same is true of the archaistic revival of the archaic style in the religious period of late Greek philosophy. And how could one understand medieval philosophy and theology without pilgrimages to Chartres and similar places?

The third, more internal key to an artistic style is its relation to the subject matter it prefers. In principle, as indicated before, every subject matter can become material for an artistic form. Actually, however, choices take place and affinities to a style become decisive. It characterizes the Gothic style that it preferred divine-human scenes in which nature remains in the background—although it appears in contrast to the Byzantine gold ground, so to speak, the transcendent color. And it characterizes the Renaissance style that human figures, portraits or imaginary ones, standing in the middle of nature, are now chosen. And it characterizes, as we shall see, the contemporary style, that the potentialities of the inorganic realm are elaborated, often exclusively so.

But there is the fourth and most internal key, the direct approach, for which the three others are preparations. It is the interpretation of those qualities of a work of art which characterize its style in contrast to other stylistic possibilities. In attempting this, one must be aware of the fact that it cannot be done without considerable risk. The deciphering of artistic styles is itself an art. One may succeed; one may fail. And in the moment in which one tries to conceptualize one's findings, one can hardly escape some tour de force. But perhaps this is the destiny of all conceptualization of life. And something must be said for a conceptual approach to works of art and especially to their styles. Although it is impossible to express in cognitive form what is expressed in artistic form, it is possible and often necessary to be guided by concepts to the point where concepts can be dismissed and immediate participation in the work of art can begin. Without such a conceptual introduction into modern art, which I got long ago from an art historian and critic, this paper would not have been written. Nevertheless, decisive for my relation to the visual arts was a kind of inspirational experience in face of a painting by Botticelli [plate 1].[2]

If I now try to distinguish three stylistic types in the visual arts, I am

2. For an account of this experience, see "One Moment of Beauty," chap. 23 of this collection.

conscious of the fact that the infinite variety of styles forbids the identification of one of the three types with any one in this large list. But it seems to me that there are elements in the nature of every artistic creation which make a useful typology possible.

In every work of the visual arts the material is taken from the ordinarily or methodologically encountered reality. Even the most fantastic or the most abstract paintings or sculptures use elements of average experience—bodies, movements, lines, colors. [While] this average experience may be enlarged by the scientific penetration into the subsurface anatomy of things, it still remains based on the direct encounter with naturally given objects. I prefer to call this stylistic type naturalistic. One could call it imitative, but this would produce the completely false connotation that any work of art could be an imitation. One could call it the realistic style and this has been done. But the term *realistic* has been used predominantly of a style which can be called "critical naturalism" and which often expresses social-revolutionary tendencies. Therefore it seems to me that the term *naturalistic* is most adequate to this stylistic type.

Contrasted with it is usually the idealistic type of style. This is partly justified, for the idealistic style is not bound to the encountered reality. It tries to bring out the potentialities which are real in a being or a situation, but not yet or never actual. In the work of art this actualization is, so to speak, anticipated. The idealistic style is anticipatory, as the naturalistic style is accepting. One should not confuse the idealistic style with attempts to idealize a beautiful reality. Idealistic style does not beautify, but it brings into the open the potential perfection and beauty in persons and things which in existence are indifferent or distorted. This statement is a protest both against the snobbish despising of genuine idealism and against the defense of a dishonest beautifying naturalism, which is the curse of the last hundred years of religious art. The stylistic type which we call idealism is a genuine and necessary element in every work of the visual arts. It is actually present in naturalism, as naturalistic elements are present in idealism, and as both are present in the third stylistic type, the expressive style. The difference in all three cases is the difference in the predominance of one of these elements.

The third stylistic type I want to distinguish is the expressive style. This term needs justification in two directions. First, one may ask why I do not speak of expressionistic against naturalistic and idealistic styles. The answer is, because the word *expressionism* has been tied up with an artistic movement in the first decade of this century in Dresden, Germany. But the stylistic type of which I am speaking here is the most widespread one. It is the style of primitives, of the Asiatic, the later ancient,

the medieval cultures. It is open to endless variations, and has returned to us since the year 1900.

It is so widespread because in some sense every work of art is expressive and because it always includes naturalistic and idealistic elements. Nevertheless it must be treated as a type beside the two others, because they can become and have become independent and have largely removed the expressive element.

The question now arises: What is expressed in the expressive style? The first answer must be a negative one: not the artist in his subjectivity. An artist who expresses only himself is like an adolescent who writes sentimental verses, without artistic validity. But the real artist expresses what he encounters in dimensions of reality which cannot be expressed in any other way. He gives symbolic expression to the artistic dimension of reality. And insofar as the expressive element is present in the two other stylistic types, every work of art has a symbolic character.

It would be interesting to discuss more fully the symbolic character of every artistic creation. A few remarks must suffice in our context. I follow Mr. [John Herman] Randall's distinction between reflexive and representative symbols and subsume artistic symbols under the latter group together with historical and religious symbols.[3] Symbols in'the second

3. John Herman Randall was professor of philosophy at Columbia University during Tillich's days at Union Theological Seminary and a fellow member of the Philosophy Club. For several years Tillich and Randall gave seminars together, usually centered in myth and symbol. In the following paragraphs from *Philosophical Interrogations*, ed. Sydney and Beatrice Rome (New York: Holt, Rhinehart, and Winston, 1964), pp. 407–8, Tillich and Randall continue the conversation. Although the word *Kitsch* does not appear in the text of Tillich's lecture, it probably was referred to in the discussion. The term was frequently used by Tillich, as the selections in this volume indicate. The relevant passages are as follows:

J. HERMAN RANDALL, JR.: How do you distinguish "painting" from *Kitsch*? How do you distinguish *Kunst* from other forms of making? Why is it not easier to distinguish "better" and "worse" art and painting than to set both off sharply from the Worst?

TILLICH: The question from Randall is a repercussion of a paper I gave at the Philosophy Club in New York City about the "Revelatory Character of Style and Contemporary Visual Arts" [chap. 12 of this collection]. One of the problems which arose in the discussion was the question of how non-art can be distinguished from art in cases in which the production of art is intended. In my paper I dealt with this problem only briefly, but I used the untranslatable German word *Kitsch* for a special kind of a beautifying, sentimental naturalism, as it appears in disastrous quantities in ecclesiastical magazines and inside church buildings. The word *Kitsch* points not to poor art, based on the incompetence of the painter, but on a particular form of

sense must be strictly distinguished from signs which are partly identical with reflexive symbols, like mathematical letters. Representative symbols—which alone are genuine symbols—participate in the power of what they represent. They are born out of a special encounter with reality. They die, if the original situation vanishes. They cannot be replaced at will. They open up dimensions of reality which cannot be grasped in any other way. Each level is opened up for spiritual grasp by artistic symbols. They express reality in this dimension, and in order to do so, they use ordinarily encountered realities as materials for artistic symbols. The relation of the different realms of representative symbols to each other can lead to the familiar phenomenon of double symbolization, a phenomenon which makes, for example, religious art possible.

deteriorized idealism (which I like to call "beautifying naturalism"). The necessary fight against the predominance of such art in the churches during the last hundred years leads me to the frequent use of the word *Kitsch* (which I even applied to describe the face of Jesus in Dali's famous *Last Supper* [*The Sacrament of the Last Supper* (plate 58)] in the National Gallery of Art in Washington).

The question of the quality of art is most difficult because of the character of the aesthetic encounter. It is an "involved" encounter, insofar as the result—the aesthetic vision—always contains elements coming from the encountered object, and elements coming from the encountering subject. In this point the aesthetic and the religious encounter are similar: Both of them create symbols and require participation in these symbols in order to be understood.

This situation makes it impossible to establish general objective criteria of artistic quality which can be applied by an outside observer. Certainly it is possible to formulate negative criteria (as the teacher in "creative writing" uses them in his class); and it is also possible to point in a work of art to those qualities which express an overcoming of these negative possibilities. But beyond this one cannot go. Every academic rule ever formulated has been broken by creative artists. This does not mean that the rule was completely wrong, but it means that the rule was only partly true and had to be restated in a larger context, which again may prove to be too small. The actual decisions about the quality of works of art are not being made in this way. They are made in terms of encounters by individuals or groups with them in acts of aesthetic participation.

The other question Randall asks is whether one should distinguish *Kunst* from other forms of making. Certainly not, insofar as they all are forms of making (technical, educational, political). But these kinds of making are so different in ends and means that the fact that they all "make" something is not of great significance. If, as Randall suggests, the word "art" be vastly enlarged, beyond "the arts" in the conventional sense, a new word must be found for the latter, perhaps "aesthetic art" or "expressive art," that is, a kind of making in which aesthetic symbols are produced or in which a special dimension of man's encounter with reality is expressed in directly sensory or imaginary-sensory symbols. The question whether there is a sharp, definable distinction between non-art, which claims to be art, and actual art, is perhaps not very important, since even if one asserted such a distinction, the actual mixture

It is now my belief that the visual arts, since the beginning of this century, must be understood as a return from a naturalistic to an expressive style, a style which in many varieties has controlled artistic creativity since 1900. This leads to our third and last part.

An Attempt to Interpret the Expressive Style in the Contemporary Visual Arts

The term *contemporary* is used in order to avoid the word *modern.* Modern perhaps should be reserved for the whole period from the Renaissance to the present. Contemporary, then, points to the limited but continuous development from the turning point at the start of the twentieth century to the artistic situation of today. In the sense of this extension of the word, Cézanne [plate 28] and Van Gogh [plates 26–27] are contemporaneous with us. Although the main examples for the following analysis are taken from painting, sculpture is not excluded.

The year 1900 can be used, symbolically, as the year in which the impressionistic variety of the naturalistic style was abandoned for the sake of different kinds of the expressive style. Impressionism can be called subjective or optical naturalism, very great art, but something different from what happened after 1900. The idealistic element was almost eliminated when, since the middle of the nineteenth century, objective, quasi-scientific naturalism took the lead.

The significance of the change since 1900—represented above all by Cézanne—can be realized most vividly by a look at the development of religious art since Rembrandt [plate 18]. I like to speak of the great gap between 1650 and 1900 with respect to religious art. Nothing significant was achieved in religious art since the last etchings of Rembrandt. Two of the greatest painters of all times, Watteau in the eighteenth, Manet in the nineteenth century, were unable to produce a religious picture, even if they tried, as at least Manet did in his *Christ Being Mocked* [plate 30] in the Chicago Art Institute. And third-, fourth-, and fifth-rate painters, those who were preferred by the church magazines and Sunday papers, produced the lowest type of a sentimental beautifying, nonessential naturalism. There is a profound incompatibility between the idealistic and naturalistic styles and the meaning of the religious symbols, and there is a profound affinity between the latter and the expressive style, which was pre-

between merely intended and real art would be so overwhelming that the establishment of a boundary line would have little practical value.

dominant in all religious periods. This excursus was supposed to show in one example the importance of what has happened since 1900.[4]

It is now my intention to enumerate the characteristic elements in the contemporary expressive style.

1. The passionate and almost desperate struggle of Cézanne was caused by his attempt to produce pictures which stand as pictures in and of themselves, independent of the subject matter, whether seen naturalistically or idealistically. The picture as picture was his aim, whatever material he used, mountains or beaches, individuals or groups, still lifes or towns. It is not astonishing that, for instance, his still lifes embody a cos-

4. A similar account of this period of history is given in Tillich's response to a question in *Ultimate Concern*, ed. D. MacKenzie Brown (San Francisco: Harper & Row, 1965), pp. 39–40. Tillich wrote:

STUDENT: I take it that in your theology you feel that, while our symbols and our myths play a very active secular role, they should be playing a more active role in relation to religion, that they need a revitalization. Can this be done outside of the church itself? Can it be done in contemporary literature or in contemporary art?

DR. TILLICH: Now this is a very interesting question. I would like very much to go into this, although it might lead us, again, into another seminar of twenty hours! I believe that something of this revitalization has already occurred—probably more by poetry, drama, and literature than through the visual arts. You see, the visual arts lack the "word"; and the religions are, in Christianity especially and in Protestantism even more, bound to the "word." Religion has had a very questionable relationship to the visual arts. Now, as you have perhaps already noticed, my own personal preference is for the visual arts. But this is one of the points where I am not considered fully Protestant, but rather "Catholicistic." Nevertheless, I would say that in some works of literature and in the visual arts, we already have possibilities for interpreting the Christian symbols in a way which is not only philosophical—something I do as a theologian—but which has in itself the other side of symbolism, the artistic. I would not be able to name those in English literature, except contemporaries like T. S. Eliot, who have done anything in this respect. But I know there are others.

With regard to the visual arts, I believe that the whole development since 1900—since Cézanne—has done a great deal to liberate our understanding of Christianity from what I call "beautifying realism," for which the German language has the wonderful word Kitsch. Such art does not express anything; it is simply a superficial prettifying where beauty as such is not called for, but rather expressive power. And I think that German Expressionism, for example, has done a great deal to show us this.

So far as my own thinking and preaching are concerned—especially preaching, which is more important ultimately than theology—I have found that my relationship to the visual arts and to drama and poetry and the novel has made it possible for me to offer fresh interpretations of the Christian symbols. Therefore I believe that your question deserves a very positive answer. But we must be careful about one thing: we should not confuse the artistic symbolization of religious symbols with the religious symbols themselves, thus implying that art can replace religion. That indeed would distort your statement.

mic power of being which is religiously far superior to sentimental Jesus portraits. His tea cups are symbols in his picture while remaining tea cups. This emphasis on the picture, liberating the picture from naturalistic bondage and idealistic transcendence, characterizes contemporaneous painting ever since.

2. The affinity of the expressive style to religion is most conspicuous in its turn toward the two dimensional in preference to the three dimensional. The block reality of mere objects is removed. One often praises the invention of perspective by the artists of the Renaissance and one has made a kind of absolute out of that, as if all previous art was insufficient preparation for the dawn of the idealistic-naturalistic alternative in style. From Winkelmann to Wöfflin one has called this the classic style, the norm of all other styles, not realizing that the three dimensional is an element in one style only. Sculpture is by its very nature three dimensional. But the expressive style has always found ways of reducing the block character of the three dimensional: the archaic gods, the saints on the walls of the cathedrals, the art of reliefs, confront the observer and keep the observer from walking around the work of art. It looks at him, but it is not a part of the world of objects, which he is used to handling. Another way of avoiding the block reality of objects dissolves their massive structure by introducing the empty space between the emphasized parts of the body. The expressive vacuum in sculpture is an analogy to the expressive two dimensionality in painting.

3. Most conspicuous in contemporary art is the disruption of the surface of the ordinarily (in the average) encountered world. One can say that the categorical structure of reality (time, space, causality, substance) breaks down under the impact of the desire for pure expression. Parts of the bodies of animals, of human groups, of faces, of landscapes, of technical structures are cut out of their natural context, put in different places, and connected with other pieces of the same reality. This is similar to contemporary novels in which the temporal sequences, the chains of causation, the difference of memory and reality, have disappeared. And it is similar to primitive and Asiatic art where vital parts of the body protrude or limbs are added to the body—hands, feet, eyes, ears, breasts. The classical work of the contemporaneous expressive style, sharing the disruptedness of the categorical structure of the ordinarily encountered world is Picasso's *Guernica* [plate 44]. Here, the historical material, used for the artistic expression, shows most obviously the meaning of the disruption of the surface in contemporary art.

4. In a more psychological than sociological way surrealist painters show the brokenness of man's rational approach to his world [plate 57]. Images of the subconscious are brought to consciousness. They show the

familiar world of men, houses, furniture, streets, buildings, fields. But these familiar things are shockingly strange. They are cut into pieces and the pieces are fantastically reorganized. The most familiar has become most strange, pointing to the general phenomenon of estrangement.

5. Artistically more consequential was the dissolution of the organic surface to show the structural elements of the inorganic realm—the cubes, the spheres, the cones, the lines, the planes, producing the cubistic variety of the contemporary expressive style. Traces of it are already visible in Cézanne, but only in Picasso, Braque [plate 42], Gris, has it come to fulfillment. It is both analytic and constructive. And it can be constructive because the geometric elements of life in these pictures are filled with power, as expressed in color, form, and interrelations. *La nature morte*, as the French call still life, is not dead at all, but represents the elementary power of being.

6. A consequence of this development is the disappearance, first, of the organic form, plants and animals, and human bodies; then, the disappearance of the human face generally and of the portrait especially. Man is swallowed by his own creation, the world of calculable objects. But not completely. He is still able to give to the structural elements of the objectified or reified world something of his own power of being and meaning. In the analysis of the contemporary expressive style we should not forget that the art of artistically expressing a disrupted and objectified world is in itself a victory over disruption and objectification.

7. The last phase which is usually called nonrepresentational is the most radical consequence of the motif which first appeared in Cézanne, the complete anatomy of the picture as picture. Not even the elements of the encountered reality are any longer of interest but only the relation of colors in an unordered-ordered geometrical network. Here the point is reached in which the physical material of every painting is transformed itself into a painting. But this painting does not transcend the material and its inner relations. The encountered world, including its structural elements, has disappeared. But even this stylistic extreme can show expressive power.

If we consider the total picture of the contemporary expressive style, we may distinguish two tendencies which often are together in one and the same stylistic expression. On the one hand, there is the awareness that the world which the artists of the idealistic-naturalistic period had encountered was falling to pieces. Its structure is disrupted, its meaning is lost. On the other hand, there is the tendency to uncover the basic elements of this world, and start, with their help, building something new. The first tendency shows that the contemporary expressive style is a part—and I believe a very important part—of the existentialist move-

ment, the strength of which lies perhaps more in the aesthetic than in the philosophical sphere. The second tendency is a part of the widespread withdrawal from a disrupted world into the security of elementary structures of life and thought. The "organization man" does not need to be disturbed in his conformist safety by semantics, logical calculus, and abstract art.

It seems to me that the contemporary expressive style gives, and has already given, new possibilities for religious art, with a decisive limitation. To say it in religious symbolism, the subject matter is man crucified, not God-Man resurrected. No convincing image of glory has been produced so far. Our interpretation of the contemporary style has tried to show why this is the case.

13

Art and Ultimate Reality

"Art and Ultimate Reality" was originally given as a lecture at the Museum of Modern Art, New York, 17 February 1959, as part of a series sponsored by the Junior Council, titled "Dimensions, 1959." After exploring philosophy, art, and religion as ways of expressing ultimate reality, Tillich develops five types of religious experience, each illumined by specific works of art, followed by five stylistic elements. The lecture was followed by questions and answers.

IT IS A GREAT and unexpected honor that I have been asked to give an address in a place which for years has been for me a favored oasis within this beloved city of New York. It is an unexpected honor; for I am far from being considered an expert in the visual arts—or in any other art. I could accept the invitation to speak here only because the Museum planned a series of "Art *and*" lectures, the first of which was to be "Art and Religion." It is the religious angle from which I am asked to look at the visual arts. This means that I must do it as a theologian and a philosopher.

A disadvantage of such an approach is obvious. One must conceptualize and generalize, where intuitive penetration into the particular cre-

"Art and Ultimate Reality" originally appeared in *Cross Currents* 10, no. 1 (1961): 1-14. It is reprinted here by permission. An abridged version of "Art and Ultimate Reality" later appeared in *Art and the Craftsman: The Best of the Yale Literary Magazine,* 1836-1961, ed. Joseph Harned and Neil Goodwin (Carbondale: Southern Illinois University Press, 1961), pp. 185-200; and in *Art, Creativity, and the Sacred: An Anthology in Religion and Art,* ed. Diane Apostolos-Cappadona (New York: Crossroad, 1984), pp. 219–35.

ation is the first and all-determining task. It is well known that many art-
ists feel uneasy if their works are subsumed to categories; nevertheless,
art criticism is as necessary as literary criticism. It serves to guide one to
the point where the immediate intuitive approach to the particular work
can occur. Attempts at conceptualization like the following should be
judged in the light of the demand to make such criticism finally super-
fluous.

The series of the *"Art and"* lectures was supposed to begin with the
lecture on art and religion, but it does not. Instead, I intend to speak
about art and ultimate reality, a subject which, although including reli-
gion, transcends by far what is usually called religious. Ultimate reality
underlies every reality, and it characterizes the whole appearing world
as non-ultimate, preliminary, transitory and finite.

These are philosophical terms, but the attitude in which they originally
have been conceived is universally known. It is the awareness of the de-
ceptive character of the surface of everything we encounter which drives
one to discover what is below the surface. But soon we realize that even
if we break through the surface of a thing or person or an event, new de-
ceptions arise. So we try to dig further through what lies deepest below
the surface—to the truly real which cannot deceive us. We search for an
ultimate reality, for something lasting in the flux of transitoriness and fini-
tude. All philosophers searched for it, even if they called change itself the
unchanging in all being. They gave different names to ultimate reality ex-
pressing in such names their own anxieties, their longing, their courage,
but also their cognitive problems and discoveries about the nature of re-
ality. The concepts in which ultimate reality is expressed, the way philos-
ophy reached them and applied them to the whole of reality fills the
pages of the history of philosophy. It is a fascinating story just as is the
history of the arts in which ultimate reality is expressed in artistic forms.
And actually, they are not two histories. Philosophical and artistic expres-
sions of the experience of ultimate reality correspond to each other. But
dealing with such parallels would trespass the limits of my subject.

The term "ultimate reality" is *not* another name for God in the reli-
gious sense of the word. But the God of religion would not be God if he
were not first of all ultimate reality. On the one hand, the God of religion
is more than ultimate reality. Yet religion can speak of the divinity of the
divine only if God *is* ultimate reality. If he were anything less, namely, *a*
being—even the highest—he would be on the level of all other beings.
He would be conditioned by the structure of being like everything that
is. He would cease to be God.

From this follows a decisive consequence. If the idea of God includes
ultimate reality, everything that expresses ultimate reality expresses God

whether it intends to do so or not. And there is nothing that could be excluded from this possibility because everything that has being is an expression, however preliminary and transitory it may be, of being-itself, of ultimate reality.

The word "expression" requires some consideration. First, it is obvious that if something expresses something else—as, for instance, language expresses thought—they are not the same. There is a gap between that which expresses and that which is expressed. But there is also a point of identity between them. It is the riddle and the depth of all expression that it both reveals and hides at the same time. And if we say that the universe is an expression of ultimate reality, we say that the universe and everything in it both reveals and hides ultimate reality. This should prevent us from a religious glorification of the world as well as from an antireligious profanization of the world. There is ultimate reality in this stone and this tree and this man. They are translucent toward ultimate reality, but they are also opaque. They prevent it from shining through them. They try to exclude it.

Expression is always expression for someone who can receive it as such, for whom it is a manifestation of something hidden, and who is able to distinguish expression and that which is expressed. Only man within the world we know can distinguish between ultimate reality and that in which it appears. Only man is conscious of the difference of surface and depth.

There are three ways in which man is able to experience and express ultimate reality in, through and above the reality he encounters. Two of these ways are indirect; one of them is direct. The two indirect ways of expressing ultimate reality are philosophy—more specifically, metaphysics—and art. They are indirect because it is their immediate intention to express the encountered reality in cognitive concepts or in esthetic images.

Philosophy in the classical sense of the word seeks for truth about the universe as such. But in doing so, philosophy is driven towards explicit or implicit assertions about ultimate reality.

We have already pointed to the manifoldness of such concepts, and "ultimate reality" is itself one of them. In the same way, while trying to express reality in aesthetic images, art makes ultimate reality manifest through these images—the word image, taken in its largest sense, which includes lingual and musical figures.

To be able to show this concretely is the main purpose of my lecture, and here I feel supported by the self-interpretation of many artists who tell us that their aim is the expression of reality.

But there is the third and direct way in which man discerns and re-

ceives ultimate reality. We call it religion—in the traditional sense of the word. Here ultimate reality becomes manifest through ecstatic experiences of a concrete-revelatory character and is expressed in symbols and myths.

Myths are sets of symbols. They are the oldest and most fundamental expression of the experience of ultimate reality. Philosophy and art take from their depth and their abundance. Their validity is the power with which they express their relation of man and his world to the ultimately real. Out of a particular relation of this kind are they born. With the end of this relation they die. A myth is neither primitive science nor primitive poetry, although both are present in them, as in a mother's womb, up to the moment in which they become independent and start their autonomous road. On this road both undergo an inner conflict, similar to that in all of us, between the bondage to the creative ground from which we come and our free self-actualization in our mature life. It is the conflict between the secular and the sacred.

Usually secular philosophy is called simply philosophy, and art simply art; while in connection with the sacred, namely, the direct symbols of ultimate reality, philosophy is called theology, and art is called religious art. The creative as well as destructive consequences of this conflict dominate many periods of man's history, the most significant for us being the five hundred years of modern history. The reduction of these tensions and the removal of some of their destructive consequences would certainly come about if the decisive point in the following considerations were established.

That decisive point is this: the problem of religion and philosophy as well as that of religion and art is by no means confined to theology and religious art; it appears wherever ultimate reality is expressed through philosophical concepts and artistic images, and the medium through which this happens is the stylistic form of a thought or an image.

Styles must be deciphered. And for this one needs keys with which the deciphering can be done, keys which are taken from the very nature of the artistic encounter with reality. It is not my task to point to such keys for the deciphering of styles in general, or of the innumerable collective and personal styles which have appeared in history. Rather, I shall indicate those stylistic elements which are expressive for ultimate reality. The best way to do this is to look at the main type in which ultimate reality is shown in the great manifestations of man's religious experience. They express in a direct way the fundamental relation of man to ultimate reality, and these expressions shine through the artistic images and can be seen in them.

On this basis, I suggest distinguishing five stylistic elements which ap-

pear, in innumerable mixtures, in the great historic styles in East and West, and through which ultimate reality becomes manifest in works of art. After the description of each of these elements, I want to show pictures as examples, without discussing them concretely, and with the awareness of the contingent, almost casual, character in which they were chosen, for many technical reasons.

The first type of religious experience, and also the most universal and fundamental one, is the sacramental. Here ultimate reality appears as the holy which is present in all kinds of objects, in things, persons, events. In the history of religion, almost everything in the encountered world has become a bearer of the holy, a sacramental reality. Not even the lowest and ugliest is excluded from the quality of holiness, from the power of expressing ultimate reality in the form of here and now. For this is what holiness means, not moral goodness—as moralistically distorted religions assume. There is actually no genuine religion in which the sacramental experience of the divine as being present does not underlie every other religious utterance.

This enables us to discover the first stylistic element which is effective in the experience of ultimate reality. It appears predominantly in what often has been called magic realism. But because of the non-religious meaning of the term, magic, I prefer to call it *numinous* realism. The word numinous is derived from the Latin *numen* (appearing divinity with a divine-demonic quality). It is *realism* that depicts ordinary things, ordinary persons, ordinary events, but it is numinous realism. It depicts them in a way which makes them strange, mysterious, laden with an ambiguous power. It uses space-relations, body stylization, uncanny expressions for this purpose. We are fascinated and repelled by it. We are grasped by it as something through which ultimate reality mysteriously shines.

Much primitive art has this character. It does not exclude other elements, and this is most conspicuous, for its greatness has been rediscovered by our contemporary artists who have been driven to similar forms by the inner development of their artistic visions. These visions have received different names. In the development of cubism from Cézanne [plate 28] to Braque [plate 42], at least one element of numinous realism is present. It is present in the stylo-metaphysics of de Chirico[1] [plates 35–36] and in the surrealism of Chagall [plates 33–34]. It appears in

1. Here Tillich appears to be referring to de Chirico's so-called metaphysical style.

those contemporary painters and sculptors who unite the appreciation of the particular thing with cosmic significance they ascribe to it.

All this is the correlate to religious sacramentalism. It shows ultimate reality as present here and now in particular objects. Certainly, it is created by artistic demands, but intended or not, it does more than fulfill these demands. It expresses ultimate reality in the particular thing. Religiously and artistically, however, it is not without dangers.

The religious danger of all sacramental religion is idolatry, the attempt to make a sacramentally consecrated reality into the divine itself. This is the demonic possibility which is connected with all sacramental religion. The artistic danger appears when things are used as mere symbols, losing their independent power of expression.

It is difficult to draw the line between an artificial symbolism and the symbolic power of things as bearers of ultimate reality. Perhaps one could say that wrong symbolism makes us look away from one thing to another one for which it is a symbol, while genuine symbolic power in a work of art opens up its own depths, and the depths of reality as such.

Now I should like to mention a group of pictures which, without special interpretation, shall give you a concrete idea of what I mean about the predominance of this first sylistic element.

Since it was difficult to find among the innumerable examples of primitive art one that was especially more significant than another, I have chosen the *Figure*, as it is called, by the sculptor, Lipchitz. Please do not forget, however, that it is a stylistic element which is predominant, not a special type.

Next we have Klee's *Masque of Fear* where we find a very similar expression, the stylized presence of ultimate reality in terms of awe, which belongs to all human relations to ultimate reality.

Again, another Klee—*Child Consecrated to Suffering.*

Then a Cézanne—*Still Life* [plate 28]. About this I must say something which goes back to my earliest encounter with the visual arts immediately after I came out of the ugliness of the First World War and was introduced to modern art by a friend, Dr. Eckhart von Sydow, who wrote the first book on German expressionism. At that time I came to the conclusion that an apple of Cézanne has more presence of ultimate reality than a picture of Jesus by Hofmann [plate 52] (which can now be found in the Riverside Church of this city).

Next we have Braque—*Man with a Guitar* [plate 42], which also shows elements of reality which otherwise are not seen, and in which elements of ultimate reality show through as foundations of the surface which never appear in reality on the surface.

Then we have Chagall—*I and the Village* [plate 33], and again it is the

individual things to which I want to draw your attention as in the styliza-
tion, the color, the lines, the relationship, and something I would like to
be able to mention at greater length—the two-dimensionality which is
not superficial but one of depth. All these express what I called presence
of ultimate reality.

Then de Chirico—*The Mystery and Melancholy of a Street* [plate 36].
This and similar pictures are especially near to my heart, not only be-
cause I am interested in depth psychology, in which things like this ap-
pear as dreams or as nightmares, but because at times I think all of us be-
come estranged from ordinary reality; and this estrangement produces a
new encounter with dimensions of reality otherwise unseen.

Miró—*Composition.* Now here you have nothing left but the surface:
nevertheless, these elements embody a power of being which you never
would find in surface reality in the same way.

Next is a picture with a funny name, which no one whom I asked,
including myself, understood. It is by Tanguy, and the puzzling title is
Mama, Papa Is Wounded. But I think these forms express something of
the potentialities which are in reality but which never come to the sur-
face without the realizing mind of the artist.

Now I come to a Gabo entitled *Spiral Theme.* This and a few others ex-
press something very important to me, namely, the possibility that man's
power of technical transformation of nature and of scientific penetration
into the ultimate elements of nature is thus able to produce still another
way of manifesting the creative ground of reality.

And the same in this. This is by Lippold and is called *Variation Num-
ber 7: Full Moon* [plate 56]. The variation expressed in these lines is a
new understanding of something which has appeared in man's
mythological thinking for ten thousand years. The symbol of the moon is
a goddess, and here the mathematical structure brings the same funda-
mental motif into another kind of expression.

Related to the sacramental type of religion and at the same time radi-
cally going beyond it is the mystical type. Religious experience tries to
reach ultimate reality without the mediation of particular things in this
religious type. We find this type actualized in Hinduism and Buddhism, in
Taoism and Neo-Platonism. And, with some strong qualifications, in some
places in later Judaism, Islam, and Christianity. It can undergo a transfor-
mation into a monistic mysticism of nature under the famous formula of
the God of Nature. In it God is equated with nature—with the creative
ground of nature which transcends every particular object.

We find this in ancient Asia as well as in modern Europe and America.
Correlate to this religious type is that stylistic element in which the par-

ticularity of things is dissolved into a visual continuum. This continuum is not a grey in grey; it has all the potentialities of particular beings within itself, like the Brahman in Hinduism and the One in Neo-Platonism or the creating God in Christianity as they include within themselves the possibility of the whole world. The continuum contains tensions, conflicts, movements. But it has not yet come to particular things. They are hidden in a mere potential state. They are not yet actual as distinguishable objects; or if so, they shine through from afar as before creation.

We find this in Chinese landscapes in which air and water symbolize the cosmic unity, and individual rocks or branches hardly dare emerge to an independent existence. We find it in the background of Asiatic and Western paintings, even if the foreground is filled with figures. It is a decisive element in the impressionist dissolution of particulars into a continuum of light and colors. Most radically it has been carried through in what is called today, non-objective painting. For instance, the latest decade of American painting is dominated by it. Of course, one cannot show ultimate reality directly, but one can use basic structural elements of reality like line, cubes, planes, colors, as symbols for that which transcends all reality—and this is what the non-objective artists have done.

In the same period in which Eastern mysticism powerfully enters the American scene, American artists have deprived reality of its manifoldness, of the concreteness of things and persons, and have expressed ultimate reality through the medium of elements which ordinarily appear only in unity with concrete objects on the surface of reality.

Here also the dangers must be seen. The sacred emptiness can become mere emptiness, and the spatial emptiness of some pictures indicates merely artistic emptiness. The attempt to express ultimate reality by annihilating reality can lead to works in which nothing at all is expressed. It is understandable that as such a state in religion has led to strong reactions against the mystical type of religion, it has led in art to strong reactions against the non-objective stylistic elements.

And now I should like to give you examples of pictures of this second stylistic element.

First is the Japanese artist, Ashikaga—*The Landscape*. This shows a pantheistic nature—trees and rocks barely emerging out of the whole.

Tai Chin, where it is even more powerfully expressed.

Klee—*Equals Infinity* [plate 47]. The word infinity here expresses this going beyond of concrete reality.

Seurat—*Fishing Fleet*, where the individual things are there, but they hardly dare to become fully individual.

Kandinsky's *Improvisation*. I remember when I was once sitting in a house in Berlin in the 20s, there was a Kandinsky similar to this. It was

really a liberation for me to be freed from the individual things and to be in a realm which at that time was very near to my own religious thinking.

Then, finally, Jackson Pollock's *Number 1, 1948* [plate 55], and I must say I found it difficult to evaluate him, but since seeing some of his very best pictures at the Brussels Exhibition, I have become very much reconciled with this fullness of reality without a concrete subject matter.

Like mysticism, the prophetic-protesting type of religion goes beyond the sacramental basis of all religious life. Its pattern is the criticism of a demonically distorted sacramental system in the name of personal righteousness and social justice. Holiness without justice is rejected. Not nature, but history becomes the place of the manifestation of ultimate reality. It is manifest as personal will, demanding, judging, punishing, promising. Nature loses its demonic as well as its divine power. It becomes subject to man's purposes as a thing and a tool. Only on this religious basis could there arise an industrial society like that in which we are living.

If we now ask what stylistic element in the visual arts corresponds to such an experience of ultimate reality, we must answer that it is "realism" both in its scientific-descriptive and in its ethical-critical form. After nature has been deprived of its numinous power, it is possible for it to become a matter of scientific analysis and technical management. The artistic approach to this nature is not itself scientific but it deals with objects, prepared as mere things by science. Insofar as it is artistic creation, it is certainly not imitation of nature, but it brings out possibilities of seeing reality which enlarge our daily life encounter with it, and sometimes antecedes scientific discoveries.

The realistic element in the artistic styles seems far removed from expressing ultimate reality. It seems to hide it more than express it. But there is a way in which descriptive realism can mediate the experience of ultimate reality. It opens the eyes to a truth which is lost in the daily-life encounter with reality. We see as something unfamiliar what we believed we knew by meeting it day by day. The inexhaustible richness in the sober, objective, quasi-scientifically observed reality is a manifestation of ultimate reality, although it is lacking in directly numinous character. It is the humility of accepting the given which provides it with religious power.

Critical realism is predominantly directed to man—personally, socially, and historically, although the suffering in nature is often taken into the artistic expression of the ugliness of encountered reality. Critical realism, as, for instance, given by Bosch and Brueghel [plate 15], Callot and Goya [plates 20–22], Daumier and Ensor [plate 37], by Grosz and Beckmann [plate 48], shows ultimate reality by judging existing reality. In the

works of all those enumerated, it is the injustice of the world which is subject to criticism. But it is done in works of art, and this very fact elevates critical realism above mere negativity.

The artistic form separates critical realism from simple fascination with the ugly. But of course if the artistic form is lacking, it is distorted reality and not ultimate reality that appears. This is the danger of this stylistic element as it also is of some kinds of merely intellectual pseudo-criticism, to succumb to a negativity without hope.

Now it would be good to look at pictures with this third element.

I never really saw the ocean, which I know and love very much, until I saw Courbet's *Wave*.

Next there is the very radical *Self-Portrait With Death* by Corinth.

Then two Americans. Hopper—*Early Sunday Morning*. Very fascinating for me, because it is based on experiences of the emptiness of reality and the sharp contours coming out of it.

And then the Sheeler *Classic Landscape*, which shows things which are in themselves of no significance but which show reality in a way which was hidden to us before.

Now I come to the critical group. First we have Goya—*What Courage!* [plate 21]; standing on a heap of corpses.

Then social caricature, and there is a title by Goya also—*Till Death She Will Beautify Herself*.

Then something about nature. Daumier's *A Butcher*. The life of man dependent on this distortion of the natural realities.

Dix—*War*, which made him famous. The trenches of the First World War, of which I unfortunately have a good knowledge—and he was right.

And finally George Grosz—*Metropolis*. Here you have the most radical form which also shows the dangers of it; the perhaps solely negative form of criticism.

The prophetic-critical type of religion has in itself the element of hope. This is the basis of its power. If the element of hope is separated from the realistic view of reality, a religious type appears which sees in the present the anticipation of future perfection. What prophetic hope expects is affirmed as given in forms of perfection which the artist can produce in the world of images. The self-interpretation of the Renaissance as society reborn was particularly conducive to this attitude. But it had predecessors, for instance, in the classical period of Greece, and has been followed in our modern period by attempts to renew this stylistic element.

As a religious attitude it can be called religious humanism which sees God in man and man in God here and now, in spite of all human weakness. It expects the full realization of this unity in history and anticipates it in artistic creativity.

The artistic style expressing it is usually called idealism, a word which is in such disrepute today that it is almost impossible to use. It is worse than criminal if you are called an idealist. But not only the word, the concept itself was under harsh criticism. In the period in which the numinous, the descriptive and the critical-realistic element dominated the whole development, the idealistic tradition was despised and rejected. In spite of the innumerable religious pictures that it produced, it was seen as unable to mediate ultimate reality. I myself shared this mood. The change occurred when I realized that idealism means anticipation of the highest possibilities of being; that it means remembrance of the lost, and anticipation of the regained, paradise. Seen in this light, it certainly is a medium for the experience of ultimate reality. It expresses the divine character of man and his world in his essential, undistorted, created perfection.

But more than in the other stylistic elements, the danger which threatens artistic idealism must be emphasized: confusing idealism with a superficially and sentimentally beautifying realism. This has happened on a large scale, especially in the realm of religious art, and is the reason for the disrepute into which idealism, both word and concept, has fallen. Genuine idealism shows the potentialities in the depths of a being or event, and brings them into existence as artistic images. Beautifying realism shows the actual existence of its object, but with dishonest, idealizing additions. This danger must be avoided as we now come to attempts to create a new classicism. I am afraid that this warning is very much apropos.

Now for this stylistic element, let us look at some of these pictures, old and new.

There is Francesca—*Queen of Sheba and Solomon* [plate 8].

And there is Perugino—*Courage and Temperance.* Here you see the anticipation of human fulfillment even in the title of these pictures.

Next is the idealization of paradise in a Poussin *Landscape.*

In Ingres—*Study for the Golden Tiger*—we have again memory and anticipation just as I said about this kind of style; it is the style of the paradise. But we have it also in more recent painters. We have it in the blue period of Picasso under the title *Life.* Tragedy is present, but in the background, and the fulfillment is shown in the form.

And finally, we have it in the form of *Dream,* which is most adequate perhaps in Rousseau. It is all-idealizing anticipation of essential fulfillment, but not beautifying.

Now I come to my fifth and last stylistic element. The great reaction against both realism and idealism (except numinous realism) was the ex-

pressionistic movement. To which religious type is it correlated? Let me call it the ecstatic-spiritual type. It is anticipated in the Old Testament, it is the religion of the New Testament and of many movements in later Church history; it appeared in sectarian groups again and again in early Protestantism, in religious Romanticism. It appears in unity and conflict with the other religious types. It is marked by its dynamic character both in disruption and creation. It accepts the individual thing and person but goes beyond it. It is realistic and at the same time mystical. It criticizes and at the same time anticipates. It is restless, yet points to eternal rest.

It is my conviction as a Protestant theologian that this religious element, appearing everywhere as a ferment—and in many places highly developed—comes into its own within Christianity.

But our problem is, how does this type express itself in the visual arts? Which stylistic element corresponds to it? I believe the expressionist element is the artistic correlative to the ecstatic-spiritual type of religious experience. Ultimate reality appears "breaking the prison of our form," as a hymn about the Divine Spirit says. It breaks to pieces the surface of our own being and that of our world. This is the spiritual character of expressionism—using the word in a much larger sense than the German school of this name.

The Church was never happy with ecstatic movements. They seemed to destroy its sacramental foundation. Society today has not been happy with the great expressionist styles in past and present because they have broken and are still breaking through the realistic and idealistic foundations of modern industrial society. But it is just this that belongs to the manifestation of ultimate reality. Expressionist elements are effective and even dominating in many styles of past and present. In our Western history they determine the art of the catacombs, the Byzantine, the Romanesque, most of the Gothic and the Baroque style, and the recent development since Cézanne.

There are always other elements co-operating, but the expressionistic element is decisive in them. Ultimate reality is powerfully manifest in these styles, even if they disregard symbols of the religious tradition. But history shows that styles which are determined by the expressionist element are especially adequate for works of art which deal with the traditional religious symbols.

But we must also mention the dangers of the expressionist elements in our artistic styles. Expression can be understood as the expression of the subjectivity of the artist, just as in the religious field, the spirit can be understood as an ecstatic-chaotic expression of religious subjectivity. If this happens in religion, ecstasy is confused with over-excitement; and over-excitement does not break through any form and does not create any-

thing new. If a work of art expresses only the subjectivity of the artist, it remains arbitrary and does not penetrate into reality itself.

And now let us recall some examples in a final group of pictures.

Van Gogh—*Hills at St. Remy.*

Munch—*The Scream* [plate 31].

Derain—*The London Bridge.*

Marc—*Yellow Horses.* I must tell you something about this painting. I was Professor at the University of Berlin in the years 1919 to 1924 and opposite the University was a modern museum in an old Imperial palace, and while I was lecturing on ancient Greek philosphy and comparing Parmenides and Heraclitus and others with the pictures of the modern artist, there were fist fights going on on the opposite side of the street. The fighting was between the lower petty bourgeoisie and the intelligentsia, and these fist fights at that time were a preview of what would happen later on under Hitler when the petty bourgeoisie became the dictatorial power in Germany. And for this reason, these horses of Marc have a tremendous symbolic meaning for me for this was one of the paintings I had been discussing at that time.

This is Schmidt-Rottluff—*Peter and Fishermen.* I am not sure of exactly how it is translated. You see much of the typical, very rough kind of German expressionism.

Now in the next one you also see the religious aspects in it—Heckel's *Prayer.*

Nolde—*Pentecost* [plate 40]. And I must confess that some of my writings are derived from just this picture, as I always learned more from pictures than from theological books.

And, finally, Nolde—*Prophet.*

The main point in the discussion of the five stylistic elements which can become mediators of ultimate reality has been to show that the manifestation of the ultimate in the visual arts is not dependent on the use of works which traditionally are called religious art. I want to conclude with a few remarks about the nature of such works and their relation to the five stylistic elements discussed.

If art expresses reality in images and religion expresses ultimate reality in symbols then religious art expresses religious symbols in artistic images (as philosophical concepts). The religious content, namely a particular and direct relation of man to ultimate reality, is first expressed in a religious symbol, and secondly, in the expression of this symbol in artistic images. The Holy Virgin or the Cross of the Christ are examples. In this relation it can happen that in the work of art as well as in the encounter with it, the one of two expressions may prevail over the other one:

The artistic form may swallow the religious substance, objectively or in personal encounter. This possibility is one of the reasons for the resistance of many religious groups against religious art, especially in a devotional context. Or the religious substance may evoke pictorial products which hardly can be called works of art, but which exercise a tremendous religious influence. This possibility is one of the reasons for the easy deterioration of religious art in its use by the churches.

The avoidance of both shortcomings is a most demanding task for religious artists. Our analysis of the five stylistic elements may be useful in this respect.

Obviously, the stylistic element which we have called numinous realism is an adequate basis for religious art. Wherever it is predominant in the primitive world, the difference between the religious and the secular is often unrecognizable. In the recent forms of numinous realism the cosmic significance of works under the control of this element is obvious, but it is hard to use them for the highly personalistic stories and myths of the religions of the prophetic type.

The mystical-pantheistic element of artistic styles resists radically the attempt to use it for the representation of concrete religious symbols. Non-objective art like its mystical background is the elevation above the world of concrete symbols, and only symbols of this elevation above symbols can be expressed in artistic images.

Descriptive and critical realism, if predominant in a style, have the opposite difficulty. They can show everything concretely religious in its concreteness, but only if united with other elements can they show it as religious. Otherwise, they secularize it and, for example, make out of Jesus a village teacher or a revolutionary fanatic or a political victim, often borrowing sentimental traits and beautifying dishonesty from the distortions of the idealistic style. This is the seat of most religious *Kitsch*.

Another problem is religious art under the predominance of the fourth stylistic element, the anticipating one. Anticipation of fulfillment can, of course, most easily be expressed through figures of the religious legend and myth. But one thing is lacking. The estrangement of the actual human situation from the essential unity of the human with the divine, the reality of the Cross which critical realism shows in its whole empirical brutality, and which expressionism shows in its paradoxical significance. Because this is lacking even in the greatest works under the predominance of the idealistic style, it can become the other source of *Kitsch* in religious art.

The expressionistic element has, as already indicated, the strongest affinity to religious art. It breaks through both the realistic acceptance of the given and the idealistic anticipation of the fulfilled. And beyond both

of them it reaches into the depth of ultimate reality. In this sense it is an ecstatic style-element, expressing the ecstatic character of encountered reality. Nobody can overlook this ecstatic element in the great religious art, however different the combination of this element with the other stylistic elements may be. To show the ecstatic-spiritual character in the expression of ultimate reality in the many great periods of religious art in East and West is a task to which the ideas of this lecture could only lay the foundation. It is enough if they have done this and made somehow visible the manifestation of ultimate reality through the different stylistic elements which appear in different relation to each other in all works of the visual arts.

Question Period

QUESTION: It is essential to art to express or seek to express ultimate reality, or is this only one thing that art does?

TILLICH: Well, this question was anticipated and, as far as I could do it, answered in my distinction between direct and indirect expression of ultimate reality. In this section I said that both philosophy and the arts do express something else intentionally—the philosophical concepts about the universe, the art images about encountered reality. But in doing so, they indirectly do something else; namely, they make ultimate reality shine through in both their concepts and their images. So from the point of view of intention, I would say that art does not have this intention, cannot have any other intention than being good art. But in being good art, it expresses—and this is the answer I would give to your question.

QUESTION: What is the relationship that exists in the experience of ultimate reality between secular painting and painting that has a religious subject?

TILLICH: This of course was the main point of the whole lecture. Ultimate reality appears in what is usually called secular paintings, and the difference from what is usually called religious paintings is real only insofar as so-called religious painting deals with the traditional subject-matters which have appeared in the different religious traditions. Now I would say that the great problem is which stylistic element is most adequate to express special religious subjects, as for instance, the Christ or the Holy Virgin, or whatever it may be. I would say all styles can do it in some way or the other, but as I feel and would derive from the whole history of religious art, only if there is a strong element of expressionist character is art really able to express the religious symbols adequately. I see this in the images of Buddha: I see it in the images of the Byzantine

art—which I think is the highest religious art in the Western world—I see it again in the possibilities which have appeared in the present-day expressionist painting—taken in the larger sense of the word expressionist, to mean everything since about the time of Cézanne.

Since I had no time to deal with this, let me say one word about it. I believe that of the two elements which I described in the spiritual-ecstatic type, namely, the disruptive and the creative, today the disruptive is still predominant. This expresses itself in the fact that with respect to the Christian legend, we have more pictures of the Crucifixion which are satisfactory than of Resurrection and related symbols. I would say this is an expression of the honesty of our artists that they don't feel adequate yet to depicting symbols of glory, and they should not attempt to do so prematurely.

QUESTION: How can bad art be good for religious experience?

TILLICH: How can every Indian believer feel that going into an extremely dirty river will give him purification? It is the same question, and you certainly can ask it very seriously. I would say this is the power of the development of a symbol. Symbols in their developments take on many elements which are not originally implied. For instance, the Black Madonna which I have seen somewhere, although not a work of art, is venerated by millions of Catholics, and not as a work of art but as an expression of the presence of the Holy. This expression can be found in fetishes of primitive men—which also should not be considered as works of art.

And here I come back to one section which I would have liked to discuss more fully, namely, the question of the relationship of the putting of religious symbols into artistic images. I had a very heated discussion about it at the University of Chicago a few weeks ago in the Department of Religion and Art (which is highly developed there in the theological faculty). I said that it is possible that when someone goes only once a year to church in order to listen to the "Passion of St. Matthew" by Bach, he may have two attitudes. One is directed to the artistic images in it, and the other possibility is that he is related to the religious drama as such. I was very much criticized for this statement because someone said you cannot really have an esthetic experience without the experiences of religious drama which are artistically expressed in the Saint Matthew Passion. This attack pleased me because it expresses what I see as the real fulfillment of the relationship between religion and art. But I asked the realistic, or pessimistic question, is that an actual possibility? Can you challenge the ability of those who visit galleries to experience the aesthetic side of art without experiencing the full impact of the religious side? Of course, if the religious side is completely out of this world, then they would not look at it probably. But in any case, the full experience of

the religious side of such a picture cannot be asked of those who go into a gallery. But I would perhaps agree, and I put this before you simply as a question, because I have no answer. Probably the essential relationship which is always at the same time the ideal, the demanded, the desired relationship, would be to have within the artistic images the full meaning of the religious reality behind it. But isn't this perhaps a problem of anticipating the re-established paradise?

QUESTION: Do you think there is an emptiness in present forms of contemporary religion which neither encourages nor forms art?

TILLICH: You put me on the spot because in the religious movement of today I am myself very much on the critical side, so I have a deep understanding of your searching question. I would say that we should not look for too much if we equate religion with the churches. I would agree with you that we are in a period in which the actuality of the religious life is in a great crisis, in spite of the so-called religious resurgence. (Crisis, meaning a separating of elements; that is the meaning of this much abused word.) There are today processes in which elements—that perhaps should be thrown out of the churches—are separated from those which are trans-historical and are valid. And of theology, you can ask exactly the same question which you asked about religious art, and which I asked of myself a hundred times, is theology possible today? If it is aware of this situation, I would say it is. So I would say the creative artist who has grasped this ultimate concern, whether or not he is a member of a church, and perhaps is against the churches more than with them, may be able even today to produce religious pictures which are expressing the foundation of the Christian message as much as a theology today must do which is equally, perhaps more critical against tradition than for it. In this sense, I would like to see many young artists who are grasped by ultimate reality, or whatever they choose to call it, deal somehow with the foundations on which the Church lived and which became distorted by the Church. They are responsible for reestablishing and making visible again these foundations.

QUESTION: Dr. Tillich, can expressionism ignore classical items of beauty such as the five orders, et cetera, that have been traditionally expressed?

TILLICH: What are they?

QUESTION: Ionic order, Tuscan, Corinthian, et cetera.

TILLICH: I don't know how any form, which as a form still stands, can be ignored by any style. I can better answer your question by referring first to philosophy. Can any philosophy ignore some of the fundamental insights of Parmenides, Plato and Aristotle? I would say no, and if they do, then they ignore elements which belong to the very nature of the task of

philosophy, that of discovering *sophia.* That means wisdom (*sapientia*) about reality. And as you know, *sapientia* means the knowledge of the principles. And if this is what has been brought into reality in Greek thinking, then I would say ignoring it, as some people do who think philosophy starts about 1890, is very wrong. And there I am quite clear about it because human thought has the love of structure, the structure of meaning, and this has elements which are changing and personal. If you neglect the personal elements, for instance, in mathematical structure, then you are irrational and confused. I would say the same thing about the arts. There are fundamental elements in artistic conception of reality which cannot be ignored. Even in the expressionist style for which I have a special sympathy because of my personal destiny, my warning is that it might neglect these elements and become the emotional outcry of an artist who did not learn his job. I think a great danger for modern art is that it is carried through by people who seem to think this is an easy job; you do not need to learn very much, you simply express your emotional substance and everything is all right. Such outcries in art are as bad as they are in philosophy. Therefore, do not let us forget to sit down first and to learn, both in philosophy and in art.

QUESTION: I would like to ask, Dr. Tillich, about what you said in relation to another idea you have discussed about the "courage to be"— which I understand to be the affirmation of life even with its limitations and separations. Can we say that an artist who has validly conveyed ultimate reality through the ways you have mentioned, can we say that he has discovered this courage and that he can convey it through, say, Cézanne in his apple, or Miró in an abstraction, or Munch in *The Girl Screaming?*

TILLICH: This question I like very much. First of all, one thing must always be said. In expressionism, there is this element of disruption of the surface. I think I described that sufficiently and gave sufficient examples. Now if somebody does not go beyond this—let's imagine Munch's outcry was not the picture, anxiety, but something like this, and there is no positive content in the picture as such, where is the courage to be? The courage to be is found in the courage to paint it as a picture and as a real picture, as a great picture. I would say this is the first fundamental courage which we must attribute to our great artists of today.

I consider all modern art, even before the period of critical realism which I described, as an element in the movement of Existentialism. This starts with Pascal and takes in the great men of the nineteenth century and everybody in the twentieth who has anything significant to say. And even in Nietzsche the representative of this movement who was most radical in his criticism, there is not only the courage to be

radical—which *is* courage to be—but also an affirmation of life which he expresses in the symbolically taken concept of the eternal, which is nothing more than the affirmation of the present moment as eternally meaningful.

So I could go to all these men and to all these artists and show the point which may be rather hidden, but which is not missing. But this I say with caution. I do not want to be dogmatic about it, but I am very much convinced about their courage to show us the negative elements. It is an expression of cowardice of many, many people in our society that they are not able to see this.

14

Excerpts from Systematic Theology

While little space is given to the arts in his Systematic Theology, *Tillich nevertheless gives more space to them than do most theologians. In the first section here reproduced, Tillich states that there are three stylistic elements that characterize every work of art: the naturalistic, the idealistic, and the expressionistic. In the second section, Tillich deals with religious symbols and the problem of the relation between the convictions of a religious community concerning art (consecration) and the artistic style in relation to religion (honesty). These brief excerpts, while intelligible in themselves, are integral to Tillich's systematic writing.*

ANOTHER ATTEMPT to find the unambiguous is made in images created by the arts. In artistic intuition and its images, a reunion of *theoria* and reality, which otherwise could not be reached, is believed possible. But the aesthetic image is no less ambiguous than the cognitive concept and the grasping word. In the aesthetic function the gap between expression and that which is expressed represents the split between the acts of *theoria* and encountered reality. The ambiguities resulting from this split can be shown in the conflicts of stylistic elements which characterize every work of art—and indirectly, every aesthetic encounter with reality. These elements are the naturalistic, the idealistic, and the expressionis-

These selected passages are reproduced from *Systematic Theology*, vol. 3 (Chicago: University of Chicago Press, 1963), pp. 71–72, 196–201, and are reprinted by permission. However, the paragraph on expressionistic style on pp. 159–60 is missing from the English edition. This section, as edited by Robert Scharlemann, has been provided from Tillich's own draft in the Tillich Archives, Andover-Harvard Library, the Divinity School, Harvard University.

tic. Each of these terms suffers under several of the ambiguities of language mentioned before, but we cannot dispense with them. Naturalism in this context refers to the artistic impulse to present the object as ordinarily known or scientifically sharpened or drastically exaggerated. If this impulse is radically followed through, subject matter overpowers expression and results in a questionable imitation of nature—the "ambiguity of stylistic naturalism." Idealism in this context refers to the contrary artistic impulse, that of going beyond ordinarily encountered reality in the direction of what things essentially are and therefore ought to be. It is the anticipation of a fulfilment that cannot be found in an actual encounter and that is, theologically speaking, eschatological. Most of what we call classical art is strongly determined by this impulse, although not exclusively, for no style is completely ruled by any one of the three stylistic elements. But here also the ambiguities are manifest; the natural object, the expression of which is the aim of the aesthetic self-creation of life, is lost in the anticipated idea of it, and this is the "ambiguity of stylistic idealism." An ideal without realistic foundation is set up against the encountered reality, which is beautified and corrected to conform with the ideal in a manner which combines sentimentality and dishonesty. This is what has marred the religious art of the last hundred years. Such art still expresses something, although not encountered reality—the low taste of a culturally empty period.

* * *

The third stylistic element is the expressionistic. Expressionism in this context refers to the artistic impulse (which is predominant in most periods and in most phases of history) to break through the ordinarily encountered reality instead of copying it or anticipating its essential fulfillment. Expressionism uses pieces of the ordinarily encountered reality in order to show a meaning which is mediated by the given object but transcends it. This is the reason why much of the great religious art is determined by this stylistic element, although it appears also in styles that have not or have not yet produced important religious works, as is true, for example, of the several styles since 1900 in Europe and America. The term "expressionistic element" is intended to prevent an identification of this style with the limited period of German expressionism. In expressionism, in this largest sense, the expressive character of the aesthetic function in general is most evident. But here also the ambiguity is not avoided. It consists in the fact that the expressive power annihilates the object both in its naturalistic actuality and in its idealistic potentiality, and that the expression stands in an empty space. But since a vacuum

cannot last in the dimension of spirit any more than in all the other dimensions, this vacuum is soon filled by the irrelevant subjectivity of the artist or the spectator. The image, lacking any criterion in reality, becomes the image of a questionable and ultimately unproductive individual. This is the "ambiguity of the expressionistic element in artistic styles."

* * *

(a) *The aesthetic function in the church.* — Those functions of the church are constructing functions in which it builds its life by using and transcending the functions of man's life under the dimension of the spirit. The church can never be without the functions of construction and, therefore, cannot forego the use of cultural creations in all basic directions. Those who indulge in contrasts of the divine Spirit with the human spirit in terms of exclusiveness cannot avoid contradicting themselves: in the very act of expressing this rejection of any contact between cultural creativity and Spiritual creativity, they use the whole apparatus of man's cognitive mind, even if they do it by quoting biblical passages, for the words used in the Bible are creations of man's cultural development. One can reject culture only by using it as the tool of such rejection. This is the inconsistency of what in recent discussion has been called "diastasis," i.e., the radical separation of the religious from the cultural sphere.

The churches are constructive in all those directions of man's cultural life which we have distinguished in the sections on the cultural self-creation of life. They are constructive in the realm of *theoria*, the aesthetic and the cognitive functions, and they are constructive in the realm of *praxis*, the personal and the communal functions. Later we shall discuss these functions in their immediate relation to the Spiritual Community; but at this point we must consider the problem of their part in the constructing functions of the churches. One question is central in all of them: How is the autonomous cultural form which makes them what they are related to their function as material for the self-construction of the churches? Does their functioning in the service of the ecclesiastical edifice distort the purity of their autonomous form? Must expressiveness, truth, humanity, and justice be bent in order to be built into the life of the churches? And if this demonic element in the ambiguities of religion is rejected, how can the human spirit be prevented from replacing the impact of the Spiritual Presence by the creative acts of its own? How can the life of the churches be prevented from falling under the sway of the profane element in the ambiguities of religion? Instead of a general answer, we shall try by dealing directly with each of the functions of construction and their particular problems.

The aesthetic realm is used by the church for the sake of the religious arts. In them the church expresses the meaning of life in artistic symbols. The content of the artistic symbols (poetic, musical, visual) is the religious symbols given by the original revelatory experiences and by the traditions based on them. The fact that artistic symbols try to express in ever changing styles the given religious symbols produces the phenomenon of "double symbolization," an example of which is the symbol of "the Christ crucified" expressed in the artistic symbols of the Nordic Renaissance painter Mathias Grünewald—one of the rare pictures which is both Protestant in spirit *and* at the same time great art. We point to it as an example of double symbolization, but it is also an example of something else, i.e., the power of artistic expression to help transform what it expresses. The "Crucifixion" by Grünewald [plate 11] not only expresses the experience of the pre-Reformation groups to which he belonged, but has helped to spread the spirit of the Reformation and to create an image of the Christ radically opposite to that of Eastern mosaics, in which as an infant in Mary's lap he is already the ruler of the universe. It is understandable that such a picture as that of Grünewald would be censured by the authorities of the Eastern church, the church of the resurrection and not of the crucifixion. The churches knew that aesthetic expressiveness is more than a beautifying addition to devotional life. They knew that expression gives life to what is expressed—it gives power to stabilize and power to transform—and therefore they tried to influence and control those who produced religious art. This was carried through most strictly by the Eastern churches, but it is also practiced in the Roman church, especially in music, and even in the Protestant churches, particularly in hymnic poetry. Expression *does* something to what it expresses: this is the significance of religious art as a constructing function of the churches.

The problem implied in this situation is the possible conflict between the justified request of the churches that the religious art they accept express what they confess and the justified demands of the artists that they be permitted to use the styles to which their artistic conscience drives them. These two demands can be understood as two principles which control religious art, the principle of consecration and the principle of honesty. The first one is the power of expressing the holy in the concreteness of a special religious tradition (including its possibilities of reformation). The principle of consecration in this sense is an application of the larger principle of form-transcendence (as discussed before) to the sphere of religious art. It includes the use of religious symbols which characterize the particular religious tradition (for example, the Christ picture or the passion story) and stylistic qualities which distinguish the works of religious art from the artistic expression of the non-religious

encounters with reality. The Spiritual Presence makes itself felt in the architectural space, the liturgical music and language, the pictorial and sculptural representations, the solemn character of the gestures of all participants, and so on. It is the task of aesthetic theory in co-operation with psychology to analyze the stylistic character of consecration. Whatever the general artistic style of a period may be, there are always some qualities which distinguish the sacred from the secular use of the style.

There is, however, a limit to the demands made on the artists in the name of the principle of consecration, and that limit is the demands of the principle of honesty. This principle is the application of the general principle of form-affirmation, as discussed before to religious art. It is especially important in a period in which new artistic styles appear and the cultural consciousness is split in the fight between contradictory self-expressions. The principle of honesty is severely endangered in such situations, which have occurred frequently in the history of Western civilization. Consecrated forms of artistic expression claim absolute validity because they have impregnated the memory of ecstatic-devotional experiences, and they are defended against new stylistic developments in the name of the Spiritual Presence. Such claims drive artists into deep moral conflict and church members into decisions which are religiously painful. Both feel, at least in some unconscious deeps, that the old stylistic forms, however consecrated they may be, no longer fulfil the function of expressiveness. They cease to express what happens in the religious encounter of those who are grasped by the Spiritual Presence in their concrete situation. But the new stylistic forms have not yet found qualities of consecration. In such a situation the demand of honesty on the artists may force them to refrain from trying to express the traditional symbols at all or, if they do try it, to acknowledge failure. On the other hand, the demand of honesty on those who receive the works of art is that they confess their uneasiness with the older stylistic forms, even if they are not yet able to estimate the new ones—perhaps just because there are not yet convincing forms with the quality of consecration. But both artists and non-artists are under the strict demand implied in the principle of honesty—not to admit imitations of styles which once had great consecrative possibilities but which have lost their religious expressiveness for an actual situation. The most famous—or infamous—example is the pseudo-Gothic imitation in church architecture.

Still another problem besetting the relation of the two principles of religious art must be mentioned: artistic styles may appear which by their very nature exclude consecrated forms and therefore have to be excluded from the sphere of religious art. One thinks of some types of naturalism or of the contemporary non-objective style. By their very nature

both are excluded from the use of many traditional religious symbols: the non-objective style, because it excludes the organic figure and the human face; and naturalism, because in describing its objects it tries to exclude the self-transcendence of life. One could say that only styles which can express the ecstatic character of the Spiritual Presence lend themselves to religious art, and this would mean that some expressionistic element has to be present in a style in order to make it a tool for religious art. This is certainly correct, but it does not exclude any particular style, because in each of them elements are present which are expressionistic, pointing to the self-transcendence of life. The idealistic styles can become vehicles of religious ecstasy because none of them completely excludes the expressionistic element. But history shows that those styles in which the expressionistic quality is predominant lend themselves most readily to an artistic expression of the Spiritual Presence. They are best able to express the ecstatic quality of the Spirit. This is the reason why, in periods in which these styles were lost, great religious art did not appear. Most of the last considerations are derived from an interpretation of the visual arts, but with certain qualifications, they are valid also for the other arts.

If we look at the history of Protestantism, we find that it has continued and often surpassed the achievement of the early and medieval churches with respect to religious music and hymnical poetry but that it has fallen very short of their creative power in all the visual arts, including those in which hearing and seeing are equally important, as in religious dance and in religious play. This is related to the turn in the later Middle Ages from the emphasis on the eye to the emphasis on the ear. With the reduction of the sacraments in number and importance and the strengthening of the active participation of the congregation in the church services, music and poetry gained in importance, and the iconoclastic movements in early Protestantism and evangelical radicalism went so far as to condemn the use of the visual arts in the churches altogether. The background of this rejection of the arts of the eye is the fear—and even horror—of a relapse into idolatry. From early biblical times up to the present day, a stream of iconoclastic fear and passion runs through the Western and Islamic world, and there can be no doubt that the arts of the eye are more open to idolatrous demonization than the arts of the ear. But the difference is relative, and the very nature of the Spirit stands against the exclusion of the eye from the experience of its presence. According to the multidimensional unity of life, the dimension of spirit includes all other dimensions—everything visible in the whole of the universe. The spirit reaches into the physical and biological realm by the very fact that its basis is the dimension of self-awareness. Therefore, it cannot be expressed

in spoken words only. It has a visible side, as is manifest in the face of man, which expresses bodily structure and personal spirit. This experience of our daily life is the premonition of the sacramental unity of matter and Spirit. One should remember that it was a mystic (Ötinger) who formulated all this when he said that "corporeality (becoming body) is the end of the ways of God." The lack of the arts of the eye in the context of Protestant life is, though historically understandable, systematically untenable and practically regrettable.

When we pointed to the historical fact that the styles with a predominantly expressionistic element lend themselves best to religious art, we raised the question of the circumstances under which such a style can appear. The negative answer was completely clear: Religion cannot force any style upon the autonomous development of the arts. This would contradict the principle of artistic honesty. A new style appears in the course of the self-creation of life under the dimension of spirit. A style is created by the autonomous act of the individual artist and, at the same time, by historical destiny. But religion can influence historical destiny and autonomous creativity indirectly, and it does so whenever the impact of the Spiritual Presence on a culture creates cultural theonomy.

15

Religion and Art in the Light of the Contemporary Development

Written by Tillich in outline form in 1964, just a year before his death, these handwritten pages indicate new accents in his thinking, such as preferring dimensions *instead of* levels *when talking about art, speaking of Abstract Expressionism in positive terms, and relating his thinking in fresh ways to all of the arts. For these reasons, this selection is included in spite of its outline form.*

To SPEAK ABOUT the religious dimension of contemporary art implies the obligation to defend such an attempt against critics from two sides, the aesthetic and the theological side. It is fortunate that these criticisms continue in a period in which theological interpretations of the arts have become as popular as they were unpopular and almost nonexistent some years ago. The dangers against which the serious critics warn us are either an easy identification of the two functions of man's spirit—which actually leads to a replacement of religion by the arts—or a valuation of artistic works, not from the point of view of their aesthetic quality, but from the point of view of their religious meaning. If these two mistakes are avoided, the defense of an attempted "theology of the arts" is less difficult, although many problems remain. For their solution an ally offers itself, ontology, the philosophical doctrine of being as being. Art as a reve-

"Religion and Art in the Light of Contemporary Development" has been transcribed and edited from Tillich's handwritten pages in the Tillich Archives, Andover-Harvard Library, the Divinity School, Harvard University.

lation of the mystery of being itself is a frequent object of discussion in contemporary philosophical writings. And it is mostly the mystical element in religion which underlies such philosophy. But whether or not we accept this ally, we must be aware of the difficulty of our task as we work on a theology of culture generally, and a theology of the arts, particularly.

I/ The Meaning of Religious Dimension

1. The subject of religion and art seems to lead naturally to an interpretation of that large and glorious realm of human creativity that we call religious art. If this were so, no defense against the double attack would be necessary. For nobody can deny its existence all over the world. But this is not our problem—at least not the primary one. Our problem is the religious dimension in nonreligious art, and if this is discussed, some consequences for the evaluation of religious art follow. We may even learn better how to distinguish good and bad religious art. We may learn to understand the absolute predominance of bad religious art in the two preceding centuries. But all of this is secondary and a footnote to my discussion of a defense of the idea of a religious dimension in all culture, including the arts.

2. The term *dimension* is a geometrical metaphor which has its merits, and as every metaphor, its limits. I have made a crusade for this metaphor against the other spatial metaphor, levels. Level puts basic realities, body and mind, culture and religion, world and God above each other. But this imagery is wrong. These basic realities are within each other. And this is what the metaphor dimension conveys, for dimensions cross each other in one point without interfering with each other. The very title, religious dimensions of the arts, implies that essentially there can be no conflict, no beside-each-otherness. There were innumerable conflicts between art and religion, but by existential dictation, not by essential necessity.

3. This leads to the question: What is the nature of the religious dimension in culture generally, and the arts particularly? What makes a cultural function religious, even if it does not deal with religion? The answer is: Everything in human culture has a religious dimension, if it points to the holy, that is, to that which is the ground and aim of everything that is. Or, in another terminology, every cultural creation has a religious dimension insofar as it contributes to the answer of the question of the meaning of our existence and existence universally. The religious dimension in a

work of art is that element in it which participates in the answer to the question of the meaning of existence.

4. In calling this religious, we deviate from the ordinary concept of religion as the activities of a human group in which the direct relation to a divine being is expressed in ritual and doctrinal symbols. If religion were only this, one could not speak of a religious dimension in culture. But the basic nature of religion is the answer one receives in oneself, or through others, to the question of the meaning of life. Being grasped by the power of this question, its answer and its ultimate source, being penetrated by it in one's whole existence, being infinitely concerned about it — that is religion. Religion in this sense can appear in all expressions of man's cultural creativity, both in the created works and in the creating person. It appears in the arts of shaping man's social existence through law and politics, through educational ideas and economic aims, and it appears in the acts of receiving the universe in knowledge and aesthetic vision.

There is consequently a theology of law, politics, education, economics, and there is a theology of scientific and philosophical knowledge, as there is a theology of the arts, our particular subject. In all these cases, the "theology of" means a consideration of the element of ultimate concern which lies behind the style of the cultural creations, though it shines through them, and determines the creativity of the one who is ultimately concerned. For the style betrays the religious dimension in a creative work and in a creative person. This is true no less of the style of politics, economics, law, and administration, as it is true of the style of philosophy and the sciences, and as it is true of the style of painting and music, of poetry and architecture. Theology of the arts, therefore, means, trying to find what a particular artistic style reveals about the religious dimensions in the creations under the domain of this style. How is the question of the meaning of life answered in a particular work of art under the predominance of a particular style?

5. A few classical examples, where no defensive attitude to the interpretation is needed.

(a) *King Oedipus* by Sophocles deals with the following existential problems: The hiddenness of man's finitude and revelation through tragedy; the objective guilt which is guilt subjectively, as hybris; the resistance against the revelation of guilt. The meaning of despair in him and the queen, the cause of destiny, the acceptance in Oedipus of Colonos. The function of this tragedy in Greek culture: [Participation of everybody].

(b) Raphael's painting [plate 10], representing the highest idea of the Renaissance: Essential being is anticipated, beyond tragedy. The

general mood of the Renaissance and the modern world. The divine perfection of man. The eschatological character of idealism.

(c) Baudelaire's poetry. The appearance of the demonic depth of the individual. This is not isolated but a part of the second period of romanticism. The fascinating ambiguity of evil. Destruction of form, but this destruction becomes itself a form. In this period the foundations were laid for what we call the expressionist or existentialist style of the twentieth century (analogies in music: Wagner, R. Strauss, Schoenberg, electronic sounds as music).

II/ The Contemporary Situation

1. The general basis already laid in the late romanticism of the nineteenth century. Since 1900 the disappearance of the daily life or average world view, and with it both naturalism and idealism. The elementary depth against the organic surface. The arts bringing the elementary to the surface in abstraction because the surface has become banal and deceptive, especially if beautified (for instance, in religious art).

2. The decay of idealism and its value judgment led to the discovery of the demonic. The depth of existing man and of everything living is not only elementary in a morally neutral sense but is ambiguous, creative, destructive, demonic.[1] This is primarily manifested in the internal subjectivity of the individual, and therefore appears in poetry and music. The support of all this (a) by the psychology of the unconscious, and the therapists use of artistic creations for exemplifying psychological insights, and (b) the break through to existentialism in philosophy.

In any case, the withdrawal to the elementary and the discovery of the demonic, expressionism is not subjective but an expression of existence.

3. The difficulty of the average consciousness to grasp the disappearance of the ordinary world. Therefore the struggle about modern art. My experience in Germany.

4. Examples of the described attitudes:

(a) Abstract expressionism. Abstracted from the ordinary encounter with reality since cubism (Picasso [plates 43–44]), the atomic and subatomic structures (which are themselves models). But this is not another kind of copying, but a new creation of realities which are potential in space, but come out only through man, especially in sculpture. Therefore expressionism, but not the subjectivity of the individual painter. Rather it is cosmic imagination.

1. The demonic is discussed in chap. 10 of this collection.

Bringing into the open hidden possibilities of reality which have not been actualized by nature.

(b) Something analogous in music. The dissolution of the classical forms and the discovery of new sounds and rhythm, the possibilities to the electronic music.

(c) The piercing of the surface in poetry. The problem of language. The impossibility of diving into the depth of the self and the world with objectifying language. The broken surface of language. Often symbols of an inner process rather than understandable meanings in the poetry of Eliot, Auden, beatniks such as Ginsberg.

(d) In novel and drama—Becket, Miller, Tennessee Williams— also in the form of movies, such as *Marienbad, The Seventh Seal,* which are particularly strong in diving below the surface of consciousness and showing an image of man which does not appear on the surface, not as merely individual psychology, but as the understanding of man in the whole of existence, expressed in inner movements and human relations. Within this the ambiguities of all life seen out of its depth, the ambiguity of the creative and the destructive (Kafka, Sartre, Camus, Joyce).

5. The countermovement:

(a) The courage in the artistic shaping of the negative and of the quest for the ground of being. Out of these depths comes the positive. The desire of penetrating the surface world with the visions of the ground. The beginning return in the visual arts—De Kooning . . ., the magic of the real, if seen from the ground; the sculpture related to surroundings (Francis Bacon). Sculptures using the invented forms for human figures but uniting the subsurface with the surface forms.

But this is not a victory over the abstract expressionistic element and it is in no way consolidated. Therefore the manifoldness of the experimental stage (example, church architecture). The collage breaking pieces of reality for producing new organic-symmetric structures. The pop-art jumping over the problem and using the figural forms in a kind of ironic imitation of daily life objects. Those who have not gone through the breaking of the surface and feel that their old style will return do not help. Those who try seriously to return, after having experienced the breakthrough, return too quickly. All these in conflict with each other. The large basis still abstract expressionism.

(b) In the drama. The symbol of waiting (for Godot). But in vain. Tragic conflict (Hochhuth) but not genuine tragedy.

(c) Is it imaginable today to find the grace of life in a work of art?

We cannot force it, as we cannot force the resurrection of the God who died or the return of the God who became absent. Artist and grace. Has the revelation of grace perhaps taken refuge in other realms? (social?)

In any case, the great panorama ceases to be a chaos, if seen in the light of the ultimate questions of the meaning of life and the paradoxical answer to which the artists are witnesses: the grace of life in a graceless world.

16

Religious Dimensions
of Contemporary Art

This lecture, sponsored by the Program in Religious Studies, University of California, Santa Barbara, in 1965, was probably the last lecture given by Tillich on art. It is notable for several reasons, chief of which are: (1) his elaborations on style, subject matter, and form, themes from his early writings; (2) the deliberate use again of the term dimensions *instead of* levels; *and (3) his taking abstract and Pop art into account.*

THE PERSON WHO speaks to you tonight is not an expert in the visual arts, but he is a lover of them. I want to suggest a vantage point from which the visual arts can be considered that is not identical with the perspective of an art critic or the curator of a museum. The approach I am adopting here is indicated by religion. It is an attempt to understand the relationship of religion in the largest sense of the word to the reality of the visual arts. I wish to examine this relationship in my capacity as a philosopher and theologian, not as a connoisseur of the arts, which I do not pretend to be. Thus my presentation involves a basic theoretical analysis, without which I would not presume to comment on this particular subject.

My first task is to deal with the concept *religious dimension.* Second, I want to describe the path which has led from the art of the turn of the century to contemporary art. Finally, I will try to interpret the most conspicuous tendencies in the art of the last ten or fifteen years.

"Religious Dimensions of Contemporary Art" was edited from the typescript in the Tillich Archives, Andover-Harvard Library, the Divinity School, Harvard University.

The choice of the term *dimension* indicates a rejection of two other possible terms, *level* and *sector.* Religion is not a level above or below others, and religion is not a sector or section beside others. These terms convey the erroneous idea that religion exists alongside other aspects of culture, but in essential separation from them. The term *dimension* gives us the proper sense of a depth and a height (or "ultimacy") that intersects with, and is present in, all the other dimensions of human concern, including the arts in general, and the visual arts in particular. This concept of religion as the dimension of the ultimate, or the dimension of depth in all sections and levels of culture, conveys the basic sense of what religion means, although certainly not in traditional terms. The basic concept of religion is that it is an experience of the ultimate meaning of life, the meaning which is rooted in the ground of being, in ultimate reality. Wherever the depth-dimension or the dimension of the ultimate meaning of life is asked for or answered, we encounter the dimension of religion. This asking and answering is not restricted to what is traditionally considered to be religion, that is, to activities within a group of human beings who have a set of symbols and rites, related to divine powers. This narrower concept of religion has its own validity and importance. But there is a larger and more fundamental concept of religion, namely, the state of ultimate concern about something ultimate.

These two meanings of "religion" make possible two ways of dealing with the relation of religion and art. If religion is understood in the narrower sense, then the religious dimension of art could only mean the use by art of the symbolic material provided by a historical religion. In this way, the arts have used as subject matter the story of the Christ, the legends of the saints, the mythical symbols of creation, salvation, consummation. This use is justified, and some of the greatest art is religious art in this sense; also some of the worst art, for example, the religious art of the end of the nineteenth century and the beginning of the twentieth.

But this kind of art is not our main concern in this lecture. Religion in the narrow sense has provided an astonishingly small amount of content for the visual arts in the last sixty years and, even more, in the arts since the middle of the seventeenth century. When we remember that a largely secular movement such as the Renaissance was still dominated by religious art in the narrow sense of the word, the phenomenon of the lack of it in recent centuries is astonishing. The explanation is given by the fact that a new attitude toward life, a secularized encounter with reality, developed during the modern period. Out of this process of secularization in all realms of life—science, politics, ethics, as well as the arts—the striking absence of religious art in the narrower sense of religion can be derived and traced.

Secularization does not mean the negation of religion in every sense; it is nonreligious only in respect to the narrower concept of religion. It denies or ignores the creeds, symbols, and acts of the churches. But it does not deny the question of the ultimate meaning of life. With respect to the larger concept of religion, secularism is indirectly religious. Just as religion in the narrow sense has many forms, so secularism exhibits many forms in which the question of the meaning of life is asked, not only intellectually, but with a total concern and an infinite seriousness. It is the religious dimension in this sense which we want to discover, whether we look at religious or at secular art.

All creative art is an expression of an encounter with reality—with the truly real in reality, with "ultimate reality." It contains an answer to the question of meaning. I once read the self-interpretations of a large group of young American artists. Whatever their style, almost all of them said: "We want to find reality!" Of course they didn't mean: "We want to find chairs as such, and birds and trees as such, and human figures and faces as such"; rather, they meant: "When we paint these things, we want to find true reality in and through them. All creative art is based on an encounter with reality in this sense. This leads to the decisive question: If the subject matter of a picture or of a sculpture is not religious in the narrower sense, such as a saint, Moses, or Christ, in what way is the religious dimension expressed? How can the picture of a secular subject—a stone, a tree, an event in our daily life—show religious depth? How can it become an expression of ultimate concern? The answer is that the religious dimension in a work of art appears in the artistic style. Since the artist, first of all, is a human being, the style of his work reveals much of his encounter with reality. It points to the answer he consciously or unconsciously gives to the question of the meaning of life.

In order to understand the nature of style more fully, let me elaborate three elements which we always find in works of art. The first element is the artistic form. It distinguishes art from sciences, from politics, from religion, from nonart. But reference to form is not enough. One can ask, is a photograph a work of art? It probably can be, but I will leave that an open question. Or, let us take the art of the insane. There are powerful examples of their work. Where is the boundary between art and nonart? Or consider the art of children, which, while somewhat overrated, is often very visionary. Or the art to which I want to lead you toward the end of this lecture, the collage, which is produced with pieces of ordinary reality. Is that art or nonart?

All artistic forms have one element in common, expressiveness. Art creates realities in which something is expressed. I use the word *expressiveness* in order to avoid the term *beauty*. In aesthetics the word *beauty*

has deteriorated and fallen into contempt. The cause of this degeneration of the word are the naturalistic forms of art that beautified reality in a dishonest way. The most flagrant abuse is the sentimental religious art of the last period of the nineteenth century, examples of which can still be found in the vestries of many churches and even in the sanctuary itself. The dishonestly beautified face, of Jesus or of an apostle, or the beautification of the Crucifixion that occurs in many paintings of this period, have made the word *beautiful* suspect. It must be replaced by something else. I suggest *expressiveness*. This, then, is the first of the three elements, the expressive power which characterizes a work as a work of art.

The second element is the subject matter. Here the decisive point is that in modern art no material is in principle excluded. The terrible is admitted as well as the tender; the strange as well as the familiar; the sexual as well as the spiritual. Furthermore, pieces and elementary structures of reality are possible subject matters as well as things in their totality and wholeness. The artist can use as his subject matter the geometrical realm with its models of the physical world. He can use the figural as well as the nonfigural; the human face as well as the faceless. This wealth of possibilities creates an important problem. Not every subject matter is chosen by every artist or every school of art. Why are some subjects chosen and others not? This question leads to a consideration of the third element, namely, style.

The word *style* is derived from the Latin *stilus*, the pencil. The idea underlying the term is that an artist shows through the use of his pencil particular traits in his writing. Hence these traits are, in metaphoric condensation, called his pencil, his *stilus*, his style. Every human expression can be understood as representing a style. I have spoken often in lectures on the history of philosophy about the style of a particular philosophical school of the past, or a style of politics in a particular century, but usually the word is not used in this larger sense; it is used mostly for artistic styles. Here, a particular artistic style makes it possible to recognize a painter or a school of painting even if represented by only a single picture, or even a part of one. Thus one can recognize a philosopher from a few quotations of his books and a composer from a few bars of his composition.

Style is generated by a special encounter with reality. For this reason some artists change styles when the character of their encounter with reality changes. Sometimes a whole period is characterized by a particular artistic style. We often specify historical periods by the artistic styles that occurred in them. We speak of the Renaissance and mean the Renaissance style, of the Baroque period and mean the Baroque style in politics

and metaphysics, as well as in painting. We speak of the romantic style, which again is basically an aesthetic category, and use it to characterize a whole period in the history of man's cultural creativity.

The style determines the choice of subject matter. Often the style prevents the inclusion of particular objects within the artistic expression. For instance, in the Gothic style nature is only a frame; it is never used as the direct subject matter. The concrete objects used as material are sacred events. Or to use another illustration, it is difficult to paint historical events in an expressionistic style; in abstract expressionism it is impossible to make portraits in the usual sense of the term. The choice of subject matter is in itself an indication of the style and that means of a special interpretation of the meaning of life, or of a special encounter of man with his encountered world.

Let us consider the kinds of style more carefully, because they are the media through which the religious dimension is manifested. The number of styles in the history of art are too many to enumerate. But we can attempt to discover if there are common elements appearing in all styles in terms of their encounters with reality. First of all, man's encounter with reality is mediated through sense impressions and his reaction to the demands of his daily life. This encounter may be on the basis of the practical forms of common-sense experience, or perhaps in more refined scientific categories. In either case the object as it directly stands before one is predominant. Such an encounter is expressed in a naturalistic style.

This naturalism always involves something more than photographic duplication; there is always a transformation created by the artist. But the style does attempt to convey what is encountered in the average, everyday encounter with things. For example, the portrait by John Singer Sargent represents an attempt to reveal the body, clothes, and other details in a style adequate to our everyday experience, in this case, preparation for a cocktail party or an evening supper. The painting is an example of objective realism in a naturalistic style, in which the encounter with reality is in the form of our conventional experience of the world.

The great impressionist, Claude Monet [plate 25] provides us with an interesting example of a more subjective naturalism. Monet gives us a constellation of optical impressions which do not in themselves constitute a fully developed objective world. Hence it can be called subjective naturalism, naturalism of an optical type, but still naturalism. Many paintings in this style have been accomplished with the help of scientific research into the optics of the human eye.

Naturalism also may become critical realism. It can be full of prophetic wrath and show reality in its ugliness and destructiveness, but fundamen-

tally still in naturalistic terms. This form of naturalism, however, provides the way for a transition to two other stylistic elements, the idealistic and the expressionistic.

What is an idealistic style? It is a way of apprehending reality, not in its empirical existence with its greatness and its destructiveness, but in its ideal perfection, or, as I would call it in a more philosophical terminology, the "true essence" inherent in its external appearance. In this sense the arts of the early and high Renaissance are idealistic, not because they are concerned with utopian ideals, but because they are forms of art that are concerned with the essences of things. A beautiful example of this style may be found in Perugino, one of the predecessors of Raphael. His *Crucifixion* [plate 9] is full of living realities, both natural and personal. In the center is the figure of the crucified. But this event is the ugliest one imaginable, in which, as the Gospels say, nature was darkened at the third hour, and from which all disciples fled; yet this most miserable and ugliest moment is shown in glory and beauty. There is little pain; there is no distortion of the body, no blood on the figure of Jesus. And there is little pain on the faces of the disciples. Nature is not disrupted, but exhibits a benign beauty. Nevertheless, this picture is not representative of a beautifying naturalism. Rather, it points to the "other side" of an event which is not yet present. It discloses what is anticipated, that which is symbolized as Resurrection and Ascension, the emergence of glory.

Unfortunately, the degeneration of this form of art has contributed to the decay of the term *beauty.* The term *beautiful* was originally connected with essentialist art, but later it was applied by inferior artists to a sentimental "beautifying" naturalism; consequently, its meaning was impoverished.

The third stylistic element, expressionism, stands in contrast to both naturalistic and idealistic elements. In its encounter with reality the expression of meaning is at the center of its concern. It is not the subjectivity of the artist that is expressed in expressionist art. Otherwise, expressionism would simply be an emotional outcry of the artist, but not the production of something which stands in itself, at which we can look, and through which we can be grasped.

Of course the character, the inner life, the subjectivity, of the creative artist can serve as the medium through which the encounter with reality takes place. But the actual subject matter of the expressionist artist is not his subjectivity but a dimension of reality which is brought to the surface and which cannot be given to us in any other way.

One cannot explain a poem philosophically. One cannot interpret a picture by stating its meaning in discursive sentences and then dispensing with the visual form. Every work of art—a poem, picture, piece of

music—has something to say directly to its audience that cannot be expressed by scientific formulas or the language of everyday experience. In order to express this dimension, forcefully and conspicuously, the expressionist element does something with the surface of reality; it breaks it; it pierces into its ground; it reshapes it, reorders the elements in order more powerfully to express meaning. It exaggerates some elements over against others. It reduces the surface quality of natural reality to a minimum in order to bring out the depth meaning that it contains. For example, it may abolish the form of natural three-dimensional space and create another space which is not three dimensional. Nevertheless, in spite of this breaking to pieces, this piercing into the underground, this distortion and reduction of dimensions, this exaggeration—expressionism still exhibits artistic form; it discloses the unity of sense impressions, the unity which embraces a manifoldness. In this manifoldness, the whole and the broken, the totality and the parts, are united by the integral act of the artist in creating his new aesthetic form. This is what is meant by the expressionistic character of art.

Expressionistic elements are predominant in great religious art all over the world. In religious experience the holy—or the ultimate—breaks into our ordinary world. It shapes this world, shakes its foundations, or it elevates it beyond itself in ecstasy and transforms it after having disrupted its natural form. This is the reason for the affinity of the expressionistic element with the religious dimension in the arts. This does not mean that the religious dimension is not disclosed in the two other elements. For example, naturalistic art reveals an awe toward the given. At this point, philosophic empiricism shares with artistic naturalism a humility before the materials it considers. By subjecting himself to what is given to him, by recognizing that his human mind is on the periphery of things and not in the center, the true scientist shows himself to be profoundly religious, whether he calls himself theist or atheist. Even in critical realism, which shows the ugliness of reality, especially the ugliness in man, the religious dimension appears. This art sometimes approximates caricature and often is transformed into expressionism. But in any case, the pictures in which some painters of the First World War displayed heaps of corpses and the horrors of the trenches, and the painters who show the horrors of the Hitler period and the Second World War, disclose the religious dimension as prophetic wrath. Natural reality in its negativity still involves a religious aspect.

As we noted, the idealistic element, in contrast to the natural, shows the essence of things which should overcome their existential estrangement. In pictures of this type we encounter eschatology, the "last things," namely, the ultimate essential fulfillment of all beings, even if it is a sim-

ple tree, a portrait, or any other scene of daily life. Idealistic painting is "anticipatory" painting. It anticipates the actualization of what is potentially in us and from which we have become estranged in our concrete existence. Such art is related to the hieratic art of the Byzantine period, an art that was not expressionistic yet transcended realism.

Such is my philosophical introduction, and it is necessary for a proper understanding of the development of art in the twentieth century. With the assistance of these philosophical terms we are now prepared to examine the religious dimensions of some of the forms of art that have appeared since 1900.

Painting in the twentieth century is mainly determined by one of the three stylistic elements, namely, expressionism. Under the dominance of this style, a fascinating number of variations have occurred that comprise a continuous trend and a meaningful pattern of transition and transformation.

It is not possible here to offer even a semblance of an adequate sketch of the history of the expressionistic movement. Let me simply mention a few points of special importance. Cézanne [plate 28], of course, is one of the fathers of this school. In many of his paintings the optical characteristics noted previously in Monet are reduced to large planes of color. Indeed, whole landscapes and the faces of human beings are so reduced. As a result, they have a kind of cosmic character. Something of the universe is embodied in every individual picture. I recall that in the year 1926 I wrote that an apple painted by Cézanne has more religious qualities than a Jesus painted by one of the beautifiers and sentimentalists of the end of the nineteenth century [plate 29].[1] I still feel that this is so. It is the style which makes the difference. The style can make an apple of cosmic importance and the figure of Jesus, trivial and empty of meaning.

German expressionism provided my own personal introduction to the world of the visual arts. This school has an ecstatic and spiritual character, as in Emil Nolde's *Christ Among the Children* [plate 39]. Its powerful use of color expresses an ecstatic spirituality. Further, this painting exemplifies the disruption of the ordinary encounter with reality and the lack of a three-dimensional perspective so characteristic of the expressionistic style.

Although a Swiss, Paul Klee is one of the popular figures connected with the German expressionistic school. In his *Departure of the Ghost* we have an example of what has been called psychological calligraphy. This style was cultivated by the Chinese and Japanese. It makes use of beautiful graphic symbols, not in order to express verbal meanings, but

1. See p. 69 of this collection.

to express psychological states. Massive bodily substance is omitted and through the emphasis on lines a completely two-dimensional world of the soul is produced. This is an example of the expressionistic reduction of reality in order to express that which transcends ordinary encountered reality. In this instance it passes over the boundary lines of the familiar into the uncanny and mysterious.

Pablo Picasso, the master of many styles, introduced a further "breakthrough" in the visual arts in the first half of the twentieth century. *Girl with Mandolin* is one of the classics of cubism. What does this word mean? It means the transformation of the organic body into cubes, into elements which belong to the geometrical basis of reality. The average experience of reality is dissolved and the geometrical abstractions are then used as the building stones of a new encounter. This new stylistic possibility exerted a tremendous influence on the development of art in this tradition.

Guernica [plate 44] represents a further development. It is one of the most famous, if not the most famous painting of the twentieth century. It is the story of Guernica, a small Basque town in northern Spain which was bombed to rubble by the Axis. Picasso's style conveys to us a world that is indeed in pieces. What is not in pieces, what is still whole, utters a cry of desperation as it is about to disintegrate through bombs, fire, and other forms of death. Men as well as animals are involved at a cosmic level in the same catastrophe. On the left side is a bull which often appears in Picasso's work and expresses the demonic element. I once called this the most Protestant painting of our time, because it encounters the reality of the world with protest and prophetic wrath against the destructive and demonic powers of the world. It is a striking example of what I have called the disintegration of the world.

The next step in artistic style is toward surrealism, which means "beyond realism." But this "beyond realism" uses pieces of the real to compose new fantastic forms of reality possessing an uncanny character that produces anxiety, or a feeling of being threatened by the absolutely unfamiliar. It is an expression of the loss of our familiar world by the destructive powers that have been unleashed in the world. Salvador Dali's *Premonition of Civil War* [plate 57] shows us an interesting example of the sense of the total disruption of the bodily structure of the Spanish nation through civil war.

This style then develops into futurism, where everything is in movement and a dynamic turbulence characterizes the appearance of things. Although it seems to be a characteristic of objects in the visual arts that they are stationary and still, futurism displays them in motion, moving toward a future.

The next several paintings show further examples of the kinds of styles devised by expressionists to generate the dissolution and transformation of conventional reality. Fernand Leger's *The Great Julie* discloses the relation of bodies and machine parts. The limbs of the bodies are themselves machine parts. Man has become a part of the machine himself. Here Leger is of great importance in helping us interpret our human situation. We aspire to rule nature through the machine. But it would seem that the machine is adjusting us to its reality, instead of man adjusting the machine to his own being.

Hans Hofmann's *Magenta and Blue*, an example of abstract expressionism, shows only the elements of things, not the things themselves. Colors, lines, circles unite into forms which are potentially in things, but which nature never had the occasion to create. Through the artist the creative ground of being creates forms which do not exist in nature but which do reveal the power of being.

Then we have examples of geometrical abstraction and its transformation into a stage of radical abstractionism. Piet Mondrian's *Facade of a Domburg Church* presents a particular church reduced to a few lines from among all the richness of its natural structure and form. Mondrian goes still further in this process of reduction in a painting he simply calls *Composition.* Everything objective in the ordinary sense of the word has been annihilated and what is left is a relationship of colors and lines which are original, primordial, and express vital forms of being.

We are now ready to consider the most recent stage in the development of the visual arts. It would seem that an artistic revolt against the disruption of the surface reality is taking place. Artists are attempting to attend to the conventional aspects of experience again. Yet the style, growing out of the expressionistic explorations, is not a simple return to naturalism. It represents a fresh and original encounter with reality. Furthermore, it discloses both an artistic and a religious change. It is a desire for concrete meaning, for filling the everyday reality with the discoveries which have been made by the expressionistic ventures into the depths below the broken surface of nature.

Let us consider some intriguing examples of this latest artistic phase. In Willem De Kooning's *Woman I* [plate 59] we have an attempt to return to the human figure and human face while still utilizing stylistic elements of the expressionists. We find an absolute rejection of any attempt to return to the idealistic or naturalistic styles before expressionism had become the dominant mode. De Kooning wishes to advance, not retreat.

Still more striking examples are found in pop art. Here is a radical, intentional return to the surface of things. Pop art tries to show the surrounding banal reality in terms of pieces taken from it. Collages are made

in which pieces of reality are mixed with paintings. There is also a radical return to the third dimension in painting and sculpture. Many of these works reveal an uncanny quality, something like the figures in a wax gallery. We see rooms which are frozen; the figures in them are immovable. For example, consider George Segal's *The Dinner Table* [plate 60]. The room itself has been made by the sculptor as a part of the work of art, and the figures then placed in it.

The *Engagement Ring* by Roy Lichtenstein uses comic-strip figures that are all surface and bring the most vulgar daily reality before our eyes. Yet in some sense it is still expressionistic, and represents a new kind of reduction of reality. Tom Wesselman's *Still Life* exhibits an extreme banality that simultaneously is aggressively fascinating and repulsive. Evidently this is what the painter wants to achieve. He desires to remain in the midst of everyday reality and to show his feeling about it. In Robert Rauschenberg's *Inside-Out* we see actual rooms. Indeed, this is not a painting, but a real room that has been built out of pieces of bricks and other objects of the natural world. Jasper Johns's *Out the Window* is a collage, put together from many elements of reality which do not originally belong together. Claus Oldenburg's *Interior* tries to show contingent, casual elements of nature brought together and made conspicuous and intensive.

What are we to think of such works? They are so new that a considered judgment is not yet possible. Many will wonder if pop art is still art. A few pointers to aid us in interpretation suggest themselves. They can be interpreted as new forms of critical naturalism. They can be viewed as representations in concentrated form of the world which actually surrounds us. Yet they are vastly different from the older, preexpressionistic applications of this style. Some of the uncanny quality of expressionism and surrealism is evident in these productions. The question which remains to be answered in the future is this: Is there something creative, original, and brilliantly new in these works?

One last development remains to be mentioned. This is a new exploration in the field of optics. José De Rivera's *Homage to the World of Minkowski* introduces us to the realm of curved space through the study of optical effects and geometrical line. It seems to be a scientific illustration of potentialities in the visual realm which nature does not reveal, but which the artist can make manifest. Thus we are introduced to op art, which produces new forms out of the illusory effects of lines and planes, shadows and light.

In conclusion, what can be said about the religious dimension of these three most recent stylistic explorations, the return to the figural world, pop art, and op art? If these movements are interpreted as various at-

tempts to deal again with the world in its concrete reality, how success-
ful have they been? The fascinating power they have exerted with many
people might be cited as evidence of a measure of success. What does
this mean from a religious standpoint? Does it not mean that for the art-
ists reality has the appearance that is displayed in these works?

Many other expressions of art in our time—for example, drama—tell
us the same thing. This leads us to the judgment that an artistic return to
reality seems to be necessary; pure expressionism seems to have ex-
hausted itself. But this return cannot be a return to what we left in the
year 1900. Reality is encountered today in a different way. Our artists, in
their honesty, show us that. They express a sense of something uncanny,
something unfamiliar, something which is certainly not the rich world to
which they wanted to return. Can we ever return to the rich world to
which our contemporary artists aspired?

Let me respond to this question with another question. What is the
meaning of art itself? Are we now in a period in which not only encoun-
tered reality has become unfamiliar to us, but in which even the concepts
with which we have dealt with reality have become impossible? Is this
new art an art of nonart? This is a paradox, because there are fascinating,
artistic elements, expressive elements in this new art; but at the same
time, one finds an element of something that is "nonart." In other realms
of culture, similar phenomena are emerging. There is a religion of non-
religion, a religion which has nothing to do with the religion of individu-
als or groups in the traditional sense. There is a theology that makes use
of a language "without God." This is a paradox because theology literally
means "discourse about God." Thus we now seek to speak of God with-
out speaking of God. Or consider psychology. This word means the
knowledge of the soul, psyche, but today the word *soul* is almost a for-
bidden word. Or philosophy, which derives from *philia*, loving, and
sophia, wisdom, now seeks to avoid the question of wisdom, that is, deal-
ing with the principles of reality and the meaning of life, and instead con-
cerns itself with logical and semantic calculation. Even music now ig-
nores the muses, the goddesses of art, and seeks simply to combine
noises together. We have a whole cemetery of dead categories. And this
certainly is a situation which makes us dizzy: A kind of metaphysical diz-
ziness grasps us. Yet we must encounter it; we cannot avoid it by looking
back to the wonderful fixed world of the years before 1900 in which ev-
erything felt familiar, and which for many people survived into our time.
But this world no longer has reality; it still exists, lingers, and does not
die easily.

We cannot look at our world as if it were the familiar one from which
our generation came. For the youngest generation the present arts are

not unfamiliar. They know that contemporary art is more adequate to the world that has been transformed by the sciences and by technical processes. From the standpoint of the religious dimension of reality, let it be that way, because this period of history and the changes in which we find ourselves are a manifestation of the inexhaustible character of the creative ground of all reality.

Question Period

QUESTION: What possibilities do you see for theology in the development of the "without God" language?

TILLICH: I would simply answer that I think we must try to devise a better theology than that which language alone can accomplish. But how to do this is the problem. This leads me to a more general remark. I believe that nothing is lost in history. When I sharply distinguished between different periods, I did not mean to imply that elements of earlier periods are finished and that we are now in a completely new one without continuity with the past. Every creative work grows out of the past and adds something to it. In theology as well as in the arts, we can be confident that out of the past, and out of the creative sources which are still very much evident at the present time, will emerge something positive that provides more than just the questions inherent in pop art and op art. We must go through the period of the questioners. I would say to the theologian, do not go back to traditional theology in its other forms; recognize that this traditional theology is no longer possible. But *know* the traditional theology, be familiar with it, and then out of it, create what is viable today, what is understandable, meaningful, and expressive of ultimate reality in a way that can grasp us. To both my theological and artistic friends, I would urge: Go forward. Take as much of the past with you as you can but without the intention of returning to it; in one way that is the meaning of this whole lecture.

QUESTION: One of the themes of recent thought is Nietzsche's famous parable of the madman who speaks of the death of God. Many twentieth-century existentialists have developed the implications of this image in their thinking; would you relate it to the themes you have discussed tonight.

TILLICH: In one pasage Nietzsche refers to the madman who says that "God is dead." In another context it is the "ugliest man" who has killed God, because he could not stand the omnipresence of God who was always the witness of his ugliness. But the idea of "the death of God" also means something else, namely, the breakdown of all the traditional val-

ues in the bourgeois society of the last centuries. In spite of their attempt to save the traditional values, according to Nietzsche's prophecy, they are doomed to destruction. There is much in the thought of nineteenth-century thinkers, such as Nietzsche, that is anticipatory and prophetic of what has happened in the twentieth century, namely, the destruction of the past world and its structure of values. Nietzsche's influence on Heidegger (who wrote two big volumes about Nietzsche), on Sartre, and on many other existential writers, painters, philosophers, theologians, is great, because in him the feeling that something is wrong with our society, in spite of its material abundance, becomes articulate and prophetic. For this reason the history of existentialism and expressionism—which belong together—is involved with Nietzsche's thought in an essential way.

QUESTION: Dr. Tillich, would you elaborate on your views of photography; can it or can it not be art?

TILLICH: First of all, we have already undermined any dogmatic definition of what art is and is not. So your question is doubly difficult to answer, because we know neither what photography can be nor what art is. Nevertheless, I will try to give an answer.

First, I will start with the meaning of a portrait painted by an artist, or sculpted by an artist. A portrait is free of the specific moment, the here and now. The photographer cannot change the way in which you are sitting before him. He can photograph you from different angles, but he is always photographing the being who at the present moment is in a specific chair. The artist can do something more. He enters into the biography of the man whom he wants to paint, into the elements which are not present in this moment, but which have formed his face. He tries, so to speak, to penetrate to the essence of this individual, to that which he could be and to that which he has made of himself in the history of his life. This is the greatness of art. In a great portrait, there is something of the eternal essence which the photographer cannot capture, although he can provide us with a number of illuminating aspects of the person. In this sense, the photographer is an artist. But in respect to the attempt to condense a full character into one moment, one view, the photographer does not achieve what a great artist is capable of doing.

QUESTION: If man can have only partial victories over evil, what do you see as his ultimate purpose and meaning in life?

TILLICH: The ultimate meaning of life cannot be in this life. If it were, then it would be identical with the last moment or some moment in the process. This would always be ambiguous and not ultimate. What can happen in this life is the breaking in of the ultimate into a particular moment of time which I have called a *kairos*. Such moments are special, cru-

cial moments of one's biography or of the history of a nation, or of the world. In these moments, partial victories are possible. So I am not without belief in victories. I have experienced victory; for instance, the victory of expressionism over the immediately preceding forms of art which were profoundly unsatisfactory from the point of view of expressing the ultimate meaning of life. Such victories always can happen. But look at what has happened to expressionism itself. It became distorted, repetitious, mechanized; consequently, a revolt against it has occurred. And it may be that this revolt is the prelude to another breakthrough. It would be a true victory if we could return to the fullness of the concrete in the power of the ideal essence. But we do not know if this is the case. And if it is, there will come a point again where a new revolt and a new breakthrough of the ultimate into the temporal will be necessary. In this sense, victory is a matter of the *kairos*, the great historical or biographical moment of the fullness of time. But it is not a matter of progressive development toward a final perfect stage within history.

QUESTION: Would you please elaborate on the religious dimensions of Cézanne's apple to which you eluded?

TILLICH: Now I didn't call it religious; I called it cosmic. Cosmic means related to the world as world and cosmic is indirectly a religious concept. An object can be painted in such a way that it shows a particular object as containing or expressing the universe; it is then not just one isolated part beside countless other isolated parts. This concept is impossible to describe without alluding to a painting that expresses what is meant. Cézanne's teapot is an example; my original reference years ago was to a teapot; the apple is an invention of this moment; it really does not matter; teapot or apple; it is all the same. Everything and anything can be elevated by art to a dimension of meaning in which something is shown which actually is in everything, namely, the creative ground, out of which it comes. More than this can hardly be said on the discursive level. Of course we make some attempts at analysis. We can say that a work is constructed through large planes and extensive fields of color that have the effect of giving a power by which the work of art transcends the particular and becomes cosmic. But if we ask the art critic to explain how and why Cézanne is great, there comes a moment when we realize that every explanation will do violence to the actual power that is in the paintings.

QUESTION: The painter Kokoshka felt that the dehumanization process expressed in much contemporary art is a degradation of art and a form of antiart. Would you comment on this view of Kokoshka?

TILLICH: Kokoshka should not have spoken like that, because he participated in the development that led to that situation. He came from Austria

and played a role in the early period of German expressionism. His manner of treating persons is definitely and grandly expressionistic. Now history has gone beyond him. I understand the opinion expressed by Kokoshka that later artists have gone too far beyond him in the treatment of persons; but that development was implied in his own works. I can confess to you that I have a similar feeling with respect to the theology "without God." I have spoken about the "God beyond God," and many similar statements have often been interpreted as the negation of God. Now appear the theologians who speak of God without God. So I feel that I am responsible for this in the same way that Kokoshka is for the development of this movement in art. However, I want to be just to the young theologians of today who go farther than I can go. I do not know what will come out of their explorations. I do not know what they mean. But I know what abstract expressionism meant. It was a venture into elementary forms of reality. You can say that it was a sin against art. But it was also honest. It was an expression of the experience that the ordinary world no longer was a world that could be used as the material for painting. In a similar way, the young theologians are making fresh explorations and we must wait and see what comes of their attempts.

QUESTION: Is there any relation between the dehumanization process in art and the dehumanization of man accomplished by the Nazis and other Fascist movements?

TILLICH: There is a relation, but it is not the one implied in the question. I remember hearing a lecture in Frankfurt in the late twenties in which the professor argued that the beginning of expressionism was the beginning of an earthquake which would destroy much. The early expressionists worked before the First World War. Their work was prophetic of the tremendous upheaval in values that the war introduced. The foundations were shaken; and in this sense there is a relationship. But there is no direct relationship between expressionism and the atrocities of Fascism.

Different and essentially sociological elements were responsible for the latter, namely, the tremendous hatred of the depossessed lower bourgeoisie, or lower middle class, which developed in Germany during these years against the intelligentsia and the upper classes. The artists who painted the disrupted reality in German expressionism were the most courageous people. They were not in despair. They were not aggressive and hostile; they had the courage to express what was happening. The great enemy of all expressionistic painting, indeed of all modern art including impressionism, was the lower middle class which was desperately afraid of losing its familiar world. Let me conclude with some personal memories. In the years 1920 to 1923, after the First World War, I was teaching at the University of Berlin. At that time, something was go-

ing on in the building opposite. In this building, the newly created German republic had used an imperial palace as space for a museum of modern art. Tension, conflict, and struggle took place between the lower bourgeoisie and the artists. The bourgeoisie hated the pictures, ridiculed them, wanted to throw them out, destroy them—and the destruction was accomplished when they obtained a leader named Adolph Hitler who called all expressionistic art distorted and perverted. Now here you have the real relationship; it is the struggle between those who dehumanize man and the expressionists who, at that time, were attempting to break through the banal and dishonest encounters with reality in order to reach a more vital relation with the creative ground of being.

17

Theology and Architecture

This is an address given by Tillich in 1955 at a forum sponsored by Architectural Forum *concerning the state of Protestant architecture. Among participants at the forum were the architects Pietro Belluschi and Morris Ketchum; and two of the clergy, Darby Betts, who had also studied architecture and was responsible for the building of one of the first modern churches in this country in Alexandria, Virginia, and the late Marvin Halverson, then of the National Council of Churches. Appended to the lecture are a few of the comments made by Tillich in the discussion.*

I CANNOT DEAL with the architectural problem as such. The only thing I can do is to give some indications of what it means from the Protestant point of view. First, I shall derive some special principles from the general Protestant principle, then I shall give some of my ideas on art in general, and third I shall speak on the position of architecture in relation to these two.

What I call the Protestant principle could best be defined as the acknowledgment of the majesty of the Divine against every human claim, including every religious claim. From this it follows that no church, and no self-expression of any church, is in itself absolute. There is no absolute unconditional style in any religion, style in thought, style in doctrine, style in cult, style in ethics. This, of course, pertains also to the artistic self-expression of the church. It is true of all self-expressions of the church. It is true of all self-expressions.

"Theology and Architecture" originally appeared in *Architectural Forum*, December 1955, pp. 131–34, 136. It was later reprinted in *Church Management*, October 1956, under the title "Theology, Architecture, and Art," without the subsequent discussion. It is reprinted here by permission.

To compare the situation with that of the Greek Orthodox Church, let me recall Father Florovsky expressing to me the classical Greek Orthodox idea that the icons [plate 5], the sacred pictures, are not simply pictures but have in themselves, by their very nature, sacramental character. Therefore the church is justified in telling the artist definite rules according to which a sacred picture must be made. He has freedom in many respects but he has no freedom in those respects which make the picture sacramental. The Father complained that the Roman Church already in early ages had deviated from that idea and that Roman iconography is much freer, but, of course, as he said, less sacred, much less representing the Holy Power. Protestantism, developing out of the Roman Catholic Church, is completely free; and no Protestant artist can accept any rule for producing a picture except one rule, that if this picture is supposed to become a ritual or cultist picture it must be an expression of *ultimate concern*—it must be an expression of the Holy. This is the first point.

The second point derived from the Protestant principle is the close relation of Protestantism to the secular world and all kinds of secular creations. Out of the very fact that nothing is absolute in relation to the Divine itself, no expression of religion can claim absoluteness. The sacred sphere, as such, cannot claim priority in relation to God or superiority over secularism.

Protestantism has, as I once wrote, a passion for the secular. This of course is understandable only if we use a larger concept of religion, namely, religion as a state of being ultimately concerned. It is not necessary to go into the Holy of Holies, in order to find God. You can find Him in every place. When Solomon built the Temple, the omnipresence of God made it a problem for him to build a house of God at all. This is the second point arising from the Protestant principle.

Man in his existential situation is in bondage all his time to preliminary concerns. He is not in the state of investing every joy, every meal, every labor, with ultimate concern; this is why there is a sphere besides the sphere of the secular. God is not any nearer to the sacred sphere but we are not in the Heavenly Jerusalem where there will be no temple because God will be all in all.

Then the third point that follows from the Protestant principle is manifoldness. Since there are many different forms of Protestantism there is variety of expression. But there must also be an element of unity. In order to be a Christian Church even a Protestant church must participate in the Christian event.

I define the Christian event as the appearance of a new reality in Jesus as the Christ.

Participation is possible only through tradition. Like my Episcopalian

friends I criticize the Protestant idea that men of today can jump over 2,000 years and immediately be in the lap of Paul or John. This is impossible; it is only through tradition that we can participate in the past. On the other hand, Protestantism carries in itself the element of protest against tradition. The history of Protestantism is the balance between tradition and reformation. If one of them goes, Protestantism goes.

Therefore, Protestantism should not become what the psychologist Jung called it, a continuous iconoclastic movement. The destruction of symbols is tremendous in the history of Protestantism. Against this we have to fight. But we have to fight not in terms of making any symbol absolute, but either by eliminating some symbols that have lost their power or by reinterpreting those which still have it.

From these three points that I derive from the Protestant principle allow me to go on to some general artistic considerations.

Religious Art Is Expressionistic

Here I want to start with a very shocking statement: namely, that all specifically religious art is *expressionistic* throughout the history of mankind.

Of course, even in naturalist and idealist art the Divine is not lacking, because there is nothing existing in which the Divine is completely lacking. Ultimately no irreligious art is possible. But in naturalist art the Divine is seen indirectly through the finite form and its relations with the finite world. Naturalism is possible regardless of whether or not the subject matter is taken from the symbols of the religious tradition. It is not necessary that a subject of a naturalistic painting is, for example, a peasant dance; it can also be a Virgin or a crucifix that is painted in such a way as to be in the realm of finitude and without the power of religious expression, without religious meaning.

This leads me to the three levels of the relation between religion and art. At the first level, there is neither religious style nor religious subject matter; a landscape, a portrait, a bridge—things like that.

The second level has religious style without religious matter. It is expressionistic in the larger sense—not restricted to the group of painters we call expressionistic.

Then there is the third level, namely religious subject matter but not a religious style, as in many pictures of the Renaissance and succeeding centuries.

The great tradition of religious art in all religions and in Christianity has the character of *expressionism*—expressing not the subjectivity of

the artist but the ground of Being itself. This is so in the early Christian era and the Byzantine art especially; but you can see it also in early and later Romanesque and Gothic, and you can see it in some Baroque pictures.

Then something happened which I like to call the Great Gap which started after Rembrandt in the middle of the seventeenth century and goes on to about the year 1900; and in this Great Gap I see no important religious art. What I actually see is the continuation of naturalism as we have it in the late Renaissance and through the eighteenth and nineteenth centuries. The greatness of the twentieth century, it seems to me, is that it rediscovers the expressionist principle, namely the principle of breaking through the beautified naturalistic surface of things to the real depths which break out with disruptive power: not that the work of the artists is disrupted but the natural surface of reality is disrupted.

The last point here is the problem of Protestant art generally. If it is true that in Protestantism symbols have disappeared, as I said quoting Jung, then the question is: are we able today to bring new symbols into existence, or is this impossible? Certainly it is impossible if done intentionally. Symbols are born and die but certainly are not produced by intentional acts. Or are we to revive symbols of the past? This is the great difficulty for Protestantism which I see every day when I try to reinterpret theologically the classical symbols of faith.

When students at Union Theological Seminary assembled an exhibition of religious art of our time, there was an awful poverty in traditional religious symbols but a richness of secular subject matter brought into pictorial form in such a way that it had expressive religious power in itself, without trying to use the traditional symbols at all.

Picasso as Religious Painter

I was once asked, which is the greatest Protestant picture produced after 1900? I replied immediately, without reflection, Picasso's *Guernica* [plate 44]—the disruption of reality in which we find ourselves. Now this, of course, cannot be the final answer because such a picture is not an affirmative picture. It does not deal with the traditional symbols in any way. It raises the question but does not give the answer. But is it not better to raise the question honestly than to give an answer that is half or totally dishonest because of the traditional bondage?

This brings me to my last subject: the special position of architecture. I must ask to be excused for my inexpert speaking about it in the presence of experts. Yet I believe that architecture cannot simply be seen in line

with the visual arts and the arts generally. It has a very special character which the others do not have. It has first of all a practical purpose, namely to build a house. This is a disadvantage because architecture cannot be in the same way directly and purposely expressive as a picture or sculpture. On the other hand, it has a great advantage: it is bound by purpose to a definite character and cannot go wild with irrational imagination.

What does this word *purpose* mean? We discussed this when the *Bauhaus* type of architecture [plates 63–64] started in Germany and somebody invented the ugly word "dwelling machine." It was repulsive, but we tried to think what it could mean in a good sense and in a bad sense. My answer is that what must be done first of all in building is to single out from the infinite space, into which we are thrown in our nakedness, a piece of finite space which protects us against the infinite. The purpose of a building is always to produce something which makes existence in time and space possible for a finite being; to give him that limited space from which he can then go forward toward infinite space; psychologically it gives him what we sentimentally call a home. The metaphysics of home includes adequate surrounding materials but goes far beyond.

Architecture excludes forms which are not born out of the creative situation and which are superimposed only out of artistic traditions. I fought this battle all the years when I lived in a pseudo-Gothic seminary with a very large pseudo-Gothic church alongside that was being shown to visitors as a very good example of religious art. It is not that I have anything against Gothic buildings that were born out of the creative situation of the time when they were built; but if architects in the middle of the twentieth century sit down and study the blueprints of architects of the thirteenth and eleventh centuries the result is repulsive. One should never confuse imitation and tradition.

Baroque—Mysticism from Below

Now a few special problems that will probably be discussed more powerfully and adequately by all of you. It was said that in the book of Rudolf Schwarz (*Vom Bau der Kirche*—"Concerning the Building of the Church") there was a burst of light over the altar in Baroque. I have a quite different interpretation of the Baroque. It is the bursting forth of the underground of religious life against the Renaissance form of humanism. Baroque mysticism comes from below. Medieval mysticism comes from above.

The development of light in the churches is very interesting. Slowly the daylight replaced the light that is broken through stained-glass win-

dows. The daylight is not the outburst of Divine light but rational light by which one can read and the congregation can see one another. Broken light is mystical light, and when in modern churches today the windows are tinted again I have a great sympathy for it. Yet I have no sympathy when they use figures. The early Gothic forms are not good when imitated. What we can do that was not done before is to use mathematical forms, pieces of color put together, and I think this is adequate to our feeling in which all forms of life have been brought down to geometric forms.

We seem not to be able any more to understand the organic forms in the way in which we did in former centuries but we are much better able to understand the underlying spiritual power of geometrical forms. We should not say that religious life must express itself in organic forms if it is the real possibility of our time to express it in cubic forms.

The Ideal of Holy Emptiness

Then another consideration is the problem of sacred emptiness. One of the most important expressions of sacred emptiness occurred in Judaism and Islam—and was then forgotten because of the Incarnation idea. Christianity was able to have the Divine again in forms of finitude, and Christianity filled the churches with them. Today these forms, most of them, have lost their meaning. Therefore I do not hesitate to say that I am most satisfied by church interiors—if built today—in which holy emptiness is architecturally expressed; that is of course quite different from an empty church [plates 65–66].

I have an especially negative feeling toward putting sculpture in a three-dimensional form into the church so that you can go around it. You never could do that in a Greek temple [plate 2]. The goddess looked at you and you could not go around her. The moment you go around it, it becomes an object among other objects. Therefore the walls are the only place where sculptures can be placed and look at you.

These few ideas bring me to an end. Probably the way modern religious art will be reborn is through architecture. If architecture leads, born out of purpose, then the same thing will probably happen that happened in early periods of mankind where the tool was loaded with magic power and therefore became beautiful. It was a tool and at the same time a work of art. The separation of technology and art is a very late development which can perhaps be recanted by an architecture which gives great possibilities in its very nature as architecture.

Let me close with a word on taste. If you are a relativist in this respect you can simply say that what was your taste in the mid-twentieth century

will pass just as nineteenth-century taste has passed and we cannot accept it any more. I do not think such relativism is justified. There are criteria which are abiding.

I mean the principle of honesty. There is truth in every great work of art, namely the truth to express something; and if this art is dedicated to express our ultimate concern, then it should be not less but more honest than any other art.

After Dr. Tillich's keynote, here are some of the things they said:

BELLUSCHI: Architects have been thinking a great deal about symbols. By being creative, architects are in effect unconsciously setting up new symbols, if they possess honesty and depth of feeling and can avoid the temptation of transitory fashion.

TILLICH: You used the decisive word, the unconscious. Of course, we do that all the time.

Church and world

KETCHUM: Perhaps the most wonderful church would be a glade in the forest with a cross at one end.

BETTS: I have a multitude of contradictory emotions on that. In the first place, I would not consider any glade in a forest an adequate space because when we are talking about a space set apart for holiness I want to bring man in contact with the Creator of that space. This is *man working on his creation*, so the forest is out.

KETCHUM: I agree. But the thought of the glade has some beauty and simplicity that our new architecture might capture.

BETTS: The church must be supernatural in the middle of natural order. Naturalism partakes of the sin itself in any age. I think our greatest struggle in Protestantism today is to avoid on the one hand the despising of Nature and on the other hand the flight to the World.

CHAIRMAN: Now you said that in building a church—if I quote correctly—God through man was working on His creation. Is the distance so very great between that concept and what Rudolf Schwarz is saying, as a Roman Catholic: that God through man is working on the creation which is then sacred?

BETTS: Bestows sacredness on it . . . Do you think, Dr. Tillich, that a *rapprochement* is going on that could be seen best of all in architecture?

TILLICH: Yes, and I believe you have the vantage point of the middle in your church.

What happens in a church?

HALVERSON: We talk a great deal about our feeling when we come into church, the kind of emotion we are supposed to have. Fundamentally we must face the fact that church building is designed not as a place where a person comes for a religious experience, although that may happen, but to house a community that is gathered together to do something. A New England meeting house of the eighteenth century expressed its relation to the community. The contemporary church is too diffused, not clearly enough articulated. I think we can never forget that church buildings are designed primarily not to create a mood but to provide a setting for the church's act of worship.

WEAVER: I don't think modern man has any trouble finding out what to do in church in connection with such activities as the men's Tuesday night supper. He eats what the church feeds him and if the food is bad you can always call it fellowship. On a list of things that people do within a religious building one is cooking—and I have seen some beautiful kitchens—another is Sunday School. . . .

BELLUSCHI: The fine answer I got one morning was that the kitchen is more important than the altar.

BETTS: What does the church do? Let's try a word on that. Of course it includes the sacraments, which may be two or seven or more that we have not thought of yet. But isn't the chief job of the church to put man's life, from the Christian point of view, in proper frame of reference, whose center of life is in God's presence? Now the whole map of the church program seems to me to be pointed to this great objective.

WEAVER: Do you think it is irrelevant to the Protestant Church that one of the tests of the service, of what goes on in the church, is the way I live?

BETTS: Certainly, that is what I mean by putting your life in a proper frame of reference whose center is God, not yourself. That has tremendous ethical consequences. Yet religion is not primarily moralistic. But the problem you are giving voice to is, Can a thinking man simply come to church and worship? He can't; he must go through a long educational process which includes the kitchen, the trustees' meeting, the Sunday School, I hope something else. It makes worship possible as an art.

CHAIRMAN: That is the first time I have heard a sensible explanation of all those institutional features.

Arrangements for worship

CHAIRMAN: In the church room itself, is it not true that the Protestant Church may well put the pulpit at the center, because the Protestant Church is a church of the Word?

TILLICH: Seeing and hearing are the *two* senses that are decisive. To be a church of the Word does not mean to be a church of talk. That is precisely what has happened to Protestantism too often. The Word is also present, according to the classical doctrine, in the Sacrament. It is conveyed not only through human language but through visualities. Without pretending to be an expert I might suggest that today usually the pulpit is in the center and the altar on one side or vice versa; perhaps a combination of the two in the center would be the ideal solution for now. And for Protestantism I like a round church, the people seeing one another.

HALVERSON: Did not classical Protestantism try that solution after the Reformation? The first church in Scotland after the Reformation had the pulpit in the middle with the congregation around the table which stood before the pulpit.

CHAIRMAN: You speak of pulpits and altars. What is the altar in Protestant worship?

BETTS: Dr. Tillich, don't you think the altar is being more and more emphasized in Protestant worship as we recapture some of the things thrown out in the Reformation?

TILLICH: Yes, it is a table.

HALVERSON: Pulpit and table.

TILLICH: In most Protestant churches the Lord's Supper is connected with the act of repentance and the essence of the Protestant concept is that it is not repentance which produces the Divine gift but the Divine gift produces the repentance. The sacrament really has two possible meanings: one is of the community, meaning the table around which we sit together; and the other is that what we eat and drink is sacrifice, that it has some special character which is symbolized in the Body and Blood of Christ, the presence of the Divine. Sometimes in Roman Catholicism the latter side has completely overcome the former. In most Protestant churches the community side is stronger than the other.

CHAIRMAN: Is there any special architectural interpretation of that?

BELLUSCHI: The altar and communion rail tend to be much closer physically to the congregation. The rail can be three-sided. At Alexandria, Va. it is four-sided which means that the minister has to turn his back to a portion of the congregation.

BETTS: Well, which way you face is not vital. But one of the main problems we have in what is known as the liturgical movement is bringing the people back to God in the worship. If the altar is far removed and the people set off, as in contemporary churches falling into the Gothic floor plan, this goes back to the Roman Church which involves so much magic.

The church as ever new creation

CHRIST-JANER: After much travel, looking at churches, may I stress that the Christian Church should reveal above all the mind and the spirit of Jesus Christ . . . He took severe issue with the dead form which encased the thinking of His contemporaries. Indeed Jesus spoke harshly only when He charged men with plodding under the letter when they should take flight with the spirit. No one pours new wine into old wineskins; new wine has to be put into fresh wineskins.

HALVERSON: A professor of architecture once said nonetheless that "Gothic was the only religious style." My reply was: "You are saying that Christianity does not have a relevant word for our society."

WEAVER: May I put a question? Mies van der Rohe designed a new chapel for Illinois Tech. It is meaningful to me as having the style and engineering of every day. Can we all, in an attempt to be honest, take this as a departure and somehow endow it with a new dimension for the church—not rejecting what is in modern life but giving it this new dimension which might be what you called "sacred emptiness"—or does architecture face going into some sharp contrast to daily life in the name of the spirit?

TILLICH: I think our whole discussion clearly says we go the first way, not the second; we use the stylistic powers of our age for church buildings.

The architect's belief

CHAIRMAN: Might not an infidel create a great church?

BETTS: Can't we also say that if he were a practising believing member of the church he would have created better?—But I guess I am limiting God.

TILLICH: Out of the man's doubt may have come his power. This is often true in theology.

Architect and congregation

BETTS: To get back to your question, basically where does the architect stand? He stands between cult and community. From his vantage point he, as a good architect, uses his tools honestly in the light of the cults standing in the midst of a contemporary community.

BELLUSCHI: I am troubled by a contradiction. His wisdom is derived from the congregation, but the average taste of an average congregation

is bound to limit more than to help the architect's creative efforts. He may easily end in compromise to please an unenlightened average of taste. It takes a great deal of good judgment to know when to add to his wisdom and when to stand pat.

TILLICH: You should receive very little of the taste of the congregation; it is one of the mistakes of Protestantism to give voice to shopworn symbols and ideals which completely fill so many middle-class people in their spiritual life.

18

Environment and the Individual

This was an address given at the Centennial Convention of the American Institute of Architects, 14 May 1957. Tillich distinguishes environment from surroundings and discusses its significance in relation to art and architecture.

THE TERM ENVIRONMENT seems simple and without problems. Actually it is complex and a difficult though open doorway for man's self-understanding. Man and his relation to his world are misunderstood if man's environment is defined as the totality of objects which are so close to the place where he lives that he experiences them in a continuous encounter. If taken in this sense, environment is identical with surroundings. In order to know the environment of a man one has to register, within an arbitrarily chosen orbit, every single object which he may regularly encounter. For instance, every single tree along the road he uses daily, every single figure in the pattern of his drapery, every single car he sees passing his street, every color, every sound by which he is consciously or unconsciously affected. All this and an infinite amount of other objects surround him. But they are not his environment. Environment is made up of those elements of his surroundings which are relevant for him as man. A man and his dog have the same surroundings, but a different environment. The Bosch painting in my living room is environment for me; it is not environment for my dog for whom only the peculiar smell of oil and varnish may have environmental character. For my maid, the environmental character of the picture may consist of the awareness of the sub-

"Environment and the Individual" originally appeared in *AIA: Journal of the American Institute of Architects*, June 1957, pp. 90–92. It is reprinted here by permission.

ject matter of the painting and of her duty to dust it from time to time. All this means that environment is not identical with surroundings and that it is correlative to him who has surroundings. The question is not environment and the individual, but the individual and *his* environment.

This means that the same surroundings are something quite different for different kinds of individuals. If one takes a New York Puerto Rican out of his slum surroundings and out of the environment which was his environment, and puts him into an apartment within a new housing project, he will bring his old environment into the new surroundings and deal with them in terms of his old. They soon will become a slum. Conversely, if somebody who grew up in a cultivated house and for whom the Bosch picture was a picture, he could make of a cave in a wartime trench a small underground living room. This is the first limit for the influence of surroundings on the individual. He selects from the surroundings what shall become his environment.

In this man is not different from any other living being—the dog, the fly, the migrating bird. But there is a difference between man and all other beings: Man's environment has the character of world. The environment of animals remains environment. It never can become world. What is world?

The Greeks called it cosmos, which means beauty, order, structure. The Romans called it universe, which means the unity of an infinite manifoldness. A definition of man in which all other definitions are implied is that he has not only environment, but also world. World is the structured unity of an inexhaustible number of actual and possible things. It is *the structure* which makes the world world: If we encounter world, we encounter it as a whole which is structured in time and space, in geometrical and biological forms, in things and consciousness of things, in laws and spontaneity, in the positive and the negative. All this makes the world world, and determines the relation of world and environment. One could say that in man's environment world is present and that every piece of his environment points beyond itself to his world. This is decisive for any attempt to change man's environment. The criterion of every change in environment is the character of the world which is manifest in the changed surroundings and which determines the character of the environment which people can make of it.

The presence of world in an environment expresses itself in many ways. And each of these expressions has symbolic character. It points to a particular self-understanding of man within his world. As such it reveals something about man and world in themselves and in their encounter. The environment as the result of an encounter wins spiritual significance. Let me give a few examples.

Environment is by its very nature limited in space. But world, present in environment, drives beyond any limited space. The world-space is open in all directions without a noticeable or even imaginable end (whatever physical theory may say about the limited space of the universe). This infinite space is potentially present in the limited space of the environment, producing two reactions each mixed with anxiety and courage. The infinite space is both threatening and liberating. It threatens to take away any place upon which one can stand by its endlessness and emptiness. It liberates from the bondage to a particular space its narrowness and its tendency to isolate from the world. Narrowness, on the other hand, has given the name to anxiety, *angustiae* in Latin. It is the cutting off of life-potentialities which produces such an outbreak of basic anxiety. At the same time the narrow place is the protected place—the mother's womb, the cave, the narrow streets of the wall-protected medieval town. The modern functional house with its large open glass walls seems to express the same courage which has conquered the space above the surface of the earth and is conquering the cosmic space itself. But man remains man, and often just in contrast to his wide openness, needs the place which is a separated part of endless space to give him a feeling of psychological as well as physical protection.

Connected with the question of the endless and limited space is that of environment which gives privacy and which prevents privacy. The spiritual problem in this respect is even more urgent than that in the former example. External privacy makes inner solitude possible or at least easier. And nothing is more needed in a period of loneliness within the crowd than solitude with oneself and the divine ground of one's being. The interdependence of the individual and his environment has produced an environment in which solitude is less and less possible. Both time which leaves no time for solitude and space which is organized without a space for privacy work against it. There is no privacy in houses for the individual member of the family. This is being caused by owners and builders under the false assumption that the family is a unity which must always appear together. But the family consists of individual selves who need self-encounter. Otherwise, they become lonely within the family group and hostile to it, or they resign to their fate of losing their individuality. It is here that a large responsibility lies with the architectural profession.

Connected again with this problem is that of environment and conformity. Its spiritual significance is still greater. Driving through the housing projects which are found throughout Long Island in commuting distance from New York, I asked myself: What does this mean in terms of human existence? Settlement after settlement with little distance between them, each with exactly the same model of house, small differ-

ences in color and design, each for itself in immediate vicinity of the others, each surrounded by a small garden. The whole thing seems to me a disturbing symbol of loneliness in a crowd, breeding as well as confirming the patternization of present-day industrial society. The impression given by the metropolitan apartment house developments is different. They lie more in the direction of mass concentration, but they seem to leave more freedom for individual non-conformism—as big cities always do. What will these developments do to the individual is the question that now arises. In the daily movement of people between model homes, office, factory, school, train, social-togetherness with people who live under the same laws of existence, are there symbols left which break the conformist compulsion?

The answer may be: It cannot be done from outside. Neither the city planners nor the architects nor those who direct the movement of the population can produce such symbols. They must come from inside. They are the concern of education and religion. But if we look in the light of this answer at the educational institutions, from family and school to public communications and at the way in which the churches consecrate conformism every Sunday morning, we shall become skeptical about this answer. Adjustment to the demands of our competitive mass society is the aim of most directly or indirectly educational activities. Such developments are useful for the ruling groups in a society and they give security to the others, not only in dictatorial but also in democratic systems. But there is a limit to their usefulness. When man becomes dehumanized in patternized security, the whole system loses those who can support it in the future, those who can say "no" to a given pattern, those who are able to experience the new in a creative spirit, those who take the risk to fail. Are there elements in the environment of our society which have symbolic power for this "no" out of which a new "yes" can spring? Let us remember that environment is a correlative concept and that surroundings are not yet environment. It may be that the surroundings develop in a way which makes non-conformism almost impossible. But they cannot suppress it completely. Every man has a source of uniqueness in his self. Participation is only one pole of being, individualization is the other. And every man has a direct approach to the ultimate ground and meaning of life—the divine. Certainly, solitude seeks for privacy. But it can even be experienced within the crowd.

And since this is so, symbols of non-conformism will always appear in the midst of surroundings which try to compel adjustment to models and patterns. We are made by our environment and we make it at the same time. Out of this follows our task, the task also of a group like this today. We should not imagine that we can change our cultural trend, either as

architects or as theologians or as educators. But where there are trends there are also opportunities. Symbols cannot be produced intentionally. They are born and grow and die. But one can tell how they are conceived and born: Out of the personal passion of individuals who in total honesty and total seriousness penetrate into the demands of the material with which they work, who have a vision of the form which is adequate to their aim, and who know that in the depth of every material, every form and every aim something ultimate is hidden which becomes manifest in the style of a building, of a poem, of a philosophy. Out of this depth, symbols can and will be born which, by their very character, say "no" to present conformity and which point to an environment in which the individual can find symbols of his encounter with ultimate reality.

19

On the Theology of
Fine Art and Architecture

*This was an address given on the occasion of the Eleventh Confer-
ence on Evangelical Church Buildings, held in Hamburg, Ger-
many, 8–12 June 1961.*

I

AT THE BEGINNING of my reflections on the theology of fine art and archi-
tecture there stands an experience that took place in the Kaiser Friedrich
Museum in Berlin just after my return from the First World War. I was
standing before one of the round Madonna paintings of Botticelli [plate
1]. In a moment for which I can think of no other name than that of inspi-
ration, there was opened to me the meaning of what a painting can re-
veal. It can open up a new dimension of being, but it can do so only if it
simultaneously has the power to open the corresponding level of the
soul. It was natural for a theologian to raise the question: "How is this in-
spiration related to what is called inspiration in theological language?
How is the aesthetic function of the human spirit related to the religious
function? How are artistic symbols—and all artistic creations are sym-
bols, however naturalistic their style may be—related to the symbols
in which religion expresses itself?" This question gained new urgency
when, a short time later, I was introduced by a friend to German expres-

"On the Theology of Fine Art and Architecture" originally appeared as "Zur
Theologie der bildenden Kunst und der Architektur," in *Auf der Genze* (Stuttgart:
Evangelisches Verlagswerk, 1962). It is excerpted here from *Gesammelte Werke*
(Stuttgart: Evangelisches Verlagswerk, 1967), 9:345–55. The translation is by
Robert Scharlemann.

sionism and at the same time became, without any introduction, an enthusiastic defender of the "Bauhaus style" [plates 63–64], which today, under the name of "International style," has burst forth in numerous variants in all countries. In the expressive power of expressionism and in the objectivity of the new architecture I found categories of spiritual creation that were significant for my theological work too.

Then something surprising happened. While I was lecturing on the philosophy of religion at the university under the linden trees[1] and making reference to ancient Greek statues and to the *Tower of Blue Horses* by Franz Marc,[2] in order to interpret the one by the other and Greek philosophy by both of them, a strange battle was taking place across the street in the Kronprinzen-Palais, the gallery for modern art, in which the painting by Marc was hanging. Representatives of the bourgeoisie, which later provided the central troops of the Nazis, fought against the new art with derision and hate and occasionally with fists. They felt it as a degeneration in art when art revealed their own degenerate existence. They called ugly anything in architecture that contradicted their own need for dishonestly making things appear pretty (*Verschönerung*). They smiled when they did not understand—they certainly had a right to do that. They hated it when they felt themselves disclosed—that was a wrong that finally led to their self-destruction. There are few occurrences that show, with such striking clarity, the ultimate seriousness—and that means the seriousness that points toward the religious—of the world of artistic symbols. Such experiences forced me to make a draft of a theology of art, including fine art and architecture. From an overwhelming abundance of problems that are connected with it, only a few central ones can be selected and discussed.

II

One problem, more verbal than real, is provided by the very concept of a "theology of art." Theology as *logos*, talk of *theos*, of God, appears to have in God its object. How can a second object, namely, art or fine art or architecture, be added to it? That seems to be impossible even grammatically. But it is possible when theology means not talk of God as of an object alongside other objects but—as it must mean—talk of the manifestation of the divine in all beings and through all beings. Theology of fine

1. *In der Universität unter den Linden*: the Friedrich-Wilhelm University, renamed in 1949 the Humboldt-Universität, is located on the street named "Unter den Linden."

2. For a similar painting, see Marc's *The Large Blue Horses* (plate 46).

art is then the doctrine of the manifestation of the divine in the artistic act and its creations.

Such a program has certain presuppositions and certain consequences. It presupposes that religion, in the fundamental sense of the word, is not an area alongside others—for example, alongside philosophy or politics or law or even art—but that it is the experience of a quality in all these areas, namely, the quality of the holy or of that which concerns us unconditionally. A theology of fine art presupposes that the manifestation of ultimate reality is recognizable in paintings and sculptures and, with a specific difference, also in works of architecture. If that is so, it results in a decisive consequence, namely, that art does not have to treat religious objects in order to be religious. Art can be religious whether it is the kind of art usually called religious or the kind usually called profane, or secular. It is religious to the extent that in it the experience of ultimate meaning and being is given expression. That alone is decisive for the construction of a theology of fine art and architecture.

In a work of art the element in which the experience of ultimate meaning and ultimate being is expressed is its style. Style is the third element in a work of art, next to its freely chosen object and its aesthetically defined form. It is the transcending element next to the free and the bound element; however, it does not lie adjacent to them but, rather, works in them and shines through them. Style defines by and large the choice of objects and the general form in those works which demonstrate a uniform style. For that reason the artistic style of every epoch is a document of the religious existence of this epoch. It is the task of the analyzing historian to decipher these documents, and the task of the understanding spectator to relive their meaning. When this happens, a light falls onto the whole and all aspects of a culture. In many cases these are the only documents that we have. But even if there are others, there are not any that give a more direct and impressive report of what the faith of an artist or of a school or a society is. One should not write a history of politics or philosophy or religion without bringing in the documents of fine art and learning from them how people of an epoch understood themselves and their place in the universe. That is to say, without a theology of culture there is no history of culture that penetrates to the depths, and without a theology of fine art there is no understanding of the ultimate meaning of works of art.

III

The number of artistic styles is legion. But the number of the basic elements of all styles is limited. They can be derived from the fundamental

modes of the human encounter with the world, that is, with the whole of what is encountered. In an act of radical abstraction, such as is the task of philosophical thought, I should like to lift out three elements of style which appear, in infinite combinations, in all styles but which are always under the dominance of one of the elements. These are the expressive, the idealistic, and the naturalistic elements. Every work of art is expressive. What was previously called beauty should today be called "expressive power," since there has been a complete collapse of the meaning of the word *beautiful*. As scientific cognition strives for truth, so artistic intuition strives for expressive power. For that reason the expressive element is present in all styles. It brings to light something hidden in the matter that is encountered, it brings to the surface a depth in things. It does not endeavor to express the subjective experiences of the artist but, with the help of the artist's openness for things, to express their depth. It is not necessary that this depth be the ultimate depth of the things, or their standing in the creative ground of all entities. But wherever art is created, there expression is given to a depth of beings that cannot be expressed in any way other than by art. What a painting says cannot be said by any art criticism or any philosophy of art or by any combination of concepts at all. And if the painting speaks of that which concerns us unconditionally, and hence shapes religious symbols artistically, it does in perceptible form what theology does in conceptual form. But no theology can replace what art does—just as the word cannot replace the sacrament.

Wherever it appears, the expressive element in styles shows similar characteristics: since it gives perceptibility to the depth in things, it breaks through the surface and alters their natural structures, whether that be through fragmentation and free recomposition, as in surrealism; whether it be through the overemphasis of individual elements, as in expressionism; whether it be through the negation of the particular, as in East Asian paintings; whether it be through the dissolution of organic forms into their inorganic, constitutive geometric elements, as in cubism; whether it be through symbolical accentuation of parts of the body, as in the "magical," or, better, "numinous," realism of primitive and modern artists; whether it be in the way spiritual substance shines through bodily features, especially the eyes, as in the mosaics [plate 61] and icons [plate 5] of Byzantine style; whether it be the attempt to give expression to the power and meaning of being by combinations of lines and colors without objective forms. All of that, this overwhelming fullness of styles, shows the dominance of the expressive element in fine art. And these are only examples.

IV

Now, it is my conviction, gained from historical facts as also from observational analysis, that the measure in which a style is defined by the expressive element is simultaneously the measure in which it is capable of expressing ultimate reality and hence symbols of the religious tradition. Only those styles which, in the portrayal of every object, give perceptibility to the depth-dimension of things can serve religious art in the narrower sense. They alone can express, in a religiously appropriate way, the depth-content (*Gehalt*) of a specifically religious symbol. For that reason the great religious art of the West came to an end with Rembrandt [plate 18], and only since 1900, with the beginning of the unfolding of the power of the expressive style, is religious art possible again, although it has thus far become actual only in tentative beginnings.

If that is true, the consequence is a critical evaluation of idealistic and naturalistic elements of style from a religious standpoint. Both elements are never entirely absent. The naturalistic element is not absent since the whole material of fine art, even in the most abstract styles, stems from the perception of the reality that one meets everyday. The idealistic element is not absent since, in every creative act, parts of the encountered reality are discovered in their essential character and shown in their potential fulfillment. Even these preliminary definitions show that the naturalistic and idealistic element belong together and stand in common contrast with the expressive element. Since historically—in the Greek and the modern development, for example—the dominance of the idealistic element temporally preceded that of the naturalistic, it makes sense to begin with a consideration of the idealistic element. It grows out of definite elements of the expressive, for example, out of the archaic element in Greece, out of the late Gothic in Western Europe. But then a humanization enters which subjects the expressive to the ideal of perfected nature. The figures of the gods in classical sculpture unite the substantial holiness of the archaic prehistory with the forms of a human measure. They represent the essential and timeless in the figure of the transitory. Therein is simultaneously the tragic signature that limits their greatness and announces their decline and that is visible in their perfect beauty. In the Renaissance, which is Christian humanism, the form of ideal perfection is simultaneously an anticipation of other-worldly fulfillment. The beauty of Renaissance paintings anticipates Paradise regained—and often alludes to it thematically. Idealism is anticipated eschatology. It is the anticipation of that which is possible only as the object of expectation.

On this basis countless religious paintings have arisen. But are the Madonnas and Crucifixions and Resurrections and biblical stories of the Re-

naissance painters real creations of religious art? They are not! They are visions of human perfection; no one can fail to see the religious dimension in this as in every art. But what is missing in them is the experience of the spirit which, as the hymn has it, "breaks the limits of our form." What is missing is the breaching power of the expressive.

The brief epochs of the dominance of the idealistic element are followed by periods of the prevalence of naturalistic tendencies, very quickly in the Greek period, in the modern period after the conquest of diverse reactions. The greatness of the naturalistic element in the history of artistic style is the attempt to create art in subjection to the immediately or critically clarified things that are encountered. It is this acceptance of the given that gives scientific empiricism and aesthetic naturalism its depth. In the humility of acceptance, its religious dimension is shown. Yet it can never create religious art. Religion lives in symbols; and when these symbols are taken literally and dragged down to the surface level of the everyday, the end of religious art has come. If Jesus, who is the Christ, the bringer of New Being, is made into a village schoolteacher, a communistic agitator, or a sentimentally long-suffering man, no religious painting can arise. Missing is the transparency, the threatening and promising element of the divine-demonic ground of things. Missing is —to repeat it—the breaching power of the expressive.

V

Let me now give a negative example. The predominance of any stylistic element has its dangers. The expressive element, through which the depth of things is to come to the surface, can be misused for the portrayal of the unimportant subjectivity of the artist; and the form-breaking power of the expressive can become a pretext for lazy or incompetent artists to withdraw from the reception of real structures. But the only person who can make a work of art out of the breaking of form is one who has mastery of the form that is broken. Yet the last centuries have shown that the danger for religious art lies at another place. It is the disastrous marriage between idealistically determined and naturalistically determined style from which there has emerged the freak which for over a century has defaced church papers and church buildings as religious art and which still plays a dismal role in congregations here and abroad. The naturalistic element in this marriage serves the wish of the many to keep at a distance the shaking irruption of the eternal into the everyday or to deflect it into sentimental religiosity. The idealistic element in this marriage serves the need for giving a pretty appearance to the surface of a social and individual existence, which in truth is not pretty. Here lie the

deepest roots of the resistance against the resurgence of power on the part of the expressive element in the styles since 1900.

In a seminar which I had once a month about ten years ago as a representative of Protestantism with representatives of Roman and Greek Catholicism, of Judaism and Islam in New York, it became clear to me that the end of religious art had long since come in all religions of the Western world and even beyond. It was especially impressive to see how the very significant representative of Roman Catholicism had to lead a desperate battle against the muddy floods of the religious kitsch that is for sale in the display windows of cathedrals in all cities of the world. And one wonders: What does that mean for Christian existence in our period?

VI

About our period we can say one thing. The surprising thing has happened; the expressive element has again taken the lead in a quick thrust forward. That offers hope for religious art. But there is a large obstacle in the way. The religious symbols, which are artistically expressed by art and subjected to a second symbolizing, have by and large lost their religious power as symbols. One constantly meets artists, in America, for example, who want to create religious art but have no living access to the symbols of Christianity. Either they then relapse into traditional and uncritical acceptance of symbols, and thus to the level of kitsch, to which they with their artistic possibilities are really superior. Or they try to apply their new style to the symbols, and the result is that they honestly but tragically fail because they can do it only from the outside.

It appears to me important to make an observation. The new expressive elements of style are obviously suited to give expression to what is contained in the symbol of the cross. But the crucified one is not the Christ; it is human being as such. Hence this art fails before the symbol of the Resurrection and related symbols of glory. For man as man, as an individual and as a species, is forfeit to death. The symbol of the Resurrection, however, indicates the eternal that appears today hardly as a question and certainly not as an answer. We should be grateful that our artists do not say more than they can say. We should not urge them for reasons of ecclesiastical tradition to become dishonest. We must wait. The expressive element is there. On its basis religious art is possible again. Whether it also becomes actual does not lie in anyone's control.

At this point, however, Protestantism has a chance that hardly any other religion has. Protestantism has, as I once put it, "a pathos for the profane." It loves to go before the gates of the sanctuary (*pro fanis*) and find the divine there. And we saw that the dimension which points to

what concerns us unconditionally is never missing in any reality. A Catholic priest—being more Protestant in doing so than many Protestants—asked the great French cubist Braque to paint him a fish, the old symbol of Christ, for the church. Braque declined, as one who stood outside Christianity. The priest insisted and asked for nothing more than a fish as Braque would otherwise paint it. He was of the opinion that there was more religiously expressive power in a profane fish painted by Braque than in a painting that had dishonestly been adapted to religious symbolism. The expressively defined style of Braque made that possible. It would be good if, in churches, sacristies, and congregational buildings, expressive profanity would replace the kitsch of religious painting that has proceeded from the unholy marriage of idealistic and realistic elements of style.

These last observations have already brought us close to the problems of a theology of architecture, which require a special treatment.

VII

The reason why architecture is specially mentioned in the title of these remarks is its double-sided character. A church building is a building that both serves a purpose and is a symbol. This doubleness has negative and positive consequences. The negative consequence is that the technical purpose can become separated from the symbolic character and be placed on its own, or the symbolic character can be turned against the technical requirements and corrupt the purity of the structure. Both things happen constantly, and it belongs to the greatness of an architect to be able to avoid both. The doubleness of purpose and symbol, however, has positive consequences too. The necessities that are connected with the technical purpose hold the powers of an archaistic traditionalism in bounds. That is one of the reasons why among all visual arts architecture is the one that has made the fastest and most impressive advances. In most Christian countries there have been erected churches which have broken with pseudo-tradition in style and symbolism, which have been born out of the possibilities of the present and cannot be separated from the cultural creating of the present. I should like to set down only one thing as a matter of principle, something that is a part of the network of principles worked out in the preceding portions of my remarks.

Every church building is subject to the tension of diverse polarities. The first and fundamental one is that of religious consecration and artistic honesty—as was already indicated in the story about Braque and the painting of the fish. In periods when artistic creativity was barren, religious consecration reigned almost exclusively. The numinous power of

the great tradition in church architecture was known and imitated. Protestants had taken over many Catholic buildings and, in them, had numinous experiences, in spite of their inappropriateness for the Protestant cultus. But to live one's way into the works of a past style is one thing, to create new things on the basis of a living tradition is another. The latter is demanded by the principle of artistic honesty. It is even demanded by a concept of tradition which does not view transmission of the past as the mechanical handing down of a valuable heirloom but views it as a challenge to the creation of the new, which also includes rejecting much of the old. If we think of the principle stated earlier—that art does not have to treat religious objects in order to be religious—then that means, in architecture, that an honestly created style, which has grown out of materially objective necessities, does not have to show its religious quality only by building churches. It has the religious dimension in itself and can thus be used for religious buildings without the architect's having to sacrifice the honesty of his creating for the sake of the numinous character. There is no authentic style that cannot be united with the demand of consecration. And it seems to me that there does exist a final unity between the principle of consecration and that of honesty. The artistically untruthful repels anyone of religious sensitivity and prevents the experience of the numinous. The convincing power of a religious building strengthens the convincing power of that for which it is built.

A church is two things in one: it is a building with a purpose, and it is a symbol. This statement leads to a second polarity of principles, that between a symbol-tradition and the communicability of symbols. There are fundamental symbols, or, better, elements of symbols, that reappear in all Christian symbolism, such as the cross. But the manner in which they reappear in concrete symbols is temporally and spatially conditioned; much of what previously had symbolic power has become meaningless, and new interpretations of the basic symbolic elements are required. That is true for the orientation of a church toward the east, for round or longitudinal construction, for the position of the tower, for the relation of altar and chancel, and so on. In most cases, an esoteric and archaic knowledge of the symbolism of these things, as that symbolism is expressed in more recent suggestions for church construction, is incommunicable, and it is not communicated either through occasional sermons on it. Symbols must be able to attest to themselves, and the one great symbol of the church building is the building itself, that which it immediately has as its purpose when it appears in a distance, when it gets closer, when it encloses the visitor. There is hardly anyone so insensitive as to think it possible to withdraw from this communication.

A new polarity appeared in the last remarks, the polarity between be-

ing closed off from and being opened to cosmic space. Whatever the answer may be, here is a symbolism that is immediately intelligible and has depth at the same time. Both solutions communicate themselves. There is much that speaks for elevating trees, flowers, clouds, and infinite space toward the infinite and all-embracing; there is probably more that speaks for enclosure, in which the universe is, so to speak, concentrated upon a point and, according to the principle of coincidence of opposites, appears entirely in something finite. This is intelligible symbolism, which draws us into itself and does not need to be explained through teaching.

To make a connection with what was said earlier, I should like to say something about light and color. Our deep understanding of the sacramental and its reception by the unconscious makes it possible for us, even in Protestant churches, to experience the miracle of refracted light and escape the one-sided dominance of white light, that is, the dominance of the intellect. But if we do so, we must avoid reducing the pure power of colors by borrowed figures of the past or, worse, as was done in the nineteenth century, by embellished naturalistic figures of the present. That we cannot do. Geometric abstraction is the important contribution of the modern style to the planning of light and color in churches.

There are still things close to my heart to be said. But I shall close with an expression of admiration for what modern church construction has accomplished, after modest beginnings, in the twentieth century. If the criticism is made that no authoritative solution has yet been found, that is right; but if that is supposed to mean a judgment upon contemporary church building, then great injustice is done. One can say that every new church in a new style is an experiment. Without the risk of experiments that fail, there is no creation. Perhaps people in the future will point to many failed experiments; but they will also point to the wondrous success: the triumph over the dishonest, the unquestioned, the anxiously conservative. New church building is a victory of spirit, of the creative human spirit and of the spirit of God that breaks into our weakness.

20

Contemporary Protestant Architecture

This article calls for Protestants to create an architecture that reflects their faith in a modern idiom.

THE GREAT PERIODS of Christian art and architecture from which we draw our tradition have been, without exception, the great periods of Roman Catholic art and architecture. The church building itself—and the frescoes, stained glass, tapestries, and statuary for which it was the frame—were, during these periods, clearly expressive of the faith that they made manifest. The great basilicas and cathedrals of the past represent the Roman Catholic Church in all its mystery and majesty and hierarchical power.

With the emergence of Protestantism, this unity of spirit with its finite expression was severed. From its very beginning, the Protestant faith has been at odds with the visual arts, including church architecture. The predominance of the "ear" over and against the "eye" in Protestant thought resulted in Protestantism creating great music and great poetry, but not great architecture, painting, and sculpture.

In the period of the Reformation the existing Catholic churches were taken over and subjected to more or less radical purges of sculptural and pictorial symbols in order to make them more appropriate to the new faith. But the buildings themselves remained, and with them the expressive power of their style—Romanesque, Gothic, Renaissance, Baroque.

"Contemporary Protestant Architecture" originally appeared in *Modern Church Architecture: A Guide to the Form and Spirit of 20th Century Religious Buildings*, ed. Albert Christ-Janer and Mary Mix Foley (New York: McGraw-Hill Book Company, Inc., 1962), pp. 122–25. It is reprinted here by permission.

This very fact created a tension between the principles and needs of a Protestant congregation and the symbolic meaning embodied in the architecture of a genuine Catholic church.

Attempts to overcome this tension were not lacking and they led to some original forms when new buildings became necessary, as seen for instance in the New England meeting house and in some European central buildings such as the great, but now destroyed, Frankenkirche in Dresden, Germany. But these attempts did not lead very far, because, since the eighteenth century, the general decline of religious art began in all churches and in the whole western world.

No new style in religious art appeared in painting, sculpture, or architecture, and the general "historicism" of the nineteenth century led to a repetition of styles of the past. One of the worst of these trends appeared in the wave of neo-Gothic church architecture, not only in Catholicism, but also within the Protestant sector of both the old and the new continent.

It is difficult to understand why the Protestant church leaders did not realize that there is expressive power in an artistic style and why they did not feel the impact of the Roman Catholic past in the contrast between the symbolism of the building and the symbolism of what was performed within it during a Protestant service. But, as already stated, Protestantism is a religion of the ear and not of the eye.

Certainly there are situations in which a house must be used for purposes for which it is not appropriate. Such emergency situations often occur in private and public life. And Protestantism, as with Christianity in general, is not bound to a special house, as is being shown by the store churches in slum districts. But if a new house is built, it is absurd to repeat intentionally, and without necessity, an emergency situation of the past. Every neo-Gothic, neo-Romanesque, neo-Baroque or other imitative church repeats the emergency situation of early Protestantism. It becomes an absurdity!

There is a defense based on the polarity of tradition and contemporaneity in all religions, including Protestantism. The Protestant protest itself is rooted in the Catholic tradition, namely the Paulinian interpretation of the Christian message. Both Protestant liturgy and Protestant theology retain many elements of the common Christian tradition: Why not church architecture?

The answer to this argument is that, until the past one hundred years or so, continuity of religious tradition did not preclude changes in its visual expression. Symbols like the cross are present in every period in the life of the Christian churches. But the style by which these symbols are shown has changed continually. The same is true of architecture.

The request that new buildings be stylistically contemporary is rooted in the nature of creativity and in the ethical principle of honesty. A creative act is normally born out of a cognitive and emotional participation in many or few creations of the past. But when the creative power of the artist or architect goes to work, it breaks through to the new, expressing the creator and through him his period. After a certain inevitable resistance and hesitation, his contemporaries come to recognize themselves in his work.

If, on the other hand, the architect is asked to imitate the style of a period which is not his own, his creativity is undercut and his honesty of self-expression is destroyed. He has ceased to be a mirror to his contemporaries and instead prevents them from awareness of their actual being. He deceives them—even though often they like to be deceived.

In the great periods of religious art such deception would have been impossible. In the religiously disintegrating development of industrial society the deceptive function of religious art, including church architecture, has not only been possible, but largely desired. It is worthwhile to notice how uninhibited former generations were in adding sections in their own contemporary style to churches built in an earlier period. A feeling for their own age, for honesty, and for unhampered creativity, was stronger than the desire to produce a stylistically consistent work. The latter approach is typical only of our own history-conscious period.

In the light of these basic considerations we can now give some answers to the question of a church architecture that is adequate to the religious character of Protestantism. Essentially, the Protestant church building serves the congregation that is assembled to hear the message of the New Being and to answer in prayer and praise. As opposed to the Roman Catholic, there are two fundamental elements that distinguish a Protestant church service:

1. The predominance of the Word over the sacrament.

2. The predominance of the congregation over the liturgical leader or leaders.

These predominances are less marked among the orthodox faiths, but gain in importance as one traverses the range of belief until, among Christian Scientists, the sacrament and the ordained liturgical leader are entirely eliminated.

Accepting, then, the fact that these concepts will receive greater or lesser emphasis depending upon the denomination, it may still be possible to describe an architecture that could be termed essentially Protestant.

The plan of the church is, of course, of first importance. A plan adequate to the Protestant purpose would be, preferably, a central one in

which members of the congregation look at each other, and in which the minister is among the congregation for preaching and leading the liturgy. The place for the altar should not be removed, but preserve the character of a table for the sacramental meal in which, ideally, all members participate.

Churches that retain a central aisle leading to a removed altar as the holiest place, separated from other parts of the building, are essentially un-Protestant. With the abolition of any kind of hierarchical dualism between laymen and clergy, between a secular and a holy role—in short, because of the fundamental Protestant concept of the priesthood of all believers—these remnants of the Catholic tradition are religiously inadequate for a Protestant architecture. No new church should have them, and existing churches should be transformed as much as possible away from this old direction.

But the quality of the church, its essential character, is more than the appropriate arrangement of seating and liturgical furnishings. The architect must aim at a particular effect to be imparted by his shaping of the interior—and at this point he encounters a conflict of two religious principles.

The first is the emphasis placed by many Protestants upon the infinite distance between the divine and the human, between God and the world, a distance bridged only by the divine Word. From this follows the ideal of "sacred emptiness," symbolizing this distance. The Jewish tradition, especially its prophetic line, represents this attitude, which was followed in Islam and partly in Protestantism. The sacred void can be a powerful symbol of the presence of the transcendent God. But this effect is possible only if the architecture shapes the empty space in such a way that the numinous character of the building is manifest. An empty room filled only with benches and a desk for the preacher is like a classroom for religious instruction, far removed from the spiritual function which a church building must have.

Yet there is also the opposite point of view. Like all Christian churches, Protestantism is based upon the divine self-manifestation in a personal life, at a definite time, in a definite place. This view justifies within the church a concrete expression of the holy, by means of "pictures"—pictures in the largest sense, comprising everything finite through which the infinite shines. Under the criterion of the manifestation of the transcendant God in Jesus as the Christ, the churches can be filled with symbolic objects of all kinds. All Catholic churches emphasize this side, and some Protestant denominations are more open for it than others.

Protestantism need not reject these elements of Catholic substance, but it should subject them to some definite criteria. First, nothing can be

admitted that furthers idolatry or ideas and attitudes of magic. For this very reason, early Protestantism emptied the Catholic churches it took over—without creating in this way what we have called "sacred emptiness." It was simple emptiness, often painfully noticeable.

But if Protestantism today tries to overcome such ugly emptiness, it should not simply bring back the statuary and painting rejected so long ago. Individual figurative pieces are too indicative of ancient idol worship to be countenanced in a Protestant church. Works of art that are actually part of the church structure would have no such connotation. Murals, for instance, would be far more appropriate to a Protestant ideology than individual canvases. They are elements of architecture rather than objects of veneration. Yet they may heighten the religious impact of the church building. In the same way, single pieces of sculpture would probably have no place in the church, but a sculptural organization of wall or door might be highly desirable.

The problem of using stained glass also requires scrutiny from the Protestant point of view. Color, pattern, and diffusion of light were prohibited in the New England meeting house, early Congregationalists considering clear glass, which emphasizes the rational element in religion, the only appropriate solution. Most Protestant denominations have long since abandoned this stricture and stained glass is nearly as common today in Protestant as in Catholic churches.

However, some recent designs have used clear glass in a new way, in large expanses, widely opening the church toward surrounding nature: trees, flowers, water, sky [plates 69–70]. The idea is, or should be, to draw nature into the sphere of the Holy Presence. But it seems that the opposite happens: the members of the congregation are drawn away from concentration on the Holy Presence to the outside world. The human situation, man's estrangement from himself, seems to prevent in actual existence what is true in principle: that the divine is not a sphere alongside others, but a dimension in all of them. Only in a state of fulfillment would man be able to experience in everything finite the infinite. But then church buildings would no longer be needed. God would dwell among us, as stated by the last visionary book of the Bible. Since every church building is an adaptation to man's situation of estrangement in which the holy and the secular are present side by side, it seems inadvisable to open the building too widely toward surrounding nature [plates 69–70]. However, a flood of clear light, if this is desired to emphasize the clarity of the Protestant faith, could be provided where it does not distract the worshipper. Opaque glass or glass brick might offer a workable solution.

Stained glass, too, effectively shields the congregation from outside dis-

traction while shedding a deeper and more mystical illumination upon the interior of the church. Because it is an architectural element, even though technically not a necessary one, it conforms to the criteria laid down for Protestant religious art. Moreover it is one of the most effective ways by which the desirable numinous atmosphere can be imparted to a church. Certainly, today its use should not be prohibited, although its special qualities may be more appealing to orthodox than to liberal denominations.

But here there arises the question of style. Nowhere is this more important than in the handling of stained glass. In a period of cubistic and nonrepresentational art it is all but impossible—as many futile attempts show—to produce naturalistic forms that are convincing. The possibilities of Chartres [plate 62] are not ours. The great artists of our time have chosen a different means of expression. Protestantism need not be bound to unbroken daylight; it too can emphasize the mystical element of religion by means of colored light. But ideally the pattern of such light should not be that of representational forms.

Wherever possible, this same ideal should be extended to painting and sculpture. Abstract, nonrepresentational works can have great symbolic power, often far more than realistic forms. If a story is to be told, representation cannot be avoided—although a naturalistic or sentimental style should be. Great expressiveness can be achieved by means of lines that circumscribe and indicate bodily reality without showing it in overly elaborate detail. A good example of this approach is the expressionistic style of the early twentieth century, which in many ways is still contemporary.

In an attempt to eliminate the realistic from religious art, the traditional symbol is sometimes considered as a substitute. Religious signs and symbols were much used during the early periods of the Christian church, but with the Reformation their usage was drastically reduced. Despite some recent attempts, it is questionable whether they can be revived. Symbols that demand a learned interpretation to be understood are without the power of genuine symbols and should not be confused with them. If such are used, however, their long tradition as expressions of the holy should be respected. Never should they be used lightly as mere decoration without a certain functional necessity. This would be artistically dishonest and religiously repellent.

In contrast to the ancient, esoteric symbols, there remains, of course, the cross, the most powerful and meaningful symbol of the Christian Church. Most Protestant communions will choose to include this sacred object even though every other type of Catholic substance be eliminated. But even this ancient and living symbol should be considered from the

Protestant perspective. The innate disapproval of figurative representation, which goes back to the roots of Protestantism, makes itself felt here, above all. The simple, non-naturalistic cross is unquestionably the preferable choice. A crucifix should be allowed only if the body of the Crucified is made one with the structure of the cross itself, and is executed in an expressive rather than a realistic style. In either case, the impression must be avoided that the sacred object is a real object alongside others in a world of finite things.

Today, genuine Protestant church architecture is possible, perhaps for the first time in our history. For the early experiments were too swiftly engulfed by eclecticism to act as evolutionary factors in developing a recognizable Protestant architectural language.

Even today, however, many congregations and ministers still assume that the choice between modern and imitative-traditional architecture is merely a matter of taste and preference. They fail to see that *only* by the creation of new forms can Protestant churches achieve an honest expression of their faith.

This expression should be made real, even if many experiments are necessary and some end in failure. An element of risk is unavoidable in the building of sacred places, just as a risk must be taken in every act of faith.

21

Honesty and Consecration in Art and Architecture

This address was given at the Twenty-sixth National Conference on Church Architecture, held in Chicago at the Pick-Congress Hotel, 27–29 April 1965.

I WANT TO START with a kind of autobiographical report about the way in which I reached the two principles—honesty and consecration—which should control religious art generally and church architecture particularly.

In my early life I wished to become an architect and only in my late teens the other desire, to become a philosophical theologian, was victorious. I decided to build in concepts and propositions instead of stone, iron, and glass. But building remains my passion, in clay and in thought, and as the relation of the medieval cathedrals to the scholastic systems shows, the two ways of building are not so far from each other. Both express an attitude to the meaning of life as a whole.

My love for architecture never died. It expressed itself in the admiration of and pilgrimage to great architecture, and in a feeling of inner fulfillment in places where good architecture surrounded me. The fact that I lived, up to my fourteenth year, in the parish house of my father, opposite a fifteenth-century Gothic church in a small town of eastern

"Honesty and Consecration in Art and Architecture" was originally published in *Protestant Church Buildings and Equipment*, September 1965, pp. 15ff., under the title, "Wanted for Religious Architecture Today: Honesty and Consecration." It is reprinted here by permission, with the title used at the National Conference on Church Architecture.

Germany, had influence on my decision to become a theologian and on some lasting elements in my theological thought. Much later, during the horror and ugliness of the First World War, in which I served as a chaplain in the German army, and immediately after the war, my eyes were opened to the glory of painting. They are usually not being opened in a Protestant parish, neither in Germany nor in this country, and I was initiated by my oldest friend, an art critic [Eckart von Sydow], into the expressive power of all modern art.

This made me a defender of modern art ever since, even if I disliked or did not understand some phases of it. But it did more. It made me not only a defender but also a severe critic in two respects: first, in the realm of painting—particularly religious painting—the Guido Reni type of sentimentalization of the Christ, which was rampant in all church leaflets and sacristies and parish houses in Germany showed to me what dishonesty in painting means. I felt that all these paintings were judged and rejected by one of the greatest of all religious paintings, the Crucified by Mathias Grünewald [plate 11] at the end of the fifteenth century. The horrible wounds on this body are an anticipation of modern expressionism. It is not a naturalistic copy or a distortion, but an artistic expression of the truth about what has happened on Golgotha.

In this way I learned to reject the beautifying naturalism of late nineteenth-century and early twentieth-century religious art. It had invaded Catholicism, in spite of its great tradition, as well as Protestantism. I began to learn what artistic honesty and dishonesty mean.

But I had a second perhaps even more important experience this time with church architecture. In Europe we had many genuine Romanesque and Gothic [plate 62] buildings. One visited them, especially the greatest of them, and I experienced a small one in my home town. But long ago pseudo-Gothic and pseudo-Romanesque imitations were built in Germany in spite of the great tradition.

Then I came into contact with the architectural ideas and persons of the Bauhaus [plates 63—64], and again, in a sudden opening of the eyes, I saw the dishonesty of the imitation of the Gothic and Romanesque style in modern churches and in buildings generally.

In 1933 I came to this country and lived for twenty-two years at Union Theological Seminary in New York, in the shadow of the pseudo-Gothic Riverside Church, attacking it in classes and talks to the dismay of many. But I must confess, this was not easy because the church reminded me, internally more than externally, of genuine Gothic art, and it had, for this very reason, some lure for me. I would call it today a temptation which I resisted. And when I had to deal in my systematic theology with religious art, I introduced the principle of honesty as one of the two main principles into the discussion of the problem.

This led me to further observations. The failure of imitation is that it is not born out of the creative inspiration of the builders of the original work. Imitation comes out of the scientific study of things done in the past. They are produced without the unconscious, symbol-creating side of the artistic process. Beside imitation, the act of adorning or trimming in order to make beautiful is an expression of dishonesty. If some building is architecturally perfect in itself, namely, completely adequate to its purpose, one should not add anything to beautify it. The beauty must lie in the adequacy and expressive power of the structure, not in contingent additions; and I believe that the word *expressiveness* must, at least for thirty years from now, replace the desecrated word *beautiful*, desecrated most by religious art at the end of the nineteenth century.

This, however, can lead to an ascetic radicalism of the principle of honesty. There was a struggle years ago about the idea of the "dwelling machine," the house which is perfect in all technical respects but in which one cannot live because life as a whole was not taken into consideration. The wish at least of some people for separation from the open space, from the world space and its infinity; the wish to have individual privacy—not only family privacy but also individual privacy; the distaste of some people against hard materials which hurt the body by their very presence, even if one doesn't touch them, as iron and concrete; all this was not taken into consideration. These people (to whom I belong), want organic materials—carpets, clothes, wood. The problem then is how can architecture combine the emotion-filled idea of "home" with the ethics of honesty? How much architectural honesty has the architect to sacrifice in order to build a cozy lower-middle-class home? How much of the sentimental idea of a home must the customer sacrifice to accept the idea of honesty by the architect?

In church buildings we have to deal with the problem of honesty in relation to consecration. In order to do so we have to discuss a few more expressions of honesty. I have stated that honesty condemns imitation as well as trimming. But it denies something else, namely, the arbitrary solution of the problems of modern church building by running for novelty. Traveling quite frequently, I saw everywhere—here and in Europe, in Catholicism as well as in Protestantism—attempts at new architectural forms in church buildings. The newness as well as the manifoldness is overwhelming, even if one chooses only the outstanding examples. Many, even of the average buildings, have some interest. Many give you a great surprise. But surprise wears off, and the new, if it lacks genuine adequacy to the meaning of the church buildings, becomes almost intolerable.

There are two reasons for this situation: one is the large amount of possibilities given by the new materials, concrete and related ones, and a

universal truth—that possibility is temptation; the other reason is the break with tradition which makes experiment necessary. The tradition broke when the turn to historical styles began. The only honest way in this situation is the creative inspiration of the architect, who meets the objective demands of the particular situation and wants to express something important. Neither imitation nor willfulness are allowed under the principle of honesty.

The demands the church architect must meet from the theological side are expressed in the principle of consecration. It implies a large amount of important theological questions. The first one is rather paradoxical, if mentioned in a group like this. It refers back to the principle of honesty, and asks whether it is honest today to have churches at all. Do we need and do we still want places of consecration? There are heavy reasons against this desire.

First, sociological: There are large groups of the population for whom the church has become a class symbol, perhaps not so much in this country as in Europe. I think of the workers in Germany after the First World War and the idea, considered in a movement to which I belonged, to have religious meetings in the back rooms of cheap restaurants where the workers would feel at home and where one could talk to them about the problems of religion and socialism.

There are analogies to this idea in present America, in the creation of store-front churches in Harlem, New York, for instance.

But also on the opposite side the question is serious. I think of educated Christians in Japan, who cannot stand the mission-created churches (which are mostly dominated by European or American denominational missionaries) and who therefore meet in private homes, Sunday by Sunday. Or I think of the religious discussion groups which I discover on my many lecture trips all over this country who got together because they are not satisfied by the traditional church services and gather around a book of sermons or on the Bible or on theology or philosophy, in a private home. Or I think of the worker priests of France and the factory meetings of workers with theologians in England. I think of religious lectures and discussions on radio and TV, beside church services on both mediums.

All this is an expression of our situation, the secularization of the world and the irrelevance of the Christian message as it is communicated for innumerable people. This refers to all social classes, but it is most conspicuous in the intelligentsia of the Western world; and it refers to the whole communist-determined civilization in countries which embrace half of the population of mankind. There are probably no new churches being built in Russia and no new Buddhist temples in China.

The people about whom everybody is excited in discussions in the Western world are artists, musicians, and especially in these last years, playwriters, poets, novelists, painters, architects who, in the majority, have no relation to church life—sometimes not even those architects who build churches. I think of Matisse, whose chapel in Vence in southern France I saw and admired as a great work of art in its simplicity [plates 67–68]. I said, to Mrs. Tillich, after we left it, "I haven't found any mistake in this building, but he never practiced religion."

But the most radical attack on church buildings comes from theology itself. It starts in the Old Testament when up to the time of Solomon there was resistance against church building, and Solomon himself spoke in the consecration prayer about the impossibility of having the infinite within a finite space. More radical is the attack against the whole temple cult in the words of the prophet Amos: "Take away from me," says God, "the noise of your songs. To the melody of your harps I will not listen, but let justice run down like waters and righteousness like an ever-flowing stream."

When the disciples of Jesus pointed to the beauty of the temple, he only repeated the prophecy of its destruction. Luther did not reject church buildings but he devaluated them as the holy spaces just as he devaluated the Sabbath as a holy time. And of the heavenly Jerusalem, this is what we read in the last book of the Bible: "And I saw no temple in the city for its temple is the Lord God."

All this expresses God's freedom from religion, even his fight with religion in the whole history of religion. It expresses God's freedom for the secular, as emphasized powerfully by the martyr-theologian Dietrich Bonhoeffer.

Theologically it has led me to the doctrine of the two concepts of religion—the larger and basic concept, namely, religion as the state of being driven by an ultimate concern which transcends the separation of the sanctuary and the marketplace, of the holy and the secular. But there is also a narrower concept of religion—religion as the life of a social group which expresses a common ultimate concern, an experience of the holy, in symbols of myth and cult as well as in moral and social ways of life.

The first concept of religion is the basis and essence of the second. It is valid for the second concept of religion directly and for all cultural creations indirectly. Through works of philosophy or science, of literature or the visual arts, ultimate reality can shine, perhaps unintended but still powerfully, perhaps intended, but without particular religious symbols; perhaps using religious symbols, but as elements of a secular work.

The statement that a house as such can have a religious quality is true

in the sense of the larger concept of religion. The honesty and nobility and adequacy of the house, of the private house, can express something of the ultimate meaning of life. It can have sacredness. Similar examples can be taken from the practical, moral, social, political side of the secular life. There are movements which do not belong to the church but which can be called expressions of the church latent. In the latent church the ultimate concern shines though as movement for social justice or as growth in personal righteousness. All this may give the impression that the secular is self-sufficient, and no church as social structure, and therefore no church building, is needed.

But this is not so. The town without temple is the heavenly Jerusalem, not an earthly town. And all those who have fought against holy places have used holy places and holy times themselves. It is the human predicament, the universal estrangement of man from his true being, which demands *church* in every sense of the word. Religions, temples, and churches are witnesses against men, showing the split between what man essentially is and what he actually is. Holy places, holy times, holy acts are necessary as the counterbalance to the secular which tends to cut off our relation to the ultimate, to the ground of our being, and to cover the experience of the holy with the dust of daily life. Churches are the treasure chests in which the revelatory experience, the experiences of the holy are enshrined and often enshrined in such a way that they are unapproachable. And this is just our situation today.

It would be the task of the churches to open themselves and their treasure by words and acts which are able to communicate through its new stylistic forms but which should not ever relapse to the dishonest, beautifying sentimentality of the near past or some earlier periods.

It is the task of the church architects to create places of consecration where people feel able to contemplate the holy in the midst of their secular life. Churches should not be felt as something which separates people from their ordinary life and thought, but which opens itself up into their secular life and radiates through the symbols of the ultimate into the finite expressions of our daily existence.

How does an architectural work express the presence of the holy? And at the same time how is it able to open up into the world what is experienced in it? The principle under which the church architect must work is expressed in the words of mystical poet Tersteegen in his great hymn, "God Himself is present, let us now adore Him." The experience of the presence of the holy by the kind of space the architect has created is what must be intended, even before anything else happens within this space. Since the experience of the holy is never directly possible, because it transcends everything finite, its presence must be mediated by authentic representation and symbolic expression.

Which kind of expression is adequate, depends on the character of the relation of a religious group to ultimate reality, the holy itself, and there are many ways, in which men have experienced the holy, and there are great differences even within the same religious tradition. A decisive difference is based on the character of ultimate reality that, on the one hand, it transcends everything finite, and that, on the other hand, it is the creative ground, of everything finite. It is beyond what can be grasped by senses or words or thought, and it is at the same time the creative ground, present in everything. This polarity is equally important for the theologian, the artist, and the architect.

If you emphasize the one side of the polarity, namely, the transcendence in a radical way, you may come to something which one could call "sacred emptiness"; and there are many architectural creations which express this, mostly in Israel and important to the two religions which are dependent on Israel, Christianity and Islam. When one uses the words *beauty of holiness*, one can call this kind of expressing the holy: "beauty of emptiness." This emptiness is not an emptiness by privation, but it is an emptiness by inspiration. It's not an emptiness where we feel empty, but it is an emptiness where we feel that the empty space is filled with the presence of that which cannot be expressed in any finite form.

In this line belong movements which have fought against images in the church. They led to bloody struggles in the eighth and ninth centuries in the Eastern church; they arose again in the Reformation period, especially in Calvinism; their spirit underlies some of the great American church buildings in the preimitation period of architecture.

One can feel the presence of the holy also in the opposite way. I think of India with its vegetative abundance in all sacred buildings, with their wild growth of limbs of the human body and the infinite manifoldness of divine-demonic beings. In Christianity such abundance never was reached. It is, because of its monotheistic basis, impossible in Christianity, at least in principle.

Nevertheless, there are Catholic churches in which with the help of the dogma of Incarnation, namely, the concrete presence of God in time and space, similar trends have developed. I think of some of the church buildings I have seen in Mexico, which also show a wild-growing abundance of holy forms and figures.

How does this polarity refer to our present situation? The richness of contents, the expression of the presence of the holy by many forms is a possibility as long as these forms were immediately understandable. But now it often happens that traditional symbols are renewed and that only a few understand them, so that an interpreter is needed. I felt this when I met, in some places in and outside the sanctuary, symbolic signs which once upon a time were understandable, but to a present average church-

goer are strange. They have lost their symbolic power. But the meaning of a symbol is to show something which cannot be given by words and interpretations. The question then is: Do we have such symbols today?

In the middle of the twenties, there was a movement in Germany of which some of you may have heard, the so-called Berneuchener movement. It was a group of still comparatively young theologians and laymen, who met once a year to revise the nineteenth-century liturgies with their sentimentality and poverty and to go back to the richness of the liturgical past.

But soon something happened to our group. It became divided: one group dug back into the past with the intention and in the hope to revive it for the present. The other, smaller group (to which I myself belonged) was related to the religious-socialist movement. We asked: What do these symbols, these liturgical forms, tell the worker, for example, in the northern part of the city of Berlin? There were some large churches with a hundred thousand baptized members, and two hundred elderly women in the Sunday morning services, no men, no youth. One asks: What can one do in such a situation? Can one offer to the young people, to the workers, to the intellectuals, liturgical expressions of the Christian faith, conceived fifteen hundred years ago in Mediterranean cultures?

The ongoing discussions were cut by the arrival of Nazism. The remaining group the "antiquarians"—as we called them—prevailed. They are still active, but were unable to communicate except to small circles within the church.

Today the difficulty to communicate is increasing. And this should be expressed in liturgies as well as church buildings and even in theology. "Sacred emptiness" should remain the predominant attitude for the next foreseeable time. One should express our experience which has been called the experience of "the absent God." This does not mean a negation of God but it does mean: God who has withdrawn in order to show us that our religious forms in all dimensions were largely lacking both in honesty and in consecration. Saying that God has withdrawn implies saying that he may return. Then he will disappoint those atheists who believe that he has confirmed their atheism by his withdrawal. What may have happened by the victory of secularization is, that his wrong image has been destroyed by himself. Therefore the expression of church buildings should be "waiting" for the return of the hidden God who has withdrawn and for whom we must wait again.

Part IV

Statements for
Exhibitions and Journals

22

Authentic Religious Art

In connection with the Second Assembly of the World Council of Churches, Evanston, Illinois, 15 July–31 August 1954, the Art Institute of Chicago sponsored an exhibition of religious art, drawn from many countries and reflecting various styles and subjects. Theodore M. Greene, Yale philosopher with an interest in religion and culture, joined Tillich in writing this preface to the exhibition. It set out criteria for the authentic in art.

WHAT IS THE essence of religiously expressive art, that is, of art that is both authentically artistic and significantly religious?

To be authentically artistic is to be artistically alive, to possess artistic vitality. Such art is the product of the artist's creative imagination, and it exhibits to the sensitive observer the hall-marks of his fresh and untrammelled creativity. It will exemplify, on the one hand, the artist's individual style—or some phase or period of his evolving style; it will carry, as it were, the distinctive imprint of his artistic personality, his signature as a creative artist. It will also, simultaneously, exemplify other more generic styles—the style of his school, movement or tradition, the inclusive style of his embracing *culture* and, above all, the style of his own historical epoch. Thus, a contemporary Picasso will be in the individual style, and more specifically in the current style, of Picasso himself; it will also be in the expressionistic Western European tradition; and it will be, in its own way, expressive of the mid-twentieth century.

A work of art can be artistically authentic or vital without being great

Paul Tillich and Theodore M. Greene, "Authentic Religious Art," reprinted from *Masterpieces of Religious Art*, exhibition catalogue (Chicago: Art Institute of Chicago, 1954), pp. 8–9. Reprinted by permission.

or profound. Indeed, most authentic art of any age is not great, and much of it is relatively slight in artistic stature. But to be *real* art, whether it be profound or slight, it must be freshly and honestly conceived and executed. The crude art of children often has this quality, as does the art of many adult artists whose craftsmanship and whose insights are more or less inadequate.

Such art, in turn, differs radically from all prescriptive or academic art, however excellent its craftsmanship and however noble its prescribed purpose may be. For such prescriptive art is produced according to some formula and lacks the sine qua non of authentic art, that is, fresh imaginative creativity. It is imitative—imitative of some older style, for example, the Gothic, which was once artistically vital but which belongs to another historical epoch, or imitative of the style of some renowned artist or established school. An artist can even imitate himself, that is, cease to be authentically creative and merely repeat his own past performance.

Artistically authentic art, in turn, can be significantly religious in two distinguishable ways, implicitly and explicitly. It is implicitly religious if it expresses, in whatever fashion, the artist's sensitive and honest search for ultimate meaning and significance in terms of his own contemporary culture. If religious be defined as man's *ultimate concern for Ultimate Reality*, all art which reflects, however partially and distortedly, this ultimate concern is at least implicitly religious, even if it makes no use whatever of a recognizable religious subject matter or any traditional religious symbols. Picasso's *Guernica* [plate 44] is profoundly religious in this implicit sense because it expresses so honestly and powerfully modern man's anguished search for ultimate meaning and his passionate revolt against cruelty and hatred.

Authentic art is explicitly religious if it expresses the artist's sensitive and honest search for ultimate meaning and significance with the aid of a recognizable religious subject matter or religious symbols, that is, by using, in whatever way, the familiar materials of some historical religious tradition. In the Christian tradition, all Biblical material and such symbols as the Cross are religious in this sense. The mere use of such material does not, of course, guarantee either artistic integrity or significant religious expressiveness. Indeed, much so-called religious art today is totally lacking in both artistic and religious value, despite its use of traditional religious subject matter and symbolism. It lacks artistic vitality and is therefore inexpressive; it is therefore necessarily devoid of significant religious content or meaning. Liturgical art which is traditionalistic and manneristic is "bad" art; the handling of religious material by such contemporary painters as Rouault [plates 49–51], Chagall [plates 33–34],

and Lebrun, in contrast, is authentic, explicitly expressive, religious art as here defined.

This exhibition contains examples of both explicit and implicit religious art, past and present. Every effort has been made to include only art of genuine vitality and to exclude all bogus religious art which is the curse of every generation.

The great religious art of the past is bound to be more intelligible and acceptable to us because we are familiar with it. Contemporary religious art which is dynamic and path-finding is difficult for us to comprehend because it speaks to us in an unfamiliar style, and it is deeply disturbing because it is so often anguished and violent. This is, however, inevitable because each age must develop its own style and idiom and because our times are times of violence and anguish, anxiety and despair. It is not strange that our most sensitive and creative artists should so poignantly express this cultural distress in such baffling ways; nor is it surprising that they should so seldom express a triumphant faith or *the peace that passeth all understanding*. For their art, as authentic art, is an affirmation of the creative imagination, and their very violence is an implicit affirmation of all the values which are being threatened and violated in these tragic times. In an age of spiritual turmoil and anxiety, when all spiritual affirmations are difficult and rare, they have at least had the courage and the artistic integrity not to retreat into an empty formalism, or a traditionalistic conventionalism, or a dishonest saccharine prettiness. This courage of theirs may well be prophetic of a new religiously oriented cultural vitality which, we can hope, is slowly and painfully coming into being in our day.

23

One Moment of Beauty

Tillich frequently refers to the revelatory character of his encounter with Botticelli's Madonna and Child with Singing Angels. *In 1955, Tillich gave a full and succinct account for* Parade *of his experience of seeing this painting at the Kaiser Friederich Museum, Berlin, at the end of World War I. The report was for a series in* Parade *titled "I'll Never Forget." For Tillich's account, it read, "I'll Always Remember . . . One Moment of Beauty."*

DIVINE REVELATION comes to few men, but understanding of it came to me one moment 36 years ago. I looked, for the first time, at beauty revealed by a man who had been dead·more than 400 years.

As the son of a Protestant minister in eastern Germany in the days before World War I, I had grown up in the belief that visual beauty is unimportant. My father's parish houses as we moved from city to city were like all parish houses of the time—gloomy, unattractive and furnished in the bad taste of the later nineteenth century. Ministers' sons spent long hours learning to recite poetry, practicing music and memorizing church history. Neither at home nor at school was I taught that there is beauty we can see.

Strangely, I first found the existence of beauty in the trenches of World War I. At 28, I became a chaplain in the German army and served for five ugly years until the war ended. To take my mind off the mud, blood and death of the Western Front, I thumbed through the picture magazines at the field bookstores. In some of them I found reproductions of the great and moving paintings of the ages. At rest camps and in the lulls in the bit-

"One Moment of Beauty" originally appeared in *Parade, Sunday Star Ledger*, 25 September 1955. It is reprinted by permission.

ter battles, especially at Verdun, I huddled in dugouts studying this "new world" by candle and lantern light.

But at the end of the war I still had never seen the original paintings in all their glory. Going to Berlin, I hurried to the Kaiser Friederich Museum. There on the wall was a picture that had comforted me in battle: *Madonna with Singing Angels* [plate 1], painted by Sandro Botticelli in the fifteenth century.

Gazing up at it, I felt a state approaching ecstasy. In the beauty of the painting there was Beauty itself. It shone through the colors of the paint as the light of day shines through the stained-glass windows of a medieval church.

As I stood there, bathed in the beauty its painter had envisioned so long ago, something of the divine source of all things came through to me. I turned away shaken.

That moment has affected my whole life, given me the keys for the interpretation of human existence, brought vital joy and spiritual truth. I compare it with what is usually called revelation in the language of religion. I know that no artistic experience can match the moments in which prophets were grasped in the power of the Divine Presence, but I believe there is an analogy between revelation and what I felt. In both cases, the experience goes beyond the way we encounter reality in our daily lives. It opens up depths experienced in no other way.

I know now that the picture is not the greatest. I have seen greater since then. But that moment of ecstasy has never been repeated.

24

The Christ in Art

This is a list of fifty-eight paintings selected in 1955 by a committee of the Commission on Art, Department of Worship and the Arts, of the National Council of Churches. Works of art from this selection were published in a special Christmas issue of Life *magazine, December 1955. Tillich alone directly represented the field of religion, the others being notable art historians and museum directors. Tillich later noted that he had fought hard to have Rouault's* Head of Christ *included, a factor that is interesting in that Tillich felt Rouault's secular works were more profound than his religious ones. The working relation of Tillich with those competent in the field of the arts is well illustrated in this project.*

NATIVITY AND ADORATION

Albrecht Altdorfer (c.1480–1538), *Nativity* (1518?; Kunsthistorisches, Vienna)

Jan Brueghel (1568–1625), *The Adoration of the Kings* (1608; The National Gallery, London)

Piero della Francesca (1410/20–92), *The Nativity* (c.1470/5; The National Gallery, London)

Hugo van der Goes (1420–82), *The Adoration of the Shepherds* [*The Portinari Altarpiece*] (1474/6; Galleria degli Uffizi, Florence)

Nativity (Fragment of a thirteenth-century choir screen; Chartres Cathedral, Chartres)

"The Christ in Art" was originally prepared in 1955 by a committee of the Commission on Art, Department of Worship and the Arts, of the National Council of Churches. Members of the committee were Alfred H. Barr, Jr., George Heard Hamilton, Perry T. Rathbone, and Paul J. Tillich. Charles Rufus Morey contributed

THE BAPTISM

Piero della Francesca (1410/20−92), *The Baptism of Christ* (c.1440/50; The National Gallery, London)

Joachim Patinir (c.1485−c.1524), *The Baptism of Christ* (c.1515/20; Kunsthistorisches, Vienna)

THE TEMPTATION

Max Beckmann (1884-1950), *Christ in the Wilderness* (1911; The Museum of Modern Art, New York)

Jacopo Tintoretto (1518−94), *Temptation* (1576/81; Scuola di San Rocco, Venice)

CHRIST'S MINISTRY

Eugene Delacroix (1798−1863), *Christ on the Lake of Gennesaret* (1853; The Metropolitan Museum of Art, New York)

Duccio di Buoninsegna (c.1255/60−1315/18), *The Calling of the Apostles Andrew and Peter* (1311; The National Gallery of Art, Washington, DC)

Tommaso Masaccio (1401−28), *The Tribute Money* (1426/8; Brancacci Chapel, Santa Maria del Carmine, Florence)

Rembrandt van Rijn (1606−69), *"Little" Raising of Lazarus* (1642; The Metropolitan Museum of Art, New York)

Jacopo Tintoretto (1518−94), *Christ at the Sea of Galilee* (c.1575/80; The National Gallery of Art, Washington, DC)

Konrad Witz (1400/10−1444/6), *Christ Walking on the Lake* (1444; Geneva Museum, Geneva)

Christ Teaching (mid-twelfth century; South Portal, Chartres Cathedral, Chartres)

Christ Healing a Blind Man [physician's case cover] (n.d.; The Vatican Library, Vatican City)

THE TRANSFIGURATION

Giovanni Bellini (c.1430−1516), *Transfiguration* (1480s; Galleria Nazionale di Capodimonte, Naples)

suggestions as a member of the committee but was unable to participate personally in the deliberations and decisions. It is reprinted here by permission. For the sake of uniform format, slight editorial changes have been made.

Fra Angelico (c.1387–1455), *The Transfiguration* (c.1440; Museo di San Marco, Florence)

THE LAST SUPPER

Dieric Bouts (c.1415–75), *The Last Supper Altarpiece* (1464/7; Church of St. Pierre, Louvain)

Emil Nolde (1867–1956), *Last Supper* (1909; Stiftung Seebüll Ada und Emil Nolde, Neukirchen)

Jacopo Tintoretto (1518–94), *The Last Supper* (1594; San Giorgio Maggiore, Venice)

AGONY IN THE GARDEN

Albrecht Dürer (1471–1528), *Agony in the Garden*, from *The Small Passion* (1509; The Metropolitan Museum of Art, New York)

El Greco (1541–1614), *Agony in the Garden* (c.1590/5; Toledo Museum of Art, Toledo, Ohio)

Wolfgang Huber (c.1490–1553), *Christ on the Mount of Olives* (1530; Alte Pinakothek, Munich)

PASSION SCENES

Hieronymus Bosch (1460–1516), *Mocking of Christ* (sixteenth century; Princeton University Museum, Princeton)

Georges Rouault (1871–1958), *Head of Christ* (c.1905; The Chrysler Museum, Norfolk)

Jacopo Tintoretto (1518–94), *Christ Before Pilate* (1576/81; Scuola di San Rocco, Venice)

Sarcophagus of Junius Bassus, *Passion Scenes* (c.350; Crypt of the Basilica Church of St. Peter, Vatican City)

CRUCIFIXION

Antonello da Messina (c.1430–79), *Mystical Crucifixion* (1475; The National Gallery, London)

Pieter Breughel the Elder (1525/30–69), *Calvary (The Kreuztragung Christi)* (1564; Kunsthistorisches, Vienna)

Giovanni Cimabue (c.1240–1302), *Crucifixion* (thirteenth century; Museo dell'Opera di Santa Croce, Florence)

Duccio di Buoninsegna (c.1255/60–1315/8), *Crucifixion* (1308/11; Museo dell'Opera del Duomo, Siena)

Mathias Grünewald (1470/80–1528), *The Crucifixion*, from *The Isenheim Altarpiece* (c.1515; Musée d'Unterlinden, Colmar)

Rembrandt van Rijn (1606–69), *The Three Crosses* (1653; The Metropolitan Museum of Art, New York)

Jacques Villon (1875–1963), *Christ on the Cross* (twentieth century; The Museum of Modern Art, New York)

Rogier van der Weyden (1399/1400–1464), *Christ on the Cross with the Virgin and St. John, Crucifixion Diptych* (1455/9; The Museum of Art, Philadelphia)

Crucifix of Werden Sacristy (c.1065–80; Lower Saxony)

The Crucifixion (c.1100; Monastery Church at Daphne, Greece)

Burgundian Crucifixion (twelfth century; Louvre, Paris)

Crucifixion (741; Chapel of SS. Quiricus and Julitta, Santa Maria Antiqua, Rome)

DEPOSITION AND PIETA

Avignon Pietà (fifteenth century; Louvre, Paris)

Giovanni Bellini (c.1430–1516), *Pietà* (c.1470; Pinacoteca di Brera, Milan)

Giotto di Bondone (1266/76–1337), *Deposition* (c.1305; The Arena Chapel, Padua)

Pietro Lorenzetti (active 1306?–45), *Deposition* (fourteenth century; Lower Church of St. Francis, Assisi)

Michelangelo Buonarroti (1475–1564), *Pietà* (c.1498/9; Basilica Church of St. Peter, Vatican City)

Rembrandt van Rijn (after), *Descent from the Cross* (1655; The National Gallery of Art, Washington, DC)

Rogier van der Weyden (1399/1400–64), *Deposition* (c.1436; Prado, Madrid)

ENTOMBMENT

Rembrandt van Rijn (1606–69), *Entombment* (1654; The Metropolitan Museum of Art, New York)

Titian (c.1487/90–1576), *Entombment* (1559; Prado, Madrid)

RESURRECTION

El Greco (1541–1614), *Resurrection of Christ* (c.1600/5; Prado, Madrid)

Mathias Grünewald (1470/80–1528), *The Resurrection*, from *The Isenheim Altarpiece* (c.1515; Musée d'Unterlinden, Colmar)

Piero della Francesca (1410/20–92), *The Resurrection of Christ* (c.1462/4; Palazzo Communale, Sansepolcro)

SUPPER AT EMMAUS

Rembrandt van Rijn (1606–69), *The Supper at Emmaus* (1648; Louvre, Paris)

THE LAST JUDGMENT AND CHRIST IN GLORY

Michelangelo Buonarroti (1475–1564), *The Last Judgment* (1534/41; The Sistine Chapel, Vatican City)

Christ in Glory (mid-twelfth century; West Front, Chartres Cathedral, Chartres)

Christ with Four Evangelists (c.1100; South Portal, Moissac Cathedral, France)

Mosaic of Christ (1189; Apse, Monreale Cathedral, Sicily)

25

A Prefatory Note to
New Images of Man

The pioneering exhibition and catalogue New Images of Man *(1959), curated by Peter Selz, then on the staff of the Museum of Modern Art in New York City, presented the human figure in the aftermath of Expressionism and in the light of abstraction among many artists. Himself an authority on German Expressionism and knowing of Tillich's interest in that movement, as well as in subsequent developments, Selz asked Tillich to do a prefatory note to the catalogue. Selz had taken photos of the works of art to Tillich, and together they talked about the exhibition prior to Tillich's writing of the introduction. Both Tillich and Selz were interested in a new realism, not over against Expressionism and abstraction, but the human figure in the light of both.*

EACH PERIOD HAS its peculiar image of man. It appears in its poems and novels, music, philosophy, plays and dances; and it appears in its painting and sculpture. Whenever a new period is conceived in the womb of the preceding period, a new image of man pushes towards the surface and finally breaks through to find its artists and philosophers. We have been living for decades at a turning point, and nothing is more indicative of this fact than the series of revolutionary styles in the visual arts which have followed each other since the beginning of our century. Each of these styles transformed the image of man drastically, even when com-

"A Prefatory Note by Paul Tillich" is from *New Images of Man* by Peter Selz, published by the Museum of Modern Art, New York, 1959. All rights reserved. Reprinted by permission.

pared to the changes of the past five centuries. Where are the organic forms of man's body, the human character of his face, the uniqueness of his individual person? And finally, when in abstract or non-objective painting and sculpture, the figure disappears completely, one is tempted to ask, what has happened to man? This is the question which we direct at our contemporary artists, and in this question one can discern an undertone of embarrassment, of anger and even of hostility against them. Instead, we should ask ourselves, what has become of *us*? What has happened to the reality of our lives? If we listen to the more profound observers of our period, we hear them speak of the danger in which modern man lives: the danger of losing his humanity and of becoming a thing amongst the things he produces. Humanity is not something man simply has. He must fight for it anew in every generation, and he may lose his fight. There have been few periods in history in which a catastrophic defeat was more threatening than in ours. One need only look at the dehumanizing structure of the totalitarian systems in one half of the world, and the dehumanizing consequences of technical mass civilization in the other half. In addition, the conflict between them may lead to the annihilation of humanity. The impact of this predicament produces, on the one hand, adaptation to the necessities of present-day living and indifference to the question of the meaning of human existence, and on the other, anxiety, despair and revolt against this predicament. The first group resigns itself to becoming things amongst things, giving up its individual self. The second group tries desparately to resist this danger.

The works of art of our century are the mirrors of our predicament produced by some of the most sensitive minds of our time. In the light of our predicament we must look at the works of contemporary art, and conversely, in the light of contemporary works of art we must look at our predicament.

The image of man became transformed, distorted, disrupted and it finally disappeared in recent art. But as in the reality of our lives, so in its mirror of the visual arts, the human protest arose against the fate to become a thing. The artists, who are shown in this exhibition, are representatives of such protest. They want to regain the image of man in their paintings and sculptures, but they are too honest to turn back to earlier naturalistic or idealistic forms, and they are too conscious of the limits implied in our present situation to jump ahead into a so-called new classicism. They tried to depict as honestly as they could, true representations of the human predicament, as they experienced it within and outside themselves. The question as to how well they succeeded artistically cannot be answered by the present writer. It is a matter of art criticism. But the question as to how well they succeeded in stating the content of their works is a matter of personal and philosophical interpretation.

The fight for a full development of man's possibilities is a continuous task. It is never completely reached and will never be completely missed. But in some moments of history as expressed in the mosaics of Ravenna [plate 61], in Giotto [plate 4], in Piero della Francesca [plate 8], in Rembrandt [plate 18], in Manet [plate 30], more fulfillment is visible than in other moments. And at certain times and with certain artists—early Romanesque, late Gothic, Breughel [plate 15], Bosch, El Greco, Magnasco, Goya [plates 20-22], and Daumier—the pain of struggle is more visible. But neither the fulfillment nor the struggle determines the artistic quality of the work. And something else must be added here: the very fact that a great work of art depicts the negative side in the fight for humanity is in itself a fulfillment of a high human possibility. The courage and the honesty which underlie such works, and the creative power which is able to grasp the negativity of the content by the positivity of the form, is a triumph of humanity.

In the development of art since the beginning of our century the negative emphasis in the expression of the fight for humanity by far prevails. This is also true of the works presented in this exhibition with their distortions. All of them show traces of the battle for the human image they want to rediscover. They resist the temptation of tired relapses or premature solutions. They fight desparately over the image of man, and by producing shock and fascination in the observer, they communicate their own concern for threatened and struggling humanity. They show the smallness of man and his deep involvement in the vast masses of inorganic matter out of which he tries to emerge with toil and pain; they demonstrate the controlling power of technical forms over man by dissecting him into parts and re-constructing him, as man does with nature. They reveal the hidden presence of animal trends in the unconscious and the primitive mass-man from which man comes and to which civilized mass-man may return. They dare to emphasize certain elements and parts of the natural figure and to leave out others in the desire to express something which nature hides. And if they depict the human face, they show that it is not simply given to us but that its human form itself is a matter of continuous struggle. There are demonic forces in every man which try to take possession of him, and the new image of man shows faces in which the state of being possessed is shockingly manifest. In others the fear of such possession or the anxiety at the thought of living is predominant, and again in others there are feelings of emptiness, meaninglessness and despair. But there are also courage, longing and hope, a reaching out into the unknown.

26

Introductory Comment on Charlotte: A Diary in Pictures

Charlotte Salomon was a Jewish woman who fled the Third Reich and lived in southern France, with her grandparents, under the sponsorship of a Mrs. Moore, an American of German extraction. In the 1940s she began to record her life in a diary and in gouaches, Expressionist in style, that are indeed competent and moving. She and the husband she married in 1943 were killed in the gas chambers of Auschwitz in the same year. Tillich's introduction, while brief, expresses the poignancy of situations he knew all too well.

CHARLOTTE SALOMON'S PAINTINGS were shown me on one of the most agitated days in my life—a day of festive celebration. Suddenly all movement around me ceased, giving way to an inner movement: I was drawn into a human life that began and ended far away, but in which nothing was strange to me. For in these pictures and notes there is something universally human, something that bridges the distance between man and man. But what makes this life a true symbol is something more than its universality. It is specifically the life of a very gifted and sensitive young woman, lived in one of the most terrible periods of European history, that speaks in the almost primitive simplicity of these pictures. One reason why they are so expressive is that instead of concentrating on the horrors of the end, they tell a life story that is close to our own experience. Against the background of this story, Charlotte's fate—known to us

"Introductory Comment by Paul Tillich" is reprinted from *Charlotte: A Diary in Pictures* by Charlotte Salomon (London: Collins, 1963).

from others—moves us all the more deeply. Books such as this will long be a needed reminder to a mankind that relapses so easily into the indifference and triviality of daily life. They remind us of what we are always tempted to forget, namely, that the value of a human life does not consist in its length, but in its substance and message. And the short life of Charlotte Salomon has a great deal to tell us through this book.

27

Address on the Occasion
of the Opening of the
New Galleries and Sculpture Garden
of The Museum of Modern Art

*The title of the address provides its New York City setting and the
contents delineate the role of modern art. Tillich was ill at the
time the address was to be given, and the text was read by his
former colleague and lifelong friend, Wilhelm Pauck. It is the sec-
ond address, the first being "Art and Ultimate Reality," reproduced
in this volume from his addresses at the Museum of Modern Art.*

WHEN IN THE YEAR 1933 we came as refugees from Hitler's Germany to
New York, it was a great moment for us when we discovered the Mu-
seum of Modern Art. It was the first place in this bewildering city where
we could say: "This is home!" It was home, not because it awakened Ger-
man and European memories but because it was good! It represented to
us all that for which we stood and fought and which made us strangers in
the old country when that country let itself be conquered by the forces
of evil. This museum then appeared to us as an embodiment of honesty in
creative expression, both in architecture and in the arts for which archi-
tecture gives the space and the frame.

Remembering this experience I consider it as a great privilege that

"Address on the Occasion of the Opening of the New Galleries and Sculpture
Garden of The Museum of Modern Art" was originally published in *Criterion* 3,
no. 3 (Summer 1964): 39–40. It is reprinted here by permission.

now I can give my thanks to those who have made such an experience possible, to the donors and builders of this house, to those who as guardians of its integrity have made an overwhelming number of right decisions and, above all, to the artists without whose works even the finest house remains an empty shell. My expression of gratitude is certainly personal, but it is meant to express the feeling of all those who, like myself, are neither artists nor art experts, but who love the visual arts and have experienced, at least in some ecstatic moments, the opening and revealing power that art can have. And finally, I want to give thanks in the name of the many millions who have visited this place and have had at least a glimpse beneath the surface of their ordinary life.

For the arts do both; they open up a dimension of reality which is otherwise hidden, and they open up our own being for receiving this reality. Only the arts can do this; science, philosophy, moral action and religious devotion cannot. The artist brings to our senses and through them to our whole being something of the depth of our world and of ourselves, something of the mystery of being. When we are grasped by a work of art, things appear to us which were unknown before—possibilities of being, unthought of powers, hidden in the depth of life which take hold of us. They reach us through the language of art, a language different from that of our daily life, a language of symbols, however realistic the artistic style may be. This is true of all arts, and in a particular way of the arts of the eye, in the service of which this building has been renewed.

If the works of art open up and reveal what was closed and hidden, a breakthrough must occur in every artistic encounter with reality, a break through the familiar surface of our world and our own self. Only if the things as they are ordinarily seen and heard and touched and felt are left behind, can art reveal something out of another dimension of the universe. Without breaking our natural adherence to the familiar, the power of art cannot grasp us. Therefore new ways of disclosing the world have always aroused the resistance of those who wanted to stay securely with the familiar. This is not the fate of a particular style, for instance the expressionistic; it is the fate of every unfamiliar way of looking at the world. It was the glory of this museum and of the artists whose works it chose, that they fought for the unfamiliar and for the insecure. Many creative breakthroughs from the familiar to the unfamiliar, from the surface to the depth, have been shown on these walls. And we who are here today as grateful friends of the old Museum hope that this will remain so in the renewed house. There is a rule in the life of the spirit, unfortunate but inescapable, "the rule of the forgotten breakthrough." The original creative breakthrough is the result of great tensions, inner struggles, victories and defeats, oscillations between hope and despair, overcoming of external

resistance, and a final feeling of inner certainty, liberation and elation. But when it has happened and its creative power is visible, the unfamiliar slowly becomes a part of the familiar, things from the depth become pieces of the surface; the new way, once opening up and revealing, has lost its power. What was breakthrough has become repetition. The toil and the glory of the first experience is forgotten. Certainly artists can always appear who, within a given form, reveal unseen possibilities, creating the unfamiliar within the boundaries of the familiar. They are rare and equal to those through whom the first breakthrough occurred. And their works, like those of the others, retain their revealing power to the spectators for all later generations. They are the lasting harvest of a breakthrough, because they have embodied the surprise, the genuineness, the revealing power of the breakthrough in their mature creation. This justifies the museums of classical art, and certainly a museum of modern art must try to grow in parts into a museum of classical art. But in order to become classical tomorrow, a work of art must have been revolutionary today.

The past history of the Museum happened in a period of continuous artistic rebellions and many breakthroughs in a short time. There is, however, a common characteristic in the whole period since the turn of the century: the predominance of the expressionistic element over against the realistic and idealistic. A consequence of this was a more radical disruption of the surface of things, a more intensive piercing into their elements, a more sensitive vision of their demonic depth than has happened for centuries. And as a theologian I want to say that this period, in spite of its poverty of religious paintings and sculptures in the traditional sense of the word, is a period in which the religious dimension has appeared with astonishing power in non-religious works. The collections of this museum and many of its exhibitions are one of the most important witnesses to this situation.

When we look from the past to the future, we discern a radical movement which really goes to the roots. Let me call it "the art of non-art" or, in a more threatening way, the death of the concept of art. It is not an isolated event: one speaks today of the religion of non-religion, of a theology without God-language, of the language of being without being. In the art of non-art one attempts to combine pieces of trivial reality which show, through a magic, uncanny composition, the triviality of our present existence. But they show it in an untrivial way. This dying of traditional concepts may be a genuine breakthrough; for these concepts are often an impediment for a fresh encounter with reality. And if they are this, they should be removed, or at least a "non" should be put before them as in "religion of non-religion" and "art of non-art."

How is all this related to our daily life, in which we ordinarily live? The breakthrough is a pre-condition for bringing the deeper things of life into our life. But it is not the end; the way into the depth must be followed by a return to the surface. The images of our daily encounter, figures and faces, must be transformed with the help of the elements out of which reality is constituted. Such returns have started. We do not know what their development will be. But one thing we know: it is not those who have remained with the familiar and have resisted the changes in the last period who will determine this development, but those who went into the depth, who dared to show the radically unfamiliar, and then returned. We hope that, while the past history of the museum was mostly a descending below the surface, the future history will also be a transforming ascendence to the surface on which we live. But what is decisive is that the works of art which will find a home in this museum retain the revealing power they had in the first period of its history.

List of Additional
Unpublished Material on the Arts
in the Tillich Archives

In describing these documents, a distinction has been made between notes and notes in statement form, the first being words and phrases, the latter, statements in propositional form, sometimes complete sentences, sometimes not; they are not complete texts. It should also be noted that the pagination for the handwritten materials is larger than ordinarily is the case, since Tillich wrote in a large script with ample space between words and sections. The items have been identified by the archive numbers and titles.

208–405:35

Religion and Culture—Application to Science and the Arts [Five handwritten pages of notes in statement form.]

221–401:2

Religious and Artistic Symbols [Eighteen pages of handwritten materials, mainly in complete sentences. Handwritten notes in a hand other than Tillich indicates address was given at the YMHA, New York City, April 1958, and at Occidental College, January 1960.]

221–401:3

Religious Problems of Church Architecture [Eight pages handwritten notes.]

223–401:4

The Prophetic Spirit in Art [Eight handwritten pages of notes in statement form. Note on manuscript, other than Tillich, indicates it was given at Drew University, October 1958.]

225–401:6

Approaches to God through Art and Literature [Two handwritten pages of notes in statement form.]

226–401:7

Art and Symbol [Seven pages of notes in statement form.]

228–401:9

I. Form, Subject Matter, and Style [Eleven pages of handwritten notes in statement form. Portion of an address.]

231–401:12

[Artistic Styles] [Six pages of handwritten notes, with references to specific works of art, covering naturalism, Impressionism, transition to Expressionism, German Expressionism, cubism and constructivism, neorealism, surrealism, and some contributions to religious art.]

234–401:15

Commentary to the Four Levels of the Relation between Religion and Art. Criticism and Qualification [Ten pages of handwritten notes in statement form.]

235–401:16

The Threefold Meaning of Religious Art [Three handwritten pages of text.]

236–401:17

Last Lecture [probably in a series] Paintings. [Fifteen pages of handwritten notes, listing many artists.]

237–401:18

Sculptures and Paintings for Religion and the Visual Arts [Four pages of sketchy notes covering Greek art, Western art until 1900, African-Asiatic analogies, and contemporary art.]

238–401:19

Religion and Art [Eight pages of notes and notes in statement form, apparently for an address at Exeter.]

239–401:20

Outline materials for Humanities course in Religion and Culture [Five typed pages, in which the four typologies in "The Existentialist Aspects of Modern Art" are used.]

240–401:22

[Listing in typewritten and handwritten forms of four groups of paintings, based on the four types, six pages.]

242–401:23

[Listing of paintings under the four levels, five handwritten pages.]

249–401:30

Five Stylistic Elements in which Ultimate Reality is Manifest. Derived from Religious Types [Four pages of handwritten notes, stressing sacramental, mystical, prophetic, criticism, humanist anticipation, spiritual-dynamic type, and religious and artistic dangers.]

253–401:34

[List of Paintings for the Four Levels] [Five handwritten pages.]

255–401:36

Art and Spiritual Situation [Ten handwritten pages of notes in statement form.]

257–401:38; 258–401:39; and 259–401:40

The Demonic in Art [Handwritten and typed notes for the address on the same subject at Drew University, published in this volume. 252–401:33 is not by Tillich, but was part of the occasion for the address. The tape of the lecture has been deposited in the Tillich Archives.]

261–401:42

Art and Religion [Seventeen handwritten pages of notes as such and notes in statement form, used for an address in May 1953, the National Gallery of Art, according to Tillich's own handwritings.]

401–45

[Handwritten notes, mainly in statement form, covering the history of art from the Greeks to the contemporary scene. The pages are numbered from 5 to 58, the first four pages not having been found. For that reason, there is no clue as to its use.]

Photographic Credits

The editors and the publisher wish to thank the custodians of the works of art for supplying photographs and granting permission to use them.

1. Bildarchiv Foto Marburg/Art Resource, New York.
2. Photograph by John Dillenberger.
3. Alinari/Art Resource, New York.
4. Alinari/Art Resource, New York.
5. Photograph by John Dillenberger.
6. The Metropolitan Museum of Art, New York. The Fletcher Fund, 1933.
7. Alinari/Art Resource, New York.
8. Alinari/Art Resource, New York.
9. The National Gallery of Art, Washington, D.C. The Andrew W. Mellon Collection.
10. The National Gallery of Art, Washington, D.C. The Andrew W. Mellon Collection.
11. Musée d'Unterlinden, Colmar.
12. Alinari/Art Resource, New York.
13. Bildarchiv Foto Marburg/Art Resource, New York.
14. The National Gallery of Art, Washington, D.C. Gift of W. G. Russell Allen.
15. Giraudon/Art Resource, New York.
16. The National Gallery of Art, Washington, D.C. The Widener Collection.
17. Bildarchiv Foto Marburg/Art Resource, New York.
18. The Hyde Collection, Glens Falls, New York.
19. Alinari/Art Resource, New York.
20. The National Gallery of Art, Washington, D.C. The Rosenwald Collection.
21. The National Gallery of Art, Washington, D.C. The Rosenwald Collection.

22. The National Gallery of Art, Washington, D.C. The Rosenwald Collection.

23. The Museum of Modern Art, New York. Gift of Abby Aldrich Rockefeller.

24. The National Gallery of Art, Washington, D.C. The Chester Dale Collection.

25. The National Gallery of Art, Washington, D.C. The Chester Dale Collection.

26. The Metropolitan Museum of Art, New York. The Rogers Fund, 1949.

27. Yale University Art Gallery. Bequest of Stephen Carlton Clark, B.A., 1903.

28. The National Gallery of Art, Washington, D.C. The Chester Dale Collection.

29. Bildarchiv Foto Marburg/Art Resource, New York.

30. © The Art Institute of Chicago. Gift of James Deering, 1925.703.

31. Bildarchiv Foto Marburg/Art Resource, New York.

32. The Museum of Modern Art, New York. Purchase.

33. The Museum of Modern Art, New York. Mrs. Simon Guggenheim Fund.

34. The Museum of Modern Art, New York. Acquired through the Lillie P. Bliss Bequest.

35. The Museum of Modern Art, New York. Purchase.

36. Private collection.

37. The Museum of Modern Art, New York. Purchase.

38. Stiftung Seebüll Ada und Emil Nolde.

39. The Museum of Modern Art, New York. Gift of Dr. W. R. Valentiner.

40. Stiftung Seebüll Ada und Emil Nolde.

41. The Museum of Modern Art, New York. Purchase.

42. The Museum of Modern Art, New York. Acquired through the Lillie P. Bliss Bequest.

43. Los Angeles County Museum of Art, Los Angeles. Gift of Mr. and Mrs. Thomas Mitchell.

44. Giraudon/Art Resource, New York.

45. The Detroit Institute of Arts. Gift of Robert H. Tannahill.

46. Collection Walker Art Center, Minneapolis. Gift of the T. B. Walker Foundation, Gilbert M. Walker Fund, 1942.

47. The Museum of Modern Art, New York. Acquired through the Lillie P. Bliss Bequest.

48. The Museum of Modern Art, New York. Given anonymously (by exchange).

49. The Chrysler Museum of Art, Norfolk, Va. Gift of Walter P. Chrysler, Jr.

50. Dumbarton Oaks Research Library and Collection, Washington, D.C.

51. The Museum of Modern Art, New York. Given anonymously.

52. The Riverside Church, New York.

53. The National Gallery of Art, Washington, D.C. Gift of Enid A. Haupt.

54. The National Gallery of Art, Washington, D.C. Robert and Jane Meyerhoff Collection.

55. The Museum of Modern Art, New York. Purchase.

56. The Museum of Modern Art, New York. Mrs. Simon Guggenheim Fund.

57. © Philadelphia Museum of Art. Louise and Walter Arensberg Collection.

58. The National Gallery of Art, Washington, D.C. The Chester Dale Collection.

59. The Museum of Modern Art, New York. Purchase.

60. The Sidney Janis Gallery, New York.

61. Alinari/Art Resource, New York.

62. Photograph by John Dillenberger.

63. Photograph by J. David Bohl. Courtesy of The Society for the Preservation of New England Antiquities.

64. Photograph by J. David Bohl. Courtesy of The Society for the Preservation of New England Antiquities.

65. Photograph by John Dillenberger.

66. Photograph by John Dillenberger.

67. Photograph by Hélène Adant. © Soeur Jacques Marie, Chapelle de Vence.

68. Photograph by Hélène Adant. © Soeur Jacques Marie, Chapelle de Vence.

69. Photograph by John Dillenberger.

70. Photograph by James K. Mellow.

71. Courtesy of The Robert Lee Blaffer Trust.

72. Courtesy of The Robert Lee Blaffer Trust.

73. Courtesy of The Robert Lee Blaffer Trust.

Indexes

NAMES

PLATES